From the Sacred Realm

Treasures of Tibetan Art from The Newark Museum

The Newark Museum

Funding for *From the Sacred Realm: Treasures of Tibetan Art in the Collection of The Newark Museum* has been made possible by grants from The Freeman Foundation, the Geraldine R. Dodge Foundation, Inc., the National Endowment for the Arts, the New Jersey Council for the Humanities, a State Affiliate of the National Endowment for the Humanities, and contributions by Joan H. Daeschler, Eleanor and Herbert Berman, June B. Cater, Constance and Carl Szego, David Falk Memorial Fund, and The Newark Museum Volunteer Organization.

THE NEWARK MUSEUM

The Newark Museum, a not-for-profit museum of art, science and education, receives operating support from the City of Newark, the State of New Jersey, the New Jersey State Council on the Arts/Department of State, and corporations, foundations and individuals. Funds for acquisitions and activities other than operations are provided by Members of the Museum and other contributors.

Valrae Reynolds

From the Sacred Realm

Treasures of Tibetan Art from The Newark Museum

With contributions by
Janet Gyatso, Amy Heller, and Dan Martin

Prestel
Munich · London · New York

The Newark Museum

This book has been published in conjunction with the exhibition
of the same name, held at The Newark Museum, New Jersey,
from October 15, 1999 to January 20, 2000

Front cover: Avalokiteshvara, detail (see page 223; photo: Sarah Wells)
Spine: Vajravarahi (see page 213; photo: Armen)
Back cover: *Ga'u* (see page 76; photo: Richard Goodbody)

Copyedited by Kate Garrat, Alston, GB

Library of Congress Catalog Card Number: 99–63868

Photographic Credits see page 264

Prestel Verlag
Mandlstrasse 26 · 80802 Munich
Tel. (089) 381709–0, Fax (089) 381709–35;

16 West 22nd Street · New York, NY 10010
Tel. (212) 627–8199, Fax (212) 627–9866;

4 Bloomsbury Place · London WC1A 2QA
Tel. (0171) 323 5004, Fax (0171) 636 8004

Prestel books are available worldwide.
Please contact your nearest bookseller or one of the above
Prestel offices for details concerning your local distributor.

Design and typography by Heinz Ross, Munich

Map (p. 6) by Astrid Fischer, Munich
Line Drawings (pp. 252–261) by Bruce Pritchard, ©The Newark Museum
Lithography by Horlacher GmbH, Heilbronn
Printed by Peradruck Matthias GmbH, Gräfelfing
Bound by Almesberger Gesellschaft mbH, Salzburg

Printed in Germany on acid-free paper

ISBN 3–7913–2148–x (hardcover edition)

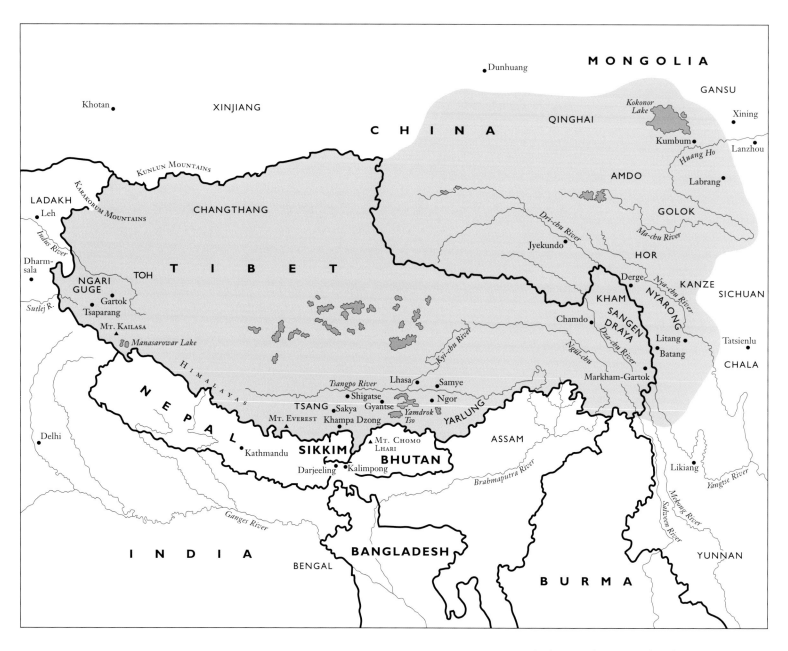

MONGOLIA

GANSU

•Dunhuang

Khotan • XINJIANG QINGHAI *Kokonor
 Lake* •Xining

 C H I N A Kumbum• •Lanzhou
 Huang Ho
LADAKH AMDO •Labrang
 •Leh *Karakorum Mountains* *Kunlun Mountains* GOLOK
 Dri-chu River *Ma-chu River*
Dharm- CHANGTHANG HOR
sala• •Jyekundo KANZE SICHUAN
 NGARI TOH T I B E T Derge• *Nya-chu River*
 GUGE KHAM NYARONG
 •Gartok SANGEN
 •Tsaparang Chamdo• DRAYA •Litang •Tatsienlu
 Sutlej R. *Dza-chu River* •Batang
 ▲Mt. Kailasa *Kyi-chu River* CHALA
 🛕*Manasarowar Lake* *Ngül-chu* Markham-Gartok
 Tsangpo River •Lhasa •Samye
 H I M A L A Y A S •Shigatse •Ngor
 NEPAL TSANG •Sakya Gyantse• *Yamdrok* YARLUNG
 Mt. Everest▲ Khampa Dzong *Tso*
•Delhi ▲Mt. Chomo ASSAM
 •Kathmandu SIKKIM Lhari
 Darjeeling• •Kalimpong BHUTAN •Likiang
 Brahmaputra River *Yangtse River*
 Ganges River *Salween River*
 I N D I A *Mekong River*
 BENGAL BANGLADESH YUNNAN

 B U R M A

Tibet and Areas of Influence

——— Political borders (prior to 1959)

▨ General area inhabited by Tibetans
(20th century)

Explanatory Notes

Phonetic spelling has been used for Tibetan
and Sanskrit words. Where appropriate, trans-
literated Tibetan spellings are also noted.
The modern Chinese system (Pin Yin) has
been used for Chinese words.

Much of the collection has been previously
published in The Newark Museum catalogues
or articles. Please consult the special Newark
Museum bibliography for citations.

C.E. (Common Era) and B.C.E. (Before the
Common Era) are used in lieu of A.D. and B.C.

Foreword

The Newark Museum's Tibetan collection is regarded as one of the foremost holdings in the world of such material. As the tragic events of the twentieth century have caused the disruption of traditional life and culture in Tibet, the Museum's collection has become even more valuable a record of a civilization now vastly altered. The Newark Museum is proud that it has not only amassed this material, but that it has also consistently supported related scholarship and interpretation. The publication of this volume, *From the Sacred Realm*, is evidence of the Museum's continued commitment to this great collection.

Valrae Reynolds, Curator of Asian Collections, has supervised all aspects of this catalogue and written much of the text. In her thirty-year career as its steward, she has brought continuing distinction to this important holding, building upon the work of her noted predecessor, Eleanor Olson, and the legions of those—Westerners and Tibetans alike—who have been vitally interested in helping The Newark Museum preserve this essential archive of Tibetan life and culture. The Trustees join me in applauding Ms. Reynolds' dedication to excellence and the significant accomplishment represented in bringing this book to press. Scholars Amy Heller, Dan Martin and Janet Gyatso have provided valuable assistance in researching many aspects of the collection as well as in contributing extensive segments of the text. Jürgen Tesch and his staff at Prestel Publishers have produced a beautiful book which will find the worldwide audience that The Newark Museum's wonderful collection deserves. We have been particularly encouraged throughout this project by Mrs. Houghton Freeman, to whom we extend special appreciation.

The publication of *From the Sacred Realm: Treasures of Tibetan Art from The Newark Museum* would not have been possible were it not for grants from The Freeman Foundation, the Geraldine R. Dodge Foundation, the National Endowment for the Arts, the New Jersey Council for the Humanities, a State Affiliate of the National Endowment for the Humanities, and contributions from Joan H. Daeschler, Eleanor and Herbert Berman, June B. Cater, Constance and Carl Szego, David Falk Memorial Fund, and The Newark Museum Volunteer Organization. The Trustees of The Newark Museum thank them for their foresight and willing partnership with us. We are also grateful for the ongoing support of the City of Newark, the State of New Jersey and the New Jersey State Council on the Arts/Department of State.

Mary Sue Sweeney Price
Director

Acknowledgements

Many people have contributed to this publication and I am indebted to all of them for their advice, comments and support. Those individuals who helped in the formation and documentation of the Tibetan collection over the last 90 years are mentioned in the *Introduction*. Many colleagues have been of invaluable assistance in my 30-year career at the Museum, shaping my understanding of Tibetan culture, of Buddhist practice and of the beauty of the objects. Samuel C. Miller, Director of The Newark Museum from 1968–93, had the vision and courage (with the enthusiastic approval of the Board of Trustees) to acquire major pieces for the collection as they became available in the world market from the 1970s-90s. Mary Sue Sweeney Price, his successor (and the current Board), has continued this support. Moreover, both Mr. Miller and Mrs. Price have encouraged the interpretation of the collection through expanded galleries, scholars' visits and publications.

I have been privileged to work with Tibetan friends who have helped me to appreciate their history and society. Foremost of those have been Nima Dorjee and Pema and Phintso Thonden. The major American collectors of Tibetan art have long been friends and supporters of The Newark Museum and I am personally grateful for their friendship and enthusiasm: Jack and Muriel Zimmerman, John and Berthe Ford and Wesley and Carolyn Halpert. Several dealers in the field have been of particular importance in forming the collection from the 1970s-90s: Doris Wiener (joined in recent years by her daughter, Nancy), Ian Alsop (who has also helped with Newari inscriptions and the study of Nepalese influence on Tibetan art), Arthur Leeper, Alan Kennedy and Tony Anninos.

In the preparation of this book, I have been fortunate to have the participation of three fine scholars: Amy Heller, who received her doctorate degree in Tibetan history and art at the École Pratique des Hautes Études, Paris, and who is now based in Switzerland, has researched and published many aspects of The Newark Museum's collection in the last twenty years, co-publishing with me the revised editions of volumes I and III of the *Tibetan Catalogue* (1983 and 1986). She has re-assessed many individual pieces for this publication. Her essays on Tibetan history and religion, which form Chapter I here, first appeared in the *Tibetan Catalogue*, volume I. Dan Martin is a scholar of Tibetan studies who has held positions at Harvard University, Indiana University, and the Hebrew University of Jerusalem. He has written pioneering articles on Tibetan popular religious practice, relics and pilgrimage. His essays on the *vajra* and bell and the *phurpa* were written for this publication. Janet Gyatso is Assistant Professor of Religion at Amherst College, Massachusetts. She has published many books and articles on Tibetan Buddhist philosophy. She has kindly allowed her essay "Image as Presence", first written for the *Tibetan Catalogue*, volume III, to be reprinted here.

Translations of Tibetan inscriptions on many of the collection paintings, sculptures, ritual objects and documents have been done by Amy Heller, Dan Martin and Nima Dorjee with assistance from Janet Gyatso and Tashi Tsering. Kathryn Selig Brown read through early drafts of the entire manuscript with many helpful suggestions and also worked on translations.

Here at the Museum, Ruth Barnet has cheerfully typed many manuscript drafts and provided able proofreading and coordinated all of the international mail, telephone, fax and Federal Express communication between the Museum, scholars and publisher. Zette Emmons backed up all curatorial chores and helped supervise much of the photography. Lisa Mazik, Kim Hoffnagle and Bari Falese, of the Registrar's Department (with the kind approval of Rebecca Buck) have also assisted in preparing objects for photography. Richard Goodbody has done a wonderful job of photographing difficult material, never losing his good humor.

It has been a pleasure to work with the Prestel publishing house on this publication. Jürgen Tesch has provided guidance and support and Christopher Wynne has shepherded the project through all of the production intricacies. I am grateful to Andrea Belloli and Michael Maegraith for their early enthusiasm for a joint Newark-Prestel publication. Kate Garratt has done a fine job of editing and Heinz Ross has produced a handsome book design.

Finally, I would like to thank The Newark Museum Deputy Directors Ward Mintz and Meme Omogbai for their assistance, and to Director Mary Sue Sweeney Price who from the beginning believed in the importance of this publication and ensured its successful completion.

Valrae Reynolds
Curator of Asian Collections

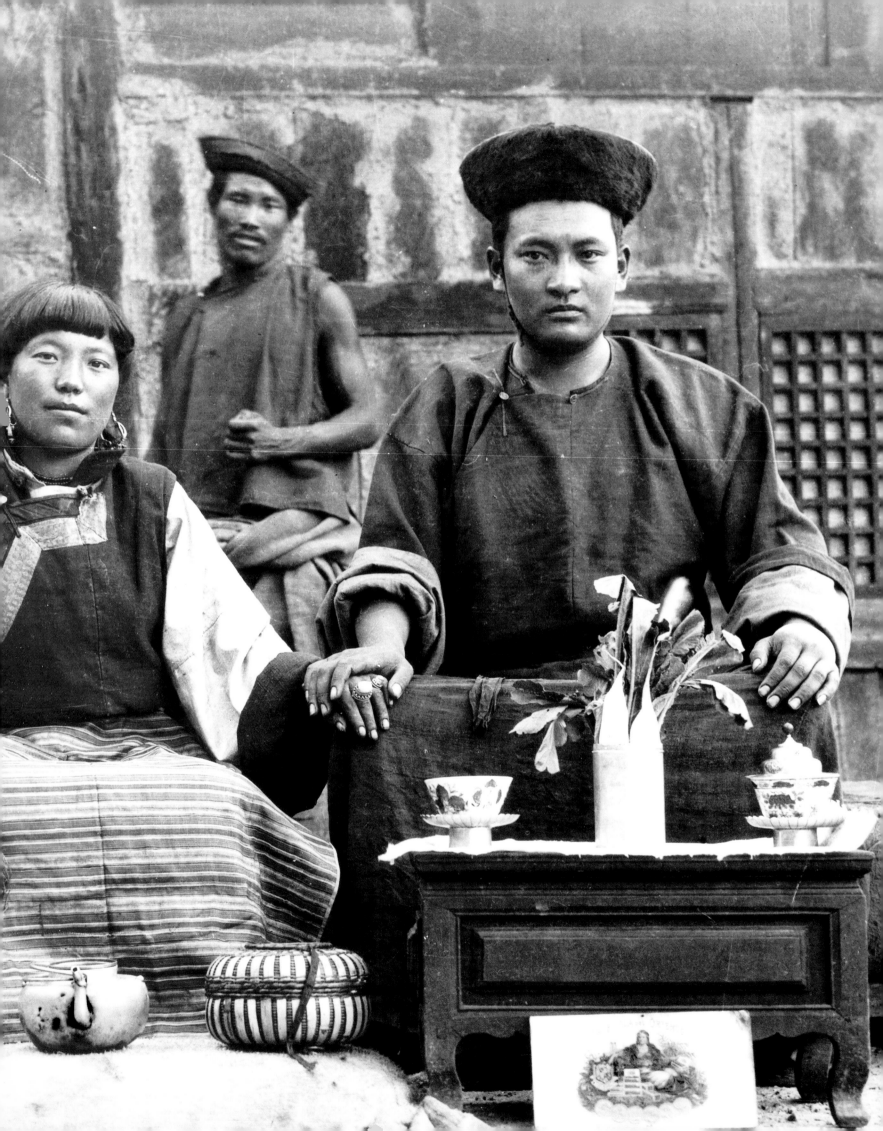

The Tibetan Holdings of The Newark Museum

In December of 1910, on the steamship *Mongolia* en route from Yokohama to America, Edward N. Crane, a founding trustee of The Newark Museum, met Dr. Albert L. Shelton who was returning from a six-year mission in western China and Eastern Tibet. As their shipboard friendship developed, Crane became interested in the group of Tibetan artifacts which Shelton had collected and wished to sell in order to finance the work of his mission hospital.

Dr. Shelton seems to have been a person with an extraordinary empathy with people, who in turn responded by placing great trust in him. Born in Indianapolis, Indiana in 1875, Shelton decided as a young man on the career of a medical missionary, obtained a medical degree and was sent to China in 1903 by the Foreign Christian Missionary Society, a group connected with the Disciples of Christ. He and his wife Flora Beale arrived in Tachienlu, a town in the mountain wilds of Sikang (now modern Sichuan), western China, in 1904. Although in political China, Tachienlu (the capital of the kingdom of Chala) was on the edge of Kham, the Eastern Tibetan province then being rent by fierce fighting between Tibetan and Chinese forces. After four years and the birth of two daughters, Dorris in 1904 and Dorothy in 1907, the Sheltons moved their mission hospital west to the more completely Tibetan city of Batang. At that time Batang was just outside political Tibet but well into the Tibetan cultural area of Kham.

All of Kham had for several decades been politically destabilized by disputes between and among local ruling clans and provincial authorities. From the 1860s through 1918, the Tibetan and Chinese governments sent troops and representatives to intervene in these disputes, with frequent changes in borderlines. These local wars were influenced by (and contributed to) the larger geopolitical situation between Tibet, China and Great Britain (which was trying to expand its control over the entire Himalayan region). The British military expedition of 1903–04, led by Younghusband, proved to be a disaster for Tibet. With British troops triumphing in southern Tibet and then occupying Lhasa, Tibet's capital, the 13th Dalai Lama fled to Amdo (northeastern Tibet), Mongolia and China in 1904–09.

The Chinese took advantage of the chaotic situation in Tibet, establishing a new post of Imperial Resident at Chamdo in Kham. This Resident traveled in 1904, first to Tachienlu where he deposed the King of Chala. The Chinese Resident then proceeded to Batang, interfering with Tibetan monastic control of the region. In 1905, the monks led a revolt and the Resident was killed. A general uprising of all the monasteries in Kham ensued. A Chinese punitive mission from Sichuan razed the Batang monastery (fig. 1) and executed the Tibetan headmen in retaliation.

The Dalai Lama returned to Lhasa in December, 1909, but Chinese forces continued to advance. In February, 1910, Chinese troops invaded Lhasa. This

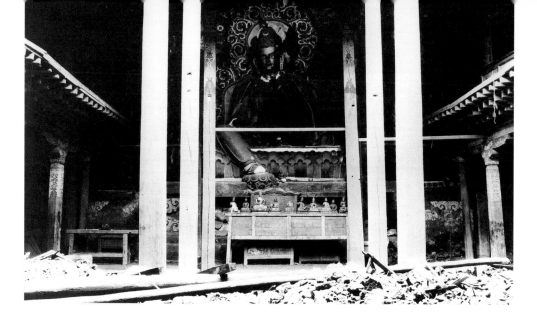

Fig. 1
A ruined chapel at the monastery of Batang, Kham, Eastern Tibet, *circa* 1908. The damaged main image is of Padmasambhava (note that a small altar has been arranged at the center).

time the Dalai Lama sought asylum in India. The 1911 Chinese revolution allowed Tibetan forces to clear Chinese troops from central and southern Tibet, but looting and destruction continued across Kham. Continued hostilities along the border led to a new mediation in 1918, upholding Tibetan claims to Chamdo, Draya, Markham and Derge, while ceding Batang, Litang, Nyarong and Kanze to China.

The Sheltons' sabbatical trip from 1910–13 to the United States saved them from experiencing the destruction of Batang following the 1911 revolution. Crane, acting upon the shipboard friendship, arranged to have Shelton's collection of approximately 150 Tibetan objects lent to the fledgling Newark Museum for display. In a letter to Crane in March, 1911, Shelton explained, "I have no desire to go into this business about the curios in any commercial spirit whatever. My only object in bringing the articles to this country at all was that they might go to some <u>American</u> institution" [underlining is Shelton's]. The fledgling institution in Newark was rather timid about purchasing items from such an esoteric location as Tibet. When the Shelton pieces had been put on view in Newark, however, the very exotic nature of the material seems to have made the exhibit a great success: from February to June, 1911, 17,724 people visited the display rooms. The matter of purchase was settled, in the end, when Crane suddenly died in the summer of 1911. His wife and brother, in appreciation of Crane's interest in the collection, purchased it from Shelton and presented it in its entirety to the Museum as a gift. This group is identified as the "Edward N. Crane Memorial Collection".

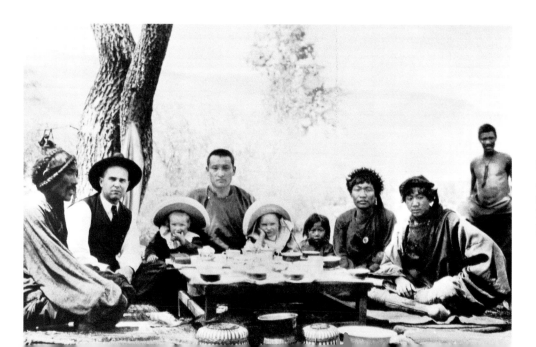

Fig. 2
A Tibetan picnic, the Jö Lama seated between Shelton's daughters, Dr. Shelton at left, Batang, Kham, Eastern Tibet, *circa* 1913.

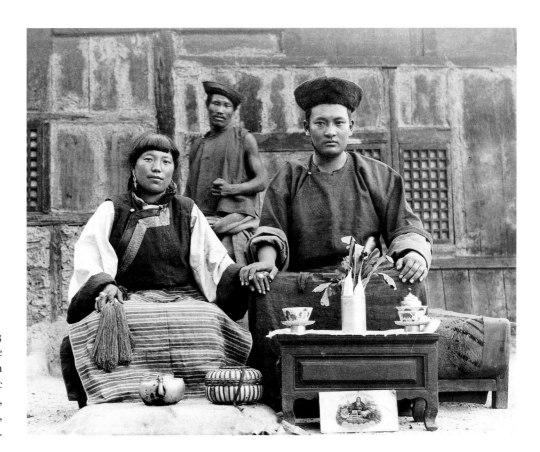

Fig. 3
The Jö Lama and his wife
posed for a formal photograph
with some of their domestic
possessions (note Italian cigar box),
Batang, Kham, Eastern Tibet,
circa 1913.

This founding collection set the precedent for The Newark Museum's Tibetan holdings: a breadth of material of the highest quality, representing all aspects of Tibetan culture. Included in this 1911 group are pen cases, sling shots, coins, teapots, earrings, boots, hats, guns, swords, monastic garments, ritual vessels, images and *tangkas*. Perhaps the most important pieces are a silver *Wheel of the Law* associated with the 6th Panchen Lama which Shelton received from the Jö Lama in Batang and a set of fourteen manuscript volumes of the *Prajnaparamita* (now Carbon-14 dated to the twelfth century) rescued from the destroyed royal palace in Tachienlu.

The Museum commissioned Dr. Shelton, upon his return to Batang in the fall of 1913, to continue to collect Tibetan "curios" with the idea of adding to the Museum's original group. The difficulties of sending freight from Tibet to America are evident in a letter to the Museum from Shelton at this time, outlining the route and expenses:

> I'll give you as near as I can the approximate cost,
> on 100 lbs. from Batang to New York.
>
> Freight
> 460 miles on Yak (Batang to Tachienlu) about 8 Ru $2.00
> 140 miles on men's backs to Yachow at 40 cash about 2.00
> 600 miles by water to Ichang at about 30 cash 1.50
> 1000 miles by steamer to Shanghai at 75 cents .75
> Shanghai to New York about 3.50
> _____
> $9.75

Further letters in 1915 and 1916 refer to the precarious situation in the border areas. Although the Shelton family's own writings have little to say on the "war conditions" prevailing from 1914 to 1918, Eric Teichman's book cites Batang, with Chamdo, as a center of Chinese military activities in the period. With the loss of Chamdo to Tibetan forces under the Kalon Lama in April, 1918, Batang became the primary Chinese garrison. Dr. Shelton was an active player in the intense peace negotiations of 1918, as cited by Teichman. Shelton's fluency in both Tibetan and Chinese and, especially, the universal trust in his honesty, made him an invaluable go-between.

The friendship and respect earned by Dr. Shelton during his first stay in Batang were amplified in the 1913–19 period, as political events put Shelton in direct contact with the Tibetan central government. Lhasa had sent the Kalon Lama, Commander in Chief of the Tibetan army, to prevent Chinese troops from advancing beyond the 1914 border. The Governor of Markham (fig. 4), southwest of Batang, was also a direct representative from Lhasa. Dr. Shelton became a close friend of both men while assisting in the 1918 negotiations with China. Locally, the Shelton family became close to the two religious authorities in Batang, the Ba Lama, an incarnate lama who headed the re-established monastery, and Jö Rimpoche, an incarnate lama from neighboring Atuntse (Jö)(figs. 2 and 3). The royal family of Derge was under house arrest in Batang, and members of the King of Chala's family also resided there in exile from Tachienlu. The remaining son of the ruling family of Batang had returned from China and lived with the Shelton family.

In late 1919, the Sheltons again left Batang for the United States, taking with them a large group of objects for The Newark Museum. In the vicinity of Yunnanfu, in the Chinese province south of Kham, twelve days out of Batang, their caravan was attacked by robbers. Dr. Shelton was taken captive and held for ransom; the rest of the party and most of the baggage escaped. Shelton was finally rescued three months later and returned with his family to the United

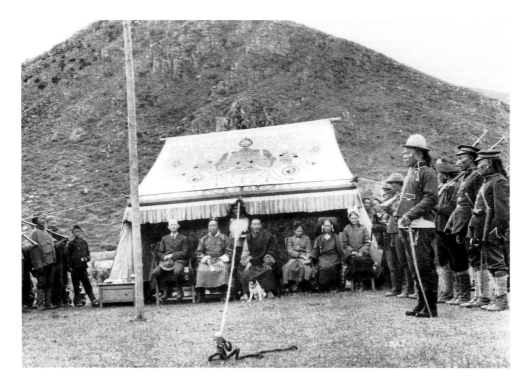

Fig. 4
Ceremonial tent set up for review of the Governor (*Teji*) of Markham honor guard, left to right: The Rev. MacLeod (a colleague of Dr. Shelton), the *Teji*, a lama, Dorothy Shelton, the *Teji*'s wife, Dorris Shelton, Markham-Gartok, Kham, Eastern Tibet, 1919.

States in the late spring of 1920. The objects for the Museum, none the worse for the trip, arrived safely as well.

Over 600 objects were included in this 1920 group which is identified as "The Shelton Collection". The diversity and quality of Tibetan pieces obtained earlier by Dr. Shelton is again to be seen, with guns, quiver and arrows, tea and beer jugs, saddles, *tsakali*, ritual textiles, sculpture and paintings. Important individual objects include a set of fifteenth-century manuscripts, brass and silver monastic musical instruments and an eleventh-century gilt-copper image of Tara.

After a recuperative stay in America, Dr. Shelton returned to Batang. This time he was alone, as Mrs. Shelton had gone to India to work on some translations and the two girls remained in the United States for their schooling. Shelton now intended to go on to Lhasa and establish a medical mission there. It is a testament to the doctor's high regard among Tibetans throughout Kham that plans for such a bold move were progressing at the highest level in Lhasa. Shelton hoped to train young Tibetan men in simple Western medical procedures such as sterile bandaging of wounds. Dorris Shelton Still has given the Museum a copy of the letter sent to the doctor from the 13th Dalai Lama giving permission to visit Lhasa, a gesture arranged by the Governor of Markham and the Kalon Lama in thanks for Shelton's help in the 1918 peace negotiations.

Shelton started out from Batang accompanied by the son of the headman of Batang, his teacher Gezong Ogdu, and some companions on February 15, 1922. One day out they received a note from the Governor of Markham, asking them to turn back temporarily to Batang as the times were unfavorable for foreign visits to Tibet's interior. The next day, while heading back, Dr. Shelton was most tragically killed by bandits.

The Crane/Shelton collection, because of its known provenance and early date of acquisition, is a rich source of documentation for ritual as well as domestic objects. Amazingly diverse for a relatively provincial area, the pieces from the noble families and ruined monastery of Batang (many purchased with the assistance of Shelton's friends, the Jö Lama and the son of the Prince of Batang) are among the finest liturgical pieces ever to have left Tibet. The violent political climate provided the conditions under which an outsider such as Shelton could acquire these treasures.

Between 1928 and 1948 three more missionary collections, all from northeastern Tibet were purchased, greatly enhancing the Museum's holdings of ethnographic and ceremonial art. These were the Robert Ekvall collection, from the Kokonor nomad region, Amdo, 1928, the Carter D. Holton collection, from Labrang, Amdo, 1936, and the Robert Roy Service collection, formed during trips to northeastern Tibet and acquired from Chinese traders in the border areas, 1948. Holton and his colleague, the Rev. M. G. Griebenow, worked at the American-sponsored Christian and Missionary Alliance Mission at Labrang.

It is interesting to note that the very existence of this Christian Missionary group in northeastern Tibet was due to the good reputation of Dr. Shelton's mission in Kham. Tibetans, and certainly the Lhasa government, were not ordinarily well-disposed to any Christian proselytizing efforts. Like Kham to the south, Amdo suffered from the internal unrest in China in the first half of the twentieth century. From 1724–1911, the entire area had been administered

by a Chinese *amban* located at Xining. The *amban* oversaw the monasteries and the local rulers who had immediate economic and legal control of the people. The nomads of Amdo, however, were noted for their independence both from the central Chinese authority and from local monastic or lay governments.

Between 1911 and 1950 the lowland areas of Amdo were subject to conflicts between the urban Chinese, the sedentary Tibetans and the Muslim traders and farmers who formed a large segment of the population. Muslim ascendancy was especially evident during periods when Chinese central authority was weak, as during the Japanese occupation of northern China from 1937–45. The highlands of southern and western Amdo were unsuitable for agriculture and thus were left primarily to the pastoral Tibetan nomads. Therefore, during the first half of the twentieth century, these Tibetans were able to preserve their independence and remained relatively free of Chinese cultural influence. The Museum's collections from Amdo are especially rich in nomadic material. Ekvall, born on the Gansu-Tibetan border, obtained costumes and objects of everyday life from Tibetan nomads in the Kokonor region. Ekvall's numerous publications give much helpful information on social and political relations between Tibetans, Chinese and Muslims in this border area.

Carter D. Holton was stationed in various Chinese cities in Gansu but made trips to Tibetan areas, primarily Labrang. It was in and around Labrang that the extensive Holton collection, purchased by the Museum in 1936, was obtained. These holdings are mainly secular artifacts recording the lifestyle of nomadic and sedentary Tibetans, but several important manuscripts and ritual objects are also included.

Rev. M. G. Griebenow was perhaps the most important American, from the Tibetan point of view, to work in Amdo. Although the Museum obtained only photographs from him, these provide vital documentation of the *in situ* use of the Ekvall and Holton collections. Griebenow, known to the Tibetans as Sherab Danpel, and his family were stationed in Labrang from 1921 to 1949 (excepting furloughs). Griebenow performed medical services and, like Shelton, was fluent in Tibetan. He traveled extensively in the Tibetan highlands where he became well acquainted with local Tibetan secular and religious authorities. The two most important personages in Labrang, Apa Alo and his brother Jamyang Shepa Rimpoche, were close friends of Griebenow. Griebenow made use of both his photographic and his medical skills to extend friendships in the Tibetan community.

The Museum's Amdo material has been enriched by the gift of color slides and black-and-white prints taken in 1949 in and around Labrang by younger members of the Christian and Missionary Alliance: Dr. William D. Carlsen, Dr. Wayne Persons and Dr. Gene Evans.

The Newark Museum was fortunate to have had C. Suydam Cutting as a catalyst to its Tibetan activities from the 1930s through the 1970s. A New York financier with estates in New Jersey, Cutting was a naturalist-explorer with personal ties to the Theodore and Franklin Roosevelt families. He traveled to the eastern borderlands of Tibet and to Ladakh and Turkestan with the sons of Theodore Roosevelt in the 1920s. Through his friendship with British Lt. Col. F. M. Bailey, Cutting obtained permission in 1930 to visit Gyantse and Khampa Dzong, towns in southern Tibet open to British trade. Probably using Bailey as

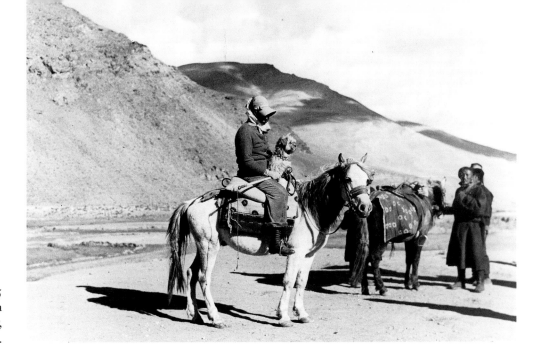

Fig. 5
Helen Cutting with a
Tibetan terrier on a pony,
central Tibet, 1937.

an initial intermediary and his own credentials as an "American aristocrat",
Cutting was able to establish a personal correspondence with the 13th Dalai
Lama at least by 1931. This correspondence, intended on the Dalai Lama's part
as a way to reach the United States Congress and President, and thus use American leverage to bypass British trade restrictions, and on Cutting's part to get
permission for big game hunting in Tibet, lasted until the 13th Dalai Lama's
death in 1933.

Contact continued, however, between Cutting and the Tibetan Assembly
(the *Kashag*) and resulted two years later in an invitation for Cutting to visit Shigatse and Lhasa. In 1935, Cutting became the first American to travel officially
to the holy city. Because of his passport, Cutting was able to meet with church
and government officials and to take hundreds of photographs of everyday as
well as aristocratic and ecclesiastic life. Cutting also obtained costumes and religious artifacts which are in the collection of the American Museum of Natural
History, New York (as are the flora and fauna collected by the earlier Cutting-
Roosevelt expeditions to the Tibetan borderlands). In 1937, Cutting returned
to Lhasa with his wife, Helen (fig. 5). He continued to correspond with various
Tibetan government figures and, beginning in 1946, with the young 14th Dalai
Lama.

It was through his wife, a trustee of The Newark Museum from 1943 to
1961, and of course through a mutual interest in Tibet, that Cutting became
involved with the Museum (fig. 6). When the Tibetan Trade Delegation visited
the United States in 1948, Cutting arranged for them to spend a day at the
Museum viewing some of the collection (fig. 7). This was the first direct contact between Newark and Tibet. The leader of the Delegation was *Tsepon* Shakabpa. *Depon* Surkhang, second in command, had a long-standing connection
with the Shelton family through his aunt who had married the headman of
Batang. Cutting endowment funds have been used since 1950 to purchase
objects for the Tibetan collection. Following Cutting's death in 1972, his widow
Mary Pyne Filley Cutting (Helen, his first wife, died in 1961) gave his collection of correspondence with the 13th and 14th Dalai Lamas, the *Kashag* and
Tsarong *Shapé*, photographs, films, and miscellaneous memorabilia to The
Newark Museum. The generosity of the Cutting and Filley families has con-

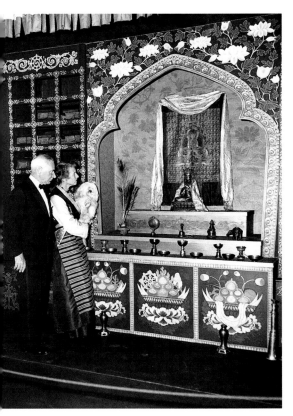

Fig. 6 C. Suydam and Helen Cutting
(with Lhasa Apso) viewing the 1935 altar
at The Newark Museum, April, 1949.

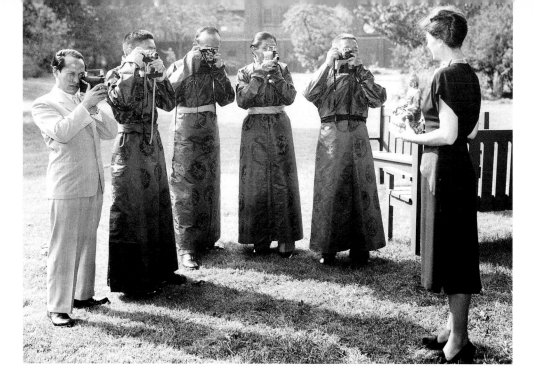

Fig. 7
Members of the Tibetan Trade Delegation
photographing Eleanor Olson, Curator
of Oriental Collections in The Newark
Museum garden, September, 1948.
Left to right: Tsephal Taikhang,
Depon Surkhang, *Tsepon* Shakabpa
and Pangdatshang. Man at left is the
Nepalese interpreter.

tinued, with endowments and gifts to allow future Tibetan acquisitions and to enhance the documentation of the collection.

The formation of The Newark Museum's Tibetan collection would not have been possible without the energy and enthusiasm of certain individuals within the institution. John Cotton Dana, founder and first director, had a personal love of Asian cultures and arranged for the creation of the Museum in 1909 with the purchase, by the City of Newark, of a private Japanese collection. Dana thus set the stage for an easy reception, two years later, of the Shelton loan exhibition as arranged by Crane. Once on the Tibetan "trail", Dana applied his characteristic energy and found funds to commission Shelton to add to the Museum's holdings. The rest of the Shelton material and the Ekvall collection were purchased during Dana's tenure. The four subsequent directors of The Newark Museum have continued with equal fervor to support the enrichment of its Tibetan collection.

In 1935 The Newark Museum built a Buddhist altar to give a meaningful setting to its extensive holdings of Tibetan sacred art. American artists working under the auspices of a Federal Emergency Relief program were commissioned to design the altar. To construct an authentic setting, these artists studied photographs of Buddhist structures in Tibet and consulted the very few American travelers to Tibet. Although initially conceived as only a temporary "tableau", Newark's altar—the first in America—over the years absorbed the affection and devotion of both casual visitors and Buddhist followers.

The most important individual to shape the direction of the Tibetan collection was Eleanor Olson (fig. 7), who had charge of the Oriental collections from 1938 to 1970. Although Miss Olson was not designated curator until such departments were established at the Museum in 1950, she had specialized in Asia and particularly in Tibet as an assistant to the Registrar. Her initial two volumes of the Tibet catalogue (I and II) were issued in 1950. Miss Olson was able to visit Tibetan areas of the Indian and Nepalese Himalayas during a tour of Asia as a Fulbright Scholar in 1956. Volume IV of the Tibetan catalogue was completed by Olson in 1961, and Volumes III and V, published in the year of her retirement, 1970, capped her long and distinguished career.

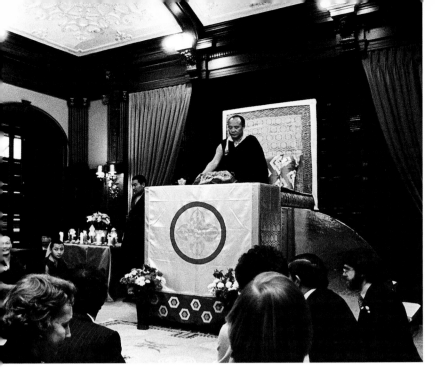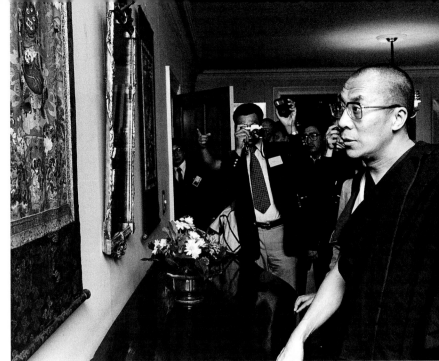

Fig. 8 His Holiness, the 16th Gyalwa Karmapa performing a ceremony for World Peace at The Newark Museum, December, 1976.

Fig. 9 His Holiness, the 14th Dalai Lama viewing the Tibetan collection at The Newark Museum, October, 1979.

Eleanor Olson's pioneering research in the Tibetan field was done at a time when such studies were in their infancy. Until the arrival of the 1948 Tibetan Trade Delegation to America, there were no Tibetans in the United States and only a handful of Tibetologists. Among these, Miss Olson was lucky to have the assistance of such individuals as Roderick A. MacLeod (Shelton's associate in Batang), Wesley E. Needham, adviser to the Tibetan collections, Beinecke Rare Book and Manuscript Library, Yale University, and Schuyler V. R. Cammann, whose wide-ranging knowledge of Tibet, China and Central Asia was especially helpful. The author of this catalogue was fortunate to serve as Eleanor Olson's assistant from 1969–70, and to benefit from her advice and friendship until her death in 1982.

In the aftermath of World War II, a refugee Kalmykia Mongol Buddhist community was resettled in central New Jersey. Their religious leader was Geshé Wangyal. Although a Kalmyk, Geshé Wangyal was the first lama to come to America who had had the full traditional Tibetan Buddhist monastic training (at Drepung outside of Lhasa from 1922–31 and again in Tibet from *circa* 1939 to 1950). Geshé Wangyal not only served the religious needs of the extensive Mongol community in New Jersey but also established a flourishing monastic center there at which many of America's leading Tibetan scholars were trained. The Museum has enjoyed the friendship and advice of Geshé Wangyal (who died in 1983) and the learned Tibetans and Americans who have been associated with his flourishing monastery and retreat center.

The first great incarnate lama to visit The Newark Museum was His Holiness, the 16th Gyalwa Karmapa, spiritual head of the Kagyu order. The Karmapa performed a private ceremony for World Peace at the Museum in December, 1976 (fig. 8). His Holiness, the 14th Dalai Lama first came to Newark in October, 1979, when he delivered a major address on "Deity Yoga" (fig. 9). In July, 1981, he toured the exhibition, *Tibet, A Lost World*, and presented a charm box to the collection.

The political events of the second half of the twentieth century and the exodus of Tibetans from their homeland have brought Tibetan artifacts into the commercial market in quantities unknown before 1959. Through gifts and pur-

chases during the last forty years, the Museum has been able to enrich its holdings of central and southern Tibetan pieces. The scholarly assistance of Tibetans in the New York-New Jersey area has allowed the Museum to greatly strengthen its research on the collection. Those who have helped particularly are Nima Dorjee, Chongla Rato Rimpoche, Lobsang Lhalungpa, Mr. and Mrs. Lobsang Samden, Tsephal Taikhang, Tenzin Tethong, Rinchen Dharlo, Mr. and Mrs. Phintso Thonden and Dorje Yuthok. On his several trips to the United States, *Tsepon* W. D. Shakabpa, leader of the 1948 Trade Delegation, helped to catalogue the archive photographs and manuscripts.

The diaspora of Tibetans has been paralleled by an explosion of scholars, collectors and Buddhist practitioners world-wide. Particularly in Europe and Japan, but as far from Tibet as Australia and Canada, universities have established Tibetan studies and private individuals and museums have acquired Tibetan artifacts. The author has had the pleasure of working with an international network of individuals, as virtually every scholar and lover of Tibetan culture has visited The Newark Museum or benefited from access to its archives and publications. Many of the Museum's masterpieces traveled to Paris and Munich for the first international exhibition of Tibetan art in 1977. From 1978 until 1981, 213 of Newark's Tibetan objects toured the United States in the exhibition, *Tibet, A Lost World*.

In the mid 1980s, The Newark Museum planned for a major expansion and renovation, with the creation of eight permanent Tibetan galleries in a new wing. The Museum realized that it had special obligations as keeper of one of the world's most extensive and important Tibetan collections. Great lamas and descendants of Tibet's noble families had visited the Museum, helped research and added to the collection. They saw the rare objects there as invested with sacred power or with weighty historical and social meaning. Moreover, the beauty of many of these objects placed them on a level with other masterpieces of the world. With this in mind, the Museum began a project entitled, *Tibet, the Living Tradition*. The Museum's curator and designers worked with lay and religious members of the Tibetan community, as well as with scholars of Tibetan religion, history and anthropology, to ensure the accurate selection and interpretation of objects from the Tibetan collection.

The renovation and expansion of the Museum complex necessitated the dismantling of the 1935 altar. As the first step in the Museum's newly self-conscious assessment of its obligations, the altar was deconsecrated by the Venerable Ganden Tri Rimpoche in a special ceremony for the local Tibetan community in January, 1988. During this ceremony, the Buddhas were asked to temporarily leave the altar and return to their celestial abode, what Buddhists call the "Pure Land". The images, paintings, manuscripts and ritual objects could then be packed away in storage awaiting the time when they would be incorporated into the new altar. The particle-board architectural elements of the old altar were carefully cut apart and saved.

The Newark Museum staff now had the exciting task of working with the team of Tibetan advisers to create an authentic new altar. Phuntsok Dorje, a Tibetan artist trained at Rumtek monastery in Sikkim, was selected as artist-in-residence. In the winter of 1988–9, Dorje began to draw designs and select colors, working with plans and a cardboard model. With final dimensions,

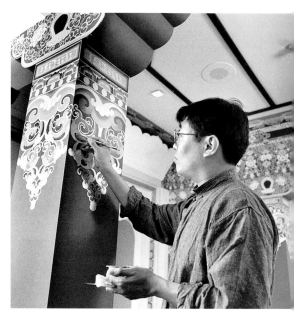

Fig. 10 Phuntsok Dorje painting the new altar at The Newark Museum, November, 1989.

Fig. 11
His Holiness, the 14th Dalai Lama
following the consecration ceremony
for the new Buddhist altar at The Newark
Museum, greeted by the Most Reverend
Desmond M. Tutu, Anglican Archbishop
of Capetown, South Africa (left) and the
Most Reverend Theodore E. McCarrick,
Roman Catholic Archbishop of Newark
(right). In background, the Honorable
Sharpe James, Mayor, City of Newark;
Phuntsok Dorje, Artist-in-Residence;
and Valrae Reynolds, Curator of Asian
Collections, The Newark Museum,
September, 1990.

shapes and details selected, special carpentry work was set in place for the columns and shrine opening. The structural sections of the 1935 altar were sealed in a recess of the new altar, in accordance with the Tibetan tradition of linking the spiritual presence of the old with the new. The "Living Tradition" team also planned the installation of eight new galleries which would show various aspects of the Tibetan collection, from boots and saddles to ancient manuscripts, in settings sympathetic to the original context of the Tibetan highlands. These were completed in 1989. Phuntsok Dorje continued his decoration of the new altar's ceiling, pillars, walls and arches, finishing in the summer of 1990 (fig. 10). The paintings, textiles, books, images and ritual implements that had been packed away were then installed in the appropriate areas.

His Holiness, the 14th Dalai Lama returned in September, 1990 to perform a consecration ceremony at the new altar (fig. 11). Assisted by ritual masters, lamas and attendants, the Dalai Lama first made three prostrations and presented a white *kata*, a silk scarf which is the traditional Tibetan greeting symbolizing primordial purity. The first flame was lighted in a special golden butter lamp.

Next, prayers were chanted; the *mantra* of interdependent origination (to "set the stage" for the ceremony, placing it in the context of universal Buddhist truths), taking refuge in the Buddhas, arousing compassion for all sentient beings, and making the Universal Mandala offering. Grain was tossed between chants to make the prayers "true" and "solid". The potent emblems of *tantric* Buddhism, the *dorje* and bell (power and wisdom), were held in special positions. The central moment of the ceremony was an invocation to the Buddhas to enter the altar and to stay there. These prayers were repeated three times, reminding the Buddhas that they have promised to stay in this world to teach enlightenment to all and not to enter final *nirvana* until this task is completed, and that they should not fail to carry out this promise, especially here at this altar. His Holiness has thus given his blessing to this large and active collection which shows the rich heritage of the Tibetan people.

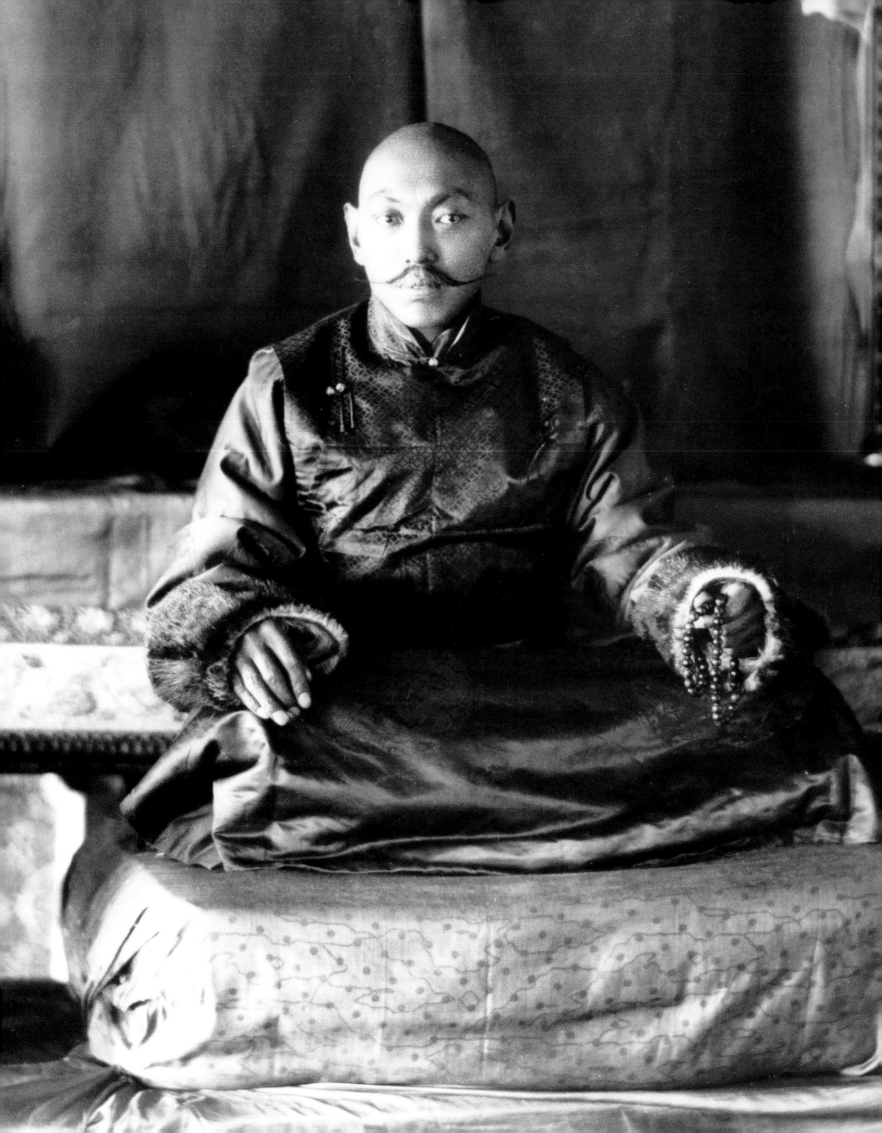

Tibetan History and Religion

by Amy Heller

History

The extreme altitudes and barren terrain of the Tibetan environment have played a fundamental role in shaping the economics, religion, and art forms of the people. Tibet is vast and empty, situated on a high plateau of approximately one and a half million square miles with altitudes ranging from 4,000 to 28,000 feet (fig. 1). The high deserts of the north and the immense mountain ranges of the west, south and east have served as isolating barriers, particularly from Tibet's densely-populated neighbors China and India. Linguistic, archaeological, architectural and artistic evidence, however, link the Tibetans through complex ties with the Greco-Roman and Persian civilizations of western Asia as well as with Chinese, Central Asian and Indic cultures.

In the seventh century C.E., when historic records of Tibet began,[1] the valley of the Tsangpo River was the home of independent tribes and minor tribal confederations. According to legends which seem to have their basis in fact, these tribes, speaking varied dialects of the Tibetan language, were politically unified from the end of the sixth century through the late seventh century. The rulers of central Tibet, based in the Yarlung Valley situated southeast of the Tsangpo, had conquered one by one the Tibetan tribes and principalities of the entire Tsangpo and gradually extended their territory to include non-Tibetan confederations in the northern, western and northeastern parts of the plateau. For two centuries this new nation was a formidable military power known and respected throughout Asia. The Tibetans of central Tibet were clustered in semi-nomadic and farming communities (fig. 2), living in tents and also stone and mud-brick houses protected by fortified stone walls and watchtowers. Although divided into principalities, the entire population took an oath to the most powerful lord, the *tsenpo* (*btsan po*) of Yarlung.[2] He unified his territory by matrimonial alliances with rival tribes and foreign powers as he further expanded the domain by military conquests.

Tibet was commercially active, crisscrossed by trade routes.[3] Early seventh-century records document export of armor and weapons, horses and other animals, textiles, salt and the prized Tibetan musk. The Chinese Tang annals record a spectacular gift received from Tibet in 641 C.E., a goose-shaped golden ewer seven feet high and capable of holding sixty litres of wine. In 648, a miniature golden city decorated with animals and men on horseback was presented as a gift.[4] As one author has written:

> To judge from the records of tribute and gifts from Tibet to T'ang which over and over again list large objects of gold, remarkable for their beauty and rarity and excellent workmanship, the Tibetan goldsmiths were the wonder of the medieval world.[5]

1 The historical sources for this period are meager but revealing. A cache of seventh- to tenth-century Tibetan manuscripts was discovered at Dunhuang in the early twentieth century; among these manuscripts are year-by-year Tibetan annals covering the reign of Songtsen Gampo. The Tibetan custom of inscriptions on stone pillars erected at the consecration of temples and signing of treaties and pacts dates from the eighth century. Buddhist theologians wrote detailed religious and political histories as of the twelfth century, compiled from much earlier material. The *terma* texts also provide historical information. For prehistoric Tibet, one must rely on legends and traditions written down at a later date, but which show the "invariability of the main sequence of the myths, legends and traditions" (Erik Haarh, *The Yarlung Dynasty*, IX).

2 Elliot Sperling, "A Captivity in Ninth Century Tibet", pp. 23, 29–30, explains that the Chinese term *tsan-p'u* used to translate *tsenpo* is the equivalent of "emperor" rather than "king", which certainly better connotes the quality of a confederation of tribes under one leader in seventh-to ninth-century Tibet.

3 On Tibetan trade in general, see Christopher Beckwith, "Tibet and the Early Medieval Florissance in Eurasia".

4 Paul Pelliot, *Histoire Ancienne du Tibet*, pp. 5, 6, 84, cites the Chinese documents *Kieou T'ang Chou* 196A and *Sin T'ang Chou* 216A for the ewer.

5 Schafer, *Golden Peaches*, p. 254.

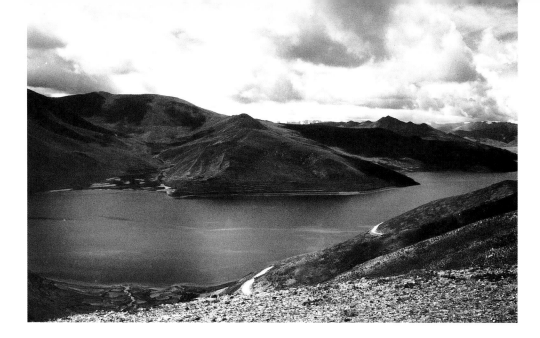

Fig. 1
Lake Yamdrok Tso with snow-covered Himalaya range in far distance (looking to the south), central Tibet, 1981.

Control of the lucrative trade routes and the sacred role of the *tsenpo* to conquer provided the major impetus for military expansion. See fig. 3 showing an eighth century pillar which proclaims Tibet's victory over the Chinese army. The *tsenpo* was believed to be divine, a warrior whose sacred helmet and radiant aura were his insignia. The ruler could guarantee the well-being and prosperity of his people in return for worship by sacrificial offerings. By extending his domain and worshiping him wherever military campaigns were conducted, prosperity was increased for all. The first historic *tsenpo*, Songtsen Gampo (*Srong btsan sgam po*, reign 620–50), conquered portions of the ancient silk route, bringing the Tibetans in contact with Central Asian and Chinese cultures. His forays into Gansu and northern Sichuan prompted the Chinese to acquiesce to his demand for a royal bride. Songtsen made vassal states of Nepal, portions of northern India and Zhangzhung, a separate area formed of Western Tibet and part of northern India. His successor occupied the oases of Khotan, Kucha, Karashahr and Kashgar from 665–92, and gained control of the Nan-chao kingdom (now the Yunnan region of China) as of 680.

Songtsen established Lhasa as his capital, moving from the Yarlung Valley with his five wives: a Chinese princess, a Nepalese princess and three Tibetan noblewomen. Tradition credits the two foreign wives with the introduction of Buddhism and for the construction of the first Buddhist temples in Lhasa.[6] It seems certain that Songtsen did not become exclusively a Buddhist, however, as

6 Giuseppe Tucci, "The Wives of Srong btsan sgam po", pp. 123–8, doubts that the Nepalese wife ever existed as she is not mentioned in historical sources prior to the fourteenth century. Tradition, however, affirms this marriage, see Rolf A. Stein, *La Civilisation Tibétaine* (1981), p. 36.

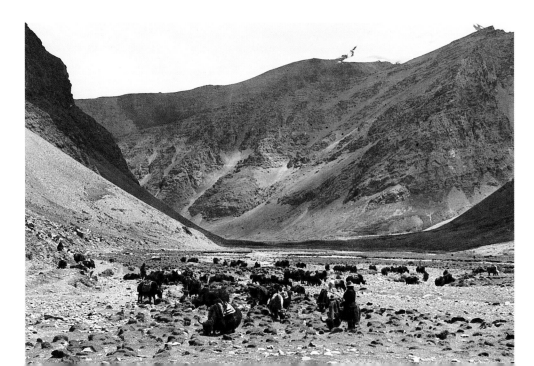

Fig. 2
Yaks grazing in a valley, central Tibet, 1935.

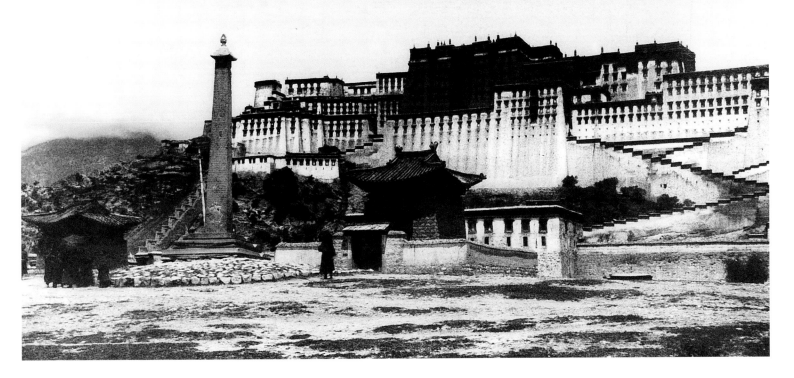

Fig. 3 The Zhol *do-ring* (pillar) of *circa* 764
in front of the Potala Palace, Lhasa, central
Tibet, 1904. John Claude White photo,
Gift of Frank and Lisina Hoch, 1997 97.9

7 See Religion, pp. 37–38. The principal
source for *Tsug* is Ariane Macdonald,
"Une lecture des P. T. [Pelliot Tibétain]
1286, 1287, 1038, 1047, et 1290. Essai
sur la formation et l'emploi des mythes
politiques dans la religion royale de Sron
bcan sgam po". A very good summary
is also to be found in Anne-Marie
Blondeau, "Les Religions du Tibet".

8 Stein, (1981), p. 37, explains that it is
highly unlikely that in the twenty years
of Songtsen's rein Thonmi codified the
alphabet, thus enabling Tibetan texts to
be in Dunhuang far from Lhasa as early
as *circa* 644. Furthermore, Thonmi does
not appear in the lists of ministers in the
Tibetan annals for the period. See Hugh
E. Richardson, "Ministers of the Tibet
Kingdom", *Tibet Journal*, vol. 2, no. 1
(1977). Nils Simonsson, *Indo-Tibetische
Studien*, Uppsala, 1957, thought Thonmi
was perhaps late eighth to ninth cen-
turies. Nonetheless, he is traditionally
attributed as the creator of the Tibetan
alphabet.

9 For a discussion of Padmasambhava's role
in the first diffusion of Buddhism
to Tibet see Tucci, *Religions of Tibet*,
pp. 5–7.

numerous documents survive indicating his royal patronage of the indigenous
organized religion, probably called *Tsug* (*gTsug*), which deified the *tsenpo* and
guaranteed his "divine right" to rule.[7] Nonetheless, the introduction of Bud-
dhism was part of a multi-faceted interaction, economic, cultural and political,
between the Tibetan royal government and the cultures of India, Nepal, Cen-
tral Asia and China. *Tsenpo* Songtsen's minister, Thonmi, was sent as an envoy
to India to adapt a script for the Tibetan language.[8] Songtsen's reign is also
credited with the establishment of the first legal code.

During the reign of Songtsen Gampo's great-great-grandson, Trisong Det-
sen (*Khri srong lde btsan*, reign 755–*circa* 797–8) (color pl. 1), Tibet again
extended its control along the silk route, occupying Khotan, Turfan and Dun-
huang, western gateway to China, from 787-866 (fig. 3). In central Tibet, an
inscribed stone pillar attests to the fact that this *tsenpo* founded the first
monastery, Samye (*bSam yas*), midway between the Yarlung Valley and Lhasa,
circa 775. Traditionally it is recounted that Padmasambhava, a Buddhist master
from Oddiyana (now believed to be the Swat Valley, Pakistan), came at Trisong
Detsen's invitation to subdue the indigenous deities opposing this monastic
center.[9] Chinese Buddhists of the Ch'an order and Indian sages of Mahayana
and Vajrayana Buddhism came to Samye, influencing the *tsenpo* to issue an edict
ordering his subjects to adopt Buddhism in *circa* 790. The noble families formed
ardent pro- or anti-Buddhist factions.

In the first half of the ninth century, three *tsenpo* in succession officially sup-
ported Buddhism, while still practicing the indigenous religion which ensured
their theocracy. A major Sino-Tibetan treaty was signed in 822. This bilingual
text between the two sovereign powers settled border disputes and established
a pact of non-aggression. The *tsenpo* Ralpachen (*Ral pa can*, reign 815–38) fol-
lowed his predecessor's policy of taxation of the noble families to support the
monasteries, and added two Buddhist clerics to the group of royal ministers. The
noble families' exclusive privileges were thus being eroded in favor of the clergy.

In 838 *tsenpo* Lang Darma (*gLang dar ma*, reign 838–42) was enthroned and is said to have severely persecuted Buddhism.[10] His assassination four years later is attributed to a Buddhist monk. Langdarma's heirs fought for the throne and the empire fell into chaos. The Tibetans lost control of the oases along the silk route as of 866. Trade with the Arab Caliphate continued throughout these troubled times.[11] According to Arab and Persian sources, Tibet maintained control of the southern Pamirs and even the southeastern parts of Farghana well into the tenth century, but the Tibetan empire was lost. Branches of the royal lineage survived in Amdo and Western Tibet, while central Tibet broke into small principalities under the rule of noble families.

This relatively short dynastic period of Tibetan history provides essential insights into the formation of the Tibetan state and the nature of Tibetan society and religion. Parallel situations recur throughout Tibetan history when, instead of rival clans, the claimants for power were various orders of Buddhism supported first by the noble families and later by various foreign rulers aligned with certain of these families. The original social structure of Tibetan society was perpetuated in the clans and nobles, all of whom vied for the *tsenpo's* favors, expressed through distribution of land grants and annuities.

The nobility was hereditary and each clan was associated with a particular geographic locale. If a noble or lord had no heir, the estate returned to the *tsenpo*. The members of the nobility were responsible for counseling the *tsenpo* and furnishing men, arms and horses for his military campaigns, in addition to providing daughters for the politically-based matrimonial alliances. Aside from the clergy, those who were not nobles were divided into subjects or serfs from conquered tribes. The subjects could be socially mobile, capable of entering the clergy or rising to the status of the nobility. The celibate clergy first relied on heredity to ensure succession, which initially passed from uncle to nephew. Later, reincarnation replaced heredity to establish succession. Already at the time of Songtsen Gampo, a non-Buddhist priestly class with several internal divisions existed. Later, as the Buddhist clergy became numerous, a tax-exempt status was accorded to both the monks living in the monasteries and to the adepts living in meditative retreat. The nobility was taxed to provide for the needs of the clergy and the upkeep of their establishments, a situation which continued through modern times. The major cohesive factor of the dynasty had been the *tsenpo* and the religion he embodied. As royal concessions to Buddhism were made, the politico-religious institution which guaranteed the *tsenpo's* theocracy and the stability of the empire disintegrated, eventually to be replaced by the Buddhist ecclesiastical state which governed Tibet until 1959.

Because of the upheaval following the fall of the Yarlung dynasty, there was a hiatus in historical records of almost one century. When records resume in the mid-tenth century, Buddhism was well established in Tibet and had become the underlying grid over which economic, political and social institutions would develop. Leaving the monasteries and hermitages of Amdo and Kham, Buddhist masters returned to central Tibet to found temples *circa* 960. Ties to the Tangut state of Xixia which, from 982 to 1227, ranged over the areas of northwestern China once ruled by the Tibetan empire, served as important cultural links between the emerging central Tibetan Buddhist communities and the northwestern Chinese frontier.

Descendants of the *tsenpo* played a vital role in reviving Buddhism in Guge, a principality of Western Tibet. Royal patronage allowed numerous religious pilgrims to travel to Buddhist Kashmir. Prominent among these was Rinchen Zangpo (*Rin chen bzang po*, 958–1055) who returned to Guge bringing Buddhist texts for study and translation, as well as artists to decorate newly-founded temples. Indian *panditas* or teachers such as Dipamkara Atisha (in Tibet 1042–54) came to Tibet to proselytize and clarify Buddhist philosophy and ritual practices. In the eleventh century, many Tibetans travelled to India, Nepal and Kashmir as pilgrims, then returned to Tibet to spread their newly-acquired knowledge. The Pala Dynasty (*circa* 750–1150), based in the northeastern Indian states of Bihar and Bengal, was the last great Buddhist civilization in India. Elements of the Pala artistic tradition such as costumes and jewelry were transmitted to Tibet through manuscripts and portable images.

In addition to making translations of Sanskrit and Chinese Buddhist texts, the Tibetan teachers began to write their own commentaries and texts on all aspects of Buddhist thought. A core of disciples surrounded each master, leading to the establishment of many diverse Buddhist religious orders and monasteries in Tibet. The Tibetan nobility and wealthy principalities patronized the various new religious movements.

It was not long before the monastic establishments vied with their very patrons for land ownership and commercial profits. Increasingly the monasteries played the role of financiers or creditors. Shifting alliances between the powerful lay patrons and the sectarian orders led some monks to adopt a political role in addition to their traditional one of religious guidance and spiritual instruction. When the Mongols threatened Tibet's northern borders in 1240, Sakya Pandita (*Sa skya pandita*, 1182–1251), a learned lama of the Sakya order, was invited to the Mongol camp of Godan Khan. Godan wanted a written form of the Mongolian language developed which the scholar started to prepare, while interceding as political negotiator to sway the Mongol invasion of Tibet. In 1249, Godan assigned political control over Ü and Tsang to the Sakya order. After the death of Godan and Sakya Pandita, another Mongol invasion of Tibet occurred, led by Kublai Khan. The Mongol factions supported different teachers inside Tibet, stimulating the rivalry among the monastic orders. Kublai Khan in turn became the patron of Sakya and again conferred rule of Ü and Tsang as well as the title *Tishri* ("Imperial Preceptor") on Pagpa Lama, Sakya Pandita's nephew and heir. Pagpa finalized the Mongol alphabet which was used for a century.

When this Mongol dynasty collapsed in 1368, Sakya power was on the wane in central Tibet. Members of rival monastic orders such as the Karmapa had also been present at Kublai's court. In central Tibet, still another religious order, the Drigung pa, had revolted against Sakya control. The Sakya order retained political control of their own monasteries south and west of Shigatse, and their religious influence at Derge in Eastern Tibet endured to the twentieth century. Kublai had granted the family of one of Pagpa's attendants administrative power over Derge, whose territory would eventually encompass 78,000 square kilometers.[12] This was the beginning of what was to become an increasingly autonomous cultural center at Derge, complete with monastery, cathedral, printing facilities and autonomous administrative power as well.

10 This is the traditional account, however Blondeau, "Les Religions du Tibet", p. 254, cites a Buddhist petition in favour of Langdarma among the Dunhuang manuscripts.

11 Beckwith, "Empire in the West", p. 35.

12 Joseph Kolmas, *Geneology of the Kings of Derge*, p. 22. The Sakya order's influence in Gyantse into the fifteenth century is evident in the great monastic complex built by them in 1425. See Tucci, "Gyantse ed i suoi Monasteri", *Indo-Tibetica IV*, part 1, pp. 39–40, 73–93.

Derge was linked to Lhasa by matrimonial alliances while religiously aligned with Sakya.

The consequences of the decline of Sakya power were pronounced in central Tibet where several religious orders and their noble patrons vied for economic and political control. The Sakya order's use of force against the Pagmogrupa, a Kagyu order and powerful principality in Ne'u dong, Yarlung, led to the complete defeat of the Sakya order in central Tibet by the mid-fourteenth century. The leader of the Pagmogrupa became known as the King of Tibet until the early seventeenth century. The influence of the Karmapa lama and his order was strong at the Ming court in China. The Ming Yongle Emperor (1403–24) was particularly supportive of Tibetan clerics and ordered the first printed edition of the Tibetan canon in 1410 (color pl. 2).

The Gelugpa order, founded in the early fifteenth century by Tsongkhapa (*Tsong kha pa*, 1357–1419), received foreign royal patronage in 1578 when the Mongol prince, Altan Khan, gave the preeminent Gelugpa lama the title *Dalai Lama* ("Ocean of Wisdom" in Mongolian). Utilizing a new principle of succession which had slowly gained popularity since the Karmapa adopted it in the late thirteenth century, the Dalai Lama was considered a manifestation of divine forces, the embodiment of Tibet's spiritual protector, Avalokiteshvara. Sacred tradition in fact asserts that Songtsen Gampo, the first historic *tsenpo*, was also a reincarnation of Avalokiteshvara. Buddhists believe that an enlightened being can manifest in numerous reincarnations; with the transfer of this spiritual energy to a human body, the scheme of reincarnation took on new political ramifications.

At the beginning of the seventeenth century, Tibet was geographically divided along sectarian lines. Toh, Tsang and parts of Ü were controlled by the King of Tsang, who was aligned with the Karmapa order. The Gelugpa had their principal strongholds in and around Lhasa, but also had important centers at Kumbum in Amdo and Litang in Kham, both protected by Gushri Khan, leader of the Koshot Mongols who had established themselves in the Kokonor region. Sporadic fighting occurred between the factions from 1637–42. With support from Gushri Khan, the Gelugpa leader, the 5th Dalai Lama (*bLo bzang rgya mtsho*, 1617–82), succeeded in regaining control of Lhasa and routed his Tsang and Karmapa adversaries. In 1642, The Great Fifth (as he is called) unified Tibet, from Tatsienlu in the east to the Ladakh border in the west.[13] Lhasa was re-established as the capital of Tibet: in 1645 the Dalai Lama ordered the construction there of the Potala Palace (fig. 4), built on the ruins of a palace attributed to Songtsen Gampo. The 5th Dalai Lama showed astute diplomacy in renewing cultural ties with India and in maintaining harmonious relations with the various Mongol factions and with the Manchu rulers of China. Within Tibet, even though he was the supreme Gelugpa authority, the Dalai Lama actively supported the foundation of several major Nyingmapa monasteries in Kham. The Sayka at Derge prospered as well during his reign. The Karmapa centers in Kham, notably at Likiang, were defeated and their canonical literature was transferred to the Gelugpa monastery at Litang.[14]

The Great Fifth conferred the title of Panchen Lama on his principal Gelugpa teacher, and declared him to be the reincarnation of the Buddha Amitabha. The relation of the Panchen Lama to the Dalai Lama was always, in

13 Tsepon W. D. Shakabpa, *Tibet, A Political History*, p. 111, states these boundaries, but Tucci, *Tibetan Painted Scrolls*, vol. II, p. 681 (note 52) cites the "Chronicle of the 5th Dalai Lama" that the Great Fifth's investiture was only over thirteen divisions of Ü-Tsang.

14 Yoshiro Imaeda, "L'edition du Kanjur Tibetain de Jang Sa-tham", *Journal Asiatique*, 1982, p. 181.

15 Kolmas, *Tibet and Imperial China*, p. 32; Shakabpa, p. 135.

16 Kolmas, *op. cit.*, p. 42, noting that the loss of Kokonor and Kham meant a reduction in Tibetan territory by almost half.

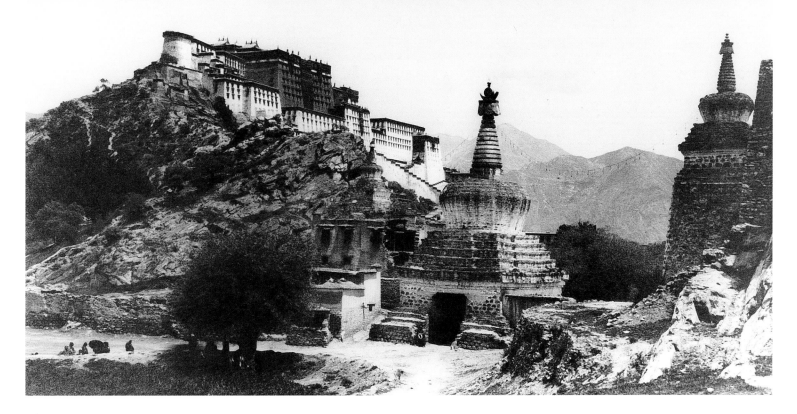

Fig. 4 The western entrance to Lhasa,
central Tibet, Potala Palace at left distance,
1904. John Claude White photo, Gift of
Frank and Lisina Hoch, 1997 97.9

theory, that of master to disciple, as Amitabha is considered senior to Aval-okiteshvara in the divine hierarchy. In fact, as time passed, whichever of the two lamas was older became the tutor of the other. To a great extent, the role of the Panchen Lama was supposed to be purely spiritual, while the Dalai Lama embodied both spiritual and political authority. Although the 5th Dalai Lama had greatly consolidated his position, *de facto* Tibetan independence remained precarious due to the threat of the Manchu rulers of China and the Mongol tribes. Gushri Khan had stationed a permanent camp north of Lhasa. His support of the Gelugpa had earned the Koshot Mongol leader the hereditary title of "King of Tibet", although the 5th Dalai Lama was the actual ruler.

The death of the 5th Dalai Lama in 1682 was concealed by his close assistant, Sangye Gyatso (*Sangs rgyas rgya mtsho*, 1652–1705) for fifteen years in order to maintain the period of peace and stability. In 1695, the Potala Palace was completed, and in 1697, the 6th Dalai was at last officially enthroned. In 1702 the 6th Dalai Lama renounced his monastic vows, much to the dismay of the Panchen Lama and the other major Gelugpa lamas as well as Gushri Khan's heir, Lhazang Khan. A Manchu ally, Lhazang resented being excluded from the secret of the 5th Dalai Lama's death. He advanced on Lhasa, assumed full political control by killing Sangye Gyatso and deposing the 6th Dalai Lama. Lhazang installed a new Dalai Lama who was not accepted by the Tibetan people. The Kokonor Mongols and the lamas of the Lhasa Gelugpa monasteries called on the Dzungar Mongols to divest them of Lhazang.[15] In 1717 the Dzungar laid siege to Lhasa, deposed the "false" Dalai Lama and killed Lhazang Khan. Their destruction of several Nyingmapa monasteries aroused the enmity of the Tibetans, but, above all, the Dzungar were unsuccessful in their attempts to restore the rightful Dalai Lama, born in Litang in 1708. Sheltered first in Derge, then in Kumbum, the 7th Dalai Lama was enthroned following a Manchu military expedition in 1720 to squash the Dzungars.

The Manchu withdrew their troops from Lhasa in 1723, retreating to the east where they annexed the Kokonor region in 1724.[16] The political adminis-

tration and boundaries of Kham were redefined in 1725 as the next move in Manchu designs on Tibet.[17] Using a branch of the Yangtse River as a rough divide, Lhasa controlled all territory west of the river while, to the east, under Chinese protection but autonomous local administration, twenty-five semi-independent native states or principalities were recognized. Derge was the wealthiest and most important of these. A pillar on the Bum La pass, about sixty miles southwest of Batang, served to demarcate the boundary which extended due north to Kokonor. Internal governmental rivalries between the Lhasa cabinet ministers and the 7th Dalai Lama's father (for the Dalai Lama was but an adolescent at the time) led to a civil war in central Tibet in 1727–8. The rival parties appealed to the Manchu who sent an army to restore order. By the time the Manchu troops arrived in Lhasa, a former ally of Lhazang Khan, the cabinet minister Pholhanas (*Pho lha nas*, 1689–1747) had already established his supremacy. Pholhanas received Manchu support in the form of two *amban* (imperial representatives) accompanied by an armed garrison. Pholhanas governed so ably that the garrison was reduced to only five hundred men by 1733 and the role of the *amban* became purely nominal.[18] The Dalai Lama had been exiled to Litang from 1729–35, officially to be safe from the Dzungar menace.[19] He returned to Lhasa, exercising a purely religious authority while Pholhanas ruled until 1747. After Pholhanas's death, the Dalai Lama reasserted his authority over all secular and religious affairs, assisted by a cabinet of three lay ministers and one monk. The presence of the *amban* was maintained in Lhasa to the end of the Manchu dynasty.

The Manchu protectorate of Tibet was tempered in the eighteenth century by the Qianlong Emperor's official adoption of Tibetan Buddhism. Invitations and munificent gifts were proffered upon Tibetan clerics and patronage extended to the publication of a new edition of the canonical literature, printed in the Tibetan language in Beijing. North of Beijing, Qianlong constructed a summer capital at Jehol with replicas of the Potala Palace and other Tibetan monuments.

In 1774–5, the Panchen Lama had the first official contact with a British representative by acting as intermediary between the Bhutanese and the British.[20] Thirteen years later, Tibet became embroiled in a trade dispute with Nepal, and in 1791, when the Nepalese sacked the Panchen Lama's Tashilhunpo monastery and occupied nearby Shigatse, it was the signal for Manchu intervention. In 1792, a combined Manchu-Tibetan army defeated the Nepalese and crushed the dissident Karmapa forces in Tsang who had supported this breach of Lhasa authority. The *amban*'s power increased in consequence, for at least a few years.[21]

During the major part of the nineteenth century, the status quo of Lhasa authority and nominal Manchu protectorate was maintained. In China weak emperors followed Qianlong. The tottering Manchu regime was threatened by internal rebellions and intervention by European powers. In the mid-nineteenth century, border and trade disputes with Ladakh and Nepal led Lhasa into contact with British India.[22] The Lhasa government was headed by regents during the reign of several Dalai Lamas: the 8th, who was predominantly interested in religion, and the 9th through 12th, who died prematurely.

In Kham, at this time, the local chief of Nyarong had been encroaching upon the lands of other native chiefs, even as far as Litang, and succeeded in

17 Eric Teichman, *Travels of a Consular Officer in Eastern Tibet*, pp. 2–3; Kolmas, *op. cit.*, p. 41; Luciano Petech, *China and Tibet in the Early Eighteenth Century*, p. 90 gives the comprehensive discussion of the period.

18 Garrison figures from Kolmas, *op. cit.*, p. 41; Richardson, *A Short History of Tibet*, p. 53, points out that the Pholanas was now resented by the Tibetans because he did not openly oppose Chinese overlordship of Tibet.

19 Petech, *China and Tibet*, p. 174.

20 Prior to this, due to the simple fact of distance, very few Europeans had ever reached Tibet. Jesuit missions were briefly established at Tsaparang and Shigatse in the early seventeenth century. Italian missionaries—Jesuit and Capuchin—had even built a church in Lhasa during their residence from 1707–45. But concomitant with the Manchu protectorate, Tibet closed its borders to all foreigners other than the Chinese.

21 Kolmas, *op. cit.*, pp. 47–8.

22 Shakabpa, pp. 176–81, for details of the Ladakhi war; Kolmas, *op. cit.*, p. 52, for date of annexation by Britain; Shakabpa, pp. 181–2, for details of the war with Nepal in 1855–6.

23 Petech, *Aristocracy and Government in Tibet*, p. 178 for the invasions of Litang and Derge. The best source for the Nyarong rebellion is Tashi Tsering, "A Preliminary Study in Nyagrong Gompo Namgyel", *Proceedings of the International Association for Tibetan Studies*, Columbia University Seminar 1982, B. N. Aziz and M. Kapstein, (eds).

24 Shakabpa, p. 206.

25 Richardson, *Short History*, p. 82.

Fig. 5
Younghusband expedition
encampment at Phari
Dzong, spring 1904.
John Claude White photo,
Gift of Frank and Lisina
Hoch, 1997 97.9

conquering the neighboring states of Derge and Hor. In 1863–64, when the Sichuan provincial authorities failed to block these invasions, Lhasa sent troops to do so, defeating the Nyarong chief in 1865. The Chinese emperor granted the Dalai Lama control of Nyarong and Derge, although the Derge prince retained his title. Nyarong revolted again in 1894. This time Chinese troops penetrated into Nyarong, occupying most of the country. From Nyarong the Chinese forces reached Derge, in the midst of a succession dispute, and the royal family was imprisoned. A settlement was reached in late 1897, reinstating Lhasa rule of Nyarong, and resolving, temporarily, the Derge succession.[23]

In Lhasa, the government of the 13th Dalai Lama (1876–1933) was increasingly preoccupied with international relations despite Manchu encouragement to maintain an isolationist foreign policy. Certain factions of the Lhasa government believed that the British would destroy their religion.[24] Tibet had a direct border with the kingdom of Sikkim, subject to British protectorate since 1850. In 1885 the Manchu granted authorization for a British expedition to China via Tibet but the Tibetans refused the British access to their territory. In 1888 the Tibetans and the British clashed briefly at the border of Sikkim, leading to a Sino-British agreement in 1890 to redefine the border and recognize British interests in Sikkim. Trade access was thus established but remained problematic. Curiously, while British overtures were being refused, a pro-Russian Buriat Mongol monk named Dorjiev had considerable personal influence as one of the Dalai Lama's councilors. In 1898 he visited Russia whence he returned with presents for the Dalai Lama and the message that, as China was weak, Tibet should turn to Russia for alliance. The Dalai Lama was invited to visit Russia, but the Tibetan assembly opposed the journey. Instead, Dorjiev, received by the Czar as "Envoy Extraordinary of the Dalai Lama", journeyed again to Russia and back.[25] Tibet's strategic position at the heart of Asia became crucial to British, Russian and Chinese schemes for the continent.

In 1903 a British military expedition led by Colonel Younghusband entered southern Tibet in order to force Lhasa into opening trade discussions and to counter Russian influence. Bhutan and Sikkim urged Lhasa to negotiate but to no avail. The expedition crossed the Sikkimese border (fig. 5), laid siege to Gyantse for three months while awaiting a Tibetan party for negotiations, and finally descended on Lhasa in August, 1904. Having authorized the regent to negotiate, the Dalai Lama fled to Mongolia, already under Russian influence. This seemed to confirm the worst of British fears, but within a month an agreement was signed by the Tibetans, authorizing a British trade agent to remain in Tibet and guaranteeing Tibetan compliance with previous Sino-British trade conventions. The British had sought direct negotiation because, as their repre-

Fig. 6
Chinese boundary markings
(over prayer stones and flags)
on a pass, Kham,
Eastern Tibet, 1909.

sentative explained, "We regard Chinese suzerainty over Tibet as a constitu-tional fiction—a political affectation which has only been maintained because of its convenience to both parties".[26]

The Dalai Lama remained in Mongolia more than a year, then traveled to Kumbum, the important Gelugpa monastery near Lake Kokonor. Here he received a message from Lhasa urging his return, and an imperial invitation from Beijing. In the hope of reversing the Chinese policies in Kham, the Dalai Lama went to Beijing. To counterbalance their loss of face as a result of the Younghusband expedition, the Chinese had established the new post of Imper-ial Resident in Chamdo in Eastern Tibet. En route to Chamdo, the Resident stopped first in Tatsienlu, capital of the autonomous state of Chala, where he deposed the King. He then proceeded to Batang, where he took up temporary residence and attempted to interfere with Gelugpa control of the area. The monks led a revolt and the Resident was killed. A general uprising of all the monasteries in Kham ensued. A Chinese punitive mission from Sichuan razed the Batang monastery and executed the Tibetan headmen in retaliation. Chao Er Feng was appointed to regain Chinese control of Eastern Tibet and he soon earned the nickname "Chao the butcher" for his aggressive actions against local Tibetan authorities. In autumn, 1908, Chao took his turn at resolving the long-standing succession dispute at Derge. By the summer of 1909, Chao, having secured Chinese control of Derge, started for Chamdo, the eastern gateway to central Tibet. With troops from Batang and Derge, Chao occupied first Cham-do, then Draya and Markham (fig. 6). Only Nyarong remained an obstacle.[27]

Using the northern route via Kumbum, the Dalai Lama returned to Lhasa in December, 1909. Lhasa sent public appeals to Europe and Beijing to stop the advance of the Chinese forces but to no avail. In February, 1910, Chinese troops invaded Lhasa. This time the Dalai Lama sought asylum in India (fig. 7), and in Beijing the British officially protested violation of the conventions in Tibet.[28] One contingent of Chao's troops advanced west of the Salween into the Brahmaputra basin, while another took Kanze, just outside of Nyarong. Chao forcibly annexed Nyarong in the spring of 1911, but was executed as the Chi-nese revolution broke out. Taking advantage of China's chaotic political situa-tion, Lhasa forces overcame the Chinese troops stationed in central and southern Tibet, and uprisings occurred in Kham. The republican successor to Chao Er Feng looted Tatsienlu where he burned the Chala Palace, then destroyed the Chamdo monastery and reinstated Chinese control of Batang, Chamdo, Derge and Kanze.[29]

Fig. 7 The 13th Dalai Lama, portrait photo taken in studio of Th. Paar, Darjeeling, India, during the Dalai Lama's stay there, 1910–12.

The Dalai Lama returned to Lhasa in January, 1913, and issued a declaration of independence. A tripartite British, Chinese and Tibetan conference was held in 1914 at Simla, in India to attempt to resolve the boundary issues. Despite the initial approval of all parties, only the British and Tibetan governments ratified the agreements.[30] A tentative settlement was reached dividing the disputed territories roughly along the 1725 Bum La boundary, but leaving the monasteries of Batang and Litang (inside "Chinese" territory) in Tibetan control. Hostilities along the border led to a new mediation in 1918, upholding Tibetan claims to Chamdo, Draya, Markham and Derge, while ceding Batang, Litang, Nyarong and Kanze to China. Further negotiations occurred in 1932, reinstating the 1918 "armistice line". The Dalai Lama remained suspicious of Chinese movements in Kham and warned, just before his death, of the coming danger of Communism to the Tibetan religious order. The death of the 13th Dalai Lama in December, 1933 offered the Nationalist government of Chiang Kai-shek, whose earlier overtures to Lhasa had been rebuffed, the opportunity to make the first official Chinese visit to Lhasa since the invasion of 1910. After offering gifts to the Lhasa government, the Nationalists proposed that Tibet become a part of China. This was rejected and the Chinese mission departed leaving in Lhasa a small Chinese garrison and a radio transmitter. In 1934, a local uprising against Lhasa authority occurred in Kham, drawing Tibet into negotiations with Chiang Kai-shek's government. At the same time Communist troops, fleeing central China, attempted to enter Kham but were turned back by Tibetan government soldiers.[31] The Panchen Lama, in China since 1923, had become a protégé of China.[32] When the Panchen proposed to return accompanied by five hundred Chinese troops, Lhasa was obliged to refuse him access unless the troops remained in Chinese territory. The Panchen traveled toward Tibet, but died suddenly in 1937 in Jyekundo. In 1939 the 14th Dalai Lama was found in the Kokonor region, administered by the Chinese since 1724 but ethnically and culturally Tibetan. Lhasa paid a substantial ransom to the local authorities in order to obtain his passage from China (color pl. 3).

During World War II, Tibet remained strictly neutral, refusing both Chinese and British requests to transport materials through Tibetan territory. A threatened *coup d'état* was aborted in Lhasa in 1947.[33] The capital was still reeling from the rivalries among the monasteries when Mao, in 1949, announced by radio that Tibet would soon be "liberated". In October, 1950, Chinese Communist forces attacked several areas of Kham and simultaneously invaded northeastern Tibet and Changthang. Lhasa sent messages to the United Nations to protest the invasion, but no official action was taken. The Dalai Lama sought asylum to the south near the Sikkimese border in order to avoid being taken prisoner. A settlement was negotiated by the former Tibetan governor of Chamdo, who now became a Chinese puppet. The settlement guaranteed the status of the Tibetan government and the safety of the Dalai Lama (now persuaded to return to Lhasa) as well as the protection of established religious customs, but admitted Chinese military occupation of Tibetan territory. The Dalai Lama returned to find that by 1951 there were 20,000 troops stationed in and around Lhasa alone.[34]

In 1954 the Dalai Lama and the Panchen Lama[35] visited Beijing in an attempt at conciliation with the Chinese government. Despite the 1951 agree-

26 Letter from Lord Curzon, Viceroy of India, quoted in Shakabpa, p. 219.

27 Kolmas, *op. cit.*, pp. 54–65; Teichman, pp. 19–27. See also pp. 11–12 for the impact these events had on the formation of The Newark Museum's Tibetan collection.

28 Richardson, *op. cit.*, p. 98.

29 Teichman, pp. 29–42.

30 Kolmas, "The McMahon Line: Further Development of the Disputed Frontier," *Tibetan Studies in Honour of H.E. Richardson*, points out in note 8, p. 183, that in fact the Tibetan and Chinese plenipotentiaries both *signed* the map and the convention; it was however, never ratified by the Chinese government.

31 Shakabpa, p. 278.

32 Richardson, *op. cit.*, p. 144.

33 Richardson, "The Rva sgreng Conspiracy of 1947", *Tibetan Studies in Honour of H.E. Richardson*, provides an excellent account of the circumstances surrounding these events.

34 International Commission of Jurists, pp. 288–311.

35 This disputed incarnation of the Panchen Lama was born in 1938 in Qinghai and his recognition was supported by the Chinese government which circumvented traditional Tibetan confirmation procedures. See Shakabpa, p. 306.

ment the Chinese had begun to implement "reforms": confiscation of large estates, deportation of children to China, assaults on the clerics and desecration of the monasteries, along with taxation to an extent hitherto unknown. Demonstrations against the Chinese accompanied active guerrilla warfare which spread throughout Tibet, instigated in Kham where "reforms" had inflicted the most economic hardships and personal humiliation on the population. The Dalai Lama and the Panchen Lama visited India in 1956 and there met with the Chinese on neutral ground to request removal of Chinese troops, restoration of the status existing at the death of the 13th Dalai Lama, and abandonment of the Chinese program of reforms.[36] The only Chinese concession was a moratorium of five years in the implementation of the reforms planned for Tibet. Tibet remained occupied and in a constant state of guerrilla warfare. By early 1959, Tibetan guerrillas controlled most of southern Tibet. The Chinese pressured the Dalai Lama to use Tibetan troops to crush the resistance movement, composed largely of men from Amdo and Kham.

The Dalai Lama fled Lhasa in disguise on March 17, 1959, receiving protection from the guerrillas as soon as he crossed the Tsangpo River. He continued to India where he was granted political asylum. The Chinese troops in Lhasa shelled the Norbu Linga, the Potala and other strategic sites and installed a military government. Approximately 100,000 Tibetans followed the Dalai Lama to India.[37] In September, 1959, the question of Tibet was at last discussed in the United Nations but no official sanctions were taken. The guerrilla movement continued unabated throughout the sixties, while further "reforms" were enacted.

The Dalai Lama established a government in exile at Dharamsala, India. The flood of refugees continued to swell, bringing news with them of atrocities in Tibet. The International Commission of Jurists stated in their report that acts of genocide had been perpetrated in Tibet by the Chinese.[38] Tibet was particularly hard hit by the Chinese Cultural Revolution and its after-effects of *circa* 1965–75. Out of some 3,000 monastic establishments in existence prior to 1959, perhaps 300 remain today. Only a handful are active teaching establishments; many are essentially museums, inhabited by one or two masters. Since 1980 some international journalists, scholars and tourists have been allowed into Lhasa and the main cities, but individual travel is subject to highly restrictive rules. The Lhasa Cathedral is reopened for public worship and portions of the Potala Palace are opened to visitors. The guerrilla movement seems to have been suppressed, yet many Tibetans flee towards India and Nepal every year. Inside and outside their country, Tibetans yearn for their independence and freedom to practice the religion which has been the matrix of their culture.

Religion

1. Buddhism

Prior to 1959, Tibet was governed as an ecclesiastical state according to the principles of Buddhism. This religion was founded in northern India during the sixth century B.C.E. by Shakyamuni, known by epithet as Buddha, "The Enlightened One". His teachings concentrated on the alleviation of the suffer-

36 Richardson, *Short History*, p. 203.

37 In regard to Tibet's other major religious leader, the Panchen Lama, already aligned with the Chinese (Shakabpa, pp. 306–7, 310–11), remained at Tashilunpo, his historic seat, following the events of 1959. Later he became vice-president of the Committee for the Autonomy of Tibet, the highest Communist Party organ in Tibet. In 1964, the Panchen Lama "disappeared" only to resurface again in 1979–80 when he was elected, in Beijing, as vice-chairman of the Minority People's Congress. He died in 1989.

38 International Commission of Jurists, pp. 288–311.

ing inherent in the impermanence of life and man's unfulfilled desires. The ethical system proposed by Shakyamuni focused on the accumulation of good moral deeds and the development of a wise and disciplined mind. The goal of the accumulation of good deeds is to purify the mind and ensure a positive rebirth in which it will be possible to attain salvation. The world of *samsara*, including divine, human, animal and infernal realms (color pl. 4), is conceived of as involving suffering in all of its aspects. To be born as a human is considered best because only man can aspire to Buddhahood. The doctrine of rebirth was common in India at the time. Shakyamuni opened the road to salvation for all, regardless of caste, who followed his precepts.

His first teaching was encapsulated in the "Four Noble Truths": 1) *Dukkha* (suffering), the fundamental nature of all conditioned existence is suffering, and 2) *Samudaya* (the cause and arising of suffering), the origin of suffering is unfulfilled desire coupled with *karma* accumulated in this and past lifetimes. Suffering and the origin of suffering are basic philosophical concepts of Buddhism. Suffering can be understood as the obvious suffering of daily life such as illness, loss and death, and, on a more profound level, as the suffering arising from the inevitable impermanence and interdependence of existence. It is this impermanence and interdependence on all other phenomena that is meant in the phrase "conditioned existence". After years of searching Shakyamuni finally discovered the state of unconditioned existence, which is 3) *Nirvana* (the cessation of suffering), to be attained by eliminating desire and *karma*. 4) *Marga* (the path), the way leading to *nirvana*, is the "Noble Eightfold Path". This consists of: 1) Right Understanding, 2) Right Thought, 3) Right Speech, 4) Right Action, 5) Right Livelihood, 6) Right Mindfulness, 7) Right Concentration, and 8) Right Views. To practice the Eightfold Path, Buddhists take refuge in the "Three Jewels": the *Buddha*, the *Dharma* (the Buddhist sacred philosophical and moral code), and the *Sangha* (the community which upholds these values).

If one followed these principles, moral imperfections acquired in previous lifetimes could gradually be cleared and no further defilements would accumulate as the individual continued his course toward *nirvana*. According to the Buddha's explanations, everything is impermanent, composed of transient aggregates in a state of constant flux and mutual conditioning. Due to the intrinsic composite nature of everything, it is said that everything is void of inherent existence. This is the Buddhist doctrine of emptiness or *sunyata*. Thus physical elements and mental attitudes and the very ego itself are all impermanent, but in the normal everyday world (termed *samsara*) these aggregates (including the perception of the self) are perceived by unenlightened beings as real and constant. When *nirvana* is realized, the transient nature of the aggregates is fully perceived, ignorance, craving and hatred are eliminated, and enlightened awareness is achieved.

In the first centuries after Shakyamuni's death, divergent interpretations of the nature of reality and of *nirvana* led to the establishment of different subschools of Buddhism. Theravada, an early school still practiced in Ceylon and Southeast Asia, maintains that *nirvana* is distinct from the world as we know it. The Mahayana tradition (the "Great Way", founded *circa* second century C.E.) postulates that *nirvana* is attainable in this world and is not, in the final analysis, different from *samsara*. *Nirvana* and *samsara* are related like the two sides of

a coin, all a matter of how we perceive the phenomenal world. If we are able to fully apprehend the doctrine of emptiness, which expounds the composite nature of the interdependent, impermanent elements constituting the phenomenal world, then we could live in a state of *nirvana* even while we are in this physical body. But herein lies a fundamental distinction between Mahayana practice and Theravadin practice. The Theravada school stresses the personal enlightenment of the individual, as epitomized by the *Arhat*, a Buddhist monk who achieves the highest state of perfection. By practicing monastic discipline in accordance with the sermons of the Buddha (*Sutras*) and appropriate meditation on the impermanent nature of reality, the *Arhat* realizes *nirvana* and will no longer be reborn. In Mahayana teachings, the practitioner emulates the *Bodhisattva* striving for the collective salvation of all sentient beings. A *Bodhisattva* ("Enlightenment Being") delays his own *nirvana* in order to assist others in their attainment of enlightenment.[39]

As Mahayana developed, the concept of the nature of Buddha, The Enlightened One, became increasingly abstract. Shakyamuni, the historic Buddha of our age, came to be considered as one of over a thousand Buddhas which will appear in the course of this aeon (*Kalpa*). The idea of a series of appearances in this world by successive Buddhas was extended further in India in the first to second centuries by the idea of a plurality of Buddhas in one timespan. Buddhahood thus came to be seen as a universal principle. Five main Buddhas representing Buddha families developed: Vairochana ("Resplendent") at the center, with Amitabha ("Boundless Light"), Akshobhya ("Imperturbable"), Amoghasiddhi ("Infallible Success") and Ratnasambhava ("Jewel-born") radiating out as the four cardinal points (see color pl. 134).

Concomitant with Mahayana, Vajrayana Buddhism developed, centered on the Buddha's doctrine as expounded in the group of texts called *Tantras*. These texts teach the transformation of all actions and emotions in the path toward Buddhahood which, according to Vajrayana, may be reached in one lifetime by a particularly direct path. The path involves disciplined concentration through yoga practices which enable an individual to gain control over his body and his mind. The practices include contemplating external objects such as images of deities which help to purify the body, speech and mind. An icon reflecting *tantric* Buddhist concepts which occurs frequently in painting and sculpture is the *yab-yum* image. In such an image, the ecstasy of *nirvana* is described in analogy to human sexuality: the male figure (termed *yab*, "father") represents active compassion, and the female figure (termed *yum*, "mother") represents transcendental wisdom. The union of these complementary forces is the essence of the enlightened mind.

The *Tantras* provide rich iconographic sources by their description of deities and their realms. But the very philosophical doctrines of Buddhism made the existence of deities possible only if the deities represent manifestations of consciousness. Buddhism is atheistic in philosophy but may be polytheistic in practical worship, depending upon individual preference. In addition to a deified Shakyamuni and other Buddhas, the religion gradually incorporated many early Indian Hindu deities into the pantheon.

Buddhism as practiced in Tibet is the integration of Theravada, Mahayana and Vajrayana philosophies in conjunction with indigenous Tibetan beliefs and

39 David Snellgrove, *Buddhist Himalaya*, gives an excellent overview of the development and the doctrines of Buddhism. See also Walpola Rahula, *What The Buddha Taught*, and Edward Conze, *Buddhism: Its Essence and Development*.

40 Both Rolf A. Stein, *Tibetan Civilization*, and Giuseppe Tucci, *The Religions of Tibet*, discuss the ideas and practices of the indigenous Tibetan religion, but the first study to establish the term *Tsug* and the most comprehensive discussion is Ariane Macdonald, "Une lecture des P. T. (Pelliot Tibétain) 1286, 1287, 1038, 1047 et 1290. Essai sur la formation et l'emploi des mythes politiques dans la religion royale de Sron bcan sgam po".

41 The term *Kula* (*sKu-bla*) is of prime importance, as the core term *bla* is pronounced "La", signifying "life force". Recent scholarship has shown the relation of this term with the word lama (*bla-ma*) signifying "spiritual master". The lama is of such importance in Tibetan Buddhism that the religion itself is often referred to as "Lamaism". See Ariane Macdonald and Yoshiro Imaeda, *Choix de Documents Tibétains Conservés à la Bibliothèque Nationale*, vol. II, pp. 12–15.

42 The term for funerary priests specialized in ritual sacrifice (*Bonpo*) has often been erroneously confused with two later concepts: the organized religion called Bon, whose adherents are called Bon po and individual exorcist priests (*dBon-po*) who practice outside of any organized Tibetan religion. Because these terms are almost homonyms, many early European visitors to Tibet thought that the pre-Buddhist religion was the shamanism practiced by the *dBon-po*. The religion described in the Dunhuang manuscripts is not shamanistic. Also, the later Tibetan historical tradition linked the early organized royal religion with Bon, further confusing the matter.

43 Macdonald, "Une lecture des P. T.", p. 304.

44 Macdonald, *op. cit.*, p. 377.

ritual practices, assimilated into a Buddhist conceptual framework. The different orders which evolved within Tibetan Buddhism (to be discussed below) reflect emphasis either on mystic meditation or on intellectual insight as the foundation of meditation, but all adhere to the basic Buddhist tenets.

2. The Indigenous Religion

Before the introduction of Buddhism in the seventh to eighth centuries C.E., Tibetans believed in a divinely ordered universe over which a deified ruler, the *tsenpo*, presided. It has been proposed that this religion was called Tsug (*gTsug*), the term used for the divine order of the universe.[40] The sacred character of the early *tsenpo* is attested by numerous early documents and contemporary inscribed stele. The persona of the ruler had a personal guardian deity, the *Kula* (*sKu bla*) [41] identified with a sacred mountain and worshiped by the populace to ensure their prosperity, through the practice of herbal burnt offerings. As a human manifestation of divine presence, the *tsenpo* first appeared on earth as he descended from a sacred mountain. The *Kula* is thus identified as a divinity/mountain, and as an ancestor and support of the vital principle of the *tsenpo*, who reunited with his *Kula* upon burial in a tomb called "mountain". There the *tsenpo's* remains awaited rebirth in a joyous paradise when a final resurrection would occur. Funeral ceremonies were elaborate, including ritual sacrifice of animals performed by priests called *Bonpo*.[42] Deification of the *tsenpo* and the mountains was accompanied by precise divination rituals, celebrated by priests called *shen*. The social ideal of human justice and equality through equal distribution of resources were part and parcel of the divine order which the *tsenpo* preserved. The organized *Tsug* religion appears to have been practiced in central Tibet and over a large extent of the Tibetan empire in the seventh to ninth centuries.[43]

The first historic *tsenpo*, Songtsen Gampo (reign 620–50), is traditionally credited with the introduction of Buddhism to Tibet by virtue of his matrimonial alliances with a Chinese princess and a Nepalese princess. The two wives are held responsible for the *tsenpo's* conversion to Buddhism, and for the construction of the first Buddhist temples in Lhasa. Yet contemporary documents state that Songtsen Gampo swore to sacrifice (hardly orthodox Buddhist practice!) a hundred horses on the tomb of his faithful minister, evidence of his continued adherence to *Tsug*. In fact, recent scholarship indicates that it was Songtsen Gampo who codified the *Tsug* religion to ensure the stability of the empire and the royal government as well as to enhance the prestige of the royalty and their descendants.[44] By offering a total vision of the world and time, the *tsenpo* governed his subjects both in life and in the afterlife.

The concepts and practices of *Tsug* were fundamentally irreconcilable with the basic principles of Buddhism; the *Tsug* belief in an afterlife and resurrection versus the Buddhist belief in the impermanence of all existence; the *Tsug* ideal of human happiness versus the Buddhist concept of suffering related to existence; and immediate human justice versus the cycle of rebirths and *karma*. The Tibetan *tsenpo* were at first inclined to support both religions despite the apparent contradictions and the fact that the adoption of the doctrines of Buddhism imperiled their divine right to rule. The process of conversion was gradual,

incorporating ideas from the many currents of Buddhism with which the Tibetans were in contact through their conquests in Central Asia, China and India, where Buddhism was firmly entrenched. The reverence formerly accorded to the deified *tsenpo* was transferred to a deified Shakyamuni Buddha, indigenous deities were incorporated into the Buddhist pantheon, and the live sacrifices previously offered were replaced by dough effigies.

3. The Early Development of Buddhism and Bon in Tibet

During the reign of Songtsen Gampo's great-grandson, Trisong Detsen, 755–97/98, Buddhism made great strides in the conversion of the Tibetans. In 779, with the help of foreign religious masters, Trisong Detsan founded the first Buddhist monastery at Samye (color pl. 5), about fifty miles southeast of Lhasa. Two great teachers came to Tibet at this time: the Indian master, Santaraksita, who preached a form of Mahayana Buddhism, emphasizing meditation and meritorious acts leading to a *nirvana* achieved gradually over many lifetimes; and Padmasambhava, a native of Oddiyana (now thought to be the Swat Valley, Pakistan), who practiced Vajrayana Buddhism accentuating *tantric* ritual meditation to attain *nirvana* in just one human lifetime. Padmasambhava is traditionally revered for miraculously subduing the indigenous Tibetan deities and incorporating them into the Buddhist pantheon. The invitation of these two religious masters indicates the persistence of *Tsug* and the early Tibetan appreciation of the complementarity of Mahayana and Vajrayana teachings and methods: in the collaboration of Santaraksita and Padmasambhava the philosophical, moralistic and rational trends of Mahayana are integrated with the more ritualistic and mystical Vajrayana. The *tsenpo* Trisong Detsan recognized this by his edict establishing separate status for monks in monasteries and for *tantric* hermit adepts. Teachers of the Chinese Ch'an Buddhist sect proselytized at Samye as well to such an extent that, according to tradition, a debate was held (*circa* 797) to determine which Buddhist school Tibet would officially adopt. The Chinese priest was defeated, and thus Tibet opted for the Indian Buddhist teachings of Mahayana and Vajrayana.[45] Tradition aside, it is clear that several schools of Buddhist thought were known in Tibet during the seventh to ninth centuries, and that opposition to any form of Buddhism was also present in those who still favored the indigenous organized religion.

In the first half of the ninth century, three *tsenpo* in succession supported Buddhism and established by edict the basis for monastic power in Tibet: two Buddhist clerics were added to the *tsenpo's* councilors, and property was allocated for monasteries, which were accorded tax-exempt status and given financial support through taxation of the populace. In this period many Indian teachers were invited to Tibet both to preach and to undertake the arduous task of translating the Buddhist scriptures from Sanskrit into Tibetan, a project which was finally completed in the early fourteenth century. Among the first texts translated were the rules of moral code and monastic discipline (*vinaya*), certain Mahayana teachings dealing with the doctrines of emptiness (in particular, the *Perfection of Wisdom Sutra*), and some Vajrayana *tantric* rituals along with a large number of mystic prayers (*dharani*).

45 According to Chinese sources, the Chinese priest in fact won; Anne-Marie Blondeau, "Les Religions du Tibet", pp. 252–53.

46 Stein, *Tibetan Civilization*, p. 200.

47 Blondeau, "Les Religions du Tibet", p. 254, mentions a Buddhist prayer for Lang Darma among the Dunhuang manuscripts, despite the persecutions attributed to him.

48 Samten G. Karmay, "A General Introduction to the History and Doctrines of Bon", pp. 7–9.

49 Stein, *op. cit.*, p. 263.

The indigenous religion was however not totally vanquished. In 822, during the reign of *tsenpo* Ralpachen who was overtly pro-Buddhist, a major Sino-Tibetan peace treaty was concluded. Two ceremonies were held to seal the pact: one sanctified by Buddhist clerics, and the other a ritual animal sacrifice.[46] The successor to Ralpacan was Lang Darma who is ignominiously remembered in history for his severe persecution of Buddhism.[47] His assassination in 842 by pro-Buddhist adherents was the culmination of the competition for political and economic power. This final end to the *tsenpo* tradition caused a century-long period of political and religious realignment.

Buddhism had established strongholds in Amdo and in Western Tibet when historical records resume in the mid-tenth century. Although the *Tsug* religion had lost its *raison d'être* since there was no *tsenpo*, many of its deities and some of its rituals were diffused into Buddhist teachings, and into another religion, Bon, codified in the tenth to eleventh centuries. As a modern Bon po historian has said, "Bon had been in an embryonic state when the *tsenpo* were in power, blending three main elements: the worship of the divine nature of the *tsenpo* and the associated gods, Iranian ideas of the formation of the world, and sophisticated Indian theories such as *karma* and rebirth".[48] By its early assimilation of Indo-Iranian elements, Bon may have prepared the terrain for the adoption by Buddhism of Tibetan deities and certain rites.[49] Bon texts of the tenth to eleventh centuries still include animal sacrifice, perhaps to be related to the functions of the Bonpo funerary priests who specialized in the ritual sacrifice known earlier in Tibet. But these same texts include many elements common to Buddhism. Bon as a religion still exists today, but it is practiced very much like other sub-schools of Tibetan Buddhism, despite maintaining its own terminology and a distinct and voluminous body of canonical literature. In southern Kham, the Bon converted the Mosso aboriginal tribes (also called *Nga-khi*) to their religion. In Tibet prior to 1959, most of the Bon monasteries were found in the western regions or in Kham, although one important monastery was near Lhasa. The Bon religion may be seen as an active counterpart to Tibetan Buddhism, organized and codified simultaneously and in parallel.

4. The Establishment of the Main Buddhist Sects in Tibet

In the late tenth to early eleventh centuries, there was a second diffusion of Indian doctrines into Tibet. Many new sects and monasteries were founded at this time. The Indian sage Atisha (color pl. 6), who arrived in central Tibet in 1042 after a sojourn in Western Tibet, found Samye largely neglected and many of the *tantric* teachings being practiced incorrectly. In response to this, Atisha advocated celibacy, abstinence, and stressed the relation of strict dependence on the individual teacher, the lama (*bla ma*, Sanskrit *guru*). *Tantric* rituals were included in Atisha's teachings but were reserved for a few initiates. Those who still followed the original teachings of Padmasambhava became known as "the ancients", the Nyingmapas, while the followers of Atisha were known as "the adherents who absorb every word of the Buddha as having spiritual significance", the Kadampas. Shortly after the foundation of the Kadampa order, two other major orders were established. The Sakyapa order was founded in the eleventh century; named after their principal monastery in southern Tibet, the

Sakyapas dominated Tibet politically and spiritually in the thirteenth century under the patronage of Kublai Khan. The head lama's succession was passed from uncle to nephew. One of the three sub-schools was based at Ngor monastery, of particular importance for its distinctive art style. The Sakyapa teachings combined monastic discipline with *tantric* doctrines in a comprehensive curriculum.

The other major sect, Kagyupa, traces its origins to the Tibetan yogi Marpa who studied in India and returned to Tibet to practice as a married farmer. His disciple, Milarepa (1040–1123) (color pls. 7 and 108), is well known for his poetic accounts of mystic visions and encounters. Milarepa's disciple Gampopa founded the Kagyupa sect, which later divided into twelve sub-orders. Of these, the Karmapa group came to have the greatest political power, perhaps for their innovative method of ensuring the succession by reincarnation. Great emphasis was placed on mystic meditation in all the Kagyupa groups. The Taglung sub-school based at Taglung monastery had several abbots who were particularly renowned for strict insistence on monastic discipline in the twelfth to thirteenth centuries.

In the tenth to thirteenth centuries, Buddhism was eradicated in India, in part by the Moslem invaders who systematically desecrated Buddhist shrines and destroyed the great monastic universities of northern India. Some Indian religious masters sought refuge in Nepal and Tibet. When the Tibetans could no longer travel to India to seek teachings, a system of revealing "hidden" texts (*terma*) flourished among the Nyingmapa. These texts, attributed to Padmasambhava, are revealed to chosen disciples through visions and recovery of the texts from their place of concealment. Longchenpa (1308–63) organized a systematic approach to Buddhist philosophy and gave new impetus to the Nyingmapa lineages by combining *terma* teachings, tantric ritual and meditative techniques.

Tsongkhapa (color pl. 111), a great Buddhist scholar and reformer, was born near Kokonor in 1357. In reaction to the overly secular activities of some schools and to what he deemed a loosening of monastic discipline, Tsongkhapa created the Gelugpa order, modeled on Atisha's earlier Kadampa group. Tsongkhapa reaffirmed monastic discipline, and placed great emphasis on metaphysical debates as part of the monastic curriculum which integrated *Sutra* and *Tantra*, including colleges of astrology and medicine in some monasteries as well. Initially the Gelugpa were able to stay outside the political factions within Tibet, but when threatened, they turned for assistance to Mongol princes whom they had converted to Buddhism. The Dalai Lama came to be the title of their principal leader, and the Panchen Lama was the other major spiritual leader within the sect. By 1642, under the leadership of the 5th Dalai Lama, the Gelugpa exercised both temporal and spiritual control over Tibet. Once the Gelugpa had established their hegemony in central Tibet, the other monastic orders tended to flourish outside the direct realm of Lhasa. In the next three centuries the religious fortunes of Tibet became inextricably bound to political events as discussed in the previous chapter.

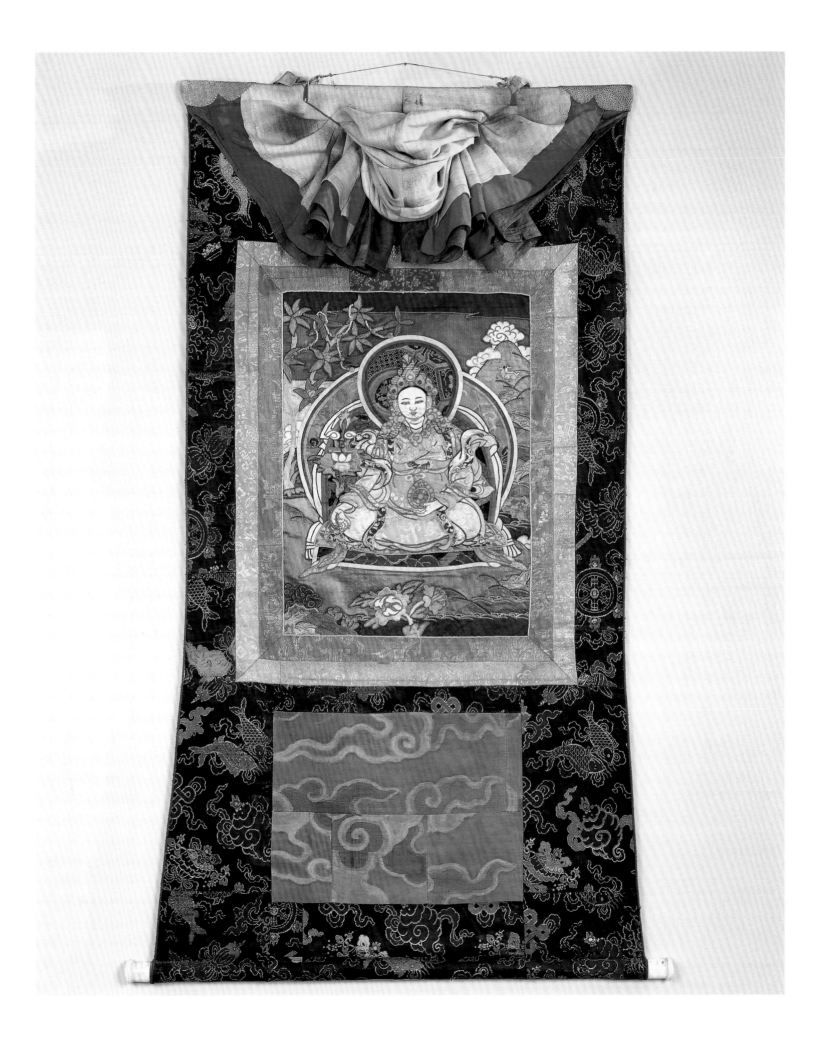

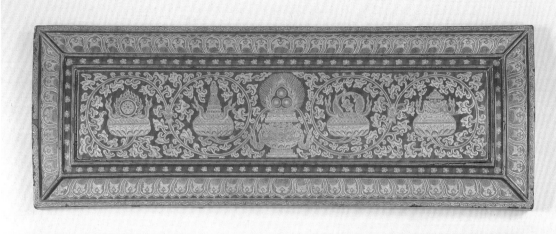

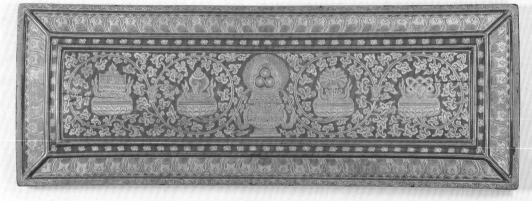

PLATE 2

Pair of *Kanjur* covers,
from a set commissioned
by the Yongle Emperor

China, 1410

Red lacquer with incised
and gilded decoration
on sandalwood, W. 28 ³/₄ in.,
H. 10 ¹/₂ in. (73.0 x 26.7 cm)
Purchase 1998 Membership
Endowment Fund and partial
gift of Arthur Leeper 98.22

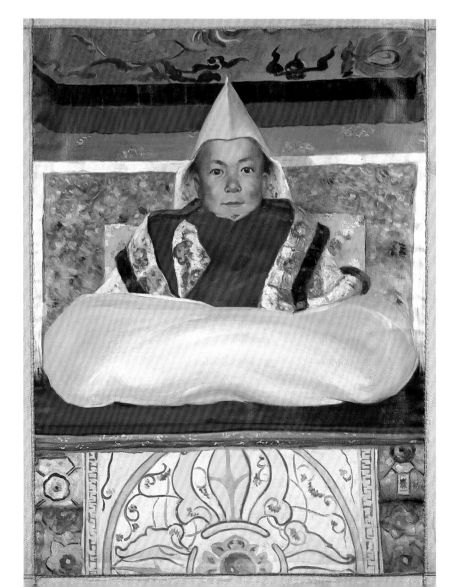

PLATE 3

Portrait of His Holiness,
the 14th Dalai Lama at age five,
at the enthronement ceremony
at the Potala Palace, Lhasa, Tibet,
February, 1940

by Kanwal Krishna (1909–93)
India, 1941(?)

Oil paint on canvas, H. 34 ¹/₂ in., W. 24 in.
(87.6 x 63.5 cm) (based on his photograph)
Gift of Mrs. C. Suydam Cutting, 1988
88.579

PLATE 4

The Wheel of Existence,
showing the different realms of *Samsara*

Tibet, 18th–early 19th centuries

Colors on cotton cloth,
H. 43 in., W. 34 in. (109.2 x 86.4 cm)
Purchase 1936 36.535

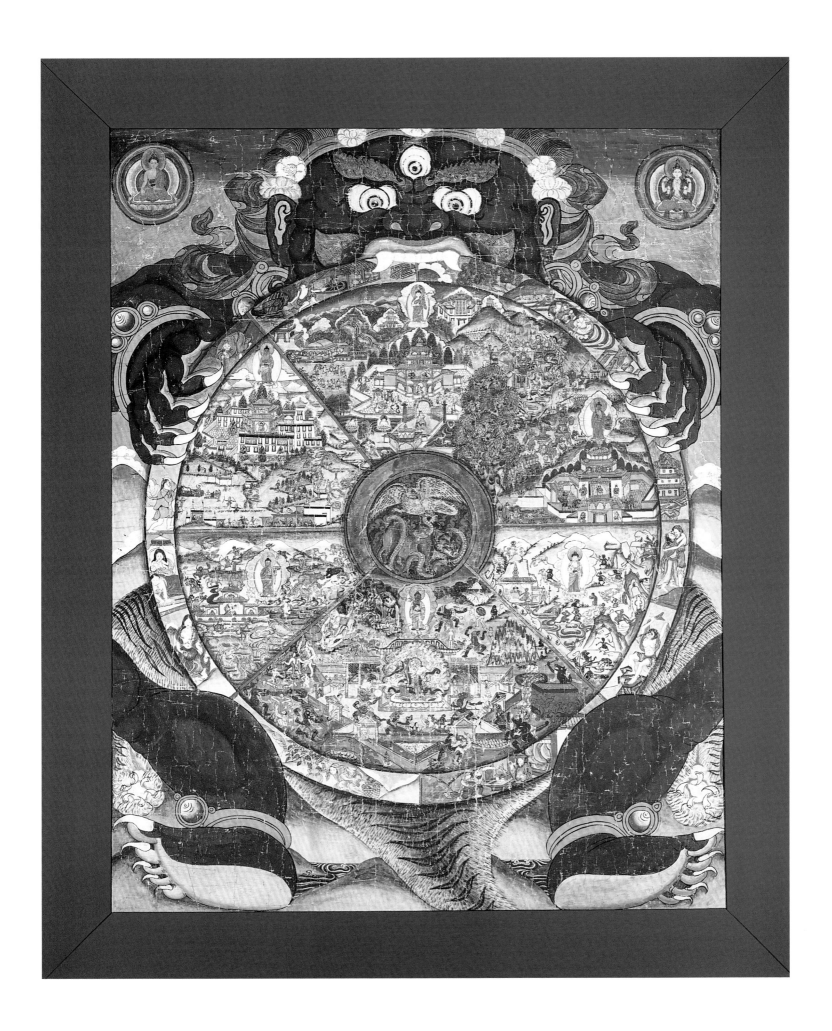

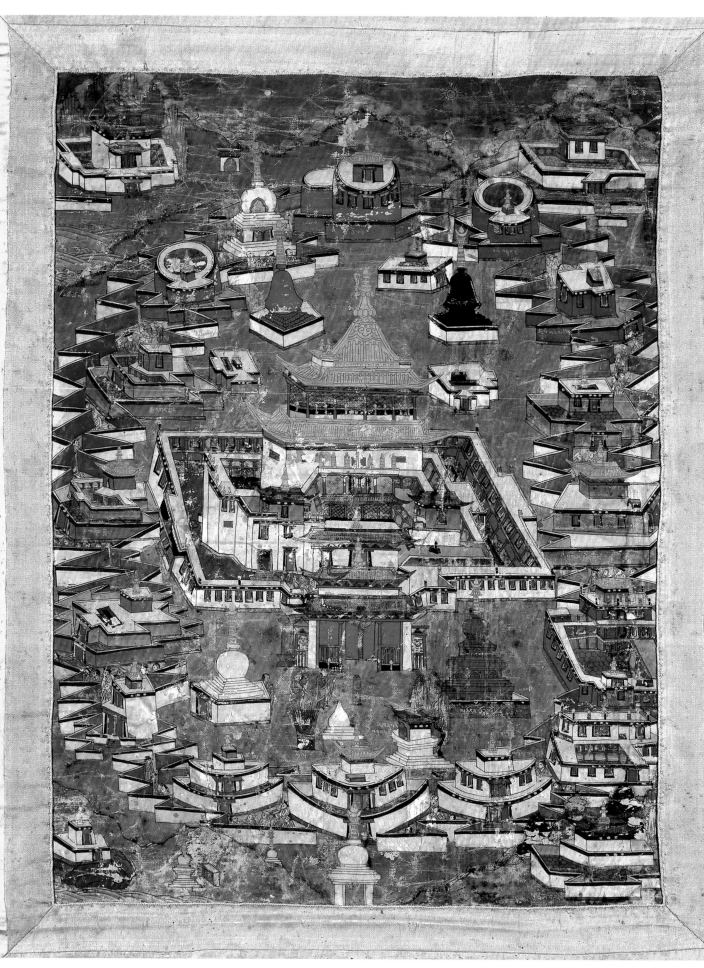

PLATE 5

Samye monastery

Tibet, 19th century

Colors and gold on cotton cloth,
H. 21 in., W. 15 in. (53.3 x 38.1 cm)
Dr. Albert L. Shelton Collection,
purchase 1920 20.271

PLATE 6

Atisha (982–1054)

Tibet, 17th–18th centuries

Gilt copper,
cast and hammered,
with painted details,
H. 7 3/4 in. (19.7 cm)
From the Baron von
Stael-Holstein Collection,
purchase 1949 49.41

PLATE 7

**Two folios from a biography
of Milarepa (1040–1123)**

Northeastern Tibet, 17th–18th centuries

Ink and colors on paper, H. 4 in.,
W. 23 in. (10.2 x 58.4 cm)
Carter D. Holton Collection,
purchase 1936 36.280

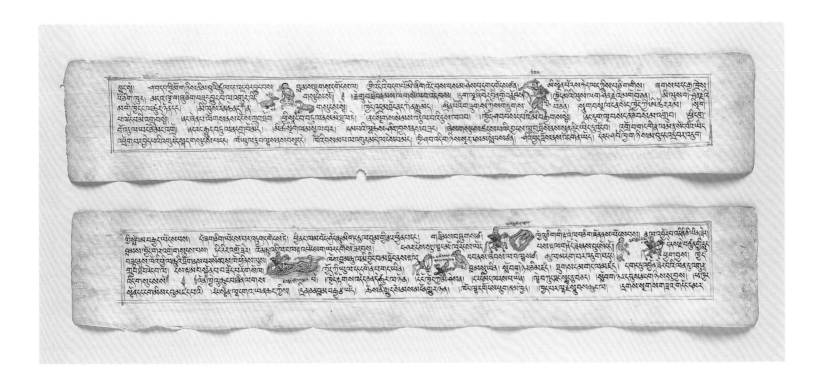

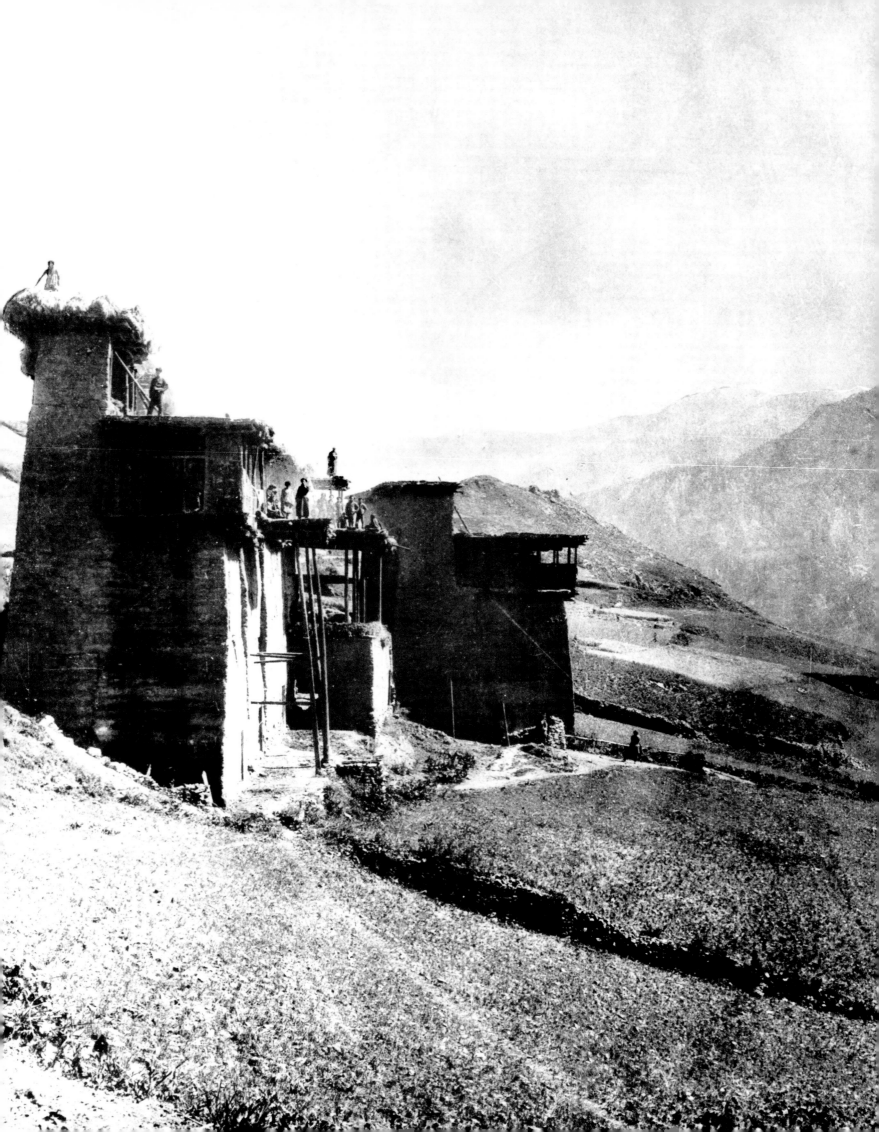

Chapter II Mountains and Valleys: Tibetan Everyday Life

The close economic and spiritual connection of the Tibetan people to their high and rugged land can perhaps best be seen at the village or encampment level. Farmers in the river valleys, herders in the high meadows and traders crossing the mountain passes have always been dependent on the rhythm (and vagaries) of climate and seasons and have needed keen knowledge of the terrain to ensure the success of crops, the health of stock animals, or safe passage between encampments.

The objects of everyday life in the Museum's collections show many aspects of a culture closely tied to the earth: sturdy tents, compact saddle gear, warm and flexible clothing and durable cooking equipment. Even these "mundane" objects, however, are equally expressive of a close attention to the spiritual rhythms of life.

Early Tibetan creation myths center on the high plateau as a sacred area. In ancient times, stone monoliths were erected to mark sites with ritual significance. The demarcation of sacred mountains, lakes, and other geological phenomena cause all Tibetans to be aware of the very ground on which they walk as potent with animated powers.

With the introduction of Buddhism in the seventh century, many of these forces were "tamed" or adopted by the new religion. Other practices and beliefs continued to a large extent outside organized religion. Such "popular religion" focuses on protection from evil, disease and misfortune and requires due vigilance and propitiation of the powers of earth, water, wind and animated spirits. Accordingly, a saddle will have auspicious decoration, a cooking pot will be adorned with propitiatory symbols, a necklace will have protective amulets. To remain mindful of dangers and to ensure safety and prosperity for oneself and family, it is important to have empowered objects in one's home or to wear on one's person.

Most Tibetans, as Buddhists, would also use potent objects for spiritual attainment, wishing in prayers, meditations and concrete acts of devotion to strive for the salvation of all beings. This form of "popular Buddhism" can be seen particularly in the use of prayer wheels and beads, and devotions at home altars.[1]

Costumes and Objects of Daily Life

The Newark Museum's collection of objects owned by farmers, traders and nomads was formed primarily in Eastern and northeastern Tibet (Kham and Amdo) between 1900 and 1948. These regions were especially close to the trade routes from Mongolia and western China, giving the local Tibetans access to imported silver utensils and ornaments, iron weapons, brilliantly-colored silks

[1] "Popular Buddhism", although primarily involving lay practices, is inspired or justified by the Buddhist scriptures, see p. 55.

Fig. 1 Nomad's tent, southern Tibet, 1935.

and rare furs. In exchange, farmers, nomads and traders profited from the sale of grains, meat, salt, hides, wool and horses to the Chinese and Muslim inhabitants in the lowlands to the east and north. These same trade routes continued westward on to Lhasa and to the monastic centers of central and southern Tibet and across the Himalayas. Contact and trade with the Tibetan heartland and pilgrimages to the great religious sites were also frequent in the first half of the twentieth century. Specific objects can sometimes show the cosmopolitan reach of this "local" culture: a saddle carpet of British-manufactured wool, a silver chatelaine crafted in China and boots trimmed with Russian leather.

The nomads, farmers and traders of Eastern Tibet, so well represented in the Museum's collection, were otherwise rather typical of Tibetans in their mixed pastoral and agricultural economy, dress and domestic possessions. The rugged nomads maintained a centuries-old rhythm of life, moving with the seasons, driving their herds to established grazing lands. Assembled in extended families, the nomads lived in large black yak-hair tents, held taut by numerous ropes and poles to withstand the fierce winds of the plateau (fig. 1). All possessions were made to be easily packed up and tied onto animals or to be worn on the nomads' bodies.

Farmers in the river valleys lived in stone and adobe brick houses, finished in whitewash with brightly-colored paint on wooden doorways and windows. In the multi-storeyed homes, animals were kept in the lowest level during severe weather; their body warmth helped to heat the upper storeys where the family lived and stored its grain. Several levels of flat roofs provided living and working space in fair weather. Limited access through doors or windows and systems of movable ladders and posts allowed the families to retreat inside the high-walled structures if attacked (fig. 2).

All lay Tibetans wore the basic *chupa*, a version of the full-length robe with overlapping front opening used throughout northern and eastern Asia. In each region, particular decoration and jewelry gave a distinctive local effect. The

Fig. 2 Farm houses, Kham, Eastern Tibet, 1910.

Fig. 3
Nomads with horses,
Amdo, northeastern Tibet,
1930.

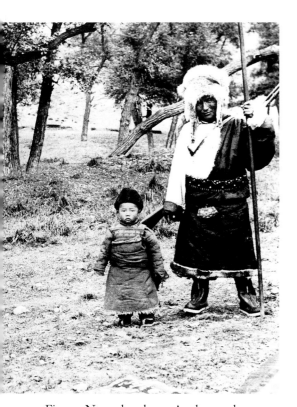

Fig. 4 Nomad and son, Amdo, northeastern
Tibet, 1930.

headdresses of Tibetan women varied greatly from area to area and served both as an emblem of identity and as the family's "movable bank" of negotiable coins, gold, silver and gemstones. Poorer individuals might have only a single sheepskin *chupa*, fur turned to their skin, worn trailing off the waist by both men and women on hot summer days. Wealthier nomads and farmers had silk and cotton undergarments and *chupas* of *pulu* (a fine native wool cloth) or imported cloth, trimmed with decorative banding and exotic furs. The *chupa* was worn wrapped tightly around the waist and secured with a belt or sash. Excess cloth was pleated or bunched to the back and pouched over above the belt; sleeves extended well beyond the hand for warmth and were rolled up while working. Nomad men liked to affect a rakish air with the robe pulled up high and the right sleeve thrown off. This also gave them freedom of movement, especially for riding (fig. 3).

The costume shown in color pl. 8 was worn by a nomad from the area around Labrang in the high pasturelands of Amdo. The heavy outer robe is the standard sheepskin *chupa* with fur turned inward. As a display of wealth and elegance, the robe's exterior is covered with shiny black cotton sateen with fine, brightly-colored silk stitching and otter fur at the cuffs, hem and side opening (see also fig. 4). The right sleeve is shown thrown off (and down the back) to reveal a shirt of raw silk. Striped and stamped wool cloth is sewn to the deerskin and Russian leather boots. Thin bands of striped wool are used to lash the leggings tight to the leg. The fox fur-trimmed hat was popular throughout Amdo in the 1930s, as can be seen in figs. 3 and 4.

In warmer weather, when hats are unnecessary, men in the Labrang area would wear their long hair braid, enhanced with tassels, wrapped around the head and secured with a large silver ornament (fig. 5). The example in color pl. 9 is formed of silver spiral motifs which seem to have archaic antecedents. The large imitation coral beads have drilled holes, suggesting that they were originally used strung as a necklace. Flawless, brightly-colored glass or paste imita-

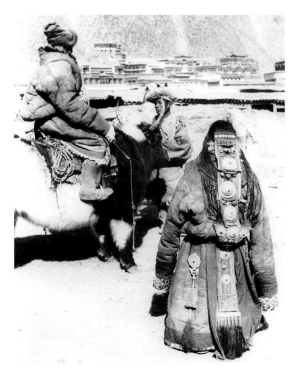

Fig. 5
Nomad boy with hair ornament,
Amdo, northeastern Tibet, 1930.

Fig. 6
Group of nomads outside Labrang,
Amdo, northeastern Tibet, 1930.

tion coral and turquoise were traded into Tibet from China and western Asia as early as the thirteenth century.

The Labrang woman's ensemble, shown in color pl. 10 features costly decoration suitable for a well-to-do nomad of *circa* 1930. The inner robe is heavy sheepskin, fur turned inward, with an exterior lining of maroon cotton sateen, edged at the cuff and hem with otter fur. Over this is a thin robe of identical cut and fur trim, made of brilliant blue and silver Chinese brocade in a European-style floral pattern. With the right sleeve thrown off, her inner short jacket is revealed, the bright scarlet silk brocade trimmed with otter fur. The collar is worn turned up around the neck to show Indian gold brocade facing. The peaked hat of blue cotton, lined with felt, is deeply trimmed with lambskin. The Labrang woman's boots are constructed of imported Russian leather and Chinese velvet, insulated with a felt lining.

On all occasions, even while milking, nomad women from Amdo wore extraordinary headdresses, variations on a heavy, gem- and silver-studded cloth pad worn down the back (see fig. 6). The Museum's headdress, shown in pl. 10, is in the fashion of Labrang, *circa* 1930. The weight of the large rectangular panel of red wool lined with silk ribbon velvet and fringe is borne by a waist-sash attached to a loop on the underside of the panel. Forty silver Chinese dollars are in five rows below and ten silver Chinese "quarters" are across the top of the plaque, attached with soldered metal loops sewn to the wool.[2] Nine large dome-shaped silver "lotus-petal" ornaments set with imitation coral are sewn above the large coins. The woman's hair, in many small braids, 108 ideally,[3] was attached to the top of the plaque (here a wig is shown) along with a narrow panel of wool cloth to which amber beads and silver discs set with coral are sewn.

Additionally, nomad women from the Amdo grasslands wore special ornaments suspended from the front of the waist-sash. The milk pail hook, color pl. 11, signifies the women's traditional role as milkers of the herd animals. Lavish

2 The coins are regular Chinese government (Beijing) currency as well as Imperial mint issue for the Chinese provinces, and British trade dollars minted in India for trade through Shanghai; dates are 1890s–1930s.

3 The number 108 is auspicious in Tibetan folk custom.

4 As with all Tibetan robes, the thin silk fabric is sewn to a heavy cotton lining which increases the garment's warmth and also enhances the stiff presentation of the tailoring.

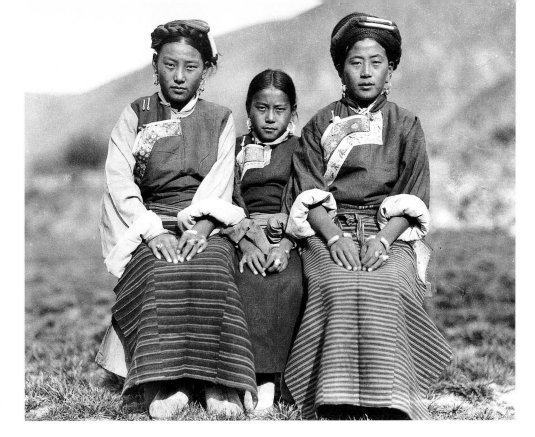

Fig. 7
Village girls,
Batang, Kham,
Eastern Tibet,
1910.

ornamentation was also a mark, like the headdress, of financial status. The Museum's example is fashioned out of heavy brass, with a finely incised floral pattern on the "hooks" and turquoise and imitation coral stones set in silver lotus medallions, suspended from the waist by a leather strap.

Also suspended from the waist was a chatelaine, color pl. 12 (and compare fig. 6), of brocade-covered leather adorned with a leaf-form plaque of scrolling silver and silver-gilt repoussé set with a large turquoise stone. From a "Face of Glory" at the base, a hinged silver pendant of scroll-form is used to attach a "rainbow" silk tassel and eating set. The set is also a beautifully crafted adornment expressing the high status of the owner. The knife handle and sheath are of wood with silver mounts decorated with auspicious deer, bats and Eight Buddhist Emblems and set with turquoise, coral, lapis lazuli, garnet, agate and glass stones. The sheath is signed in Chinese characters by the maker. The chopsticks are ivory. Such eating sets, whether of fine or simple materials, were used by Tibetans when traveling or visiting. The use of chopsticks is an adaption of Chinese custom.

The costume shown in color pl. 13 is a type worn by village women in Batang, Eastern Tibet for festivals and fancy occasions. The Museum's set was given to Dorris Shelton by her father just before she left Tibet at the age of fifteen in late 1919 (see pp. 14–15 and figs. 7 and 8). As can be seen in fig. 7, it is identical to Batang teenage girls' ensembles, of this period, complete with boots and silver belt pendants. The bright blue silk brocade is cut as a typical sleeveless *chupa*, except for the exaggerated dip to the front diagonal closing which is trimmed with a golden floral Indian brocade and a wide Chinese ribbon border. This closing, obviously a variant of Chinese and Manchu dress, seems to be specific to Batang which has historically been close to ethnic Chinese borderlands. The robe is worn, in the Tibetan style, wrapped tightly to the body at the waist and hips, with excess fabric folded back in deep pleats[4] (see fig. 8). An inner belt secures the pleats, covered with a decorative outer belt of scarlet silk damask.

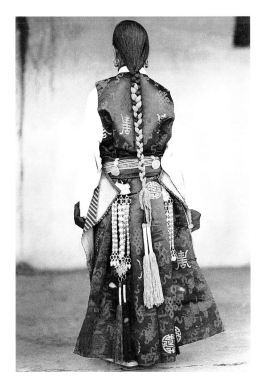

Fig. 8 Village girl, showing hair and belt ornaments worn down the back, Batang, Kham, Eastern Tibet, 1910.

The matching long-sleeved scarlet damask blouse has a beautiful embroidered collar and an enameled silver butterfly pin set with coral and turquoise at the throat. As a woman who had reached maturity, Dorris Shelton, like the teenagers in fig. 7, wore a striped apron, here fashioned in silk velvet (of Indian manufacture?) with Indian gold brocade triangles at the upper corners (see also fig. 8). The boots are of white quilted cotton with thick layered paper and leather soles. The red wool and black velvet uppers are wrapped to the leg with silk ribbon ties. Blue silk tassels wrapped in silver wire were woven into the hair braids and worn either hanging down the back or wrapped around the head (see figs. 7 and 8).

The women of Batang wore a particular type of earring (see figs. 7 and 8) with paired "dragon" heads, color pl. 14. Cast in heavy silver, the highly stylized dragon heads, which actually look more like ibex or wild goats, face each other across a coral glass bead topped with turquoise. The use of such animals connects to Central Asian and Chinese "animal-style" ornaments dating back thousands of years.

Of similar antiquity is the form of the hair ornament in color pl. 15, showing a *khyung* bird grasping snakes. The Tibetan horned *khyung*, absorbing the Indic concept of *garuda*, also a bird-deity, can be found in *tokche* amulets, see color pl. 35. The Museum's *khyung* hair ornament was worn by a woman of the Jarong tribe of the Sino-Tibetan borderlands, reportedly in the same manner as the man's hair ornament in fig. 5. The *khyung's* body grasping snakes is formed of gilt silver with rough turquoise and coral stones set in silver to represent the magical bird's outstretched wings and tail. As with *tokches* which are worn at the throat or chest, a head ornament of the bird-deity would offer magical protection, especially against disease.

The belt pendants shown in color pl. 16 are similar in style to those shown in use in fig. 8, worn hanging down the back from the waist sash. The Khampa women's belt pendants, like so much of their attire, reflect a mix of Chinese and Tibetan traditions. Here, a series of silver medallions and discs set with orange-colored coral and green malachite stones are suspended by fine silver chains from the waist. Below these, suspended on three separate chains apiece, are finely-cast silver miniaturized replicas of Chinese silk brocade bags and ornaments. The ornaments are of auspicious flowers and animals. The bags and pouches imitate popular Chinese women's accessories (in silk) of the eighteenth and nineteenth centuries. The use of small, polished pale coral and malachite stones here suggests Mongol or Manchu craftsmanship.

The "Khampas" and "Amdowas" appear formidable in early twentieth-century photographs, bristling with weapons and ready for action (see fig. 13). All objects pertinent to daily business were strung on the body or stowed in the pouch of the *chupa*. The primitive matchlock gun was in general use in Tibet between the sixteenth century and 1904 when the British introduced rifles; eastern nomads, however, continued to use the matchlock until 1959. It was carried as protection against brigands and to shoot game. The wicked-looking prongs at the tip folded down to serve as gun rests while firing from a kneeling position. Swords and knives, tied on or thrust through the belt, were used for fighting and cutting. Bows and arrows were the ancient weapon of Tibet, used in the twentieth century in lieu of or alongside guns for protection, as well as

for hunting and in archery contests. All these weapons reflected the social and financial position of their owners and were finely crafted and inlaid with precious substances when possible.

The handsome matchlock gun in color pl. 8 is similar to the pronged guns worn slung across the back in figs. 3 and 13. The iron barrel and firing mechanisms were probably imported from China, to be set into the wooden stock with inlaid decoration by a local artisan. The beautiful inlaid bone design is of arabesques, with silver and brass bands and plates attached along the stock. The leather "slow-match" case and power pad are decorated with brass studs. The antelope horn and wood prongs snap down to be used as a support while firing.

Stowed in the belt, with hilt at the ready, are the swords worn by nomad men in photographs from the 1920s–50s (see figs. 3 and 13). The Museum's fine example, color pl. 17, has an iron blade with beveled tip and iron hilt chased with an interlace motif, set with a turquoise. The hand grip is wrapped with silver wire. The wood sheath is wrapped in leather and edged in iron. The tip of the sheath is deeply incised with a scroll pattern, gilded and set with a large turquoise stone, while down the front an applied relief design of silver scrolls is set with three coral beads.

More rarely used in the twentieth century was the ancient Asian weapon, the bow and arrow. The beautiful quiver shown in color pl. 18 is constructed of wood covered in red wool on the upper side and leather on the underside. Finely chased silver bands and a medallion on the hinged lid have scrolling floral patterns. A leather strap wraps around the waist. The arrows stored inside are bamboo with feathers and green and red painted decoration on the rear shafts. Some of the arrows have steel tips and were used for hunting. Others have hollow perforated wooden heads which created a whistling sound to scare up game. The whistling-head arrows were also used in archery contests (see fig. 9).

Domestic paraphernalia was compact and portable and made from the richest materials the family could afford. Eating sets, after Chinese and Mongol custom, were carried hanging from the belt by both men and women. Flint and tinder pouches for starting campfires were tied to the belt. Stored in the family tent or home was the equipment necessary for preparing and serving tea, beer, *tsamba* (a staple of the diet made of parched and ground barley), cheese, butter, yogurt and meat. These domestic utensils, though for mundane purposes, show the Tibetans' love of fine woods and metals and use of decorative design to enrich surfaces.

Flint and tinder were used up to the mid-twentieth century by all Tibetan men, when traveling or herding, to start a camp fire or light a tobacco pipe. The small pouches made to carry these supplies were often quite ornate, worn suspended prominently from the belt (see fig. 4). The example in color pl. 19 is constructed of different colored leathers and decorated with velvet and silver studs. A heavy steel bar is attached to the bottom of the pouch. When fire was needed, a chip of flint and bit of tinder (soot or powder mixed with leaves) were struck against the steel to produce a spark and then a flame.

Snuff (tobacco mixed with ash) was popular among Tibetan men from all tiers of society in the nineteenth and early twentieth centuries, and taken even by monks and women on occasion. The elegant snuff container in color pl. 20 was used by a nomad in Amdo in the 1930s. The yak horn has been hollowed

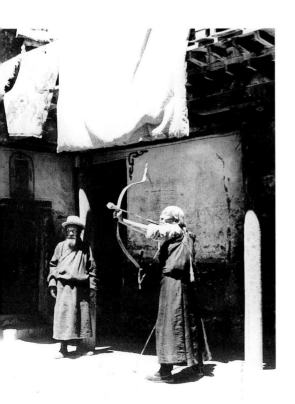

Fig. 9 Archery contest, Shigatse, southern Tibet, 1935.

out, carved with lotus petals (at the narrow end), and decorated with fine relief silver depicting dragons and a key fret. Large turquoise and coral stones are set in high bezels. The wide top of the horn is stoppered with a wood plug covered in silver decorated with dragons and a lotus-petal border. The container was filled from this wide end and snuff taken for use from the small hole in the silver-covered tip.

Covered pails were practical items on a Tibetan farm or at a nomad encampment. They were used for storing and carrying milk, water or beer. The handsome pail in color pl. 21 is a sturdy copper cylinder with a tightly-fitting lid, both decorated with brass. On the body, interlace medallions are set in two registers separated by brass bands. On the lid the brass band on the outer rim is incised with lotus flowers and the raised brass central knob and finial are also of lotus motifs, set in a scrolling medallion.

Very similar interlace and lotus designs in brass are applied to the robust wooden teapot, color pl. 22. The dense burl wood of the body and lid beautifully contrasts with the bright brass and copper decoration. Such pots were used to serve the "national drink" of Tibet: steaming hot black tea to which salt and butter are added and the mixure churned to a frothy soup.[5] Traditionally, the tea is sipped throughout the day for warmth and sustenance. This is especially important in the bitter cold of a highland nomad camp.

On festive occasions, *chang*, the Tibetan beer of fermented barley would be served in fine containers. The iron *chang* jug in color pl. 23 is one of a pair especially prized by Dr. Shelton. They were a gift to him from the Kalon Lama in thanks for Shelton's service to the wounded at Chamdo in the fighting of 1918 (see p. 14). The canteen-shaped body of such jugs shows they are descended from the flat-sided flasks tied to horse and camel bags while traveling. However, the elegant brass dragon handle, lotus finial and *makara* spout here would preclude such treatment. Chamdo was famous for producing these *chang* jugs which feature damascening of silver and gold in the iron body. Here the design depicts some of the Eight Buddhist Emblems and other auspicious symbols.

Nomadic existence led to the imaginative use of many forms of flat textiles, for bedding, seats, walls and decorative effects. Imported Chinese or Indian silk and cotton cloth was cut and sewn into garments, saddle pads and many domestic objects. Felts and woolen cloth are made locally. Polychrome striping and tie-dyed circles and crosses are popular designs for wool. Narrow widths of striped wool or imported silk are woven and used as belts, garters and trim. Felt rugs are used for sitting and sleeping areas in northeastern Tibet, their light weight, softness and portability making them ideal for traveling encampments. The felt in color pl. 24 is the type made in Inner Mongolia and traded into Amdo in the 1920s and 1930s. The brown and buff fibers come from fine goat wool; the auspicious design of deer and "endless knot" was popular in China and Mongolia.

Knotted carpets are used, like felts and animal skins, to make warm and soft sitting and sleeping areas in tents and houses. Fine saddle carpets in bright colors and patterns are also used under and over horse and yak saddles, see fig. 3. The notched rectangle under-rug in color pl. 25 is a fine example of the type produced in central and southern Tibet in the nineteenth and early twentieth centuries. The peony design in the two center orange panels "grows" out of a

5 Tea is also added to *tsampa* flour and kneaded into dough or mixed to an oatmeal consistency. Regarding tea/diet see Goldstein and Beall, *Nomads of Western Tibet*, pp. 22 and 114.

6 Dan Martin has written eloquently about the "problem" scholars or outside observers have had in understanding or even giving credence to beliefs, practices and ritual objects associated with Tibetan "popular" religion. Cf. "Pearls from Bones", pp. 296–7.

7 Such lists are included in texts by Gnubs-chen Sangs-rgyas-ye-shes (*Bsam-gtan Mig-Sgron*, tenth century), Zhang Rin-po-che (*Phyag-rgya-chen-po Lam-zab Mthar-Thug*, twelfth century), and O-rgyan-bstan-'dzin (*Gu-ru Bkra-shis*, eighteenth century). I am grateful to Dan Martin for bringing these lists to my attention.

8 These prayers are specifically *mantras* used for achieving high aspirations.

9 Dan Martin has done the first serious study of prayer wheels in English. See "On the Origin...Prayer Wheel".

jagged rock base, surrounded by a stylized rainbow-colored wave border. The center and all edges are bound with red woolen cloth and the holes cut for the girth are bound with leather.

Popular Religion

Many objects for prayer and ritual are primarily associated with Tibetan laymen. Although these can be used by monks, they are most commonly for "popular" or lay practice. These lay ritual objects and related religious practices such as prostrations and pilgrimages, can seem to be quite different from the more philosophical realms of canonical Buddhism, but nonetheless most of them do have justification in passages from the Buddhist *Sutras*.[6]

Many lay religious practices can involve everyday acts of altruism. Among those most often cited in codified lists are:

- prostrations and circumambulation
 [of a sacred site or structure, see fig. 12]
- recitations [of *mantras*]
- fire rituals
- making *tsa-tsa* and *chortens*
- offering mandalas
- releasing animals and small fishes
- fixing roadway obstructions
- instituting ferries and bridges
- giving medicine and food to the sick
- taking day-long monastic vows
- fasting
- sweeping and cleaning[7]

Prayer Wheels

The prayer wheel is the quintessential Tibetan lay device for "popular Buddhism". No other Buddhist, let alone non-Buddhist, culture uses such a tool for creating prayers.[8] As with other objects and practices of "popular Buddhism", both serious Western scholars and Tibetan commentators have largely ignored prayer wheels.[9]

Owned and used by Tibetans of every social rank, prayer wheels are devices for creating prayers by hand power. Rolls of written prayers or *mantras* are sealed in the cylinder; with each revolution, the prayers are "sent out". Cylinders containing prayers are also set up on roofs or in streams, with blades to turn them by wind or water powers. Giant wheels are placed in niches in the walls surrounding temples, to be turned by passing pilgrims and monks (see fig. 10).

The Tibetan terms for prayer wheels can be translated as "hand wheels" or "*dharma* wheels" but most commonly they are called, in Tibetan, "*mani* wheels" because of their usual association with Avalokiteshvara, Bodhisattva of Compassion and his *mantra* (the "Six Syllables"), "*om mani padme hum*". *Mani*, "jewel", and *padme*, "lotus", are Avalokiteshvara's emblems, hence the *mantra*

Fig. 10
Large prayer wheels
outside Derge monastery,
Kham, Eastern Tibet, 1910.

should be understood as "hail the jewel-lotus". It is this *mantra*, repeated "endlessly", which is typically written or printed on paper and wound tightly inside the cylinder of a prayer wheel.

The benefits of spinning a wheel, while maintaining the proper visualizations and compassionate mind, are many. "Just being struck by a wind which has touched such a prayer wheel cleanses a great number of sins and obstacles to enlightenment and is said to implant the seed of liberation".[10]

The hand wheel in color pl. 26 was probably used by a farmer or nomad as it has a rough, home-made quality. The cylinder is large and very heavy, requiring some effort to keep in rotation with a repetitious wrist movement.

Mani Stones

"*Mani* stones" used to form walls or piles (see figs. 11 and 12) are another manifestation of the objectification of prayer. Prior to the Chinese invasion of

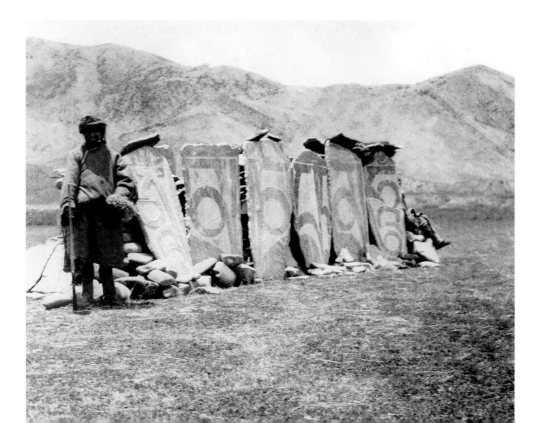

Fig. 11
Mani wall,
Kham, Eastern
Tibet, 1910.

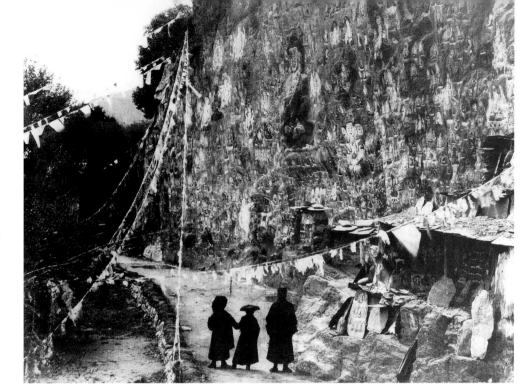

Fig. 12
Pilgrims on the *Lingkhor*
(circumambulation route)
around the Potala Palace,
Lhasa, central Tibet, 1904.
Note *mani* stones at right,
prayer flags overhead
and images on the wall.
John Claude White photo,
Gift of Frank and
Lisina Hoch, 1997 97.9

1950–59, *mani* walls and piles (often decorated with flags) marked sacred places such as mountain passes and temple precincts throughout Tibet. The religious decoration of small stones and the custom of piling them seems to relate to ancient Tibetan practices of erecting stone circles and stone pillars to mark places of power. In Buddhist practice, one can get great benefit from just drawing the "Six Syllables" (*om mani padme hum*) or other religious text on a stone or on a wall, or just by touching such a drawing.[11]

The small flat shale stone in color pl. 27 is typical of those placed in piles or on walls in Tibet. The *mani* prayer is here carved in relief and painted in bright colors. References to the *om mani padme hum mantra* can be traced back to the Buddhist documents found at Gilgit (sixth to seventh centuries) and Dunhuang (eighth century). The "Six Syllables" are used to purify one each of the Six Realms of Existence (see color pl. 4).[12]

Prayer Beads

Prayer beads (Sanskrit: *malas*; Tibetan: *trengwa, phreng-ba*, "string of beads") are used by all Tibetans, lay and cleric, in religious practice. Evolving from prayer beads in ancient India, probably connecting via western Asia to the rosary of Christian practice, they are used in all Buddhist lands. In Tibet, the beads, 108 in number, are used to count repetition of prayers. The counters record multiples of the main beads, and can thus count thousands of repetitions.

The prayer beads in color pl. 28 are constructed of fine amber divided into six sections by rose-colored agate stones and silver discs. Three amber and agate beads of decreasing size, terminating in silver discs and a tassel, are at the juncture of the cord. There are four strings of counters (*grangs'-dzin*) to record (by sliding down on the leather cord) repetitions of one, ten, one hundred and one thousand prayers. Two of these end in a decorative silver and coral ornament and two end in silver *vajra* and bell (see p. 133), perhaps symbolizing that the owner has had *tantric* initiations (see Chapter IV, fig. 1 for a view of a monk holding a similar string of beads). The amber and agate beads on this set are

10 Martin, *op. cit.*, p. 18.
11 Stone carvers often work near sacred precincts to create "*mani* stones" for practitioners.
12 See Martin, *op. cit.*, p. 23, footnote 14.

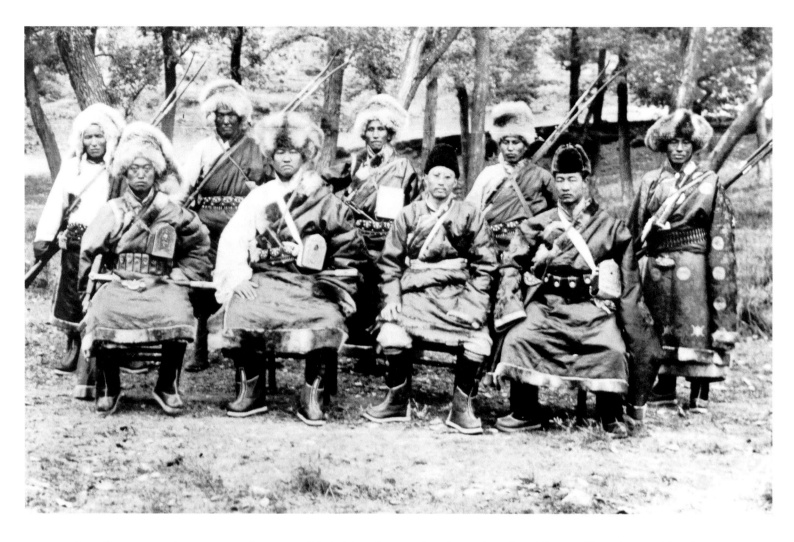

appropriate for prayers/*mantras* to the peaceful deities. Prayer beads made of skull discs, see pp. 143–144, would be used for *mantras* to *yidam* deities such as Yamantaka.

Ga'u

Ga'u, often called "charm boxes", could be better translated "relic shrines." They are used to enclose *mantras*, written texts, small images, relics and other sacred objects. This is most obvious in the actual shrine-shaped *ga'u* of metal or wood, usually decorated with auspicious emblems. Smaller *ga'u*, adorned and worn like jewelry (at the neck, chest or in the hair) by Tibetan women and men, are more variable in shape, following in their outer form traditional shapes for adornment.

As can be seen in fig. 13, the shrines were worn strapped to the chest (if large) or the neck (if small). When traveling, they served as small portable shrines for use in devotions and meditations; while at home, *ga'u* would be kept on the household altar. The precious and sacred contents of the *ga'u* also protect the wearer.

The arch-shaped box in color pl. 29 is quite like those seen in fig. 13. Here the central motif is of the "All Powerful Ten" of Kalachakra in copper, set into fine scrolling lotus plants and a beaded edge, in silver repoussé. Loops on the copper sides would have secured a leather carrying strap. This box was opened

after it came to the Museum with the first group of Tibetan objects from Dr. Shelton. The contents include many of the powerful sacred objects such as relics and religious texts appropriate for enclosure in a *ga'u*: 210 woodblock prints in red ink on paper, each representing a deity or saint with Tibetan inscription, fastened together at one corner to form a book; five folded papers containing relics; two fragments of gauze, one of them tightly twisted and knotted and a folded woodblock print in black ink showing a lama. One of the folded papers contains bits of thread and cloth including a piece of red wool from a lama's garment. Three hold the sacred crystals (Tibetan: *ring-bsrel*) which are said to be found in the ashes of holy men after cremation. The knotted gauze is from a *srung-mdud*, literally "protection knot", which is knotted and breathed upon by a lama and given to worshippers who come for a blessing.

The oval-shaped *ga'u* in color pl. 30 was worn by a man or woman in the Labrang area of northeastern Tibet. The silver front is beautifully decorated with filigree in swirling patterns set with coral beads and a turquoise stone. The outer repoussé bands are of stylized lotus petals. A chain or strap passing through the loop at the top passed around the owner's neck. See also pp. 96 and 127 for *ga'u*.

Tsa Tsa

Small votive images of clay, called *tsa tsa*, are often placed inside *ga'u*. Such images have an ancient Buddhist history, dating at least from the fifth century in South Asia.[13] They are usually made of sun-dried clay mixed with sacred substances such as body relics. This soft mixture is pressed into a mold. The flat back is often inscribed with *mantras* or a mystic syllable. *Tsa tsa* enclosing or consisting of saints' relics are commonly inserted into *chortens* and large images as consecration contents, see pp. 124 and 179.[14] Those containing the remains of laypersons are placed in a protected cavern or sacred area.

The brass mold in color pl. 31 was used to make impressions of a standing eleven-headed, eight-armed image of Avalokiteshvara. A lug cast onto the back of the mold facilitated handling. This mold was obtained in the Amdo area in the 1930s. A modern clay image formed from the mold is shown in the photograph.

The old *tsa tsa* in color pl. 32 was acquired in Lhasa in 1981. The fine painting and gold on the surface suggest that it was used in a *ga'u* or other shrine. In a lobed arch sits the corpulent figure of Jambhala, Lord of Wealth, holding the mongoose who spits jewels.

Astrological Handbooks

Tibetans consult astrologers when embarking on any important venture to obtain information on auspicious or inauspicious dates and times, places and persons. An individual's horoscope would be considered a crucial element in marriage discussions. Lamas or specially trained laypersons can be called upon for divinations and astrological consultations. Tibetan astrology combines aspects of ancient Chinese, Indian and western Asian traditions. The Tibetan calendar is based on the *Kalachakra* ("Wheel of Time") *Tantra*, using a lunar

13 See Huber, "Some Eleventh Century Indian Buddhist Clay Tablets", pp. 493–6, for Indian examples of eleventh century and Bentor, "The Redactions from Gilgit", pp. 39–45, for textual references *circa* sixth to seventh centuries.

14 Martin, "Pearls from Bones", pp. 299–300.

cycle of twelve months. Each month is associated with an animal: dog, pig, mouse, ox, tiger, hare, dragon, snake, horse, sheep, monkey and bird.

To mark the passage of years, a cycle of five elements is added to the twelve; the five are wood, fire, earth, iron and water. This produces the sixty-year cycle which is also used in China and Korea and corresponds to the astronomical sixty-year cycle of the moon. The Tibetan calendar begins with the year 1027 C.E. We have begun the seventeenth cycle since that time: 1999 = the earth-hare year.

The finely calligraphed astrological handbook seen in color pl. 33, includes colored drawings and charts which can be consulted by a trained astrologer for a one-year cycle. The title page is missing, so the actual year is not known. The book follows a binding system used for Tibetan government documents, with folded and stitched bundles of folios and a delicate silk cover.

Dough Molds

Small wooden boards are commonly used in Tibetan popular rituals to make dough or flour effigies called *zan par* ("dough print"). The boards would be carried from village to village or home to home by a trained priest, to cure sickness or deal with various misfortunes. Such a practitioner could be a Buddhist or Bonpo priest or a layman whose family specializes in such work. The ritual is a form of protection (*mdos*), ransom (*glud*) or exorcism (*gto*) in which the dough effigy serves as a substitute for the actual sacrificial offering or affected being (human, animal, etc.). The mold set shown in color pl. 34 is an unusually complete and finely-carved example. Small inscriptions identifying the type of obstacle, and direction of placement accompany many of the incised animals, birds, insects, deities and symbols. The practitioner presses a rectangular slab of dough (*tsampa* flour and water) onto the appropriate incised images and then places the dough, face up, in an offering plate on a specially constructed altar. Chants by the practitioner complete the transfer of misfortune into the dough effigies.[15]

Tokche

Votive objects particularly treasured by Tibetans are called *tokche* (*thog-lcags*, "thunder-iron"). Although these can have Buddhist symbolism, *tokche* are valued for their magical protective properties. Worn as amulets, *tokche* are "found objects", always of metal and usually showing much wear. Some are of geometric or animal shapes which recall the ancient bronze "animal style" plaques and ornaments of the Eurasian steppes.[16]

The two examples in color pl. 35 are in specifically Tibetan shapes. The horned bird-deity *khyung* seizing a twisting serpent has ancient mythic origins in Tibet which combined with the Indic sun bird *garuda* in the seventh to thirteenth centuries in Tibet. Both bird-deities have powers over water serpents, giving them particular protective potency. The crossed *vajra* amulet has obvious *tantric* Buddhist meaning. The protective function of the *vajra* comes from its association with the thunderbolt weapon of Indra and many of the Buddhist protector deities.

PLATE 8

Amdo man's ensemble

Northeastern Tibet, *circa* 1920–30

Cotton sateen and sheepskin *chupa*, trimmed with silk and otter fur; raw silk shirt; satin and damask silk hat trimmed with fox fur; long hair braid with shell ornament; yak hide and Russian leather boots with deerskin uppers trimmed with tie-dyed and striped wool; striped wool garters
Carter D. Holton Collection, purchase 1936 36.378, .358, .483, .361, .363

Matchlock gun

Eastern Tibet, *circa* 1900

Iron barrel; wood stock inlaid with bone, brass and silver; leather case and pad with silver decoration; antelope horn and wood fork; leather strap,
L. 62 in. (157.5 cm)
Edward N. Crane Collection, gift 1911 11.639

15 Nebesky-Wojkowitz, *Oracles and Demons of Tibet*, pp. 362–3.
16 See Anninos, "Tokches, Images of Change in Early Buddhist Tibet", *Orientations*, October, 1998, for Tibetan examples and Bunker, *Ancient Bronzes of the Eastern Eurasian Steppes from the Arthur M. Sackler Collection* for older ornaments.

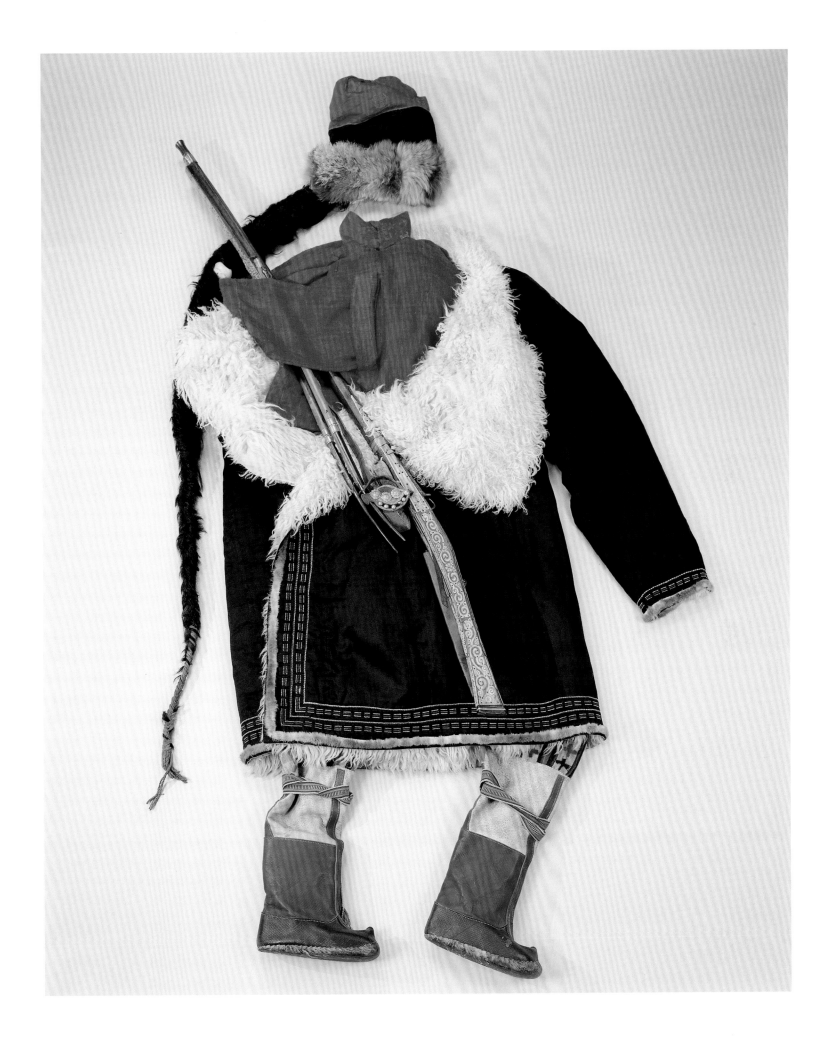

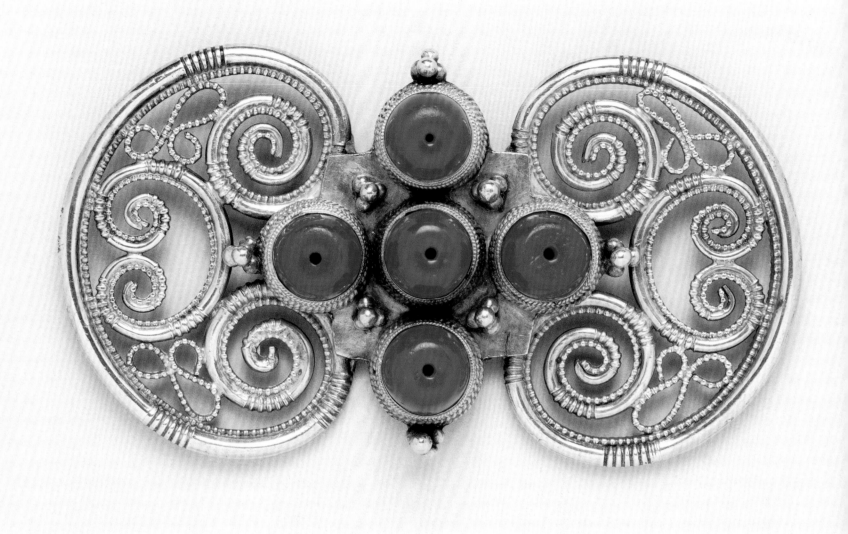

PLATE 9

Man's hair ornament

Northeastern Tibet, *circa* 1930

Silver, glass beads, W. 4 in. (10.2 cm)
Carter D. Holton Collection,
purchase 1936 36.423

PLATE 10

Labrang woman's ensemble

Northeastern Tibet, 1920–30

Silk brocade *chupa*, trimmed with
otter fur; cotton sateen inner robe
lined with sheepskin, otter fur trim;
silk brocade jacket trimmed with
otter fur; cotton and felt hat,
lined with lambskin; padded wool
headdress, with silk, velvet and
silk fringe, silver coins and discs,
coral, glass, paste and amber;
Russian leather boots with
cow and horsehide, velvet
and felt lining and trim
Carter D. Holton Collection,
purchase 1936 36.362,
.364– .366, .368, .382

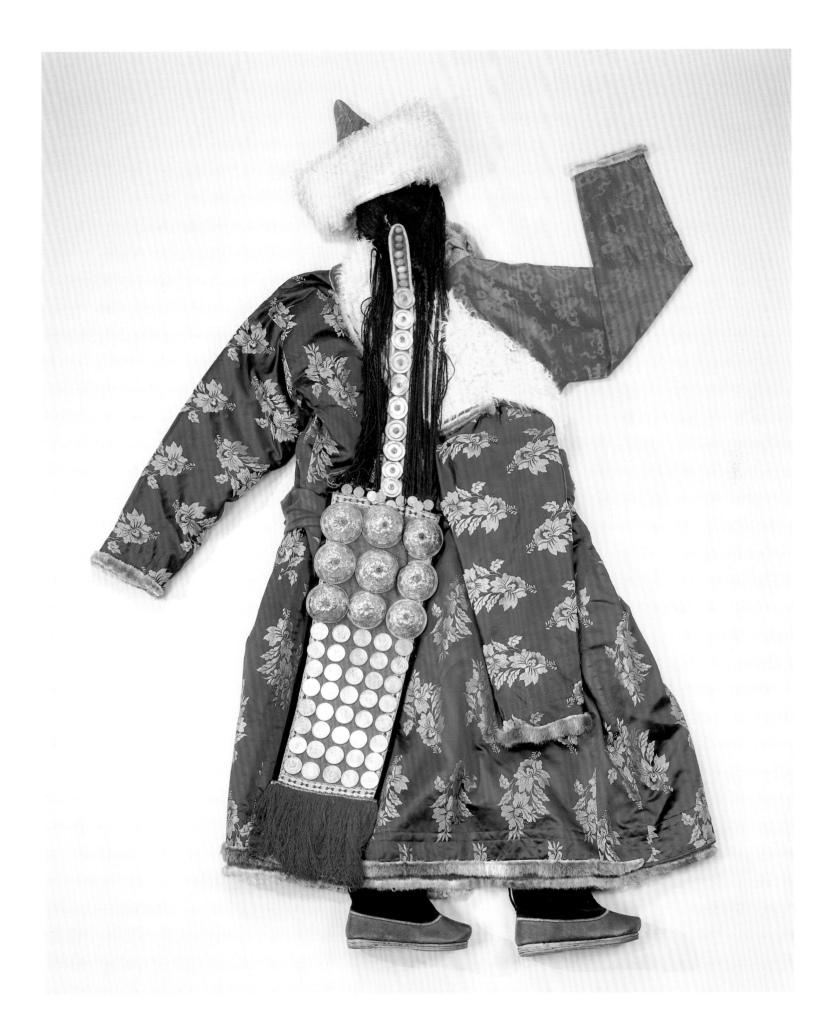

PLATE 11

Labrang woman's milkpail hook

Northeastern Tibet, *circa* 1930s

Leather, brass, silver medallions
with turquoise and glass,
L. 6 ¼ in. (15.9 cm)
Carter D. Holton Collection,
purchase 1936 36.419

PLATE 12

Labrang woman's chatelaine and eating set

Northeastern Tibet, *circa* 1930s

Leather, silk brocade, silver and gold plaque
with turquoise, L. 13 in. (33.0 cm); hinged
silver pendant with attached silk tassel and
eating set of steel, wood, silver, turquoise,
coral, lapis lazuli, garnet, agate and glass;
ivory chopsticks, L. 8 ½ in. (21.6 cm)
Carter D. Holton Collection, purchase 1936
36.420, .446

PLATE 13

Batang woman's costume

Batang, Eastern Tibet, *circa* 1919

Silk brocade *chupa*, silk damask
blouse and sash; velvet apron
with brocade inserts; enameled
silver pin with coral and turquoise;
silver and silk belt tassels; cotton,
leather, wool and velvet boots
Gift of Dorris Shelton Still, 1988
88.584– .599

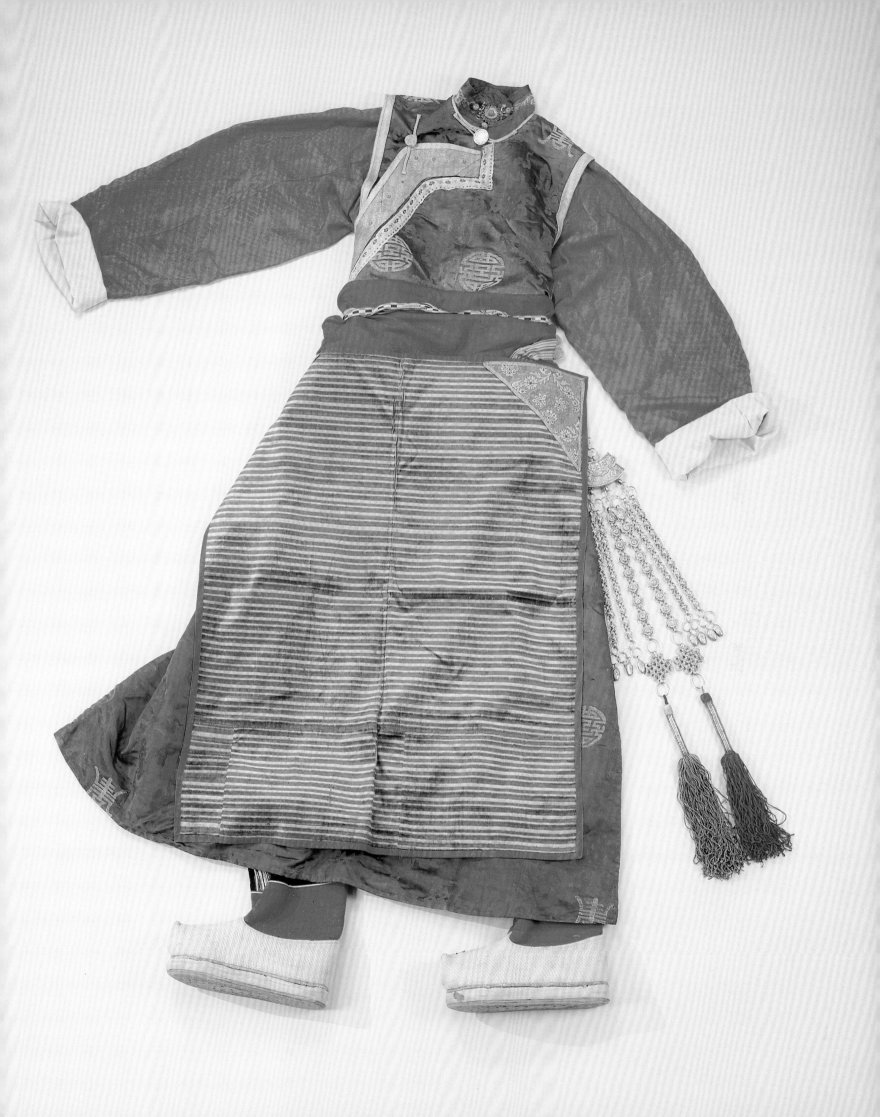

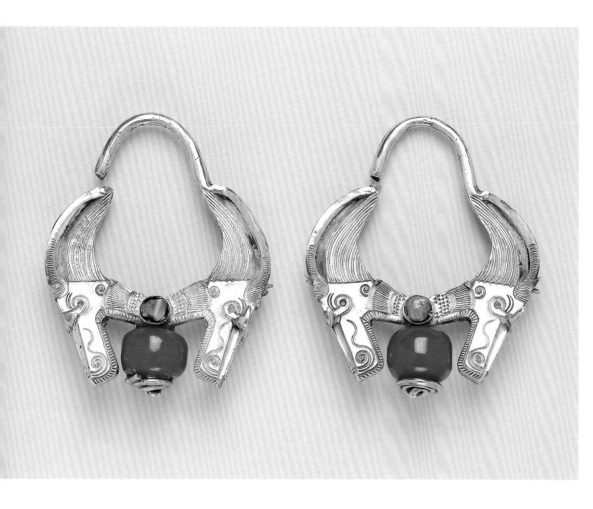

PLATE 14

Batang woman's earrings
Eastern Tibet, *circa* 1900

Silver, coral (glass), turquoise,
L. 2 ¹/₂ in. (6.4 cm)
Edward N. Crane Collection,
gift 1911 11.629

PLATE 15

Jarong woman's hair ornament
Eastern Tibet, *circa* 1930s

Silver, gilt silver, coral, turquoise,
copper, W. 4 ¹/₂ in. (11.4 cm)
Gift of Schuyler V. R. Cammann,
1941 41.550

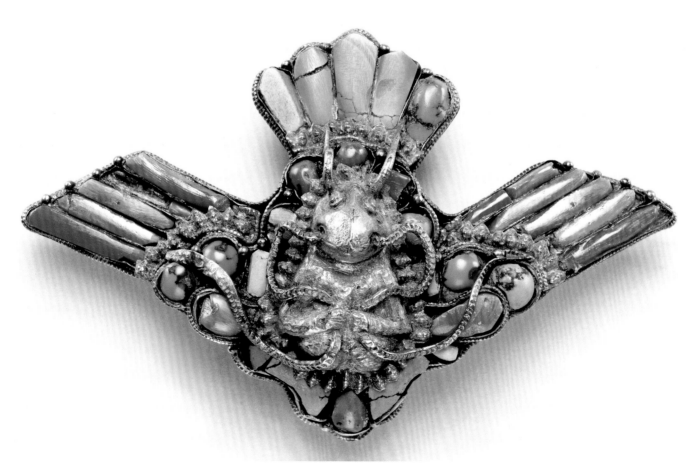

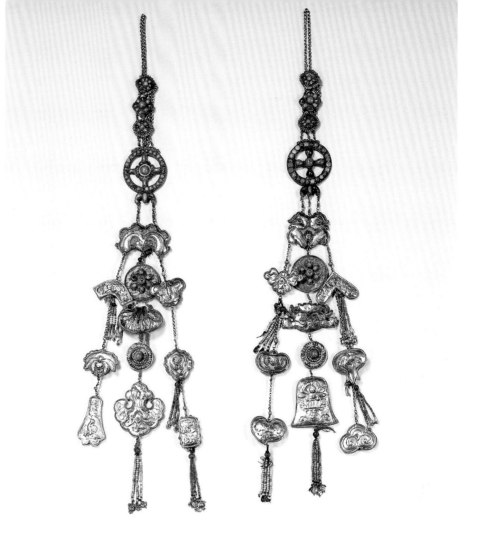

PLATE 16

Woman's belt pendants

Eastern Tibet, *circa* 1940s

Silver set with coral and malachite,
L. 28 ¹/₂ in. (72.4 cm)
Robert Roy Service Collection,
purchase 1948 48.17

PLATE 17

Sword and scabbard

Northeastern Tibet, *circa* 1930

Iron blade, iron hilt with turquoise stone,
silver wire on grip; leather-covered
wood scabbard with iron edges, silver
set with coral, L. 32 ¹/₄ in. (81.9 cm)
Carter D. Holton Collection,
purchase 1936 36.340

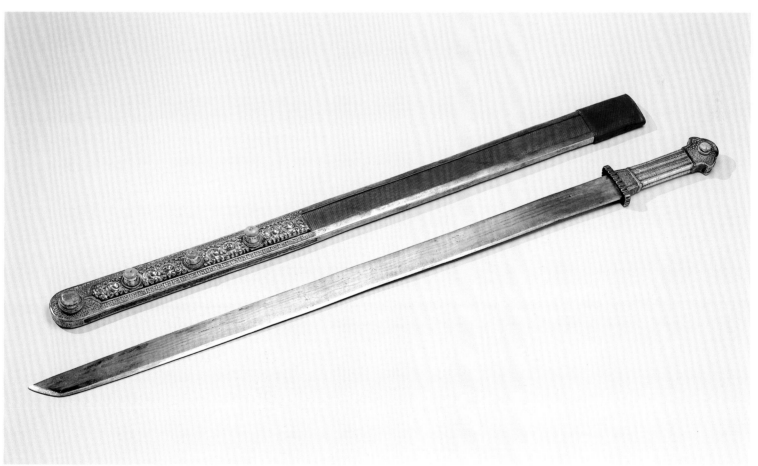

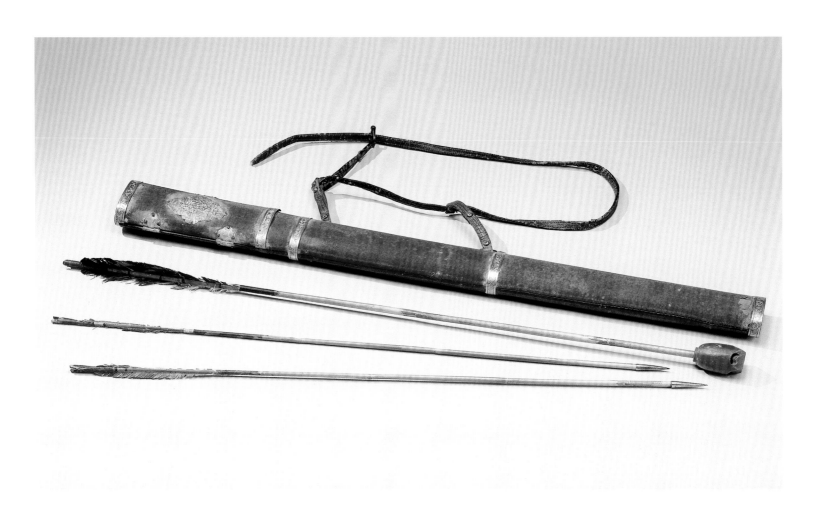

PLATE 18

Quiver and arrows

Eastern Tibet, *circa* 1900

Quiver: wood covered with wool
and leather, silver, L. 34 in. (86.4 cm)
Arrows: bamboo, iron and wood tips,
feathers, L. 31 in. (78.7 cm)
Dr. Albert L. Shelton Collection,
purchase 1920 20.459

PLATE 19

Flint and tinder pouch

Eastern Tibet, *circa* 1900

Steel, leather decorated with velvet
and silver studs, incised silver medallions,
brass ring, L. 6 ¹/₂ in. (16.5 cm)
Edward N. Crane Collection,
gift 1911 11.590

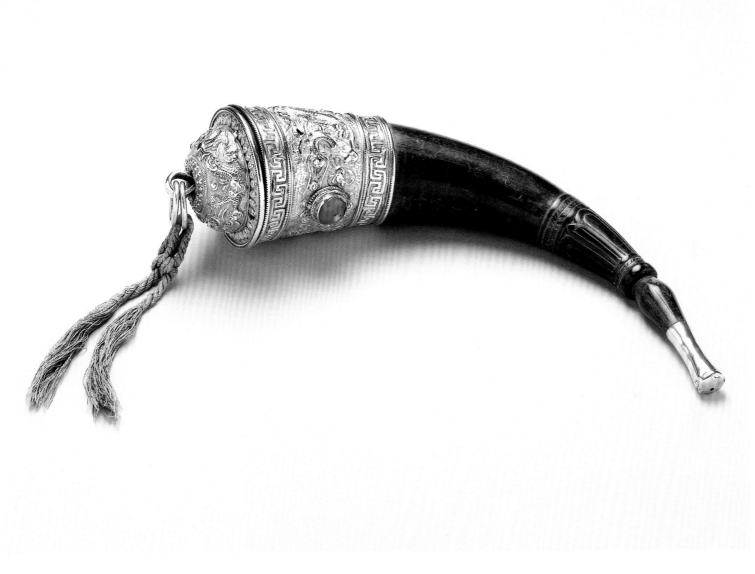

PLATE 20

Snuff horn

Northeastern Tibet, *circa* 1930s

Yak horn with silver, coral and turquoise,
silk tassel, L. 11 in. (27.9 cm)
Carter D. Holton Collection,
purchase 36.470

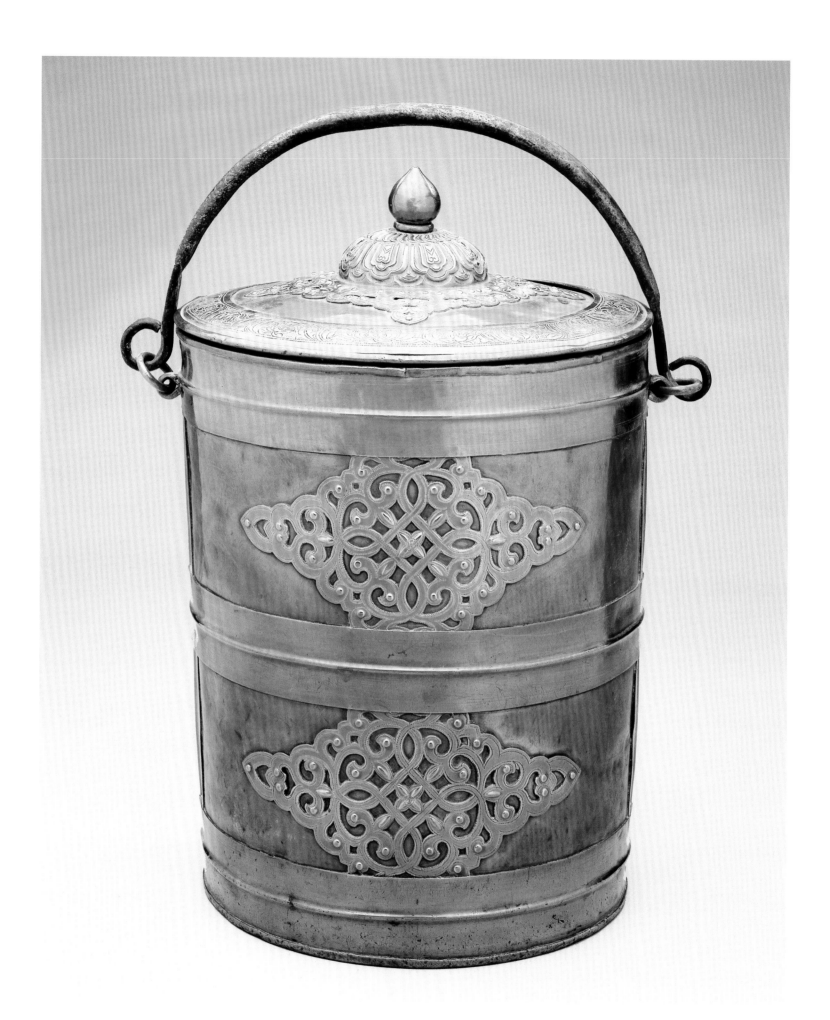

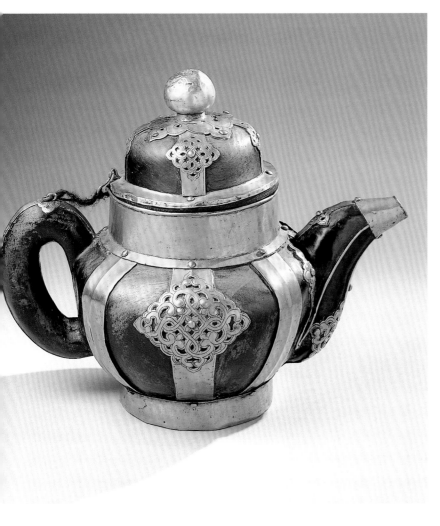

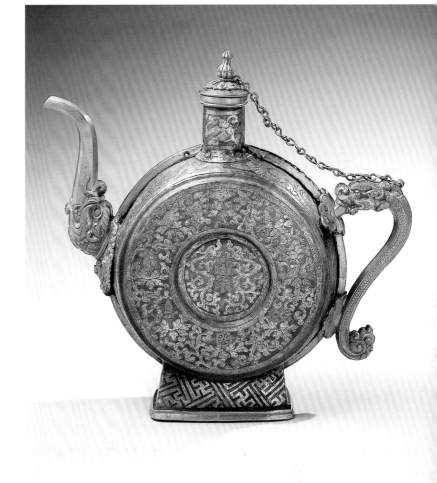

PLATE 22

Teapot

Northeastern Tibet, *circa* 1940s

Wood burl with brass and copper
decoration, H. 12 ¹/₂ in. (31.8 cm)
Robert Roy Service Collection,
purchase 1948 48.9

PLATE 23

Beer jug

Eastern Tibet, *circa* 1900

Iron with gold and silver decoration,
brass handle and spout, H. 15 ¹/₄ in.,
W. 15 ¹/₂ in. (38.7 x 39.4 cm)
Dr. Albert L. Shelton Collection,
purchase 1920 20.1340

PLATE 21

Pail

Northeastern Tibet, *circa* 1940s

Copper with brass decoration, iron handle,
H. 13 ¹/₂ in. (34.3 cm)
Robert Roy Service Collection,
purchase 1948 48.8

Plate 24

Felt rug (detail)

Northeastern Tibet, *circa* 1930s

Wool, L. 72 in., W. 49 ¹/₂ in.
(182.9 x 125.7 cm)
Carter D. Holton Collection,
purchase 1936 36.453

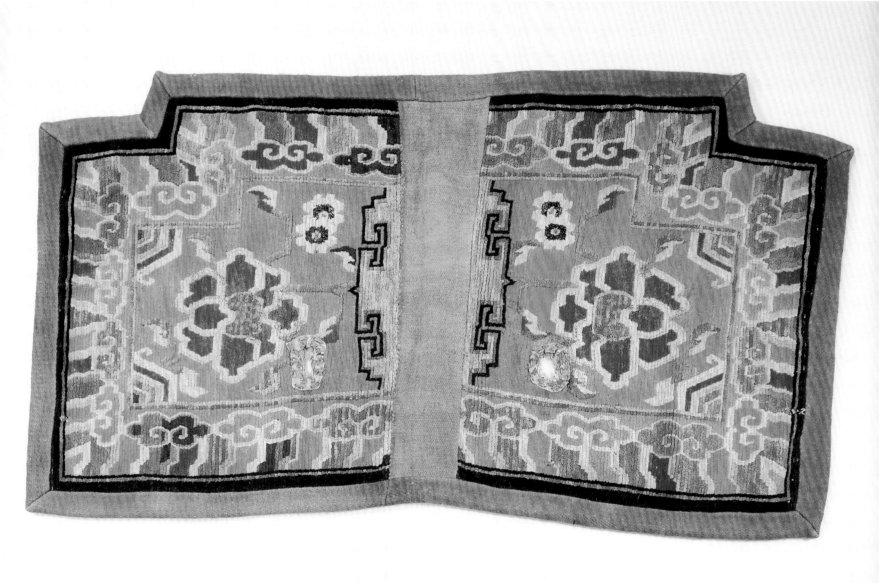

PLATE 25

Saddle carpet

Southern Tibet, *circa* 1900

Wool pile, wool cloth trim;
leather banding to stirrup openings,
L. 48 in., W. 27 $\frac{1}{4}$ in. (121.9 x 69.2 cm)
From the Marie-Louise Lehner Martin
Collection, anonymous gift 1996 96.11

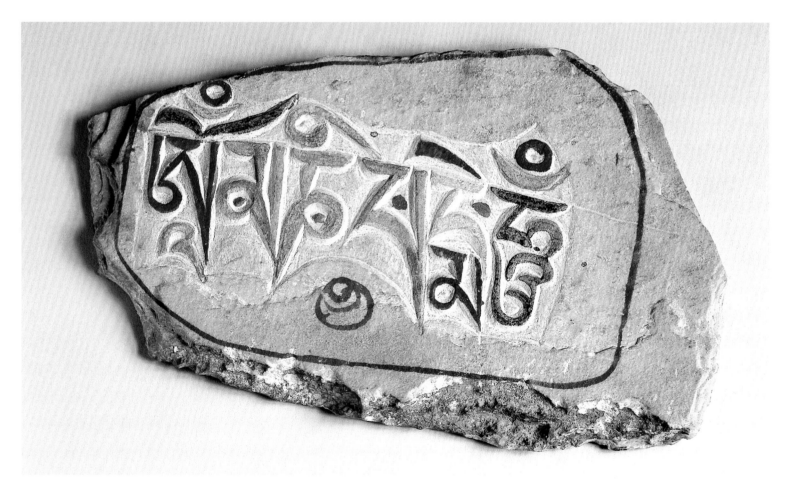

Prayer beads

Northeastern Tibet, *circa* 1930

Amber and agate beads,
silver wire and beads,
iron bell and *dorje* set
with turquoise and coral,
leather cord, L. 33 in. (83.8 cm)
Carter D. Holton Collection,
purchase 1936 36.302

Ga'u shown with contents

Eastern Tibet, *circa* 1900

Silver, copper, H. 6 ½ in. (16.5 cm)
Edward N. Crane Collection,
gift 1911 11.685

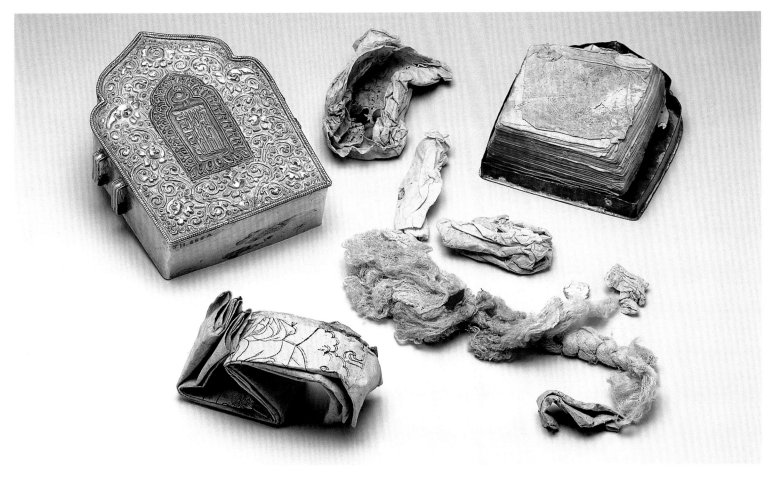

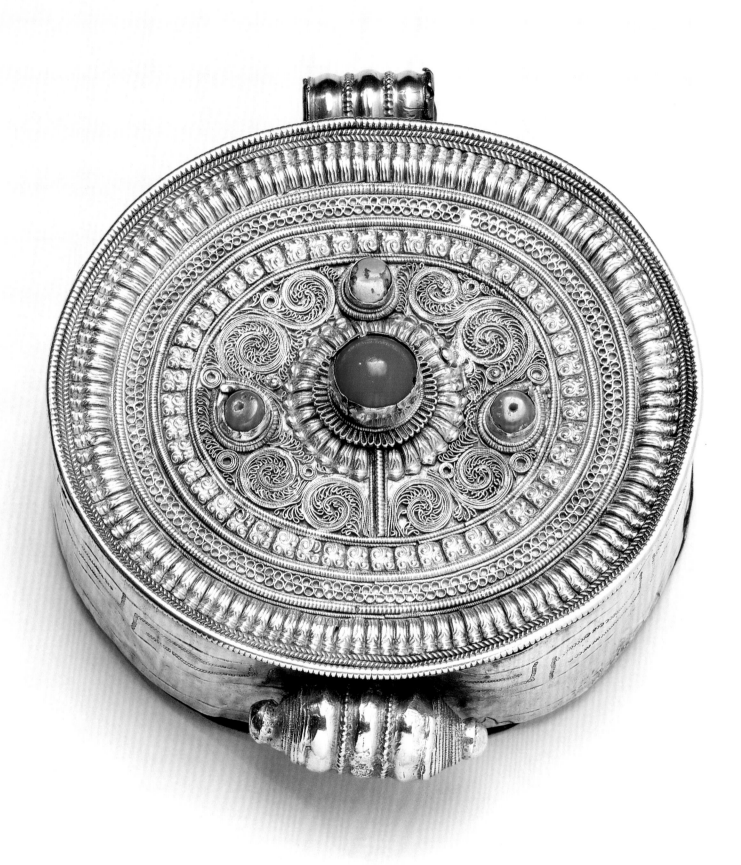

PLATE 30

Ga'u

Northeastern Tibet, *circa* 1930

Silver set with coral and turquoise, copper
center and back, L. 5 ¹/₂ in. (14.0 cm)
Carter D. Holton Collection, purchase 1936
36.328

PLATE 31

Mold for a *tsa tsa*
of Avalokiteshvara

Northeastern Tibet, *circa* 1930

Brass (with modern clay casting),
H. 2 ¹/₄ in. (5.7 cm)
Carter D. Holton Collection,
purchase 1936 36.326

PLATE 32

Tsa tsa of Jambhala

Lhasa, Tibet, date uncertain

Clay, H. 1 ⁷/₈ in. (4.8 cm)
Anonymous gift 1981 81.373

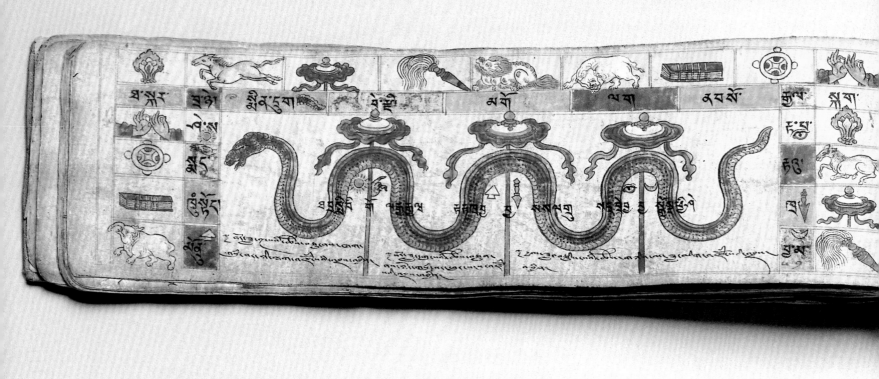

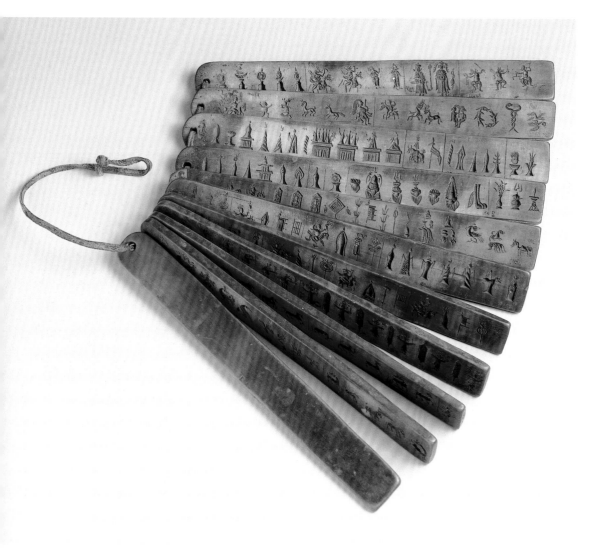

PLATE 33

Astrological handbook

Northeastern Tibet, 18th–19th centuries

Ninety-three folios, ink and color
on paper, stitched binding, silk covers,
H. 3 in., W. 10 in. (7.6 x 25.4 cm)
Carter D. Holton Collection,
purchase 1936 36.283

PLATE 34

Dough mold

Tibet, *circa* 19th century

Wood with incised images,
strung on leather cord, each L. 12 in.,
W. 1 ³/₄ in. (30.5 x 4.4 cm)
Purchase 1995 Avis Miller Pond
Bequest Fund 95.89

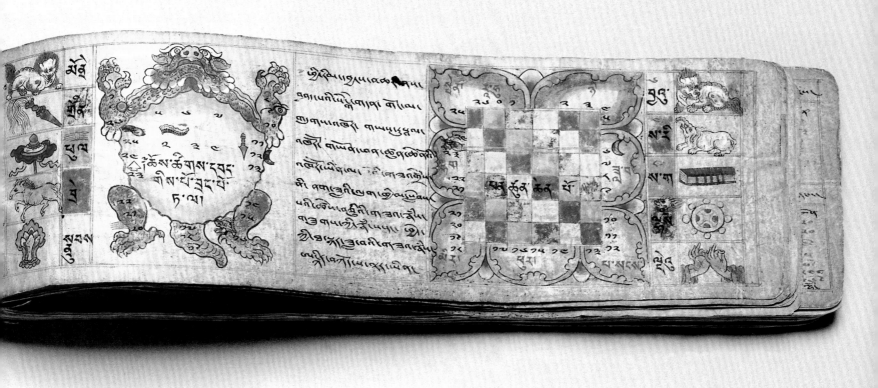

PLATE 35

Tokches of Khyung bird
and crossed *vajra*

Tibet, date uncertain

Brass; bird: L. 2 $^{1}/_{2}$ in.,
W. 1 $^{7}/_{8}$ in. (6.3 x 4.9 cm);
vajra: L. 1 $^{5}/_{8}$ in.,
W. 1 $^{1}/_{2}$ in. (4.2 x 3.8 cm)
Gift of Jack and Muriel
Zimmerman, 1991 91.136 a-b

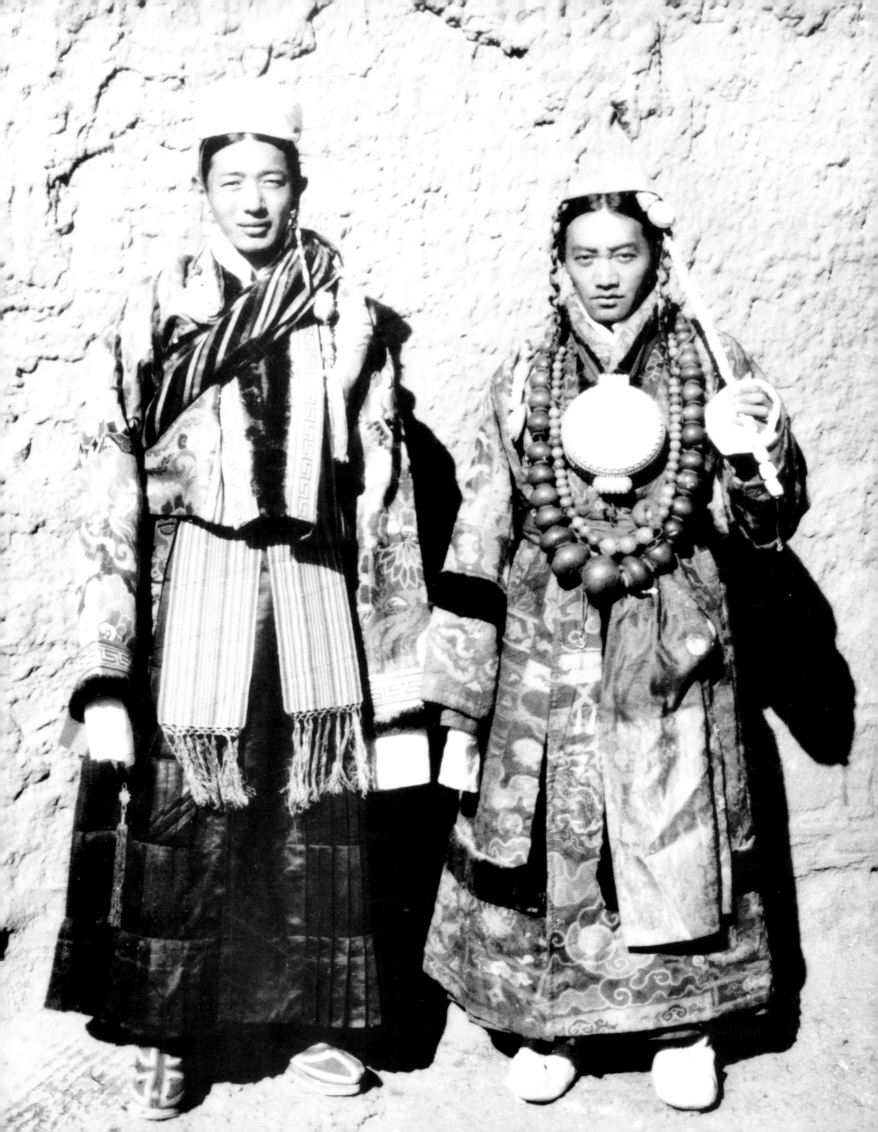

Castles and Tents:
Structures of Power and Patronage

Tied firmly to their dramatic land as were Tibet's farmers and herders, the noble families had a complex heritage of military might, political power and patronage of religious structures dating from the earliest history of Tibet. From their castles on craggy rock promontories, or ornate traveling tents, the nobility ruled Tibet in alliance with the *tsenpo* in the seventh to ninth centuries and, after the eleventh century with various monastic establishments. Through marital alignments, military conquests, land acquisition and trading rights, the nobility controlled the secular portion of the government and heavily influenced the religious governing systems until the 1950s.

The trappings of power and wealth are particularly well represented in The Newark Museum's Tibetan collection. The decoration on a tent or a storage chest, the form of a noble woman's headdress, the insignia of an official hat, the precious silk of a noble's robe, are all indicative of the prestige and ranking of the aristocratic families of Tibet. Ennoblement could occur through descent from one of the ancient kings or chiefs of a local area (such as Yarlung, Guge or Kham), or from the families of the Dalai Lamas (most of whom were originally nomads or farmers). Ennoblement could also be attained by performing some special service to the government. The nobility derived their wealth from ownership of land and their power from membership of the government. All noble families sent sons into the clergy where they could rise to positions of importance in the theocracy, or into the civil service where they, similarly, could become lay officials. Daughters were married into other noble families to ensure that estates were not split and weakened and that there were ample descendants.[1]

Although they maintained houses in Lhasa, to be close to the social and political life of the capital, most noble families spent considerable time managing their provincial estates. Lay or religious officials were also posted in outlying towns or monasteries to administer policy for the central government. This small group of families thus had wide-ranging influence outside Lhasa.

A complex relationship between the nobility and the religious communities existed from the earliest days of recorded Tibetan history up to 1959. Sons of the nobility who entered the clergy retained close connections with their families. Also, wealthy princes and military heroes were important patrons of monastic activities, sponsoring building programs and rituals. The noble families ensured the ritual and political protection of their holdings via the support of certain monastic establishments and religious leaders.

The nobility lived in handsome houses both in the capital (see fig. 1) and on their provincial estates but, like all Tibetans, also felt at home in a tent. The appliquéd tents (see figs. 5 and 6 and Chapter IV, figs. 4 and 8) are typical of the sort used all over Tibet for festival days and picnics. Intended for religious as well as secular occasions, the tents were appliquéd with auspicious emblems.

1 All vestiges of such power and prestige were destroyed or suppressed by the Chinese conquest beginning in 1959. See Yuthok, *House of the Turquoise Roof*, pp. 29–47, 135–53, for a description of noble marital alliances and distribution of wealth in 1930–50s Lhasa.

Fig. 1
Lhalu House in Lhasa, central
Tibet, where Col. Younghusband
had his headquarters, 1904.
John Claude White photo,
Gift of Frank and
Lisina Hoch, 1997 97.9

Household possessions reflected the wealth and sophistication of the upper class and included fine metal, porcelain and ivory objects imported over the high mountain passes from China, India and Nepal, as well as the finest work from craftsmen in Tibet. The nobility were stylish travelers and loved to have their horses outfitted with the best saddles and trappings.

By the seventh century, Tibetans were known as valley dwellers with castles and fortresses, and also as tent dwellers. This seeming contradiction can be explained by the need for Tibet's early rulers and nobles to have fortified strongholds in their respective valleys and also to be on long marches outside these strongholds for part of the year to secure borders or conquer enemies. During these marches the *tsenpo* or leader and his court and soldiers lived in elaborate tents formally arranged to resemble a traveling palace. The tradition of such ceremonial tents persisted into the middle of the twentieth century in the festive appliquéd or painted rectangular tents used by church hierarchs and nobility while traveling, attending festivals, or when simply enjoying fair-weather outings.

The fortress aspect of almost all Tibetan architecture can be seen at its most pronounced in the *dzongs* (castles/forts) of which Shigatse *dzong* and Khampa *dzong* were prime examples (figs. 2 and 3). Like the earliest royal fortresses, both of these *dzongs* were built on rock outcrops which increased impregnability. The sloping walls, staggered system of rectilinear and curved surfaces, flat rooftops and ramp and stairway accesses beautifully suited the architecture to its natural rock setting, although these features were probably selected for strategic rather than aesthetic functions.[2] As in the times of the ancient Tibetan kings, such *dzongs* served as military and administrative headquarters, and as palaces of the rulers.

Fig. 2
Shigatse Dzong,
southern Tibet, 1935.

Fig. 3
Khampa Dzong, southern Tibet, 1903.
John Claude White photo, Gift of
Frank and Lisina Hoch, 1997 97.9

2 The window system and south-facing
 sites also took maximum advantage
 of available sunlight to help warm the
 interior rooms.

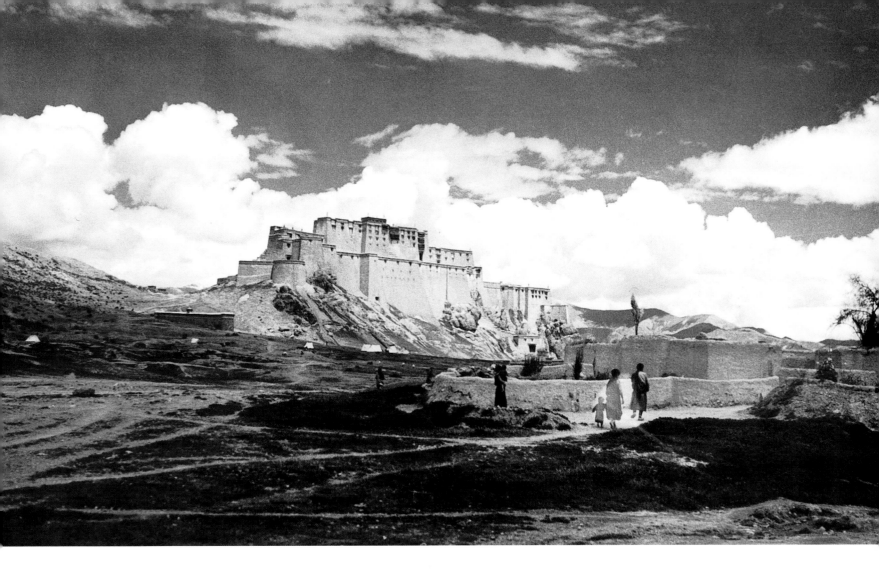

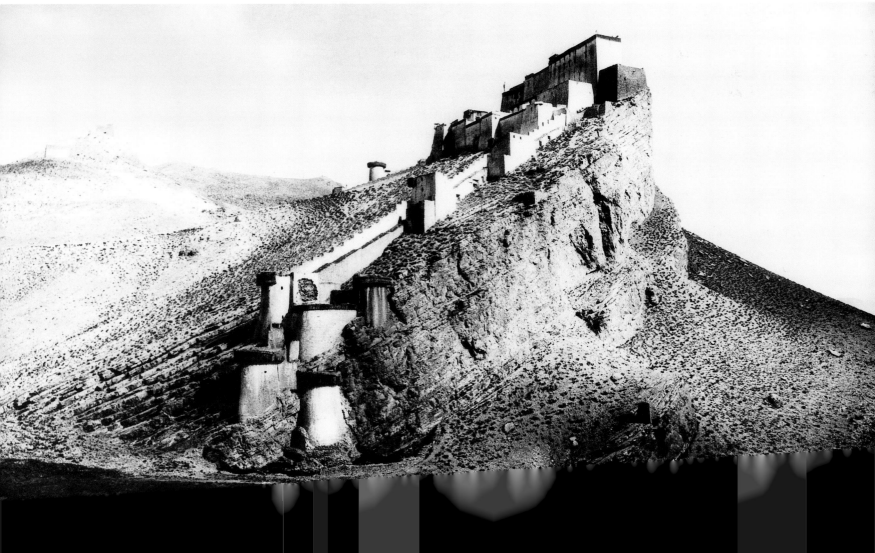

Costume and Regalia for the Tibetan New Year

On the 2nd day of the Tibetan New Year, the ceremonies of the "King's New Year" (*Gyalpo Losar*) were held in Lhasa. This followed a day-long religious observance of the "Priest's New Year" (*Lama Losar*). Usually corresponding to the middle of February to March in the Western calendar, the two days confirmed the joint sacred and temporal roles of the Dalai Lama and state government. The "King's" and "Priest's" New Year's ceremonies were established by the Great 5th Dalai Lama *circa* 1672 as a deliberate effort to recreate the customs of the "Religious Kings" of the Tibetan Empire (seventh to ninth centuries) and co-opt the *Chösi Nyiden* ("Rule of Church and State") of that period.[3] These were added to the more simplified "Great Prayer" (*Mönlam Chenmo*) ceremonies begun by Tsongkhapa in 1409.

For the "King's New Year", all of the lay officials wore the *gyaluché* ("royal dress"), which re-created the costume of the old royal princes of Tibet (seventh to ninth centuries; fig. 4, left).[4] The officials in *gyaluché* prostrated themselves before the Dalai Lama (or Regent) at the Great Audience Hall of the Potala Palace, and were then offered refreshments and entertainment.

The Museum's *gyaluché* costume (color pl. 36) was last worn by Dundul Namgyal Tsarong who served as a government official from 1940–59. The long-sleeved jacket of Japanese gold brocade, trimmed with silk cord in a fretwork pattern and seal fur, was worn over a pleated black silk skirt of French manufacture, which had been made for Tsarong's father, the famous Dasong Dadul Tsarong (1885–1959), favorite of the 13th Dalai Lama. The weight of the deeply-pleated skirt is borne by an attached vest of Indian brocade (not visible under the jacket). Also passed down from D.D. Tsarong are the Japanese brocade cup case (to carry his personal cup for tea served during the ceremony) and scarf case (to hold the white *kata* presented to the Dalai Lama). A striped silk sash, tied at the waist, hangs down the front of the skirt.

The most distinctive element is a striped shawl rolled tightly on the diagonal and worn over the left shoulder and under the right arm. The Tsarong shawl, of Indian silk velvet, was a family heirloom. The *gyaluché* shawls were dramatically unrolled as rugs for the prostrations to the Dalai Lama, symbolizing the obeisance of the "princes" of the government to their sovereign.

An even rarer costume was worn by selected officials at the "Priest's" and "King's" New Year's ceremonies and also by the *Yaso* officials on the 22nd to 24th Days of the 1st Tibetan Month, the final ceremonies of the *Monlam Chenmo* (see fig. 5 of two Yaso—seated—with retinue). *Yaso* is a Mongol title, as is the name of the heavy gold brocade robes of the selected officials: *Khalkha Su* ("Khalkha style"), after the Khalkha Mongols who historically controlled the area north of the Gobi Desert.

The robes are constructed of heavy metallic gold brocade. The Museum's example (color pl. 37) is made of Russian brocade so stiff with gold thread that it can "stand by itself", trimmed in cord forming a key-fret pattern and otter fur, with two detachable collars, one of brocade and one of fur. The distinctive division of the robe into "layered" upper, middle and gathered lower sections mimics Mongol robes and vests still seen in the early twentieth century. The Museum's robe, which has a fine eighteenth-century silver sash of Persian ori-

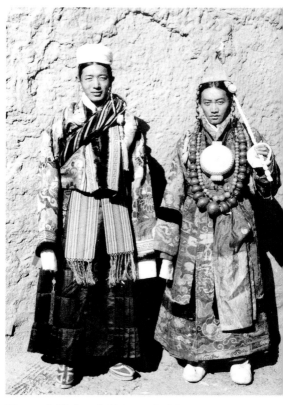

Fig. 4 J. Taring (left) in *gyaluché* costume and D. N. Tsarong (right) in *ringyen* ("ancient ornaments") costume, Lhasa, central Tibet, "King's New Year", *circa* 1940. D. N. Tsarong gift, The Newark Museum Archives

3 The 5th Dalai Lama was incorporating the mid-fourteenth century reforms of Changchub Gyaltsen (1302–64) who had sought to return to the ceremonial and legal practices of the old Tibetan Empire and cast off the remnants of a Mongol-Sakya hegemony in central and southern Tibet. The 5th Dalai Lama actually had Chengchub's old stronghold at Nedong (southeast of Lhasa in the heartland of the old kings) sacked and took the "ancient ornaments" (*ringyen*) to Lhasa for use by his government. These *ringyen*, worn by thirteen officials at the "King's New Year", were heavy brocade and fur robes with immense turquoise, coral and amber jewels (see fig. 4, costume at right). See Richardson, *Ceremonies of the Lhasa Year*, pp. 11–20 and Shakabpa, *Tibet, A Political History*, pp. 81–2, 120.

4　Current research cannot substantiate this style of Tibetan garment during the royal period. The *gyaluché* was also worn, but only by selected officials, at the end of the year ceremonies, *Tse Gutor*, and at the "Priest's New Year" and the 24th day of the New Year. See Richardson, *op. cit.*, pp. 39–51, 116–23.

5　Several garments are so described in Dr. Shelton's handwritten notes of December, 1920 in the Museum's files.

gin, was last worn by Gyurmi Gyatso Tethong (1884–1938) who was a *shapé* (minister) of the Tibetan government from 1932–5.

Jewelry worn with the Khalkha costume includes a gold finial attached to the top of the broad black fur hat (seen in fig. 5). The Museum's finial (*shalok*) (color pl. 38) which is detachable and can be worn at other times of the year on different style hats (see summer robe, color pl. 42) is shaped like the sacred Buddhist Vase of the Elixir of Immortality. Opaque blue glass stones carved as petals and teardrops, pearls and faceted red, green and clear glass "gems" are set into the surface. A large turquoise is at the apex of the vase, set in a silver rod which passes vertically through the center of the finial and screws into a silver plate for attachment to the official's hat. The gold material is fashioned from thin sheets with repoussé and pierced floral designs. The *shalok* was last worn by *Tsepon* Wangchuk Deden Shakabpa, Finance Minister of Tibet, 1939–51 (see Introduction, fig. 7).

A single long gold, glass and turquoise earring (*so-byis*; color pl. 39) was worn in the left ear by all lay government officials for ceremonial as well as day-to-day activities. The gold circular rod at the top passes through the pierced left lobe; the woven silk tape goes over the ear and helps carry some of the earring's weight. A cultured pearl is set at the upper midsection of the pendant. The small turquoise and cultured pearl strung on wool is worn through the pierced lobe of the right ear.

A variation of the *gyaluché* ("royal dress") costume was worn in Batang, Eastern Tibet, for the New Year's ceremonies. The pleated skirt and long jacket in color pl. 40 was in the collection of the Batang "royal family".[5] The skirt is constructed of dark red Chinese satin brocaded with small medallions of dragons and clouds, deeply pleated with inset panels of a slightly different brocade. The

Fig. 5
Two seated *Yaso* officials with other officers, south of Potala Palace, Lhasa, central Tibet, *Lubu Gardrik* ceremony, first Tibetan month, *circa* 1920.

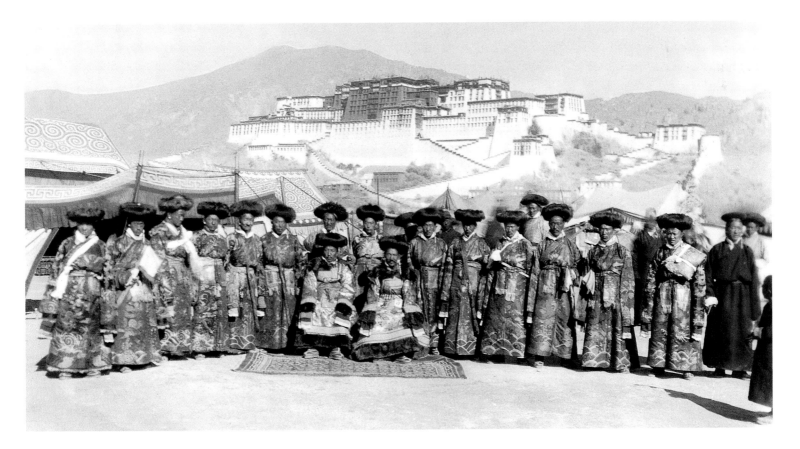

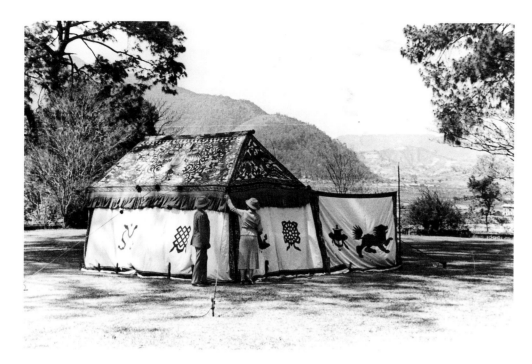

Fig. 6
Lt. Col. F. M. Bailey's tent
in use in Sikkim, *circa* 1930s.

pleats are stitched down at the hip to a sleeveless vest of green and rose damask. This is not meant to be visible but it supports the heavy weight of the skirt (lined, as are Lhasa garments, with blue cotton). The wide jacket, which falls to the hip level hiding the vest and stitches, is of deep blue Chinese silk tapestry (*kesi*) with a pattern of gold dragon rondels over a "sea and mountain" border. The straight front opening is banded to form a raised collar and lappets which extend below the jacket edge. The long tapering sleeves are set with an Indian red and gold palmette brocade with cuffs trimmed in small sections of the tapestry silk. Red cording and thin strips of fur (quite worn) edge the cuffs and jacket bottom. The violent disruption of Tibetan official life all over Eastern Tibet in the Sino-Tibetan wars of 1905–18 had curtailed the wearing of noble regalia. Dr. Shelton mentions these garments as belonging to the last generation of the Batang ruling family and had no photographs of them in use.[6]

The ceremonial appliquéd tents which were set up for many of the outdoor events of the long Tibetan New Year can be seen in the background in fig. 5. Such tents were also employed by noble families, monastic colleges and ordinary folk throughout the year, when attending religious rituals and to shelter them from the sun while viewing folk opera performances in the summer. These tents hark back to the royal enclosures of the ancient kings. The Bailey family[7] tent (color pl. 41 and fig. 6) is decorated with bright polychrome wool and cotton appliqués of specifically Buddhist auspicious designs on white cotton. On the two long sides of the tent roof is a *garuda/kyung* devouring snakes with coiling dragons at the sides. A phoenix protects the triangular short roof ends. Stylized clouds are above, and scroll patterns and fretwork below, with a fringed edge flap on all four sides. The tent is constructed so that a ridge pole and two uprights, held taut by ropes decorated with yak hair pompoms, support all the weight. If needed, curtain-like sides can be hooked onto the roof, held secure at the bottom with small pegs. The sides of the Bailey tent are decorated with the Eight Buddhist Emblems, with the Tibetan snow lion and tiger at the entrance flaps.

6 All but one of the Batang ruling family had perished by 1913. The sole surviving son, whose mother was from the noble Lhagyri family of Lhasa, returned to Batang and lived with the Shelton family from 1913–20. Through him, Shelton obtained altogether two pleated skirts and three jackets, made of fine Chinese and Indian silks.

7 Lt. Col. F. M. Bailey was an important British diplomatic figure in twentieth century Himalayan and Tibetan exploration and politics. He was a personal friend of C. Suydam Cutting who arranged for the tent to come to The Newark Museum. Cutting, *Fire Ox*, p. 151.

8 *Shotën* had long been held at the end of Buddhist summer retreats, when monks would mark their return to monasteries with special feasts. *Ache Lhamo* is popularly credited to Tangtong Gyalpo ("Chaksampa"), *circa* 1361–1485, who introduced the dance-dramas throughout central Tibet. After the seventeenth century, although curds were eaten (at the parties given by noble families and by monks completing their summer retreats), the main focus of Shotën was the *Ache Lhamo* performances. See Richardson, *Ceremonies*, pp. 97–107 and also Joanna Ross, *Lhamo. Opera from the Roof of the World*.

Festive Garments for the Lhasa *Shotën*

9 Shakabpa led the Tibetan Trade Delegation to the United States in 1948, see Introduction, fig. 7.

10 The Lhasa hierarchy, both lay and clergy, had official summer and winter garb, which always changed on the same auspicious day, spring and autumn. The spring *Gyetor* = 8th day, 3rd Tibetan month (May). Fall = 25th day of 10th month (December). See Richardson, *Ceremonies*, pp. 82, 114.

The warm summer days of the sixth and seventh months of the Tibetan year (corresponding to August and September in the Western calendar) were the time for outdoor parties and festivals. Primary among these in Lhasa was the *Shotën* or "Curd Feast" when *Ache Lhamo* was performed.[8] *Ache Lhamo* ("Sister Goddess") is a Tibetan form of opera, costumed dramas with dialogue, singing and dancing, of historical or religious themes (see fig. 7). In Lhasa, several established companies would perform at the Potala, the major monasteries, the Norbulingka, and then in courtyards outside the homes of the various noble families and wealthy merchants. In other parts of Tibet, *Ache Lhamo* or more informal dances were part of harvest festivals.

When attending performances at the monasteries and also at the homes of friends, noble men and women wore their finest summer robes. The official's costume in color pl. 42 was worn by *Tsepon* Shakabpa when he was the Tibetan finance minister from 1939–51.[9] The golden yellow silk brocade features auspicious emblems in clouds in a satin weave with the Chinese character *shou* ("longevity") in metallic gold scattered throughout. The robe is tailored in Tibetan style from imported Chinese cloth, lined with Indian printed cotton and trimmed with red silk damask. This yellow color, related to both the imperial hue of China and the dark gold of the Buddhist clergy, was restricted to lay government officials. The dome-shaped hat, with red fringe and long streamers, was also a sign of office. *Tsepon* Shakabpa's gold finial (color pl. 38) would have been attached, in summer, to such a hat.[10] The boots also use the yellow brocade, with "rainbow" cording of a distinctive Tibetan type.

Fig. 7
Alche Lhamo dancers,
Lhasa, central Tibet, 1937.

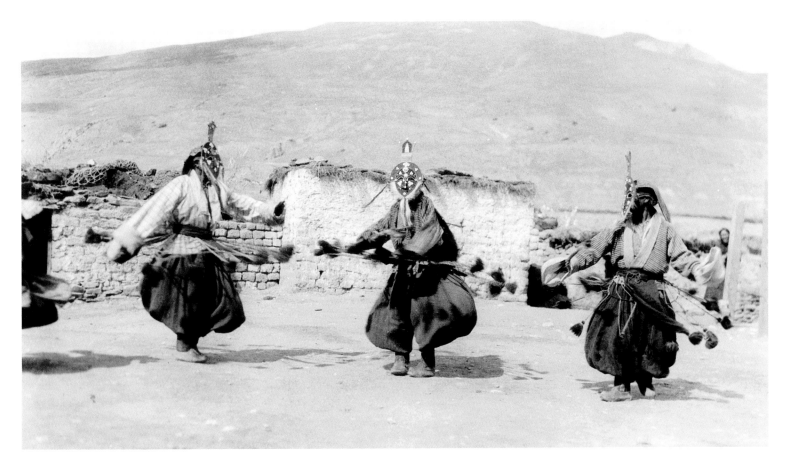

When not wearing a hat, a lay official would have a special *ga'u* hair ornament, called a *takor*, fastened to the front of his long hair braid which was worn piled on top of the head (see fig. 8). Like the hat, this turquoise and gold amulet box was similarly an ornament of rank.[11] The Museum's example (color pl. 43) is fashioned of petal-shaped turquoise pieces set in a floral form into a gilt silver mount. The locket-like back enclosed silk-wrapped religious and auspicious amulets (see pp. 58–59).

At age sixteen (or sometimes younger), a woman from one of the noble or wealthy families of Lhasa would have been required to wear her fine robes and jewelry for all state and religious occasions, and her family would have a suitable headdress, necklace, etc. made for her. All the women would also be dressed in their finest attire for the social parties and entertainment of *Shotën* (see fig. 9).

The ensemble shown in color pl. 44 features a magenta satin *chupa* with cut-velvet *shou* medallions made from imported Chinese cloth, lined with silk damask and Indian printed cotton. The rainbow-striped apron with three lengths sewn to offset the stripes is traditional for women of central and southern Tibet. Silk and metallic gold floral brocade imported from India is used for the triangular reinforcements at the upper corners.

The extravagant shape of the traditional Lhasa women's headdress (*patruk*) has been remarked upon by foreign visitors. Although it was worn every day throughout the nineteenth century, by the 1930s it was donned only on special occasions (see fig. 9). The shape also seems to have evolved, with changing fashion, from a tiara-like band fitting close to the head to the Y-shape of the Museum's example (color pl. 45), typical of the 1930s–50s.[12] The headdresses required a wig structure (*lentse*), supplementing the owner's own long hair, to support the prong-like front and to give added length to the "tail" which fitted down the back. Although they differ in shape, all of the Tibetan headdresses are based on a stiffened cloth structure, with the turquoises, corals, pearls, etc. sewn

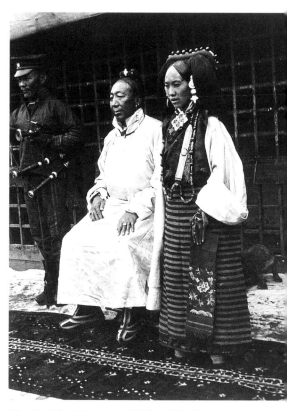

Fig. 8 The Governor (*Tèji*) of Markham and his wife (in Lhasa dress), Markham-Gartok, Kham, Eastern Tibet, 1915.

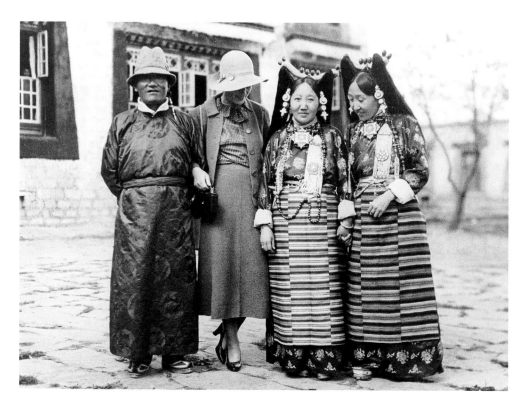

Fig. 9
Helen Cutting with Dasang Dadu Tsarong, Mrs. Tsarong and Mrs. Horkhang, Lhasa, central Tibet, 1937.

11 Dorje Yuthok recalls the family disgrace when her father *Depon* (General) Surkhang had to have his *ga'u* removed by the monk government officials at the Potala Palace to mark his (temporary) demotion, see Yuthok, *Turquoise Roof*, p. 41.

12 The meaning of the shape is difficult to determine, but there appears to be a long tradition of stiffened and bejeweled women's headdresses in Mongolia as well. See Yuthok, *op. cit.*, pp. 321–5 for a discussion of noblewomens' ornaments.

13 This is consistent with reports of clusters of *dzi* found at royal tomb sites (seventh to ninth centuries). Other stories say that *dzi* are petrified insects with magical powers.

14 The antiquity of *dzi* in Tibet is further attested by references in literature such as the *Gesar* epics and in the Chinese Tang *Annals* (cited as "*se-se*"). The question remains whether *dzi* were manufactured in Tibet in the seventh to ninth centuries or imported from Persia or India. See Ebbinghause and Winsten, "Tibetan Dzi Beads," *The Tibet Journal*, vol. XIII, no. 1, spring 1988, no. 1, pp. 38–56.

on. The *patruk* in the Museum's collection was made *circa* 1950 for the marriage of a Lhasa noblewoman, and the mid-century date is evident in the use of precious stones such as sapphires as accents in the pearl field and also in the *tsigyu thakpa* in the central opening, worn on the crown of the head, which has a large jade stone as its center rather than the usual turquoise. Sapphires from India, and jade from China, were fashionable in the 1940s and 50s but were not traditional to Tibet. The fourteen large, deep red coral stones, as here, were the most important element to the headdress. To have a matched set, women might save stones for years and also dismantle pieces from their mothers' or grandmothers' jewelry. The strands of freshwater pearls completely cover the cloth armature.

The earrings (*eh-kor*), color pl. 46, are actually ear coverings. Their great weight was supported by hooks secured to the headdress (figs. 8 and 9), and the linked medallions and floral forms framed the face. The Museum's *eh-kor* are typical of the fashion of the 1930s and 40s, using flat plaques of very clear blue turquoise imported from Persia. The gold used in the Museum's *eh-kor* is very much in Tibetan taste: the twenty-four karat sheets and wire darkened with an orange wash. Earrings or ear coverings are the primary jewelry for women, worn always, even when the headdress and other ornaments were not. They also seem to be the only adornment directly linked to sacred prototypes. The goddesses (and male Bodhisattvas) shown in sculpture and painting from at least the fourteenth century wear heavy gold disks and plaques set with turquoise and other gems.

The *ga'u* worn by Lhasa women is in a star shape (see figs. 8 and 9), the outer face set with turquoise. The Museum's example (color pl. 47), made *circa* 1940, shows, as does the headdress and earrings, the influence of foreign taste. Indian clear stones such as diamonds and rubies, and imported flat Persian turquoises have replaced the earlier native turquoise stones. The necklace holding the *ga'u* is strung with freshwater pearls, coral, turquoise and glass beads as well as a distinctive Tibetan bead, called *dzi*. *Dzi* beads are greatly valued by Tibetans for their protective magic (note long necklace of *dzi* beads worn in fig. 8). Genuine ("pure") *dzi* were found in the ground and believed to be ancient ornaments of the demigods.[13] *Dzi* beads are agate or carnelian stones which have been polished into oval or tubular shape with a drilled center hole. The line and circle designs which mimic natural markings were created by firing the beads after an alkali paint has been applied, permanently altering the color of the stone. Although stones with the specific markings of "pure" *dzi* have been found only in Tibetan cultural areas, similar alkali-painted agate and carnelian beads of various shapes and designs are known from Indus Valley and Mesopotamian sites (2700–1800 B.C.E.) and from Sassanian Persia (to 642 C.E.). Such beads were widely traded in the ancient world.[14]

Objects of Authority

The Newark Museum is fortunate to have received, often directly from the original owners, objects which signify the authority and power of the noble families. Documents and official letters were used to consolidate Lhasa's control over the many far-flung towns and estates in Tibet.

One fine and rare document now at The Newark Museum and once in the collection of the Prince of Batang, color pl. 48, is written on brilliant deep yellow satin. This is a decree dated 1740 issued by the Lhasa government to settle a regional dispute in Batang, a rich agricultural and trading region in Eastern Tibet. The text in beautiful *bru-sha* script gives an historical overview from the time of the 5th Dalai Lama (1617–82) when Batang had clearly been under Lhasa rather than Chinese jurisdiction, locally administered by one leading family. In 1719, however, Manchu troops occupied Batang and violently suppressed local opposition to foreign control. Batang became part of China in 1725 but was allowed to be administered by the same local princely family. The Museum's document is mostly concerned with a dispute by two brothers over this local power. Miwang Pholhaneh Sonam Tobgye (Mi-dbang Pho-lha-nas bsod nams stobs rgyas, 1689–1747), the secular authority at the time in Lhasa, states his support for the older brother and his descendants. Both red seals on the document are those of Pholhaneh, who ruled from 1728 to his death in 1747 (the 7th Dalai Lama was either in exile at this time or limited to religious affairs by Pholhaneh). It is clear from the Lhasa document that Tibet continued to be concerned in Batang's affairs despite Chinese control. Batang proved to be a source of contention between Lhasa and Beijing until the 1918 peace treaty (see pp. 32–33).

The letter on fine Tibetan paper shown in color pl. 49, is a petition of *circa* 1830 to the 10th Dalai Lama by the Dichung Kyibuk family. The noble Kyibuk family had originated in Bhutan and had risen to power in association with Pholhaneh (see color pl. 48). In the letter, written in the traditional Tibetan manner, the Dichung Kyibuk family humbly (at the bottom of the page) appeals to the government to be released from its obligations to a large estate near the Ladakh border. Although this is not mentioned explicitly, the family feared being caught up in the war between Ladakh and Tibet which raged intermittently between 1830 and 1842, and requested, in exchange, a smaller estate closer to Lhasa. The replies are equivocal, with both the Dalai Lama (at top, with official seal) and *Kashag* (at center) promising to "think over" the situation.

The letter is a gift from Dorje Surkhang Yuthok. The Yuthok noble family has an interesting relation to the 10th Dalai Lama (1816–37) who was brought to Lhasa as a child in 1820 from his birthplace in Lithang, Kham. It was the custom for the family of the Dalai Lama to be ennobled in Lhasa as part of the installation of the new incarnation. As it happened, the Yuthok family at that time had no heirs and so the government merged it with the 10th Dalai Lama's family, turning over to them the Yuthok name and all estates. The present Yuthok family (into which Dorje Surkhang married) are all blood descendants of the 10th Dalai Lama's brother. The letter was folded accordion-style and wrapped in a rectangle of Chinese red and gold brocade. The wear on the brocade suggests that it was a treasured fragment, perhaps from a garment, which was cut and reused as a precious wrapping.

Such reuse of luxury silk textiles is most commonly seen, in Tibet, in religious contexts (see pp. 124–127). Of course, with the words and seal of a Dalai Lama, the Kyibuk letter was a form of sacred object, to be preserved appropriately. Many extraordinary silk textiles from Tibet have come onto the market in the last decades. A large group of these, dated eleventh to fifteenth centuries

and in many styles and techniques, have been trimmed and folded to a similar rectangular shape, appropriate for protecting and decorating a letter or the top folio of a religious book. The twelfth-century tapestry fragment in color pl. 50 is a fine example of this group. The fold marks down the center and sewn edges suggest that this was preserved in Tibet as a document cover (turned, contrary to the design, to a horizontal orientation).

The fragment has many losses but retains its original brilliant color, particularly the bright blue ground shading to a deeper blue. Amidst the densely scattered oval leaves are a scampering purple deer at center and part of a spotted white deer at lower right. Two birds fly by in the upper area. A small green curved section at upper right shows stylized calligraphy which is unreadable. Similar fragments, preserved in Tibet and Central Asia, may have once been part of carpets or tent decorations, with fields of idealized flowers and animals and birds around central medallions. The texture of the silk yarn, the color scheme and the mixed styles of animals and vegetation suggest a Central Asian rather than a metropolitan Chinese weaving center. Such a tent hanging or carpet could have been given as tribute to a government or religious official or traded to a noble family, used and then stored as a precious object.

Pen cases were a mark of status in Tibet, declaring the owner a man of learning. The gold-damascened iron tube, color pl. 51, held the wooden or bamboo pens used to write on paper or silk such as the documents seen in color pls. 48 and 49. The case was secured with silk cords passing through the loops at the bottom left center. As with so many Tibetan objects, pen cases were usually in a portable form, worn thrust through the belt.

The openwork decoration on the Museum's fine example, is also seen on early Tibetan saddles (see color pl. 55) and armor. The decorative theme, a deer leaping through foliage and three long, undulating dragons, recalls that seen on imported silks of the eleventh to thirteenth centuries (see color pl. 50) and also much earlier "animal-style" metal decorations from northern Asia. Although the connection between these metalworking traditions is still uncertain, such ancient motifs were collected and prized by Tibetans as amulets into the modern era, see p. 60.

As was customary in east and north Asia, all letters and documents in Tibet were signed with a personal or official seal (see color pls. 48 and 49). Higher dignitaries, such as the Dalai Lama, used red ink (mercury oxide or cinnabar); everyone else used black ink (lamp black). Wax was melted and impressed with the same seals to mark personal property and to secure the outside of letters and packages. The group of iron and brass seals, strung with a lump of wax, color pl. 52, was obtained by Dr. Shelton in the Batang area. The *tri-ratna* shape and handsome scrollwork decorations on the seals and their incised impressions (of medallions, quatrefoils or conch shell) can be linked to the earliest surviving designs in Tibet on the stone pillars (*do-ring*) of the royal period (seventh to ninth centuries).

Although wealth in Tibet was traditionally measured in land and herd holdings with their yearly yields of grains and animal products, exchangeable commodities of set value such as gold, silver, copper and silk were used in ancient and medieval times for trade and tribute. The collection of currency, coins and stamps assembled by the nobleman D. N. Tsarong and acquired by the Museum

from him in 1980 (color pl. 53) records the establishment of more modern Tibetan government control of the economy in the twentieth century.

Tibet had two separate monetary systems. The first one, introduced from Nepal in 1551, consisted of a single denomination called *tamka* (also *tangha* and *trangka*), minted in Nepal for Tibet until 1769, and minted in Tibet from 1792. The second system, a modern decimal system introduced in 1912, consisted of silver and copper coins of denominations called *kar*, *sho* and *sang*.

Paper currency and a regular postal system were introduced by the 13th Dalai Lama after his return from India in 1913. The earlier notes were in denominations of five, ten, fifteen, twenty-five and fifty *tamka*. Later notes were issued in denominations of five, ten, twenty-five and one hundred *sang*. All notes show the government emblem of the lion and give the sixty-year cycle, either the fifteenth (1867–1927) or the sixteenth (1927–86). When more specifically dated, they give the number of years which have elapsed since the legendary founding of the government in 257 C.E., which is the first year of this Tibetan era. Thus by adding 256 to the date on the note, Tibetan era dates are converted into C.E. dates.

Documents and other precious objects were kept in leather or wooden chests within the storerooms of *dzongs*, monasteries and noble homes. The largest of these chests are fairly uniform in size and shape, as exemplified in the Museum's handsome dark red leather chest, color pl. 54. A group of such chests (empty) have appeared on the market in the 1990s. The shape, decorative motifs and Carbon-14 dating tests confirm that the leather chests are thirteenth to sixteenth centuries in date. Initial research suggests that the chests are a Tibetan response to imported red and gold (or polychrome) lacqured leather or wood shipping and storage containers from China.[15]

The Museum's box is formed of heavy leather shaped to a rectangle, slightly tapering in from the bottom to the top. The lid has scalloped edges. A deep red color, very like cinnabar lacquer, is painted directly on the leather surface, and over this a black and gold linear decoration of a central four-lobed scroll-filled medallion enclosing a flaming jewel with the *mantra* (sacred syllable) *om* in *Lantsa* script topped by a sun-and-moon emblem. Scroll-filled bands adorn the front and sides of the chest. A crouching rabbit looking backwards is painted in the center of the left and right sides. Such rabbits were popular motifs in textiles and other decorative arts produced in Yuan and early Ming China. A three-letter Tibetan inscription, *dGa*, is marked in black under the front lid flap.[16] The entire leather surface is coated with tung oil which protects the delicate pigments and gold and gives a shiny lacquer-like surface. The sides, bottom, corners and lid are reinforced with straps of iron, secured with iron nails through the characteristic "arrowhead"-shaped ends. There are iron handholds at the two sides, hinges and lock plate, and loops to secure binding straps at the front.

The ornate silver saddle in color pl. 55 was owned by one of the headmen in the retinue of the Prince of Batang, a close friend of Dr. Shelton. As befitting his rank, the headman would ride a fine horse on a saddle exhibiting wealth and superior craftsmanship. The stirrups on the saddle were reportedly quite old, made in the famous metalworking center at Derge. The dragon-headed arches and gold and silver inlay on the stirrups are characteristic of Derge work, reflecting ancient Chinese and Central Asian forms.

The silver repoussé work on the saddle's front and back may also have been done at Derge. The front panel depicts coiling dragons and celestial musicians flanking a turquoise-inlaid *tri-ratna* in a field of dense foliage. The back panel has a similar design but with deer and birds flanking a central gold medallion depicting an enthroned monk in a cave. The red silk damask saddle pad is attached with four silver buttons carved with whirling motifs. The saddle blanket features a brilliant red British wool center with silk cording in a T-fret and black velvet border. "Rainbow" silk fringe hangs down on either side.

Home Furnishings and Family Ritual Objects

The most prominent noble families had manor houses on their estate holdings as well as large homes in Lhasa. Life in these homes has been well described by twentieth-century members of these families as well as by European visitors.[17] Both the urban and rural houses were constructed in response to Tibet's cold, dry climate as well as to withstand earthquakes. The distinctive battered (sloping) walls of these structures, used for *dzongs* and monasteries as well as private dwellings, gives Tibetan architecture its imposing silhouette and provides structural stability (see figs. 2 and 3). The thickness of walls decreases, on the exterior side only, from ground level to roof. The ground floor walls, usually built of stone on shallow stone foundations, can be up to a meter thick. Stone rubble and rammed earth are used to fill cavities between the rectangular stones. Mud bricks can be used on the lighter upper floors. Hardwood or fir form the structural beams and pillars and soft woods such as poplar are used for carved lintels, railings and window frames which are beautifully painted in bright colors to contrast with the white-washed walls (see fig. 1). The flat roofs are formed of layers of pebbles and mud over wood rafters with an outer surface of stamped and oiled clay or sand which absorb or repel water. The filled ceilings as well as the thick walls ensure maximum insulation against the cold.[18]

The layout of a typical manor house or urban mansion was a main building, usually three storeys and attached, lower, outbuildings arranged around a central open quadrangular courtyard. The family members lived in the upper storey in the summer, in the warmer second storey in winter. The ground floor and outbuildings housed offices, kitchen, storerooms, servants' quarters, granaries and stables. Open verandahs faced the courtyard (see fig. 1).

Within the family rooms, eating, sleeping, studying, meetings and prayer and reflection could all take place during the course of a day because of the flexibility of furnishings. Usually a large upper room was reserved as a chapel for special religious activities, weddings and *Losar* celebrations, and here would be kept the most important religious images, texts and ritual objects owned by the family. But there would be small altars in the other living quarters, including the kitchen.

Otherwise, most furnishings were portable and storable: rugs on low divans could be rolled out for sitting or sleeping, and small tables set up for eating or reading, then collapsed when not needed. Utensils, clothes, books, etc. were put away in wooden or leather chests. The portability of these objects was an asset when entertaining or living in tents at festivals or in pilgrimages, or when moving between Lhasa and country estates.

15 Chinese chests, *circa* twelfth to thirteenth centuries, decorated in true lacquer but similar in shape and size, have been preserved in Tibet. These probably held imperial documents, silk or other precious gifts sent from the Yuan capital to hierarchs and local rulers in Tibet. Because of their official importance, the chests were beautifully decorated. Tony Anninos will be discussing these Chinese lacquer and Tibetan painted chests in a forthcoming *Arts of Asia* article (1999).

16 This single syllable is obviously shorthand for a maker's or owner's name, impossible for the moment to decipher.

17 See for example Bell, *People of Tibet*, and Yuthok, *Turquoise Roof*.

18 Alexander and Azevedo, *The Old City of Lhasa*, Chapter 2.

The carpet *khaden* (*kha-gdan*) in color pl. 56 is typical of the type used on a sitting or sleeping couch in a Lhasa house. The deep indigo blue ground sets off the brightly colored pink and orange peony floral sprays. Carpets were produced to order in small factories near towns in southern and central Tibet in the nineteenth and the first half of the twentieth centuries. Few were exported before 1959 as the industry was geared to local consumption. The distinctive wool warp and weft and wool "cut Senneh loop" pile is unique to Tibetan carpets and suggests a long indigenous tradition. Tibet's nomadic, sheep-rearing culture would also support an ancient carpet history.

Among the few non-portable furnishings in a well-to-do Tibetan home would be built-in or free-standing painted wood cabinets. Such finely decorated chests were used to store silver, brass or porcelain vessels, silks or other personal objects. The painted scenes on the four doors of the Museum's cabinet (color pl. 57) are suggestive of wealth and prosperity and were probably specially commissioned by a family. The four doors which swing out on wood dowels were originally secured by a metal plate and lock around the central brass loop. The scenes are: (upper left) Central Asians and Manchu officials gambling and eating in the garden of a Lhasa nobleman (seated in a pavilion at left); (upper right) a party in the home of a Chinese gentleman with a magician conjuring up coins and celestial beings; (lower left) the Chinese sage Hva-shang under a flowering peach tree attended by monks, devotees, small boys and riders on elephants; (lower right) horses playing in a Tibetan landscape.

All but the "Chinese scene" are executed in a charming Tibetan genre style which can only be glimpsed in the backgrounds of religious paintings (see color pl. 4). The Chinese-style scene was executed by the same artist who did the other three doors, probably copying an imported illustrated woodblock print.

The chest in color pl. 58, the size of a Western "steamer trunk", is a more portable storage unit but it probably wasn't moved much as its delicate painted surface would have suffered from handling. The rectangular wood box with hinged lid is covered inside and out with cotton cloth, but only the outer areas are decorated. The front has a finely worked medallion pattern copied from Chinese brocade, with a central four-lobed medallion enclosing a dragon holding a tray of gems. On the four inner corners are triangles filled with gold scrollwork reminiscent of that on the leather chest, color pl. 54. The border is filled with peony flower sprays, interrupted at the center, top, bottom and sides with gold scroll-filled cartouches. The two ends of the chest have a central panel with a brocade-derived flower pattern, central flaming *tri-ratna* and the same scroll corners. The borders (and lid edge) are painted with a red "damask" cloud design. The top has yet another textile-derived pattern with a central quatrefoil and whirling emblem, scroll corners and a floral border. Iron straps reinforce the chest, and there are iron hinges, lock and lock plate.

The fidelity of the brocade copies suggest that the chest was close to the date of the actual textiles, *circa* sixteenth century. Similar chests have actual pieces of brocade glued to them which seem to be the prototype for the painted patterns. All of the motifs on this chest convey images of wealth and power, with the exception of the *tri-ratna* which has a specific Buddhist meaning.

Among the precious objects used in a noble home (and stored in the above cabinets or chests) were silver or imported jade or porcelain tea and rice bowls

used on ceremonial occasions. The handsome silver-lined wood burl bowl in color pl. 59 would be used as a personal container for *tsampa* (see p. 53) or rice. This bowl was obtained by Dr. Shelton in the Batang area. It was probably made by a local silversmith.

A stem bowl such as that shown in fig. 10 would have been the type of rare and expensive utensil kept inside the beautiful cup-holder, color pl. 60. The leather case was certainly made for a specific stem bowl (inverted for stability); the cylindrical top and gentle curve of the base follow the shape of the stem bowl exactly. Mimicking Chinese lacquer, the leather has been painted a deep cinnabar red with a design of gold lotus flowers on green stem and leaf sprays. The entire surface was then coated with tung oil to preserve the pigments and gold and to create a shiny finish. The iron hinge, lock and loops (to hold a wrapping strap) are like those on the leather chest, color pl. 54. The case appears to copy closely a fifteenth-century Chinese lacquer piece.

Tsampa, the Tibetan dietary staple, and butter are stored in covered containers, usually of fine wood. The large and elaborately decorated box, color pl. 61, is unusual in its large size and rich use of metal. It was probably used for ceremonial occasions and carefully preserved for centuries. The cylindrical iron

Fig. 10
Porcelain stem bowl,
Kangxi period (1662–1722), China,
H. 6 in. (15.2 cm).
Herman A. E. and Paul C. Jaehne
Collection, gift 1941 41.1013

body divided into two registers has fine silver wire inlaid to form a swirling vine pattern in eight panels; at the center of each is one of the Eight Buddhist Emblems. Each panel is bordered in a pattern of linked circles. Raised bands of iron encircle the body at the bottom, center, top and the rim of the flat lid, each filled with bands of the same pattern of linked circles but here damascened in gold. Eight hourglass-shaped panels divide the two registers vertically, each filled with relief scrolling foliage around the Eight Buddhist Emblems and Eight Auspicious Emblems damascened in gold. The lid has a central lotus petal knob, damascened in gold, and segments repeating the scroll and circle patterns. Brass handles, iron loops for securing a binding strap and a lock for the lid are applied with brass pins to the container. The decorative patterns of swirling vine and linked circle were popular on textiles, ceramics and metalwork of the Mongol period, thirteenth century, and it is possible that this massive *tsampa* container dates from that time of active Mongol-Tibetan interaction.

A noble family would commission the finest craftsmen using the most precious materials for the religious objects in the home. The large *ga'u* (portable reliquary) in color pl. 62 comes from the Surkhang family shrine in its Lhasa home. The shrine-shaped copper base and ornate silver and gilt front would originally have held relics, prayers and other sacred objects with a small Buddhist image visible in the open central area. Two silver bars at each side would have secured decorative scarves or carrying straps (compare Chapter II, fig. 13), but the large size of the *ga'u* would have restricted its portability. The beautiful repoussé and openwork front was executed by a silversmith, probably working in the traditional craft area of Zhol, below the Potala Palace, just outside Lhasa city proper. In the dense background of scrolling leaves and flowers is a set of eight gilt-silver dancing goddesses holding auspicious emblems with Tara at the top and an offering of the Five Senses below. Gilt-silver dragons and phoenixes in foliage and a beaded edge border the shrine front.

Similarly elegant is the silver and jewel-adorned prayer wheel shown in color pl. 63. This would have been used for personal prayers. The small cylinder is filled with a paper roll printed with the *mantra, om mani padme hum* (see pp. 55–57), and the heavy silver weight and chain control the revolutions (like the robust example in color pl. 26). The precious nature of the container amplifies the sacred function of the object. Large and small turquoises and small rubies are set into the side of the cylinder as well as the handle. Jade beads decorate the top finial and the end of the handle.

PLATE 36

Gyaluché costume

Tibet, *circa* 1940

Silk brocade, silk velvet, and plain silk, trimmed with fur
Tsarong Collection, purchase 1980
Robert O. Driver Fund 80.288

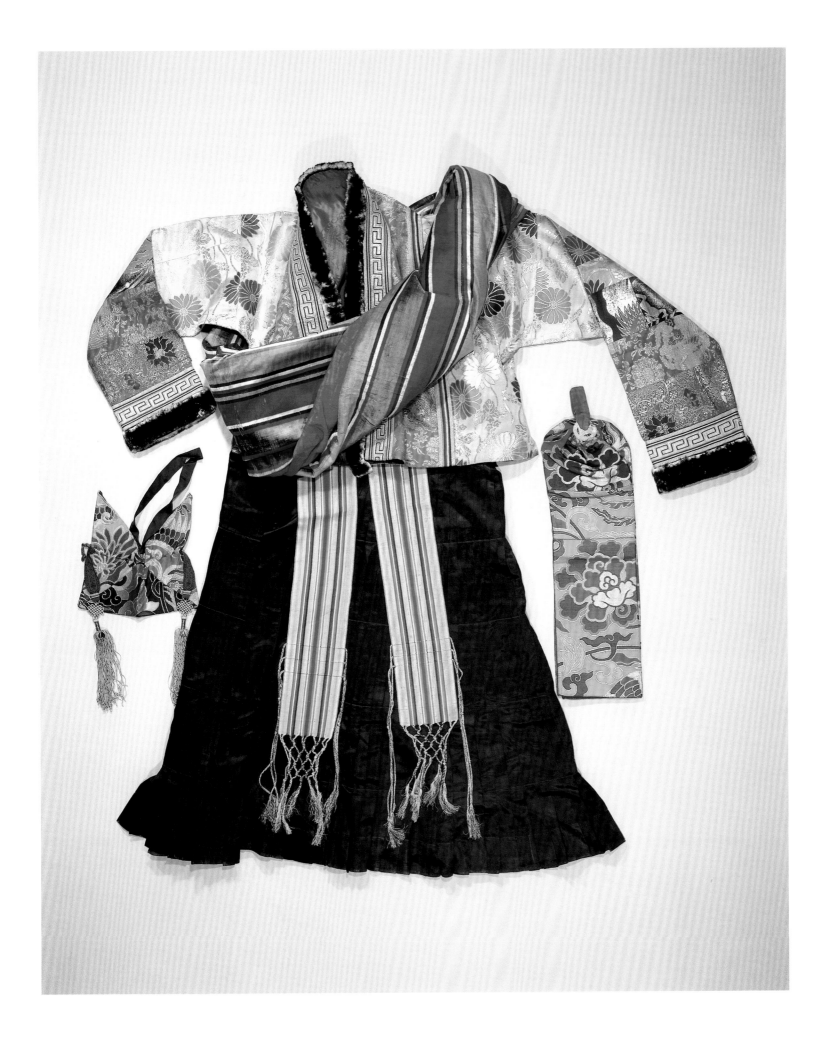

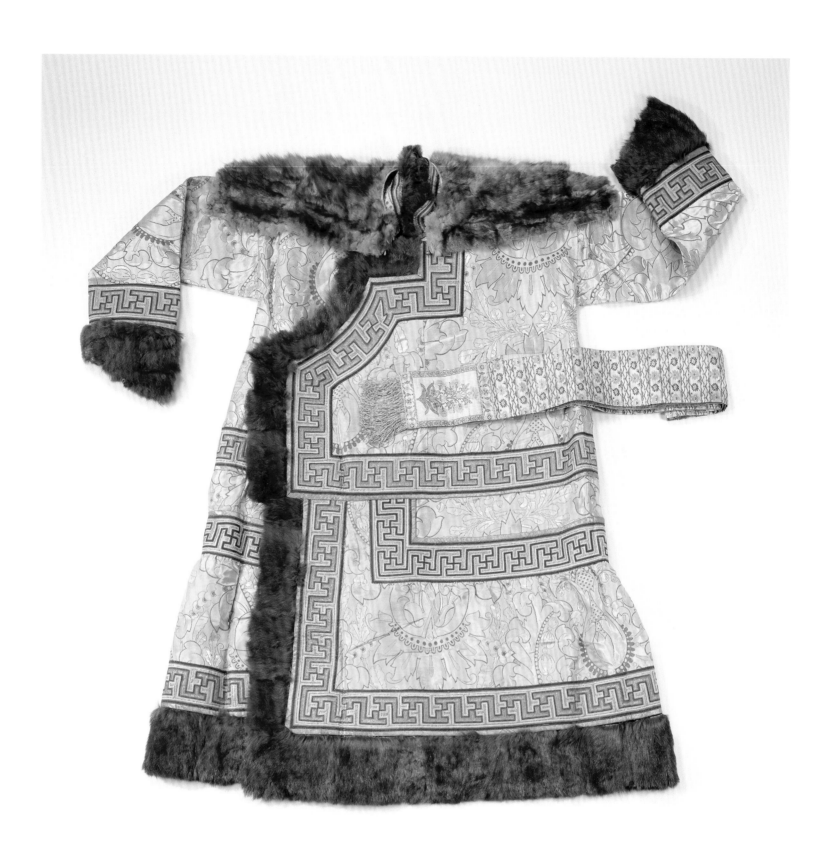

PLATE 37

Khalkha Su costume

Tibet, *circa* 1930

Silk brocade, trimmed
with silk cording and fur
Tethong Collection, purchase 1977
Sophronia Anderson Bequest Fund 77.30

PLATE 38

Official's hat finial *shalok*

Tibet, *circa* 1940

Gold, silver, turquoise, glass,
H. 3 ¹/₂ in. (8.9 cm)
Shakabpa Collection, purchase 1972
C. Suydam Cutting Endowment Fund 72.16

PLATE 39

Official's pendant earring *so-byis*

Tibet, *circa* 1940

Gold, turquoise, pearl, glass, silk, tape,
(with turquoise and pearl on wool string)
L. 6 ¹/₈ in. (15.6 cm)
Tashi Tshering Collection, purchase 1961
C. Suydam Cutting Endowment Fund 61.5

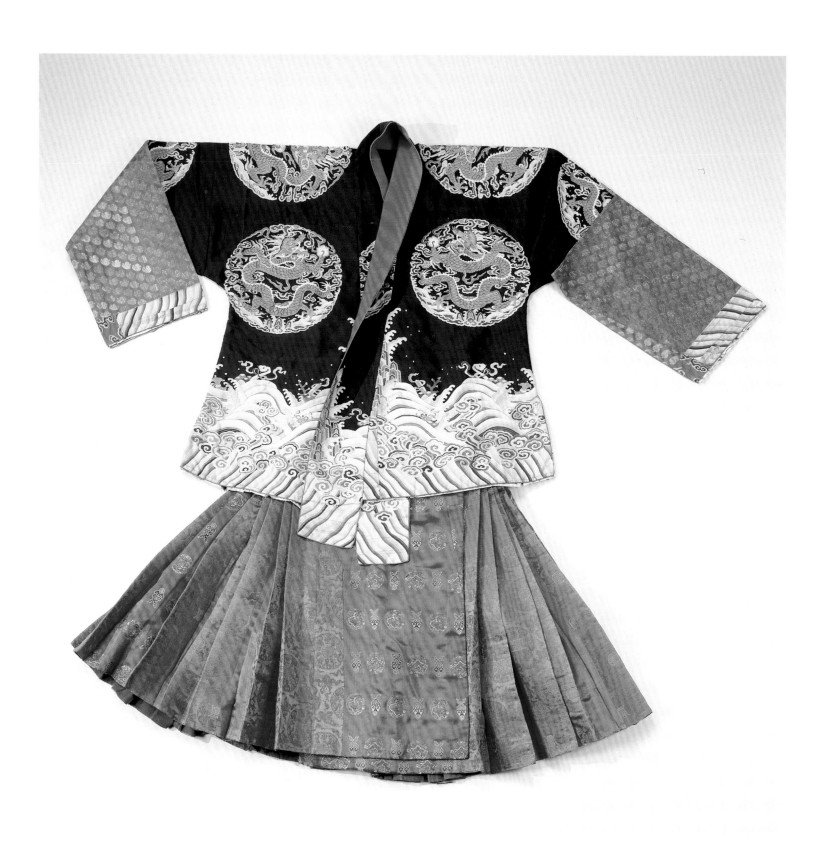

PLATE 40

New Year's costume
Batang, Eastern Tibet,
late 18th–early 19th centuries

Satin brocade skirt with cotton lining;
silk tapestry and brocade jacket with fur trim
Dr. Albert L. Shelton Collection,
purchase 1920 20.308, .310

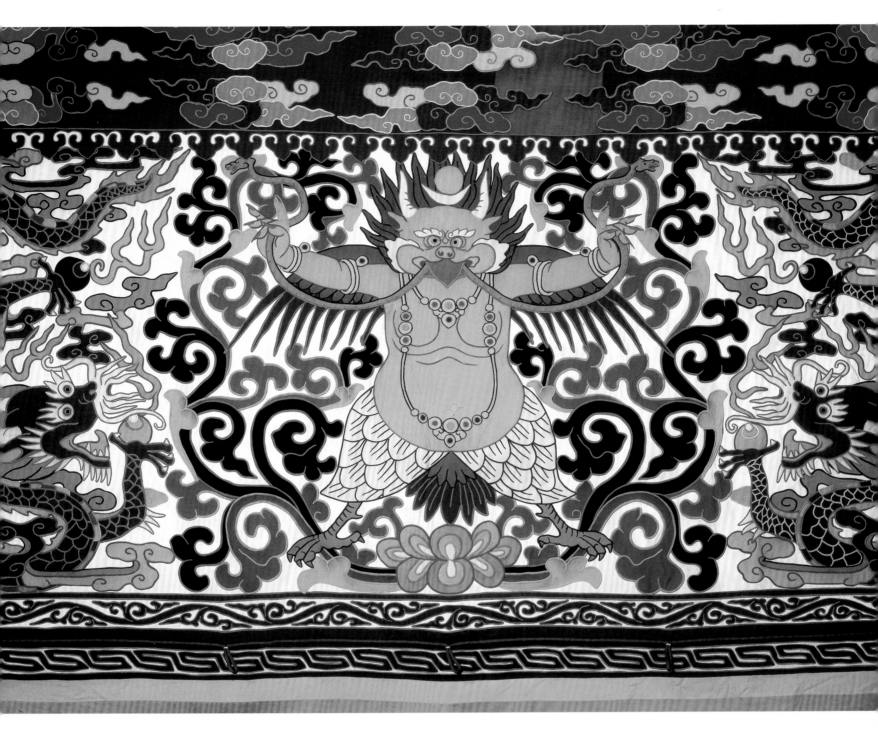

PLATE 41

Ceremonial appliquéd tent (detail)

Sikkim, *circa* 1930s
(made by a Lhasa tent maker)

Cotton, wool, yak hair ropes and pompoms,
L. 180 in. (1161.3 cm)
Bailey Collection, purchase 1959 59.71

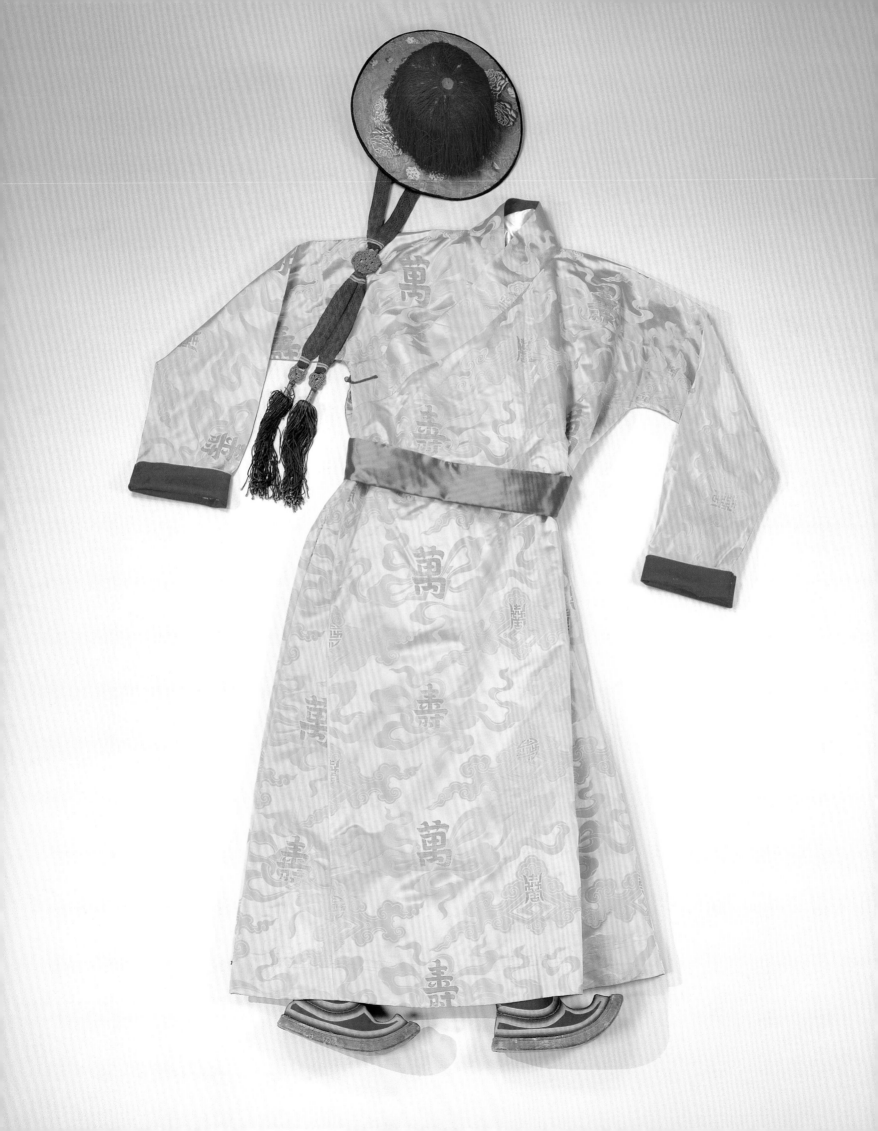

PLATE 42

Official's summer costume

Lhasa, Tibet, mid-20th century

Silk brocade *chupa*

with damask and cotton lining, gold button
Tsepon Shakabpa Collection, purchase 1972
C. Suydam Cutting Endowment Fund
72.17

Silk brocade hat

with damask and silk fringe, silk streamers
Purchase 1974 C. Suydam Cutting
Bequest Fund 74.128

Wool boots

with cording and leather soles
Purchase 1981 C. Suydam Cutting
Bequest Fund 81.357

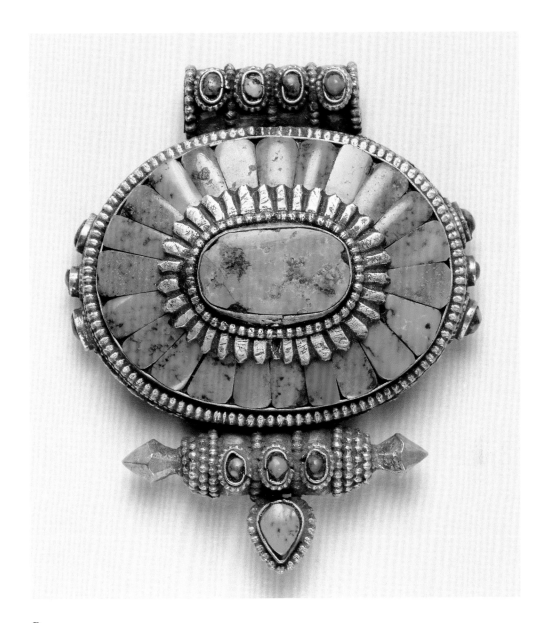

PLATE 43

Ga'u hair ornament (*takor*)

Lhasa, Tibet, mid-20th century

Turquoise set in gilt silver,
H. 2 ⅝ in. (6.8 cm)
Purchase 1990 C. Suydam Cutting
Bequest Fund 90.292

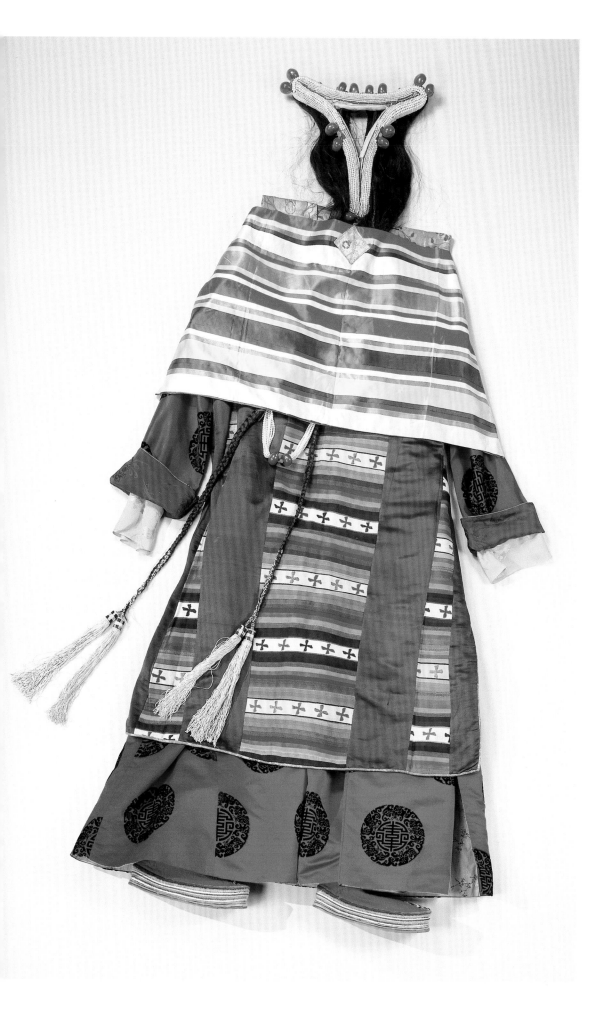

PLATE 44

Woman's festive costume

Lhasa, Tibet, first half 20th century

Satin and cut-velvet *chupa*

with damask and cotton lining
Collection of the 14th Dalai Lama's older
sister, purchase 1971 C. Suydam Cutting
Endowment Fund 71.89

Ceremonial overdress

of silk and brocade with embroidered details
Surkhhang Collection, purchase 1979
C. Suydam Cutting Endowment Fund
79.182

Shawl

of striped silk with brocade detail
Ragasha/Tsarong Collection, purchase 1980
Robert O. Driver Fund 80.289

Replica headdress

of imitation pearls, coral and turquoise
on cotton and silk support; human hair wig;
silk tassels
Purchase 1973 John J. O'Neil
Bequest Fund 73.20

Wool, cotton and leather boots

Purchase 1978 C. Suydam Cutting
Bequest Fund 78.141

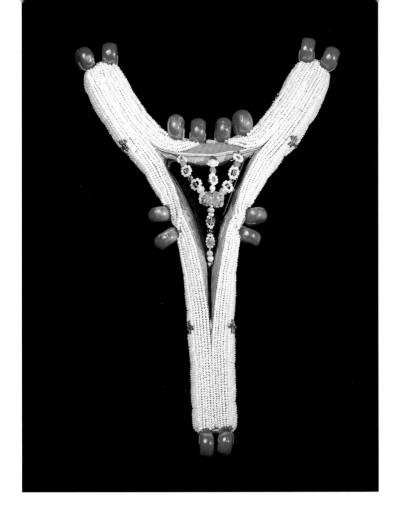

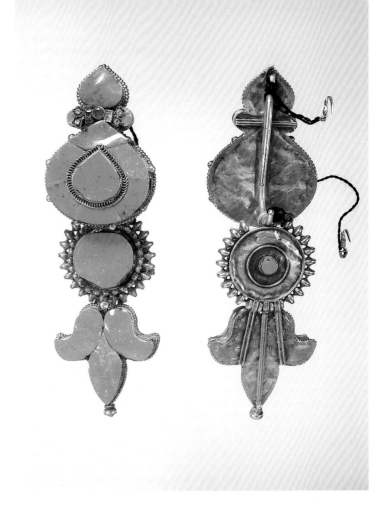

PLATE 45

Headdress (*patruk*)

Lhasa, Tibet, *circa* 1950

Coral and freshwater pearls sewn to a cloth frame
with additional precious and semi-precious stones,
W. 11 ³/₄ in., L. 19 ¹/₂ in. (29.9, 49.5 cm)
Purchase 1981 Special Tibet Fund, The Members' Fund,
Mary Livingston Griggs and Mary Griggs Burke Foundation
and Anonymous Fund 81.37

PLATE 46

Earring (*eh-kor*)
[front (left) and back (right) shown]

Lhasa, Tibet, first half of 20th century

Gold, turquoise with additional precious stones,
L. 6 ³/₈ in., W. 2 ¹/₈ in. (17.0 x 5.4 cm)
Purchase 1981 Anonymous Fund
and The Members' Fund 81.14

PLATE 47

Amulet box (*ga'u*)

Lhasa, Tibet, *circa* 1940

Ga'u: Gold, pearls, turquoise, precious and semi-precious stones,
H. 4 ¹/₂ in. (11.4 cm); Necklace: Freshwater pearls, coral,
dzi beads, turquoise, glass, total L. 13 ¹/₂ in. (34.2 cm)
Purchase 1986 C. Suydam Cutting Bequest Fund 86.279

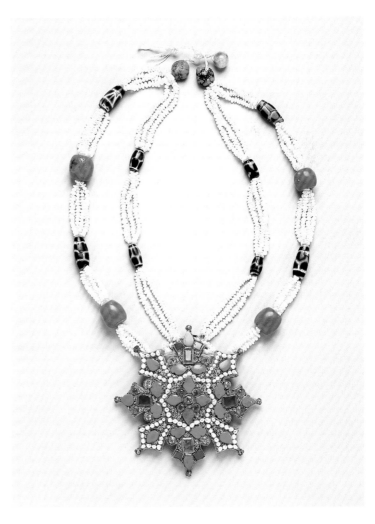

PLATE 48

**Document signed by
Miwang Pholhaneh**

Lhasa, Tibet, 1740

Ink on satin, H. 70 in. (177.8 cm)
Dr. Albert L. Shelton Collection,
purchase 1918 18.141

PLATE 49

Petition to the 10th Dalai Lama

Lhasa, Tibet, 1830

Ink on paper, H. 19 ⅝ (49.8 cm),
silk damask wrapper
Gift of Mrs. Dorje Yuthok, 1983 83.442

PLATE 50

Textile fragment with bird,
animal and flower design

Central Asia, 12th century

Silk slit tapestry, H. 20 $\frac{3}{4}$ in.,
W. 9 $\frac{1}{2}$ in. (53.8 x 24.1 cm)
Purchase 1990 John J. O'Neill
Bequest Fund 90.258

PLATE 51

Pen case

Derge, Tibet, 15th century or earlier

Iron with traces of gilt,
L. 15 ³/₈ in. (39.1 cm)
Dr. Albert L. Shelton Collection,
purchase 1920 20.415

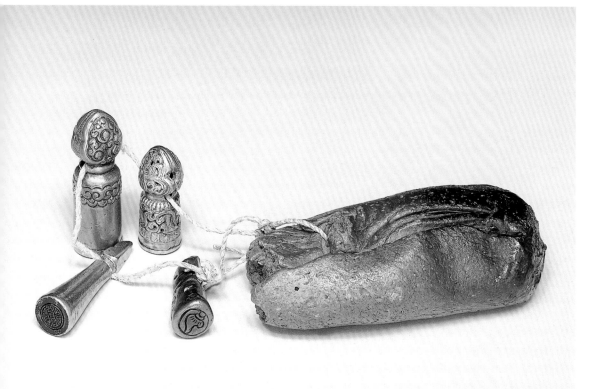

PLATE 52

Seals and wax

Kham, Tibet, 19th century

Seals: two iron, one brass, one iron and
brass, H. 1 ¹/₄ in. – 2 ¹/₄ in. (3.2 – 5.7 cm),
atttached by cord to a lump of sealing wax
Edward N. Crane Memorial Collection,
gift 1911 11.583–.587

PLATE 53

Framed collection of paper
currency, stamps and coins

Primarily Tibetan, or Nepalese
and Indian used in Tibet, 1909–59

Assembled by D. N. Tsarong who,
as government official at the Drapchi Mint
1946–50, was instrumental in the issue
of several of the types shown here
Purchase 1980 Louis Bamberger Bequest
Fund 80.292 a, b–.321

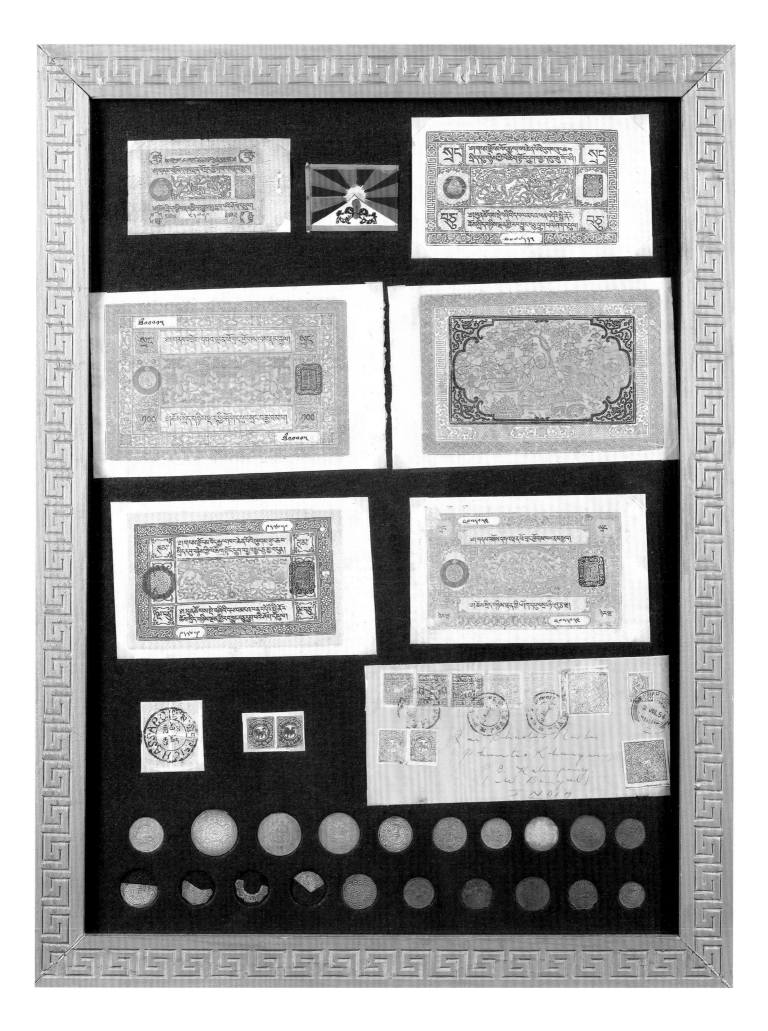

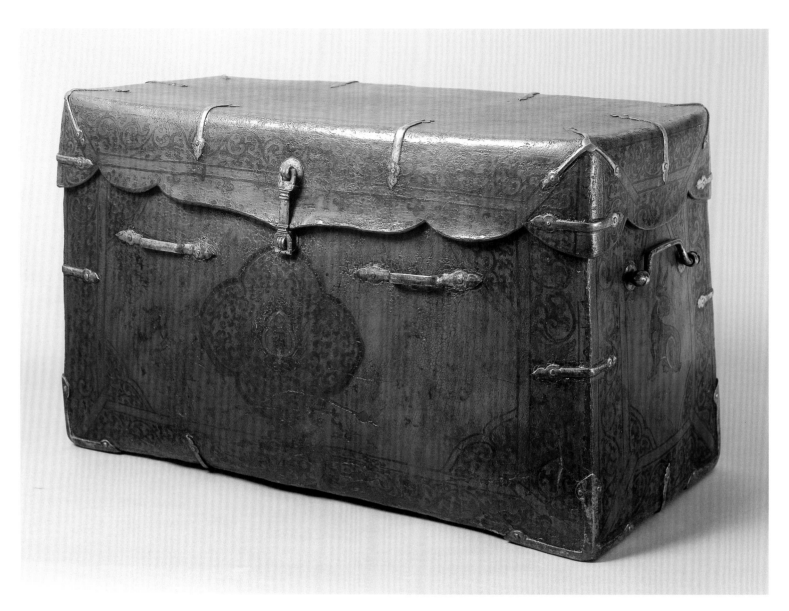

Plate 54

Painted storage chest

Tibet, 15th century

Leather with painted and gilded designs and
iron fittings, H. 17 in., W. 27 in. (43.2 x 68.6 cm)
Purchase 1997 C. Suydam Cutting Bequest Fund
and Life Membership Fund 97.17

Plate 55

Saddle

Batang, Eastern Tibet, 19th century

Silver and gilt silver over wood, turquoise
inlay, L. 22 in. (55.9 cm); leather straps;
gold and silver damascened iron stirrups;
silk damask pad with silver button; wool,
velvet, silk cord and silk fringe blanket
Dr. Albert L. Shelton Collection,
purchase 1920 20.496–.497, 20.315

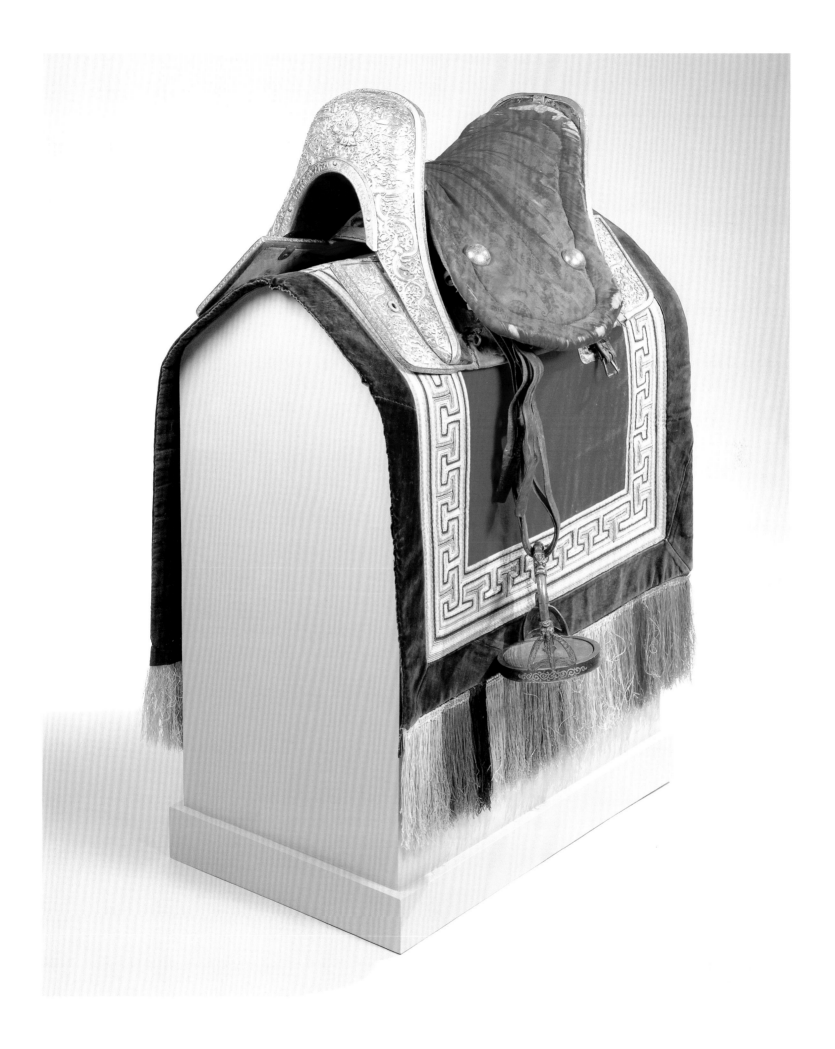

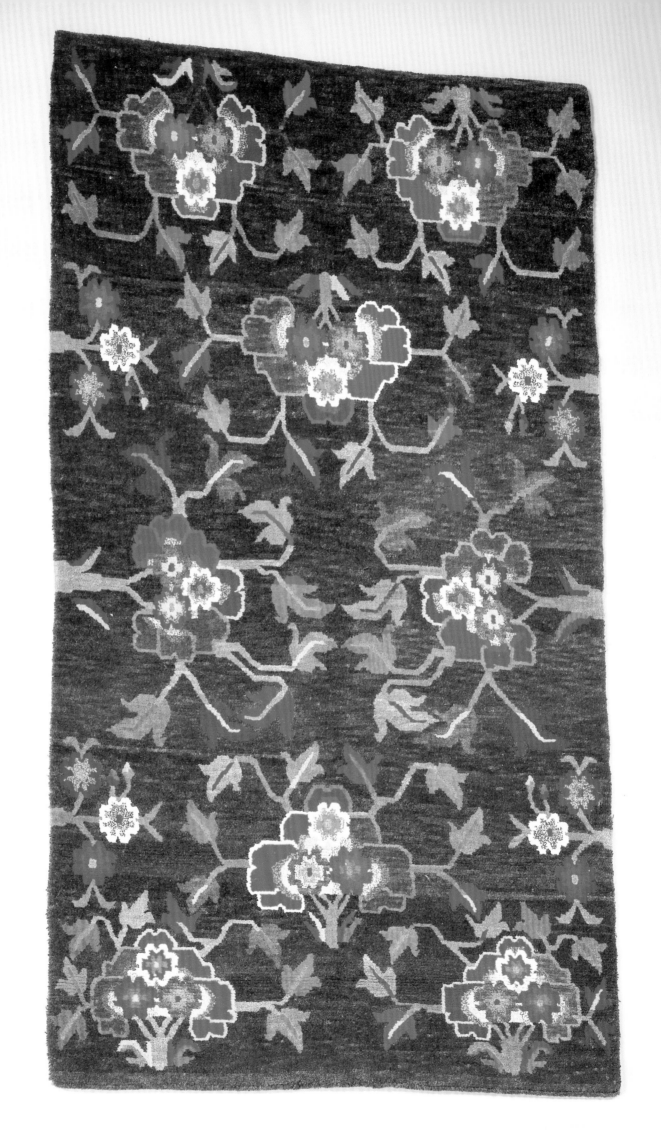

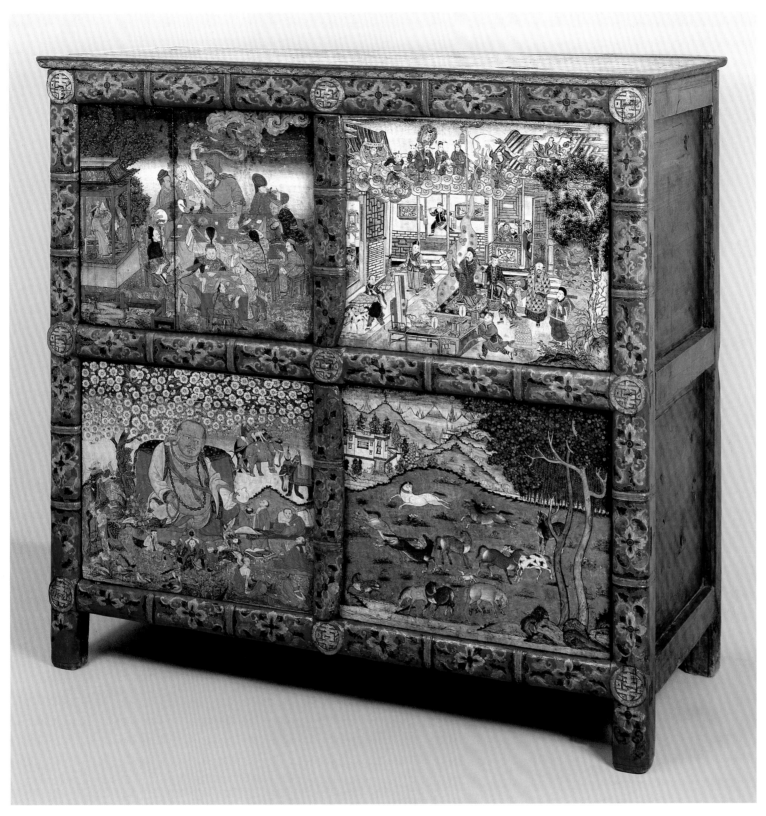

Plate 57

Cabinet

Tibet, 19th century

Painted wood, H. 39 in. (100.3 cm)
Purchase 1990 Mr. and Mrs. C. Suydam
Cutting Bequest Funds and
The Members' Fund 90.365

Plate 56

Carpet *khaden*

Tibet, *circa* 1920–30

Wool, L. 78 ³⁄₈ in. (199.1 cm)
Purchase 1978 C. Suydam Cutting
Bequest Fund 78.138

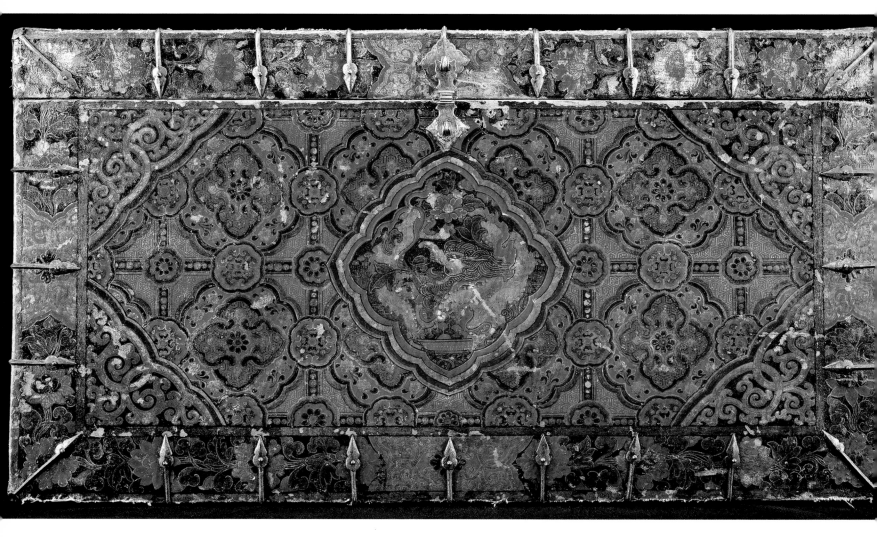

PLATE 58

Chest

Tibet, 16th century

Painted cotton cloth over wood, iron fittings,
H. 17 ½ in., W. 32 ½ in. (44.5 x 82.6 cm)
Purchase 1993 Willard W. Kelsey Bequest
Fund 93.245

PLATE 59

Tea bowl

Tibet, 19th century

Silver-lined wood burl,
H. 2 in., D. 6 ¾ in.
(5.1 x 17.1 cm)
Edward N. Crane
Collection, gift 1911
11.620

PLATE 60

Cup holder

Tibet, 15th century

Painted and gilded
leather, iron fittings,
H. 6 ½ in. (16.5 cm)
Purchase 1998
The Members' Fund
98.20.2

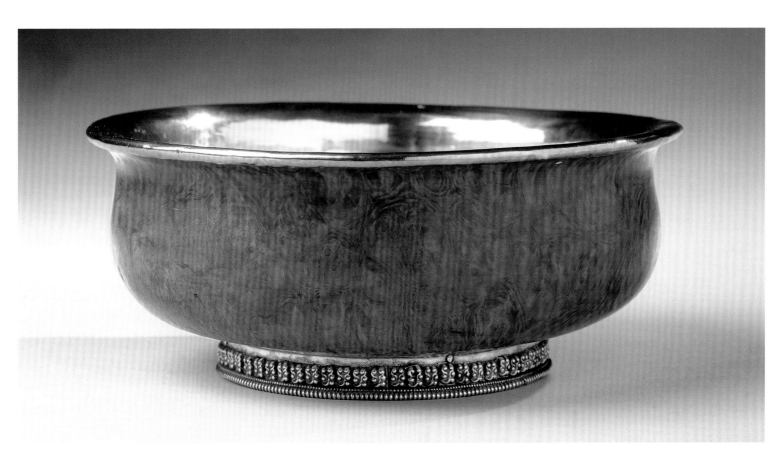

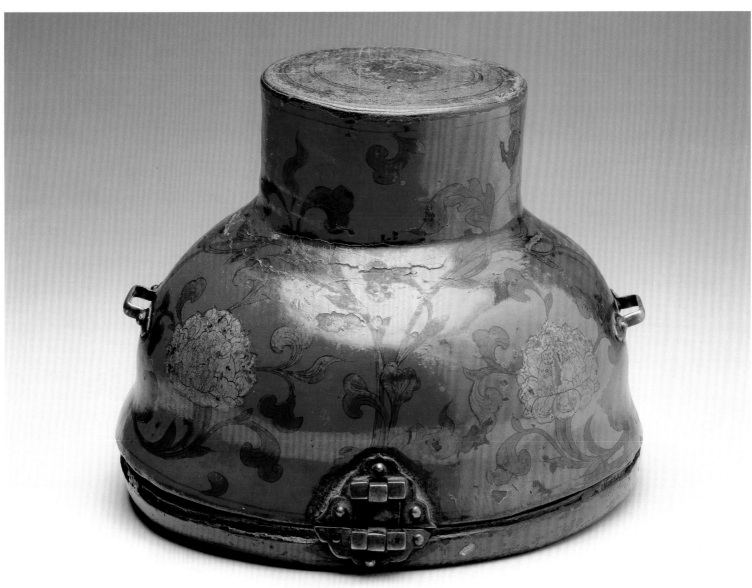

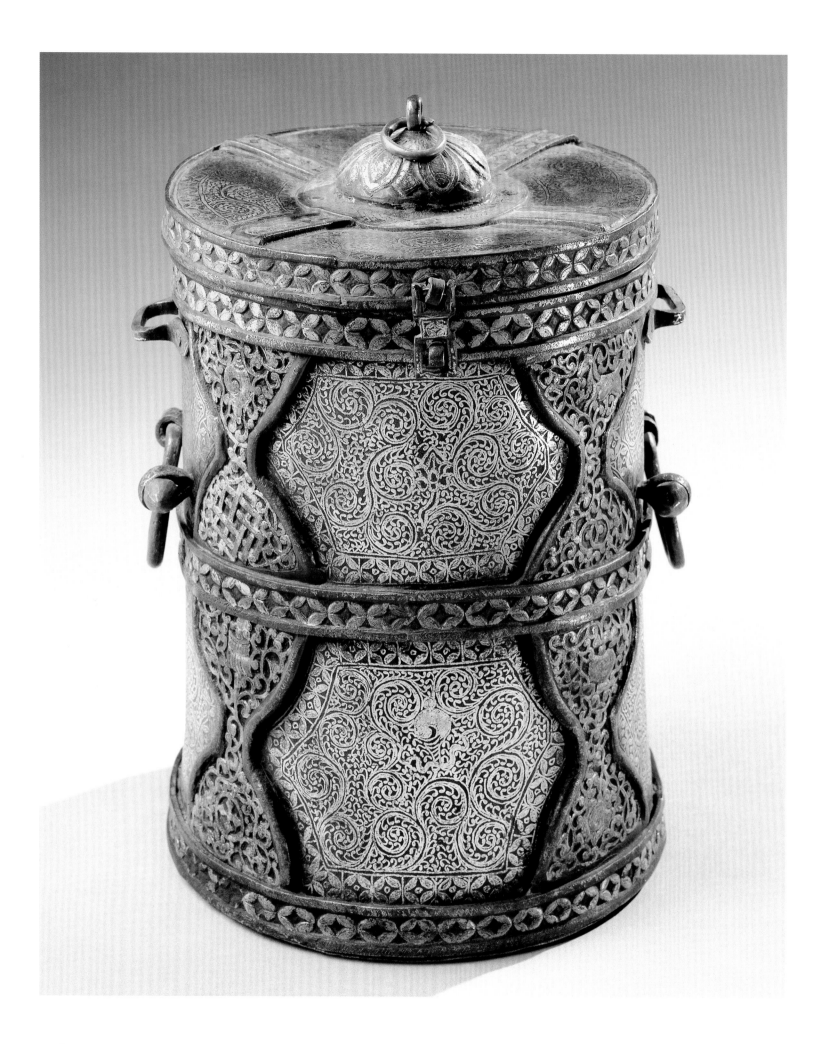

PLATE 61

Tsampa container

Tibet, 13th–14th centuries

Iron with silver and gold inlay,
brass fittings, H. 10 in. (25.4 cm)
Gift of Dr. Wesley Halpert
and Mrs. Carolyn M. Halpert,
1988 88.698

PLATE 62

Relic box

Lhasa, Tibet, early 20th century

Silver and gilt repoussé, copper
back, H. 11 $\frac{1}{4}$ in. (28.6 cm)
Surkhang Collection, purchase 1979
W. Clark Symington
Bequest Fund 79.184

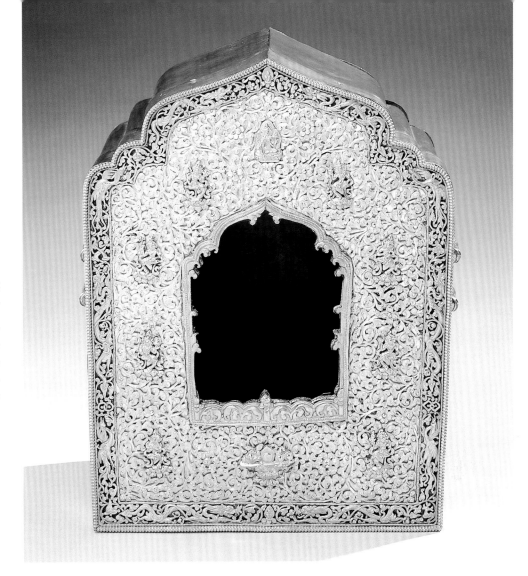

PLATE 63

Prayer wheel

Tibet, 19th century

Silver set with jade, rubies and shell,
L. 9 $\frac{1}{4}$ in. (23.5 cm)
Gift of Dr. Wesley Halpert and
Mrs. Carolyn M. Halpert, 1984 84.406

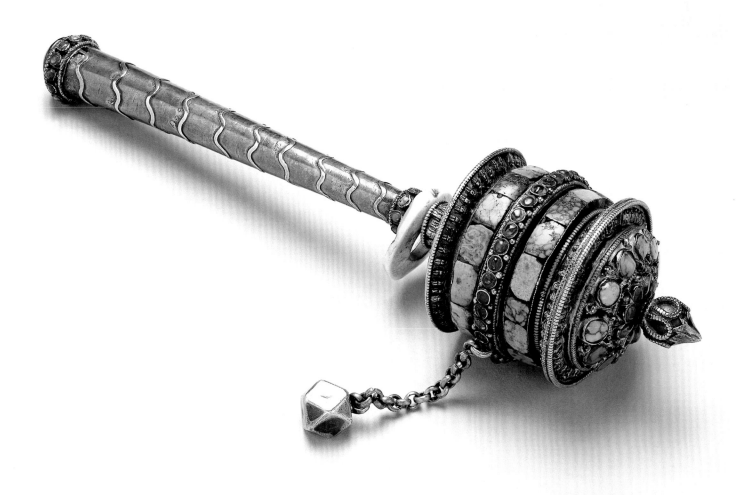

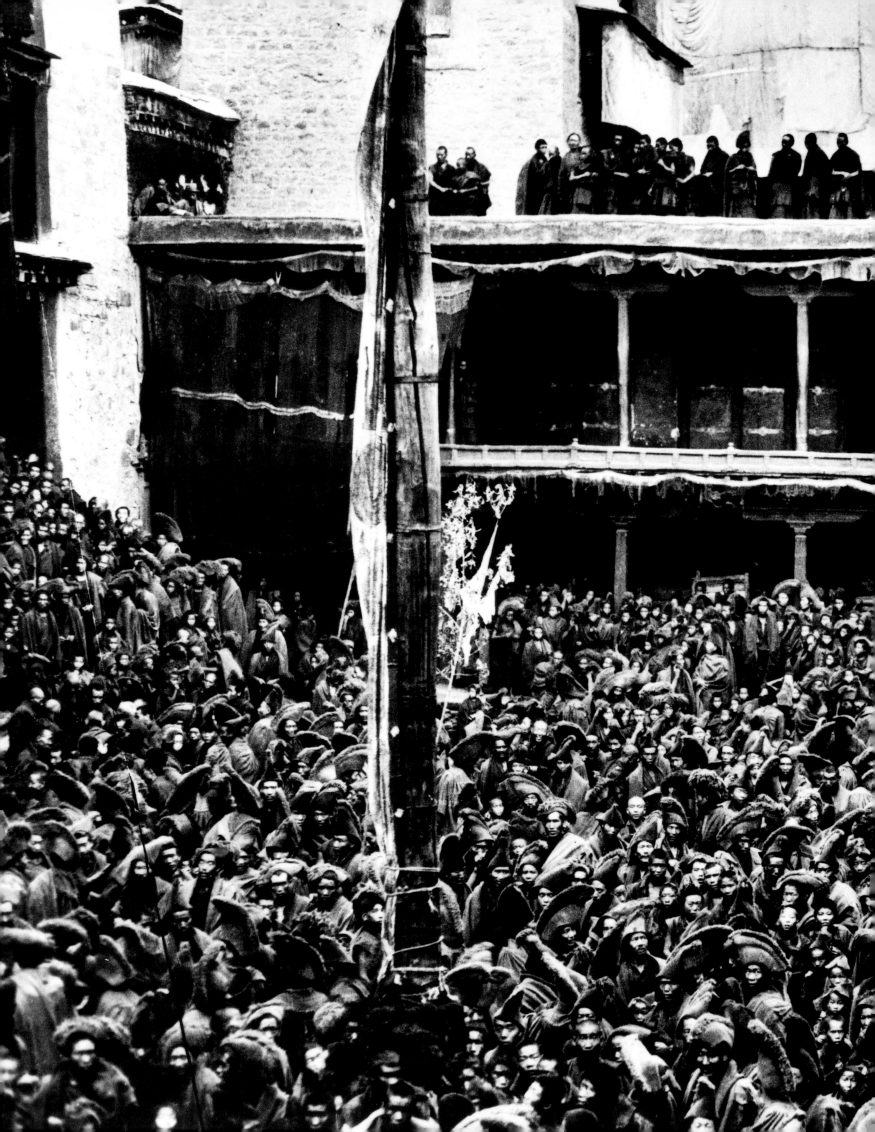

Courtyards and Temples

Prior to 1959, Tibet had long held the distinction of being a Buddhist ecclesiastical state. This "theocratic" aspect has seized the popular Western imagination.[1] From its first formal introduction to Tibet in the seventh century, Buddhism was allied with the ruling powers. The *tsenpos* ("emperors") of the Tibetan Kingdom, during the seventh to ninth centuries, gave sanction to the new religion, while still supporting indigenous rituals and beliefs. The irreconcilability of Buddhism to these existing religious structures, and the opposition of important noble clans who resented ceding any economic or political power to Buddhist monks, led to the collapse of the Buddhist establishment in Tibet in the mid-ninth century (see pp. 25–26).

When Buddhism was revived in Tibet in the late tenth century, the country was divided into princely realms and small kingdoms. Many of these sponsored Buddhist teachers from India to come to Western and central Tibet, and in Eastern and northeastern Tibet existing Buddhist communities were given renewed status. In the eleventh and twelfth centuries, Tibetan masters established hundreds of monastic centers. Alliances between these religious orders and their lay patrons led to the accumulation of political power by certain clerics, who often came into conflict with each other.

From the mid-seventeenth to twentieth centuries, the Buddhist establishment in Tibet and in regions of Mongolia and China was dominated by the Gelugpa sect. Gradually taking over the secular powers of the ancient Tibetan kings and the vassal princes, the Gelugpa sect gained political ascendency over the older sects, the Sakyapa, Kagyupa and Nyingmapa. Powerful Gelugpa religious leaders, such as the 5th Dalai Lama (1617–82) and the 13th Dalai Lama (1876–1933) unified Tibet and effectively guided the political, economic, and spiritual concerns of the nation.

Tibetan Buddhism was imbued with physical manifestations of its power and splendor. Monasteries were awe-inspiring structures suggesting, and often serving as, fortresses. Monks of high rank dressed in rich robes and were treated like royalty. Learned lamas were regarded as living vessels of spiritual forces. This assumption of sacred qualities in a living person was epitomized by the idea of incarnate lamas such as the Dalai Lama and Panchen Lama.

The Newark Museum's collection of monastic materials shows the extraordinary richness of the Tibetan Buddhist establishment prior to its destruction in the mid-twentieth century. As a sad prelude to that destruction, the Crane/Shelton holdings were acquired because of the great damage done to Buddhist monasteries and royal temples during the Sino-Tibetan border wars of 1905–18. Fine ceremonial silver and ancient manuscripts, among other objects from the destroyed altars and libraries, were entrusted to Dr. Shelton for safekeeping (see pp. 11–14).

Homeless liturgical pieces brought out of Tibet by refugees have continued from 1959 to enrich the Museum's collection. The staff in Newark have striven

1 See Lopez, *Prisoners of Shangrila*, for a book-length treatment of Western perceptions and misperceptions of Tibet and Tibetan Buddhism.

to present these sacred objects in an accurate and sympathetic context. This is exemplified by the construction of a complete Buddhist altar to house the images, manuscripts and ritual vessels at the Museum in 1935 and then the creation of a new altar space, working with Tibetan artists and advisers, from 1988–90 (see pp. 18, 20–21).

The Altar Space

A Tibetan Buddhist altar is traditionally constructed as a sacred space to house images of the Buddha and his teachings. The altar serves as a focus of Buddhist religious ritual and as a place for profound contemplation. Offerings are placed on the altar as an expression of the practitioner's devotion to the principle of enlightenment.

The Newark Museum's altar (see color pl. 64), completed in 1990, provides a richly decorated setting for many of the finest liturgical objects in the Tibetan collection. Beautifully painted by artist Phuntsok Dorje, the ceiling, walls and pillars are filled with rainbow clouds, jeweled hangings and sacred emblems. The most complex of the painted areas is the shrine opening itself. A jeweled and beribboned "Wheel of the Law", the symbol of Buddha's teachings, flanked by two deer and lotus blossoms, fills the crown over the shrine. Below this are lotus petals and jewel garlands. The shrine niche border is decorated in rainbow-hued lotus petals. The arched opening is filled with auspicious beings frolicking amidst lotus plants, which grow out of two golden vases. Supporting the altar surface are fierce Tibetan snow lions, wheels, and a central double *dorje*.

A gilt-copper image of the historical Buddha Shakyamuni is in the center of the altar niche, its importance as the focus of devotion enhanced by a small throne. The Buddha position is that of the meditating yogi—the lotus pose: back straight and immobile, legs closely locked, and soles of both feet visible. The right hand of Shakyamuni forms the gesture of earth-touching or witnessing; the left hand rests on the lap in a meditative pose.

A gilt-copper image of the eleven-headed, eight-armed Avalokiteshvara, Bodhisattva of Compassion, stands to the left side of the Buddha. Avalokiteshvara belongs to the vast assemblage of Bodhisattvas, advanced souls who renounce the bliss of Buddhahood in order to aid all suffering creatures. Buddhist art represents them in royal garments and jewelry such as that which the Bodhisattva who later became Shakyamuni Buddha wore as a prince.

A brass *chorten*, or reliquary, stands to the right of the Buddha. The *chorten* (Sanskrit: *stupa*) commemorates Buddha's death or *parinirvana*. Thus it has come to be the highest Buddhist emblem, comparable to the Christian cross, symbolic of the Buddha's attainment of the state of consciousness known as *nirvana*, which is beyond all concepts and forms. The thirteen discs or wheels have evolved from the sacred parasols surmounting the earliest Indian *stupas*. They are surmounted by a parasol that has retained its original form and symbolizes universal spiritual emperorship. The topmost emblem represents the crescent moon, sun and sacred flame of Buddha, or eternal changeless wisdom. According to a popular Tibetan interpretation, the *chorten* also symbolizes the five ele-

Fig. 4
Monks' boots outside a ceremonial tent, Lhasa, central Tibet, 1937.

The boots (color pl. 70) are an especially ornate version of the upturned-toe boots of all monks (see fig. 4), with yellow silk damask and rainbow-cord trim on a leather and wool foundation.

The garments of revered teachers are blessed by their association with the lama and would be treasured following the death of such an individual. The garments might be divided up and kept as precious objects by disciples, reused in ritual textiles (see color pl. 76) or placed inside *chortens* as relics.[3] The fragmentary cape in color pl. 71 may be such a relic. One quarter of a Buddhist *kashaya* of red plain-weave silk, it is divided into sections by vertical and horizontal green silk damask panels. This type of construction, and the red and green color scheme, can be seen worn by Tibetan lamas and *Arhats* in painted portraits of the fourteenth and fifteenth centuries (see color pl. 104). In the corners inside the borders are two guardian kings, their position indicating that this fragment formed the (proper) leftmost part of the original cape. An extraordinary feature of this piece are the tiny seated Buddhas arrayed on the green panels as well as on the wide borders. The ninety remaining (some partially) separate Buddhas, the sixty-six Buddhas in triple rows on the three solid borders (also partially removed) and the two guardians are all executed in counted stitch on buff silk gauze. Fade marks on the red plain-weave ground silk indicate that originally the three border lengths were complete and met, as is still observable at the lower right, in a beveled corner. Originally, each green vertical divider held thirteen Buddhas (as can still be seen in the leftmost divider) and each short horizontal divider held two. The separate Buddhas and those on the border lengths are identical in their homely artlessness, but they vary slightly in shape, size, and the patterns and colors of robes, haloes and double lotus bases. All have enormous ears and voluminous robes which cover the entire body, and all hold their hands clasped in a devotional gesture at chest level. The two guardians, in a similar stance, wear swirling garments and scarves and both grasp a wavy sword.

3 Martin, "Pearls from Bones", pp. 297–301.
4 Reynolds, "Myriad Buddhas", *Orientations*, April, 1990, pp. 88–99.

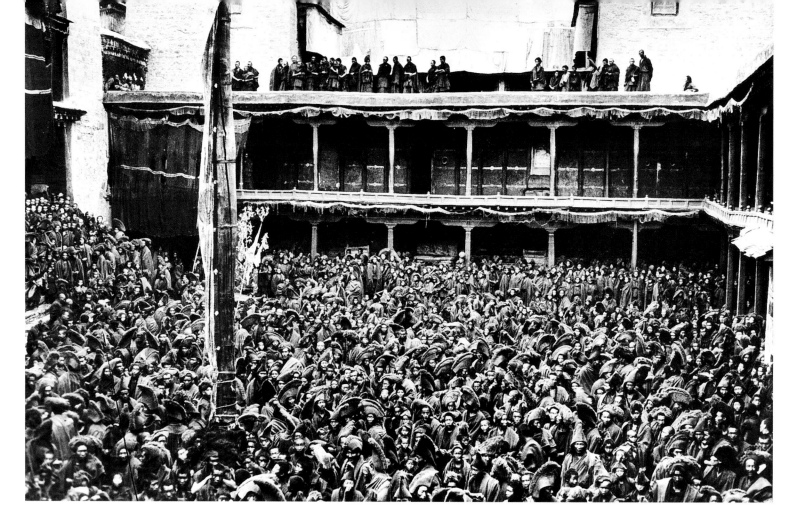

Fig. 2 Monks gathered at Tashilhunpo monastery, southern Tibet, 1935.

and meditation became fully ordained as *gelong* (*dge slong*, Sanskrit *bhik shu*) and to rise through the ranks to become abbots or distinguished teachers.

The garments shown in color pl. 70 are the type worn by fully ordained monks for certain ceremonies such as empowerments (*wang*). The pieced construction of the cape (Sanskrit *kashaya*, Tibetan *chos-gos*, "cape") symbolizes the vow of poverty taken by all Buddhist monks and recalls Shakyamuni Buddha's cloak of donated, patched cloth. Tsongkhapa (1357–1419), the founder of the Gelugpa order, decreed that his followers should wear this cape in emulation of this vow and is himself depicted wearing such a robe in sculpture, painting and appliqués (color pl. 111). The tailoring particular to Tibetan examples, as here, forms rectangles which are open at the lower, outer edges, with "arrow" stitches at the corners to accentuate this feature (see fig. 3). Otherwise the segmented vertical columns are like Buddhist capes worn in China and Japan. The Museum's example belonged to the Ba Lama, the incarnate Abbot of the Batang Monastery when Dr. Shelton first came there in 1908. It is made of golden-yellow Chinese silk damask with an overall swastika-fret pattern. The decorative stitching is in blue silk thread and a red satin square embroidered with auspicious emblems is sewn to the center back.

A sleeveless deep red wool vest is worn by all Tibetan monks. Appropriate for high-ranking lamas, fine Indian gold brocade and blue silk trim have been added to the vest shown in color pl. 70 (see also fig. 1). The brocade detailing is enhanced with carefully gathered tucks to surround the armhole. The vest as official monastic attire seems to be a uniquely Tibetan garment for warmth. The earliest known portraits of Tibetan clerics, in the eleventh century, feature such vests cut exactly like those of the twentieth century.

Fig. 3 *Gelong* lama at Labrang monastery wearing *kashaya* robe, Amdo, northeastern Tibet, 1920.

where it was displayed once a year over the throne of the Abbot, in a ceremony commemorating the *parinirvana* of the monastery's founder. This infrequent use explains the extraordinarily fine condition of the canopy, especially the vividness of the colors, which are extremely sensitive to light. The canopy is constructed of Chinese silk *k'ossu* (tapestry) of the late Ming period (early seventeenth century), which probably came into Tibet in its original format as paired dragons bordered with sea-mountain forms on a panel or curtain. The silk has been cut and pieced back together in a complex manner suggesting that first the silk was used in Tibet as a robe and then resewn as a canopy. The backing is nineteenth-century heavy cotton, and the borders are nineteenth-century Chinese satin and silk gauze.

Other decorative objects appropriate to an altar setting are textile hangings and coverings which might be used once a year for a special ceremony or commemorative occasion. Because they would otherwise be stored in monastery vaults, many silk objects have been preserved in Tibet for centuries. A pair of banners (detail of one shown in color pl. 69) which were acquired by the Museum in 1974 are reportedly from Lhasa. The great length (over nineteen feet) indicates their use in a large hall. Filling the arched top plaque of each is a "Face of Glory" spitting jewels, with more jewels in the top finial and curved sides. Silk and silk brocade appliqué, edged with horsehair covered in silk, has been used to vivid effect here. The long rectangular section, in three lengths, is pieced from eighteenth- and nineteenth-century Chinese brocades, sewn into the traditional panels with inverted triangle bottom, each point ending in a silk tassel. The custom of reusing older silks to construct such banners can be seen as well in examples from the eighth to thirteenth centuries.[2]

Lamas' Robes and Personal Objects

The exalted position of the lama (*bla ma*) or spiritual teacher—*La* (soul, spirit or life force) has been used in Tibet since the eighth century to translate *guru* ("high religious teacher")—is a particular feature of Tibetan Buddhism. "Guru yoga" or "union with the teacher's nature" is the goal of Vajrayana practitioners. The qualities necessary for an authentic teacher are set forth in many of the *Sutras* and *Tantras*. The accurate passing of teachings from one lama to another, in a lineage, is a vital part of Tibetan Buddhist tradition. Hence the great reverence accorded to one's teacher, to the community of monks (*Sangha*), and especially to incarnates (*sprul sku, tulku*) who represent successive rebirths of great teachers seen as actual embodiments of Buddhist truth (see p. 179). This reverence explains the numerous lama portraits in Tibetan religious art (see color pls. 107–113).

In renouncing worldly life, all Buddhist monks (and nuns) take vows, including one of abstinence, and seek to devote their lives to Buddhist principles. Cloistered monks (fig. 1) could reside in small remote hermitages or in one of the enormous monastic cities such as Tashilhunpo (fig. 2). To support the large cloistered population, the monasteries held land and engaged in trade. Individual monks might rely on family assistance or earnings from performing rituals. Only those monks who were able to devote themselves to scholarship

2 Reynolds, "Buddhist Silk Textiles", *Orientations*, April, 1997, pp. 188–89; and Whitfield and Farrer, *Caves of the Thousand Buddhas*, pls. 90, 93, 96, 97, 104–6.

Fig. 1 Lama with prayer beads at Labrang monastery, Amdo, northeastern Tibet, 1920.

ments: the base represents the earth; the dome, water; the steeple, fire; the moon and sun, air; and the flame, ether. The thirteen discs typify the thirteen Buddhist heavens (see color pl. 65 for a similar *chorten*).

Behind the altar opening are a set of *tangkas* (painted scrolls) showing the principal Buddhas of the Five Buddha Families, each representing one of the five types of Full Knowledge. Each painting's central Buddha figure has a golden body, wears Bodhisattva ornaments and jewelry and is flanked by two standing attendants.

The Buddhist scriptures are placed in the bookcases to the right and left of the shrine. Each volume is a Tibetan-style book consisting of a stack of 320–380 loose, unbound paper leaves between two wooden boards that serve as covers, bound by a leather strap. This format was derived from India. Most of the books in the Museum's collection lack their original covers. The Tibetan script was adapted from an Indian alphabet during the seventh century, when Buddhism was introduced in Tibet. Like other Indo-European languages, it is alphabetic and reads from left to right in horizontal lines.

Tibetan monks were great calligraphers, and the copying of the scriptures was a way of acquiring exceptional merit. Fourteen of the volumes in the Museum collection are Carbon-14 dated to *circa* 1195. The other volumes date from the fifteenth to eighteenth centuries. The texts are hand-lettered in gold and silver on darkened paper, and many title pages are illuminated with figures of deities and monks. Such magnificent volumes are treated as objects of worship and are seldom opened. They are large and heavy, often weighing as much as sixty pounds. The books were obtained by Dr. Shelton from Tibetan friends who had rescued them from destroyed royal and monastic libraries.

The entire Tibetan Buddhist canon includes the *Kanjur* in 100–108 volumes, and the *Tanjur* in 209–225 volumes. The *Kanjur* gives the sermons and teachings of the Buddha, both the standard teachings, which were first written down in India some four hundred years after the historical Buddha's death, and the esoteric teachings, which were recorded somewhat later in the Indian treatises called *Tantras*. The *Tanjur* consists primarily of commentaries on *Kanjur* texts and also covers religious rites, language, medicine and the arts. See color pl. 66 for an elaborate single volume, the *Prajnaparamita* ("Perfection of Wisdom").

Wherever Tibetan worship is practiced, an image, a book and a *chorten* should be present, symbolizing the body, speech and mind of Buddha.

Six silver butter lamps, the offering of light, are placed across the top step of the altar. See color pl. 67 for an exceptionally large lamp once used at the Batang monastery. In the center, just below the Buddha, is a three-tiered visualization of the universe, constructed of rice and precious gems. The silver bowls spaced across the lower step of the altar hold saffron-colored water, barley and rice. These fine ceremonial silver vessels were obtained by Dr. Shelton from the ruined monastery of Batang in Kham, Eastern Tibet. Additional special offerings of butter sculpture, incense, flowers and music symbolize the aesthetic pleasures of the senses. A small *dorje* and bell (see pp. 133–139) and holy water vessels, for use in rituals, are placed at the sides of the altar.

A decorative silk canopy, color pl. 68, hangs in the space reserved at the ceiling's center. The canopy is from the monastery of Ngor in southern Tibet,

The lengths that form the borders of the fragment have strips of leather sewn onto the gauze ground in between the Buddhas. They were originally covered with silver foil, traces of which can still be seen in some areas. The top border uses red silk thread to secure the leather strips, the right (vertical) border uses green and the bottom border uses yellow. The use of leather rather than paper as support for the silver foil may be a characteristic of Central Asian textiles. The deliberate finishing of the edges on the border lengths, particularly the beveled lower right corner, indicates that the lengths were made specifically for use on a cape.

A few other "Thousand Buddha" capes or sections have appeared outside Tibet in this century; most, as in this example, have Tibetan provenances, but others are from China or Central Asia. Their exact original meaning and purpose remains uncertain although they appear to relate to transcendental concepts of myriad Buddhas developed in India and Central Asia in the fifth to tenth centuries.[4]

A costume which is worn for rituals involving visualization of Bodhisattvas and other beneficent deities is called *rigna*. During the ritual or *sadhana*, the monk is aided in his visualization of becoming a deity by wearing the appropriate garments. The five-leaf crown, usually depicting the Five Cosmic Buddhas, and decorative pendants are worn over a tiered wig and scalloped collar, similar to the traditional "royal" garments of the beneficent deities (see color pls. 140 and 142). The pendants (color pl. 72) have very fine silk appliqué and embroidery of the Eight Buddhist Emblems and butterflies with rainbow tassel ends. The pendants loop over the headdress on a silk cord. The crown (color pl. 73) is one of several which have come to the West in the last decade. They were probably made as a group in China for ceremonial use and appear to be fifteenth century in date. Heavy gold thread is couched down to form the Five Buddhas, with soft blue, green and white silk in various stitches delineating the garments, jewelry, lotus throne and haloes.

A small low table would be placed before lamas performing rituals or receiving refreshments, see figs. 5 and 6 and color pl. 111. Tibetan tables usually have folding legs to facilitate moving and storage. The wooden example seen in color

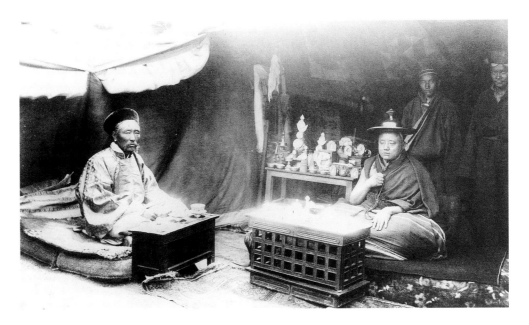

Fig. 5
The Abbot of Tashilunpo and a government official meeting Col. Younghusband at Khampa Dzong, southern Tibet, 1903. John Claude White photo, Gift of Frank and Lisina Hoch, 1997 97.9

Fig. 6 The Abbot of Litang monastery (seated), with the Abbot of Batang monastery at center left, with attendants, Kham, Eastern Tibet, 1915.

pl. 74 is constructed of a flat top and three solid upright panels which are connected by pegs and holes to allow folding. The brightly-colored decoration features a "Face of Glory" spitting a jewel and clutching lotus flowers on the front upright and trefoil motifs on the two sides. The top has a central "whirling emblem". Gold accents are painted over gesso relief areas.

A special table is used by lamas when reading from the loose-leaf scriptures (see color pl. 66). These reading stands, also low-set to accommodate the height of a monk seated on a cushion, have an upright back section and, often, front extensions to allow comfortable turning and reading of successive pages.[5] The charmingly painted example seen in color pl. 75 is like a small throne with a scalloped top edge and "jewel" finials on upright posts. Three panels on the lower front open to reveal storage areas (not for books, which are appropriately kept in niches on the upper levels of the altar or library room). The painted design features peony flowers on the front and sides and a fanciful landscape of snow-capped hills and clouds on the scalloped back panel.

The altar cloth in color pl. 76 would have been used on a wide offering table as its size is too large for a lama's personal table. This cloth is sewn from many small squares and rectangles of fine silk twills, plain weaves, brocades and lampas weaves which are similar to larger pieces of fabric excavated in Mongolia and found in Tibet, all of thirteenth century date.[6] The central square of the Museum's cloth is formed of two lengths of golden lotus rondels in silk twill with supplementary wefts, in the deep gold favored for Tibetan Buddhist garments and ritual textiles. The surrounding patches are smaller rectangles and squares or even narrow slivers of fabric with no apparent sequence to the place-

ment of pattern or color. Two are in a dark red silk lampas weave with gilded wrapped thread forming a medallion pattern. Nineteen patches are woven in silk twill with brocaded patterns formed of gold on paper strips: nine (one pieced together) are red, with dragons and pearls amidst clouds; six (one with many small panels) are brown with deer amidst flowers; and four are a bright blue with dragons among flowers (these patches have been sewn together with no regard for the proper "reading" of the pattern). Four squares are a white silk twill with supplementary weft pattern of cranes and peonies. The brown silk border is decorated (except for losses on two corners) with white silk needle-loop embroidery in a triangle pattern. This very simple needle-looping appears to pre-date the elaborate patterned work known on Buddhist textiles of the fourteenth to fifteenth centuries.[7]

The old stains on the Museum's altar cloth confirm its use under butter lamps and ritual offerings, etc. The individual silks were probably recycled from garments and hangings but the use of an early form of needle-looping indicates that the patchwork was completed by the thirteenth or early fourteenth centuries, probably in Central Asia, for a Tibetan patron.

A small shrine (ga'u) might serve as a container for a lama's personal religious images, relics and sacred objects. The unusual painted wood shrine in color pl. 77 has metal-hinged doors on the front which would allow viewing images, etc. when placed on a table or cabinet. It is small enough to be easily portable, with two metal loops on the sides to secure a carrying strap, mimicking those on metal ga'u (see color pl. 62). The two doors each have a beautiful gold peony in a lobed cartouche at the center and a narrow gold band bordering the edges. The decoration can be compared to Chinese red and gold lacquer of the thirteenth to fifteenth centuries and this may be an early Tibetan adaptation in painted wood. (Compare the cup holder, color pl. 60.)

Fine utensils would be used to serve lamas and guests with tea and other refreshments during ceremonies and audiences. The large teapot seen in color pl. 78 has replicated the robust form of the ordinary Tibetan vessel (compare color pl. 22) in precious silver. The dragon handle and makara spout symbolize the life-giving power of water and the lotus finial is an emblem of purity. Around the narrowest section of the neck are auspicious emblems amidst leaf scrolls.

The elegant bowl and stand in color pl. 79 were brought from Batang, Eastern Tibet by Dr. Shelton. Although they fit together perfectly, the jade bowl is from the "Prince" of Batang (see p. 14) and the repoussé and openwork silver stand is from the Batang Monastery. Such bowls on raised stands are used for ceremonial rice or small fruits, placed on the low table before a lama (see fig. 6). The decoration on the stand features a bulbous lotus flower on which the jade cup sits, and conventionalized lotus-petal lower base. The eight "petals" which fan out from the flower each contain one of the Eight Buddhist Emblems. Similar eight-petal silver cup stands are known from fourteenth-century China. The Museum's example is difficult to date but it certainly follows ancient Buddhist liturgical traditions.

Of similar antiquity is the form of the libation ewer in color pl. 80. This silver piece was originally from the Batang Monastery. The pear-shaped six-sided body curves in and up to a rectangular mouth and domed lid. Vessels of this

5 Anninos, "Painted Tibetan Furniture", *Arts of Asia*, Jan.–Feb. 1997, p. 48.

6 Watt and Wardwell, *When Silk Was Gold*, pp. 107–63.

7 *Ibid.*, p. 182.

type were called "heron jugs" (from the slender spout and distinctive curved and angled handle) in China when they were first seen in imported Persian ewers of the thirteenth and fourteenth centuries. As on the teapot, color pl. 78, there is a *makara* at the base of the spout and a dragon on the angled end of the handle. Chinese motifs can be seen in the raised medallion, enclosing paired conventionalized dragons, on the two sides and the embossed fungus on the curving lower end of the handle. Delicate incised lines over the surface of the ewer depict cranes (lid), pomegranates and other auspicious symbols (neck) and horses and waves (base). A thin gold wash enhances the high relief areas.

Objects of Religious Authority

Lamas who have administrative duties within the monastery or who serve as religious officials in the Tibetan central government wear special garments or appear with symbols of their office during appropriate ceremonies. When not in use, these garments and objects are carefully stored and preserved. This explains the extraordinarily fine condition of many of the pieces, even after centuries.

One of the most beautiful and historically significant objects which Dr. Shelton brought to The Newark Museum is the silver Wheel of the Law, color pl. 81. The wheel is a complex symbol in Buddhist Asia, recalling the sun with its halo of flames, the setting of the Law of Buddhism in motion and, in Tibet, Burma and Thailand, serving as an emblem of sovereignty. Images and portraits of the Dalai Lamas often show them with a Wheel of the Law. This particular wheel is believed to have been the symbol of office of the 6th Panchen Lama (died 1780), smuggled to Kham during the Nepalese invasions of southern Tibet (including Shigatse and the seat of the Panchen Lama, Tashilhunpo) in 1791–2. It was in the possession of the Jö Lama in Batang.[8] Silver repoussé forms the two identical sides of the sixteen-spoke wheel which are pegged together around a central core, the composition of which is unknown. The weight of the wheel and its contents have caused the lotus-petal base to collapse in on itself but this auspicious emblem is otherwise in good condition, despite its dramatic history.

Official documents on golden satin were used to affirm the authority of religious leaders as well as lay officials (see color pl. 48). The edict in color pl. 82 was issued by an important Tibetan Buddhist lama living in Beijing in 1836. The lama, Yeshe Tenpe Gyaltsen (*Ye-shes bstan-pa'i rgyal-mtshan*), who was the 3rd Changkya Huktuktu (*lCang-skya qutugtu*, 1787–1846), is portrayed in the upper register. The 2nd Changkya Huktuktu had been the Tibetan Buddhist advisor to the Qianlong emperor, and had long served as an intermediary between China and Tibet. The 3rd Changkya continued to live in Beijing as adviser to the Daoguang emperor (reigned 1821–50). In this decree, written in *bam-yig* script on yellow satin bordered in blue, the 3rd Changkya refers to the 2nd Changkya's missive congratulating the Pende-ling (*Phan-bde-gling*) monastery in Batang on its excellent teachers and high level of Buddhist studies. Here he declares that this monastery is still most praiseworthy, exhorts the monks to continue their efforts and urges the lay populace to actively support the monastery. There is a small, round personal seal affixed after the lama's

8 Olson, *Tibetan Collection*, vol. II, pp. 30–2.

name, while a square, official seal is used at the conclusion of the decree. The square seal is positioned in the center of a lotus pedestal carried on the back of a Tibetan snow lion, a mythical creature often used as the emblem of Tibet.

The lama is shown seated with legs pendant on a Chinese throne draped with silk scarves, a common Tibetan sign of homage and religious honor. The Changkya lamas are incarnations of the Tibetan Gelugpa monastic order, usually recognizable by their yellow hats. Here the lama is dressed, not in typical monastic apparel, but in Chinese official robes and a pointed hat. The long rosary and the vase of holy water held in his lap indicate the lama's religious role. In portraits of lamas of the Changkya lineage the vase of water is the characteristic attribute.

In the lower register, Lhamo, the guardian goddess of Tibet, is portrayed on her mule inside flames above the waves of a sea of blood. Immediately below the snow lion, Yama and Yami tread on a bull and a prostrate body. Yama is regarded as the lord of the hells. In the lower right corner is a wrathful, three-eyed warrior, wearing armor and an elaborate helmet decorated with triangular flags, small peacock feathers and skulls. Mounted on a black horse, he rides in the midst of a cloud of red flames, wielding a club and a lasso, and a long, pointed lance with a triangular banner. This warrior may be Begtse, since Yama, Begtse and Lhamo belong to a group of protectors venerated by the Gelugpa order.

Offerings of incense are an important aspect of all Buddhist rituals. Both laymen and monks burn incense (fragrant woods, such as juniper, pulverized and mixed with musk and clay) at domestic and monastic altars. Fine ceremonial incense containers would be among the special objects held by the "offering servants" (mchod-g.yog) of high lamas in rituals. A handsome pair of silver censers from the Batang monastery were offered by two monk officials (gekö) (color pl. 83 shows one of the pair). They can rest on their wide-spreading bases or be suspended from their long silver chains (in place or in a procession). The bulbous bowls, which would have held sand as a bed for the smoldering incense sticks, are plain. The open-work domed tops, through which the fragrant vapors floated, have a complex decorative scheme of interlacing vines and two dragons clutching jewels, a lotus flower top and bud finial. Three chains connect from the body to an umbrella-like canopy with repoussé designs of lotus petals and the Eight Buddhist Emblems and dangling petal ornaments. From each of the canopies, a single chain of one-foot length ends in a hook. An inscription incised into the base of each censer gives the amount of silver used, the date, wood-hog and fire-ox years respectively, and names of the "proctor lama" (ge-kö) donors.

When traveling, monastic officials and monks in the central government wore a special over-robe and a distinctive stiff hat (see fig. 5). The Museum's robe, color pl. 84, was worn by the Abbot of Ngor monastery in southern Tibet in the nineteenth century. It is made of handsome golden Chinese brocade of phoenix and dragon medallions and the Eight Buddhist Emblems. The cut of the coat has a center opening and upright collar. The front is closed with (invisible) red silk ties at the chest. The coat is worn without a waist sash to allow the wide vents to spread out over the rider's mount.

The stiff papier-mâché hat has a wide flat brim and center dome with a distinctive pyramid finial. The low-relief decoration features dragons, lotus

flowers, *shou* and "All Powerful Ten" and the three jewels. The surface has been gilded and coated with a lacquer-like finish.

The single most important garment in the Museum's collection is a magnificent ceremonial cape (*sKu-ber*) in color pl. 85. It was made for Tatsa (*Rta-Tshags*) Rimpoche II, Regent of Tibet from 1875–86, who ruled the country after the death in 1875 of the 12th Dalai Lama and during the minority of the 13th Dalai Lama (1876–1933). This type of cape was worn only when a Regent, Dalai Lama, Panchen Lama or Karmapa Lama was seated on the throne of office, so that the voluminous gathered circumference flowed from the shoulders to the throne surface. The front panels of contrasting cloth, outlined in fur and jewels, and the gem medallions on crossed cords are all characteristic of the cape. This example is constructed of eighteenth-century imperial Chinese brocade, cut so that the two dragons are centered on the shoulders. This Chinese brocade was probably kept in the Kundeling monastery, Lhasa, and used for the robe (and matching throne cover, kept in place when the throne was not in use) when that monastery supplied Tatsa Rimpoche II (Choskyi Gyaltsen Kundeling) as Regent in 1875. The brocade is typical of Chinese imperial curtain material in scale and design. As was customary in Tibet, the silk has been completely (except for the gold metallic and peacock feather thread areas) overpainted in vivid hues; for example, the originally paler yellow ground has been intensified by pigment to the present deep gold. The front panel is Russian gold brocade with freshwater pearls and coral strands as edging, bordered by sable fur. The nine gold medallions are set with turquoise and pearls. A very similar robe can be seen placed over the shoulders of the five-year-old 14th Dalai Lama when he was first enthroned at Lhasa on February 22–23, 1940 (color pl. 3).

Monastic Music and Dance

On the great festivals of the yearly cycle (the New Year, saints' days, harvests, etc.), ceremonies involving chanting, music, dancing and presentation of special ritual objects are performed by the congregation of monks. These performances take place in monastery courtyards or in an open space large enough to accommodate assemblies. These occasions are an opportunity for laymen to witness and gain merit from public forms of spiritual activity. Giant paintings, appliqués (see Chapter V, fig. 4), and images can be viewed and circumambulated at this time. Scriptures are recited and ritual dances presented. The power and magnificence of the Buddhist faith, and the hierarchy which explains and preserves that faith, are thus made manifest, renewing and reinforcing the daily devotions of laypersons.

Ritual music in Tibet is a powerful element in all ceremonies and an important aid to spiritual pursuits whether public or for cloistered or individual rituals. The instruments which create the music provide background and punctuation to the basic sounds of chanting. Though restricted to drums, wind instruments and cymbals, the temple orchestras achieve complex rhythms and tones through the varied sizes and shapes of the instruments. Drums range from large double-headed wood and leather instruments beaten with a stick to small drums (*damaru, gcod-dar*) shaken rapidly so that attached clappers hit each

This very different form makes it impossible to claim that this apparent Greek influence reached Indian Buddhism by way of Gandhara. This leaves us still in the dark about a particular route of transmission that would explain the similarities.

What led the revealers of the Buddhist *Tantras* to name their method Vajrayana? We would suggest that the reasons are to be found in polarity symbolism developed already in the *Sutras*. For example, the *Eight Thousand Transcendent Insight Sutra*, often dated by scholars to the first century C.E., repeats hundreds of times the phrase "transcendent insight and skillful method", as the two things most necessary for progressing toward Enlightenment. Furthermore, there are at least a dozen places in the same scripture where transcendent insight is called the Mother[15] of Buddhas and Bodhisattvas, since it is she who gives birth to them. Although we find in the text no corresponding statement that skillful method is the Father, this would certainly be a logical step to take.

Also, in the *Eight Thousand Transcendent Insight Sutra*, the "Vajra Wielder" (Vajrapani) makes a brief but perhaps for our purposes significant appearance:

> Furthermore, oh Subhuti, those Great Heroic Minded Bodhisattvas
> who do not turn back will always be followed by the great *yaksha* Vajra
> Wielder, who is difficult to overcome, and humans and non-humans
> will not be able to get the better [of them].[16]

Here the Vajra Wielder has a clearly protective function for Bodhisattvas of the highest levels, and, in Buddhist art from Gandhara dating from the first centuries C.E., it is common to see the Buddha depicted with an accompanying figure holding a (Gandharan-type) *vajra* in his right hand. Vajra Wielder has often been viewed as the prototype of all the many later wrathful forms of Buddha known to the *Tantras*.

In the *Vimalakirti Sutra*, for example, the *vajra* is a simile for the firmness of a resolution, for the solidity of the Tathagata's form, and for the highly penetrating power of the Full Knowledge of the Buddha. In commentarial literature, and most notably in the *Abhisamayalamkara*, attributed to Maitreyanatha, teacher of Asanga, the Vajra-like Contemplative Concentration is the one associated with the very highest level of the Bodhisattva's Path, which is there called the Stage of No More Learning. Since it is at least consistent with Vajrayana's general practice of "taking the goal as the basis", this *vajra*-like *Samadhi* may help explain why it was that the *Tantras* took the *vajra* as their most important symbol. For them it was the goal that forms the very basis of the Buddhist Path.

In some *Tantra* texts, such as the *Secret Meeting* (*Guhyasamaja*) *Tantra*, the word *vajra* occurs on almost every line. Particularly in the opening chapters of the *Secret Meeting Tantra*, *vajra* is frequently used to qualify the thought of Enlightenment (*Bodhicitta*); the Buddha's body, speech and mind; but also the divinized sense faculties and elements, which are called such things as Vajra Seeing, Vajra Tasting, Vajra Earth, Vajra Water, Vajra Space, and identified with specific Buddhas and Bodhisattvas.

There is a very interesting twelfth-century Tibetan work by Grags-pa-rgyal-mtshan, with explanations of the symbolism of the parts of the *vajra*. Grags-pa-rgyal-mtshan suggests that the proportions should be (as they seem to be in actual practice) in three equal parts—the two pronged ends and the

15 We find significance in the fact that the Tibetan text of the *Sutra* uses the honorific word for "mother", *yum*, in this context. As is well known, the Vajrayana portraits of deities in sexual embrace are called "father-mother" or "parental" (*yab-yum*) figures, most frequently interpreted as symbolic of the union of Insight and Method.

16 Snellgrove, *Indo-Tibetan Buddhism*, pp. 60, 134–141.

17 Grags-pa-rgyal-mtshan, *Rdo-rje Dril-bu dang Bgrang-preng-gi De-kho-na-nyid*, in *Sa-skya-pa'i Bka'-'bum*, Toyo Bunko (Tokyo 1968), vol. 3, pp. 271–2–4 through 272–3–6.

The *Vajra* and Bell

By Dan Martin

9 Richardson, *Ceremonies*, pp. 116–23.
10 Nebesky-Walkowitz, *Tibetan Religious Dances*, pp. 26–30.
11 See p. 39 and Nebesky-Walkowitz, *op. cit.*, pp. 1–2.
12 All the Tibetan sects accept *Tantra* in its Buddhist form, even while simultaneously continuing to revere and practice pre-*tantric* forms of Buddhism. This distinguishes Tibet from other "Northern" Buddhist countries such as China and Japan where *tantric* texts, rituals and ideas tended to be made the exclusive preserve of distinctively *tantric* schools.
13 In order to refer without ambiguity to diamond as a mineral substance, Tibetans use the word *pha-lam* or, very often, *rdo-rje-pha-lam*.
14 In the Iranian *Avesta*, the *vazra* is a weapon used by the god Mithra. It is worth noting that earlier representations of Indra in India do not bear anything that might correspond to the *vajra*. These seem to make their appearance in about the tenth to thirteenth centuries, and in a form quite similar to Indian Buddhist and Tibetan *vajras*. In other words, Indian Buddhist representations of pronged *vajras* seem to occur before Hindu representations of Indra with a *vajra*.

The *vajra*, together with its counterpart the bell (see color pl. 90) is, of all the various symbolic implements used in Tibetan Buddhist ritual and iconography, the most significant from several perspectives. It is precisely its pervasiveness/ubiquity within the tradition of *tantric* Buddhism,[12] which is most frequently identified by the name Vajrayana, "the Vehicle of the *Vajra*", that makes its meaning so difficult or impossible to pin down with any illusions of simplicity.

It is usual to understand the *vajra* to mean originally a thunderbolt, while Tibetan Buddhists understand it to mean "adamant" or "diamond". The Tibetan *vajra* is *dorje* (*rdo-rje*), which might be etymologically analyzed as "Stone" (*rdo*) "Lord" (*rje*), an epithet for the diamond, the Lord of Stones.[13] The symbolic significances of Indra's weapon (which may or may not be precisely a thunderbolt) and of the diamond are united by the qualities of hardness and durability.

It is certain that the first mention of something called a "*vajra*" appears, very approximately four thousand years ago, in the *Rg Veda* as a hand-held weapon of the god Indra.[14] Even if common, the statement that this Vedic *vajra* is a thunderbolt is controversial. Its identity as a thunderbolt may be at least in part a product of nineteenth-century comparativists who preferred to find natural (and therefore universal) phenomena behind mythological items. Most twentieth-century Indologists see Indra's *vajra* as a metal-headed instrument along the lines of a hammer, axe or club. It is interesting that there are passages in the *Rg Veda* which describe the *vajra*-weapon as "stable" and "durable", since these words could equally apply to the Tibetan understanding of the *vajra* as a diamond.

Other types of instrument are, unlike the Vedic weapon, not meant to be held by an attached handle. Rather, they are "scepters" in form, relatively small at the center where they are almost always held, and with each of the two ends being mirror images of the other. This type of *vajra* is found, with minor variations, in all the "Northern" Buddhist countries as well as in medieval Indian art. It is most probable that the form of this Buddhist and Indian *vajra* had its transmission from Greece by way of the Middle East, perhaps as early as the Hellenistic period. The medieval Indian, Tibetan and Central Asian *vajra* is strikingly similar to the *keraunos* held by Zeus in Greek mythology and art. Behind the shape of the *keraunos* may be still earlier Middle Eastern representations of lightning held in the hands of depicted deities.

The main problem that confronts us is how to account for the transmission from Greece to India and beyond. The logical time and place for us to look is the Gandharan art of the early centuries C.E. It was in Gandhara, in the area of modern northern Pakistan, that Buddha images were produced under strong Greek artistic influences. The *vajra* does exist in Gandharan Buddhist art, but in a form that does not very closely resemble either the *keraunos* or the Indian and Tibetan *vajra*. The Gandharan *vajra* looks like a plain, solid squared beam about the length of a forearm, only attenuating at the center where it is held.

certain set times of the year. In Lhasa, the ritual dances are a major component of the year-end ceremonies, *Tse Gutor* on the 29th day of the last month (February in the Western calendar).[9] *Cham* is crucial at this time to focus the ill deeds of the old year into a human effigy (*linga*) which is dismembered or burnt at the end of the ritual.

The *cham* costume in color pl. 88 is reportedly from Nechung, the monastery of the State Oracle, located just northwest of Lhasa. Several special ritual dances were traditionally performed at Nechung either on a yearly or twelve-year cyle to accompany trance states by the Oracle.[10] The Museum's example consists of a robe cut with the striped "sorcerers" sleeves and deep side pleats of all *cham* costumes. The black satin color may indicate that this was worn by the "Black Hat" dancers. The disembodied eyes sewn onto the robe are like the red-rimmed eyes of the wrathful face on the apron, which has gold *dorjes*, skulls and heads on its borders. Four "monster" faces in bold appliqué form the collar worn over the gown. The costume is worn with an ornate version of the upturned-toe monk's boots.

The hat in color pl. 89 would have been worn by a monk portraying one of the "Black Hat" dancers. Although it has earlier shamanic symbolism, the dance commemorates the slaying of King Lang Darma, the notorious persecutor of Buddhism, by the lama Paldorje at the end of the ninth century.[11] Paldorje, assuming the guise of a "Black Hat" magician, attracted so much attention that he was summoned to perform before the king. In the sleeve of his robe he had concealed a bow and arrow with which at the first opportunity he shot and killed Lang Darma. This hat was obtained by Berthold Laufer in Beijing in 1903. It was part of a group made for use at the great Buddhist temple there, the Yonghe Gong.

Fig. 8
The start of a *cham* performance
at the Batang monastery,
Kham, Eastern Tibet, 1915.

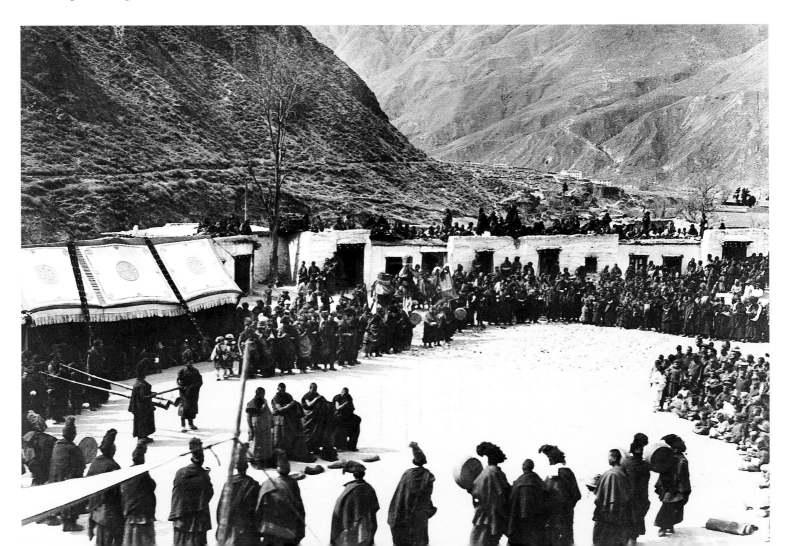

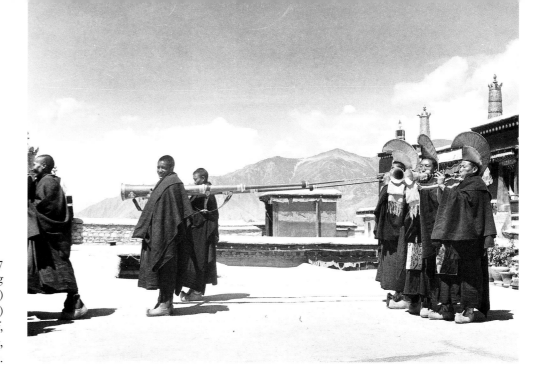

of the double heads. Trumpets and oboes, always in pairs (fig. 7), are especially numerous and varied. In Tibetan trumpets (*dung*), the sound is manipulated solely by the player's lips vibrating against the mouthpiece and the force of the blowing. The oboes (*gyaling*, *rgya-gling*) have finger and thumb holes. Large cymbals are struck together on their edges or clanged together with great force to create delicate or clamorous sounds, depending on the music.

As in all Tibetan ritual objects, the physical structure of the temple instruments is crucial to their ritual power. The rich use of brass, copper, silver and wood is augmented by precious stones and symbolic decoration, or by forms of special significance such as the dragon heads. Substances such as skulls, bones, horns and shells are also incorporated into instruments of particular ceremonial use (see color pl. 100).

These forms, in company with the heightened psychic state of the players and singers in the orchestras, produce a profound and unique sound which has no parallels in other Asian music, creating a mystical experience transcending the rhythm and noises of the "real" world. (See Dan Martin's essay on the meaning of sound in the context of the historical Buddha's teaching, pp. 137–139.)

The pair of silver trumpets in color pl. 86 have an elegant shape enhanced with relief and incised leaf-scroll decoration on the narrow end near the mouth and the wide bell end. The upper side of the bell opening is outlined in a scalloped border and set with turquoise and coral.

The dragon-head trumpets from the Batang monastery, color pl. 87, are formed of high-relief repoussé silver with added silver bands (for the dragon's "whiskers") over the copper base. Conventionalized patterns fill the bands behind the dragon heads and at the center and mouth ends.

Ritual dance in Tibet has its roots in early shamanic practices which mixed with imported Indian Buddhist customs. *Cham* ('*chams*, "ritual dance") has been performed in the open before a public audience by most Tibetan schools since the seventeenth century. Earlier, *cham* was reserved for non-public esoteric rituals. In the public stagings, *cham* is performed by trained monks with a full monastic orchestra, in the open courtyard (see fig. 8) or other large space, at

center being of equal length. He also recommends that there should be a bulging part (a "globe") at the center where the *vajra* is held (generally between the thumb and fingers of the right hand).[17]

Although this feature may be difficult to discern on many Tibetan *vajras*, they usually show the heads of water-monsters called *makara* (see color pl. 91) at the base of each peripheral prong. The prongs themselves may be seen to be made up of a *makara* head and its protruding "tongue". The *makara* seems to be a composite of several different aquatic and semi-aquatic creatures, and descriptions as well as representations sometimes suggest crocodiles, dolphins or other fish, or even the octopus or squid, as well as semi-aquatic creatures such as the elephant (since it often appears in art with something like an elephant's trunk). It lurks beneath the water among the lotus stems, and a lotus stem is sometimes depicted coming out of its mouth. It is the ruler of the depths of the ocean, that vast and dangerous realm which seems to us so chaotic, or at least subject to totally different norms, but nevertheless may be a source of great riches—so much so that one common epithet of the ocean is "jewel source". The *makara*, as a composite creature, embodies all the dangerousness and strangeness, as well as the potentialities, of that other world beneath the water's surface. It represents not only all-consuming passions, but also radical transformation (by way of a process of "digestion"), a symbolism that is evident also in the Face of Glory (see color pl. 69), but becomes especially clear in the case of *phurpa* symbolism (see pp. 140–143).

The prongs of the *vajra*, as in the iconography of the Buddhas they represent, rest on a "lunar seat", and the lunar seat is further supported by an eight-petalled lotus. While the lotus is generally a symbol of purity (especially purity of conception and birth), here Grags-pa-rgyal-mtshan identifies each petal with one of the eight Bodhisattva disciples of the Buddha, or with one of a set of eight goddesses. The rounded bulge at the nave of the *vajra* symbolizes the Dharma Realm (*Dharmadha*) in its utter simplicity, completely self-contained. Each of the two sides of the nave is ornamented, says Grags-pa-rgyal-mtshan, with a string of pearls symbolizing the dawning as play-acting—or ornamentation—of all of the vicious circle including its transcendence in *nirvana*.

Each prong symbolizes a male or female Buddha. The five-pronged *vajra* is predominantly a symbol of Full Knowledge, since the "upper" set of five prongs symbolizes the five families of Buddhas (as found in many mandalas) and the five Full Knowledges which they embody. The "lower" set of five prongs symbolizes the immaculate five "mothers", also belonging to the five Buddha families.

The Everything *vajra* is sometimes called the Crossed *vajra* since it has four sets of prongs arrayed in the four compass directions.

To reiterate, the *vajra*—in both its name and symbolic, mythological associations—originated in India where in very ancient times it was the weapon of Indra. Still, it is most likely that the *form* of the *vajra* known to Tibetans (and other Buddhist countries) came to India, perhaps somewhere in the third to fifth centuries, in a form known to the Greeks as the *keraunos*, weapon of Zeus. In the earlier Buddhist art of Gandhara the *vajra* was portrayed, but in a quite different form. The *vajra* as a whole may be described as a symbol of indestructibility, stability and firmness. By extension it became for Buddhists a symbol of particular things characterized as adamantine: the resolution to obtain

Fig. 9
Monks making a sand or powder mandala, Drepung monastery, Lhasa, central Tibet, 1937.

Enlightenment (usually called the Thought of Enlightenment), Full Knowledge, and the Buddha's body, speech and especially His mind. Those particular meanings, which were known and employed in the Buddhist *Tantras*, all seem to have found direct inspiration in Mahayana *Sutras*.

The *vajra*, in the form of the four-ended Everything *vajra*, plays a role in accounts of cosmogonical developments. This is the reason why the Everything *vajra* is visible as the "ground" for the manifestation of the mandala (see fig. 9).

The use of the *vajra* for protection, especially with the early protective role of Vajra Wielder, is quite pronounced in ritual contexts, without in the least excluding or replacing all the usages we have discussed so far. The contemplative visualization of a *vajra* wall is essential to the inner work of the *tantric* practitioner, since this wall (in effect an encompassing three-dimensional sphere), entirely made up of *vajras*, protects the mind (as does the *mantra* repetition known as Vajra Recitation) from distracting or delusive invasions that might otherwise disturb the meditative practice.

Other ritual and visualizational uses of *vajras* are too numerous to mention individually. During most monastic rituals, the *vajra* and bell are held in the right and left hands while making various ritual gestures, symbolic of the interplay and union of method and insight, the two parents who give birth to Buddhas, as well as the yogic dissolving of the energies of the right and left psychic channels into the central channel. Some ritual sequences are directly devoted to the *vajra* and bell, such as the "Vajra and Bell Blessing" which often forms a part of the preliminaries of a number of rituals such as the Fire Ritual (*Homa*). Another such ritual is Vajra Master Initiation, in which the initiate is presented with a *vajra* and bell as a symbol of the capability to preside at *tantric* rituals. Still another specific usage is in consecrations and in the blessing of sacramental medicines. In these contexts, a relatively small, approximately hand-width sized *vajra* is kept tied to one end of a *Dharani* Thread which acts as a kind of ritual "power line" to conduct the meditation-generated force from the ritual master to the item(s) being consecrated. In short, the *vajra* and bell, presented to the *tantric* practitioner through a ritual initiation, remain for them the most essential implements, and will be kept on the altar of everyone who is engaged in *tantra*. Now we will turn to the bell.

Just after the Buddha Shakyamuni attained enlightenment on the Vajra Seat (*Vajrasana*) beneath the Awakening Tree, He was hesitant to speak since He was sure that He would not be understood. The gods Brahma, famous for his melodious speech, and Indra, famous for his power, came to convince Him that it would be worth the effort to begin teaching His insights in the form of the *Dharma*. The wheel is one common symbol of the *Dharma*, since the Buddha is said to have "set the Wheel of the Dharma in motion". As a symbol of the same thing, Indra presented to the Enlightened One a conch-shell. The *Sutras*, when they describe the Buddha's first acts of teaching, prefer sound metaphors that emphasize the pealing or booming quality; sounds that are clearly identifiable and smooth and carry for a long distance. Such metaphors as the conch (color pl. 92), the large drum, Melodious Brahma Voice, the cymbal, the Lion's Roar and the cry of the Kalapinka Bird are common in many *Sutras*.[18] These sounds are unified by their startling quality, communicating not only the Buddha Speech as a kind of "wakeup call" to greater awareness, but also the revolutionary nature of His revelation which, in His time, seemed to be coming right out of the blue.

The bell as such (*ghanta* in Sanskrit and *dril-bu* in Tibetan) is not listed among these metaphors of *Dharma* in the Mahayana *Sutras* we have consulted. It appears rather as a meritorious offering which then became a permanent fixture of the Buddhist reliquaries called *stupas*. Bells, and probably rather small ones, equipped with cloth hangings on their clappers causing them to ring when the wind blew were evidently hung in strings attached to *stupas*. Even without being explicity identified with the *Dharmas* (scriptural or phenomenal) in the Mahayana scriptures as far as we know at present, the brief explanations of the symbolisms of the bell in its entirety and in its parts all identify the bell as the *Transcendent Insight Sutra* and the Voidness of all phenomena, which is the main message of that *Sutra*. The head of Transcendent Insight even looks out at us from the center of bell's handle (see color pl. 90).

Grags-pa-rgyal-mtshan says on the symbolism of the bell in its entirety: "Its empty interior means Voidness, the main point of the Transcendent Insight [*Sutra*]. The center [of the bell] is the reality of Full Knowledge of awareness. Its sound indicates Voidness."[19]

Following Grags-pa-rgyal-mtshan's brief explanations of the individual parts of the bell, we start with the handle. The handle is composed of (in descending order) a half-*vajra*, a lotus (or crown?), a face, and a "vase of plenty". Grags-pa-rgyal-mtshan says of it: "As for the *vajra*, its use as a decorative covering is a symbol of Insight being ornamented by Method". Like the prongs of the complete *vajra*, the prongs of the half-*vajra* are also supposed to be supported by a lunar disk and a lotus, although the lotus is not always clearly distinguishable in every example, often looking more like a crown for the face below. The face is one element which is clearly present in nearly every example of the Tibetan bell (if they have any designs on them at all), and in every explanation known to us this face is identified as the face of Insight or Transcendent Insight, sometimes simply as the Mother (*Yum*), while some authorities call it the face of *Dharma* (which is, given our earlier discussion, entirely apt, even if not directly supported in our particular Tibetan-language sources). Here is Grags-pa-rgyal-mtshan's explanation of the face: "Above [the vase] is a face of

18 For examples of all of these, see the life of the Buddha as told in the *Lalitavistara Sutra*, Chapter 26, "Turning the Wheel of the Dharma".

19 Grags-pa-rgyal-mtshan, *op. cit.* and also Mireille Helffer, "A Typology of the Tibetan Bell", *Soundings in Tibetan Civilization* (eds. Aziz and Kapstein), New Delhi, 1985.

Transcendent Insight which indicates *Dharma* Body [and] Voidness." Beneath the face is a vase or pot, which Grags-pa-rgyal-mtshan calls "an elixir pot, as a symbol of the origination [or emergence] of all [magical or spiritual] attainments". The attainments or *siddhis* may be magical powers or the "supreme *siddhi*" of Complete Enlightenment. Elixir often stands as a metaphor for the *siddhis*. The pot is generally a symbol of wealth, but to follow Grags-pa-rgyal-mtshan, we would have to say that when it occurs on the handle of the bell, it must refer to a wealth of attainment rather than secular riches. The vase is not always clearly distinguishable on every bell. Like the *makara* faces on the *vajra*'s prongs, the vase has often become artistically distorted or reinterpreted to the point that it is no longer recognizable as such. Sometimes it is simply absent.

Proceeding down from the handle to the lower part of the bell which is the bell proper, we will divide it into two main parts: [1] the "dome" at the top of the bell encircling the point where the handle is attached (Tibetan texts on occasion refer to this part as the "shoulder") and [2] the "slope", or the external surface of the bell, which slopes down from the "dome" to the "lip". The surface of the dome is always decorated with an eight-petalled lotus flower design. Within each of the eight petals is a "seed syllable", a Sanskrit letter represented in Tibetan transcription, each letter with a circle above it representing the Sanskrit *anusvara* (shown in English transcriptions as "m" and usually pronounced as "ng"). The tops of the letters are pointing outward, away from the point where the handle is attached. These eight syllables are the "seeds" of eight female Buddhas, which might be used as a basis for fully generating their forms in contemplative visualizations.

Moving down to the slope of the bell, we find first a circular band of horizontal *vajras*. At the bottom of the slope, close to the "lip", is another circular band of *vajras* that stand vertically. These are protective circles, called "*vajra* walls" (or sometimes, "rosaries") in the Tibetan texts. Between these two bands is the greater portion of the surface area of the slope, and it is here that we find interesting differences in the designs which allow us to categorize various types of bell. The most common type of bell has eight different symbols depicted around the central part of the slope. These eight symbols include the emblems of the five Buddha families, although the symbols are not always distinct enough to identify them with certainty, and there appears to be a certain amount of variation.

Each of the emblems on the slope of the bell is often placed within a "niche" formed by a monster-head, which is known to us by its Sanskrit name *Kirtimuka*, "Face of Glory" (see color pl. 69), with pearl strings pouring out from its mouth. The Face of Glory most frequently appears at the tops of archways over entrances to temples and shrines. Its symbolic significance is not clarified in Tibetan texts, but its use in the design of the bell probably has to do with protecting the entryway into the sacred space of the bell's chamber, rather like the *vajra* walls.

Vajras and bells are generally made in pairs. This is illustrated particularly by the fact that a *vajra* with five prongs must always go together with a bell having a half-*vajra* with five prongs. Likewise, a nine-pronged *vajra* goes with a bell having a nine-pronged half-*vajra*. A closed- pronged "peaceful" *vajra* goes with

a closed-pronged "peaceful" bell. A peaceful bell is distinguished not only by its closed-pronged half-*vajra*, but also by the fact that the bottom "lip" of the bell turns inward slightly "like the mouth of an ox." Wrathful bells have not only open prongs on their half-*vajras* but also a bottom "lip" that inclines outward "like the mouth of a fully grown lotus".

In our general comments about the symbolism of the *vajra* and bell, we have not emphasized those aspects of the symbolism that lend themselves to "erotic" interpretation. Insight and Method are equally symbolized by the female and male forms of Buddhas frequently shown joined in the parental (*yab-yum*) pose of sexual intercourse. It is true that in modern colloquial Tibetan as well as in the more graphically erotic passages in some of the *Tantra* texts, the *vajra* serves as a metaphor for male sex organs. However, it is the lotus, not the bell, that frequently serves as a metaphor for female sex organs. Vajrayana often appears to be a sea of symbolic waves tossing aimlessly in the wind, and this makes it all the more important to develop a sense of perspective on what might be the metaphor and what the thing metaphorized. By simply seeing the general Buddhist background of much of this symbolism, we believe that some of the problem of perspective is solved. Followers of Buddhist *Tantra* never lost their central Buddhist emphasis on the primacy of the motivation for complete Enlightenment. Finding their own methods of dealing with the fundamental Buddhist problem of human desires and aggressions, they did not shy away from using, and developing into the most extravagant symbolic forms, the sexual and militant imagery suggested to them by the Mahayana *Sutras* toward that end. [DM]

Vajras and crossed *vajras* (the four-ended Everything *vajra*) are seen "marking" many Tibetan *tantric* objects. In general, this use of the *vajra* signifies the "Adamantine Method" or marks the "place" of a *tantric* practitioner. *Vajras* can be seen as peripheral emblems on many objects in this catalogue, but on a few it is the dominant motif. The sitting carpet with a crossed *vajra* design, color pl. 93, is an example of such usage. The brilliant orange ground color reinforces the "seat" as appropriate for use in *tantric* meditation.

The finely-embroidered crossed-*vajra* design on the small altar cloth, color pl. 94, is similarly marking the "place" for *tantric* implements. The cloth would be put on an altar table or lama's low table (see color pl. 111), the implements, such as *vajra* and bell, skull cup (see color pl. 98), etc. would then go on top of the cloth.

An unusual use of the crossed *vajra* can be seen in the saddle cover, color pl. 95. The central quatrefoil is formed of the double emblem rendered in elegant scrolling bands with *yin-yang* at the middle. The rest of the cloth, sewn with beautiful Chinese silk brocades and gilt leather, is tailored to be used over a saddle, complete with cloth ties for attachment. The matching under-saddle cloth, color pl. 96 makes clear the exact ritual use of this set: to dress a living mule who is "carrying" Lhamo, the fierce protector goddess (see color pl. 119). Although the provenance of this saddle cloth and cover is unknown, the association with Lhamo seems certain. The goddess' son's flayed skin (seen twice) lies on a "sea of blood", all formed of finely appliquéd satin pieces. The skin area is padded slightly and veins painted in. On the borders are rows of grinning skulls, also padded, sprouting golden flames.

Phurpas: Pointed Compassion

By Dan Martin

The Tibetan *phurpa* cult employs the elements of an effigy which represents an enemy, while the *phurpa* itself is the sharp-pointed instrument (see color pl. 97) used to ritually assault the enemy. This basic magical import cannot be denied either as a small part of the background or as a continuing motive for some followers of the *phurpa* cult, but it is nevertheless insufficient for a general explanation, especially since we need to also take into account the use of the *phurpa* in foundation rituals where it is used to mark off the boundaries and basic orientations of a sacred area. That apparently thin line between the use of the *phurpa* as an instrument of magical assault and as an instrument for Buddhist Enlightenment is of course crucial but at the same time deeply problematic in the past as now, both within and without the tradition.[20]

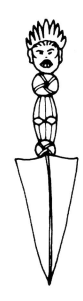

One thing that distinguishes the *phurpa* from other ritual implements which are "instrumental" within larger ritual and iconographical realms is the fact that the *phurpa* has also become the central pivot of a cult all its own. It is capable of standing alone as an object of worship, as an "image". It very often incorporates within its design a divine image, with a certain range of possibility as to the deity involved. There are contexts in which the *phurpa* serves as "chosen deity", as a Buddha, with a total program of ritual and meditation—a *sadhana*—which can, independently, lead all the way to Complete Enlightenment. It is not always a simple matter to draw this line, either.

While there can no longer be any doubts, such as those expressed by some earlier writers on the subject, about the fact that the *phurpa* as such came to Tibet from India, it still remains to be clearly established whether or not the full cult of the *phurpa* as it is practiced in Tibet existed previously in India. Textual evidence for the *phurpa* or *kila* in Indian texts is abundant, but it is still curious and requires explanation that archaeology has not unearthed from Indian soil instruments closely similar to the Tibetan *phurpa*. The *phurpa* is fifth among the Eight Pronouncements (*Bka' Brgyad*), and according to Nyingmapa histories, Padmasambhava received the transmission of the *phurpa* from the Indian Prabhahastin. Modern writers speculating about the Tibetan or shamanistic origins of the *phurpa* have unknowingly expressed their opposition to the traditional historical accounts. As one of the first five of the Eight Pronouncements, *phurpa* is clearly numbered among the transworldly deities employed for the pursuit of Enlightenment (the last three of the eight Pronouncements do employ worldly deities for mundane purposes). *Phurpa* is associated with the compassionate "activities" (*'phrin-las*) of the Buddha. It will also be interesting to speculate on the Bon school's role in the historical transmission of the *phurpa*, on how certain elements of Indian epic literature might have entered into the history of the *phurpa* as told in Bon works. In terms of the five major schools of Tibet, all of them accept the *phurpa* as an instrument. The Bon and Nyingmapa schools in particular accept *phurpa* not only as an instrument but also as a "chosen deity" (i.e., a focus of high aspirations), a form of Buddha usually called in Tibetan *yidam*. This sectarian difference of opinion is rather subtle, however. Tsongkhapa tells of Indian texts which recommend that *phurpas* should be "generated" into

20 Those within the *phurpa* tradition refer to the pursuit of magical goals as the "low actions" (*smad las*) and the pursuit of the goal of enlightenment as the "upper actions" (*stod las*).

wrathful deities (but within the context of the Earth rites, which precede the construction of the mandala and the main body of the ritual), and these wrathful deities are each individually capable of serving as "chosen deities". Compare the Dorje *phurpa* deity, color pl. 118.

Perhaps the only features always found in all *phurpas* are the three-sided blade and some kind of handle. Usually the blade may be seen to emerge, just like the peripheral prongs of the *vajra*, from the mouth of the *makara* sea creature. There are usually symbolic "knots" generally occurring in pairs on the handle. Some examples have various other types of nodes in the handle, the most frequent one with a hexagonal shape. Very often there is the face or faces of a wrathful deity (see color pl. 97) at the top of the handle, which might then be crowned by a half-*vajra*. In relatively rare instances, the entire upper body of a deity may be portrayed, even with the deity's arms extended outward from the handle, and still other elements of the deity's iconography may also be present. In those cases in which both head and trunk of the deity are portrayed, the portion of the deity's body below the chest is nearly invariably replaced by the three-sided blade (see color pl. 125).

We will begin by looking at those elements that are unique to the *phurpa*, in particular the "nodes", by which we mean the octagonal nodes and the knots. The knot higher up on the handle is said to represent *nirvana* or the realm of the Buddhas, while the lower knot represents the realm of *samsara*, of the transient world of suffering.

Whatever contemplative usages and symbolic meanings the "nodes", both the octagonal node and the "binding knots", might have for Tibetan Buddhists, they do have an interesting background in India, possibly as far back as the *Vedas*. As with the *vajra*, the *kila* (the Sanskrit word translated into Tibetan as *phurpa*) too is associated with Indra. In an old cosmogonic myth, Indra wanted to make the earth, which was then floating freely on the protocosmic ocean, firmly fixed in its place. To do this, he had first to overcome resistance in the form of *vrta* ("resistance"), a sub-marine force of primordial chaos. After slaying *vrta*, Indra was able to pin down the earth (and at the same time hold up the sky) with a cosmic mountain, sometimes called "Indra's Peg" (*Indra-kila*). Buddhist sources most often refer to this cosmic mountain as Mt. Meru, and both the whole and the parts of the *phurpa* are often explicitly associated with this mountain. Indian pre-building rituals called *naga-bandha*, "binding the nagas", would re-enact this myth by using a peg (*kila*) to immobilize the subterranean forces and thus stabilize the building site. Similar rituals are still in use by Tibetan Buddhists in their "earth rites" (*sa-chog*) performed prior to constructing a temple or mandala. A peg at the center might also serve as a "compass" with which to chart the various proportions and orientations of the planned structure. When the mandala is drawn, one first places a peg at the center and then (at least symbolically) uses a loop of string to draw circles around it. Since some Indian building manuals suggest that the middle part of the *kila* should be octagonal, this may explain the octagonal "node" in the *phurpa* design.

There is a clear symbolic reason why the *phurpa* blade has three sides. A stake, one intended to stake out territory and especially one used to tether an animal, will stay more firmly anchored in the ground if it is three-sided. There

is an even better reason for this three-sidedness in the realm of symbolism. The *phurpa* is often equipped with a three-sided stand. This triangular stand may be clearly associated in Indian Buddhist symbolism with the triangular fire-pit. The Fire Ritual is a very important one for Vajrayana, used for a wide variety of purposes, frequently accompanying most rituals. If the aim is of a coercive or violent nature, the fire pit is triangular. Like the *phurpa*, the triangular fire pit is associated with "forceful" or "violent" (*drag-po*) actions. See the skull-cup triangular stand, color pl. 98.

The three-sided blade very frequently displays on each of its sides a pair of intertwined snakes or *nagas*. *Nagas* are always associated with the underground and underwater realms, and often are guardians of the wealth of those realms (as well as guardians of scriptural treasures, as in the story of Nagarjuna's revelation of the *Transcendent Insight Sutras*). We suggest that their presence on the blade of the *phurpa* is simply that they are the "powers" of the subterranean and submarine worlds, and the blade on which they are portrayed is intended to be placed beneath the ground.

Aside from the *kila* itself, one other item from Indian religious culture apparently entered into the design of the *phurpa* already in India, and this is the *yupa*, or sacrificial post. The later Vedic texts described it as having an eight-faceted shaft, and a "three-fold rope girdle wound from *kusa* grass, to which the sacrificial victim is to be tied".[21] This sacrificial post not only shared in some of the same cosmogonic associations as the *kila*, it was also said to act as a sort of conduit for the sacrifice to rise upward to the gods.

Even after the Buddhist transformation of the *yupa* and *kila* into the *vajra-kila*, there remained a clear interest in consciousness raising. The being portrayed in the "effigy" (called the *linga*, which means "mark" or "sign") is said to be "liberated" when it is ritually stabbed with the *phurpa*. This means that the enemy is not simply killed, but the consciousness is also raised up to a higher realm of existence. Generally speaking, the *phurpa* practitioners' struggle is not one against flesh and blood, but against the opponents and obstructions—whether these are conceived as belonging to the psychological sphere or spirit world is of little concern here—that prevent their complete Enlightenment. This is all part of the Vajrayanists' vow not to turn away from the darker impulses of the human soul, but rather to use their inherent power as a high-octane fuel to speed them on the Path.

Likewise, the theme of consciousness-raising is a prominent theme in the *phurpa* origin stories. The myths of genesis of the *vajra-kila* along with other wrathful forms of Buddha have a set of common elements. The general scenario is likely to open with a monstrous birth due to incest or bestiality, negative aspirations and/or the breaking of *tantric* vows. The powerfully monstrous spirit or humanoid thus engendered wreaks havoc through gross distortions of the Buddha's teachings and/or through serial killings. Such drastic evil calls for drastic counter-measures, so a peaceful form of Buddha, compelled by His or Her compassion, emanates a wrathful form equal to the task, a form often called (in the case of male forms) a Heruka, a "Blood Drinker". Radical evil calls for this kind of radical compassion, inspired to help the being who has fallen to such depths.

In bloody scenes of combat, the *tantric* stories often tell how the compassionate emanation first pierces, then penetrates and finally fully pervades the

bodily form of the monster. The monster is, significantly, often called by one of the several names and epithets of Shiva, suggesting to us that the stories might reflect a time in history when followers of Shiva and Buddha were at odds with each other. In the *phurpa* version of the story, as in several others, the opponent is called by one particular name of Shiva, and probably the original name, Rudra or "Dreadful". Perhaps needless to say by now, the "Rudras" are often identified as mental or "spirit" factors standing in the way of Enlightenment. Very often they are equated with the Maras, the quasi-spirit forces of delusion that tried to forestall the Buddha's Enlightenment. They are products of the three "poisons", the negative aspects of the ego—attachment, aversion and befuddlement—that prevent people from seeing the larger picture beyond their particular self-interested predicaments.

Like the *vajra*, the Indian and Tibetan form of the *phurpa* may owe something to influence from the ancient Middle East, where human- and (more rarely) animal-headed ritual pegs were used in temple foundations from very early times, particularly in Sumeria.

Whatever its ultimate source, the Tibetan *phurpa* as an object is certainly based on the Indian *kila*, both Buddhist and pre-Buddhist, with which it clearly shares many ritual usages. Some of the *phurpa*'s elements such as the "binding knots" and "octahedrons" connect it with the sacrificial post of Vedic-period India. Its triangularity links it to the symbolism of the triangular fire pit used for coercive ritual actions in *tantric* Buddhism. In name as well as symbolism, it harkens back to the Indian cosmogonic story of "Indra's Peg". Since we have relatively early Dunhuang textual evidence, it is highly probable that the *phurpa* was introduced into Tibet in the late eighth century by Padmasambhava. As a whole, the *phurpa* is a manifestation of wrath placed in the service of compassion, and therefore belongs to the Method side of the *tantric* polarity symbolism. [DM]

The use of ritual weapons to chop, stab, pin or dismember the "enemy" in *tantric* Buddhism is perhaps the most difficult practice for non-initiates to understand when they look at Tibetan culture. Related to these weapons and the stories of "blood combat" and transformation of opponents through "murder" (see above) are the equally disturbing (to non-initiates) use of human skull cups, human bones and cemetery imagery in Tibetan rituals.

Tibetan mortuary customs lend themselves to the availability of such objects. In a practice called "sky burial", the corpse is taken to a high, isolated place, cut up and fed to vultures.[22] Cemetery "yogis" preserve skulls and leg bones from appropriate bodies.[23] They then turn the skulls and bones into bowls, rosaries, trumpets and drums which are used in *tantric* empowerments and rituals involving the protector deities and *yidams*. When depicted in painting and sculpture, these deities are often wearing bone ornaments and/or carrying objects made of skulls and bones (see color pls. 115–126).

As with the *vajra* and *phurpa*, use of human skulls and bones can be traced back to *tantric* practices in Indian Buddhism and Hinduism of *circa* sixth century. Such practices are recorded in Tibetan texts by the twelfth century.[24] A special ritual practice in Tibet called *Chö* (*Gcod*, "cutting") requires skull cups, human thigh-bone trumpets and skull drums. *Chö* rituals take place at cemetery sites, actually the "sky-burial" places set aside for body dismemberment. *Chö*

21 Robert Mayer, "Observations on the Tibetan Phur-ba and the Indian Kila", *The Buddhist Forum*, vol. II (1988–90), Tring, 1991, p. 171.

22 This practice is also used in Zoroastrian tradition. See Martin, "On…Sky Burial", *East and West*, December 1996, pp. 353–60.

23 Andrea Loseries-Leick, "The Use of Human Skulls in Tibetan Rituals", pp. 159–73.

24 *Ibid.*, pp. 159–60.

practitioners are the only people able to handle the corpses of people who have died from contageous diseases or violence.[25]

25 Martin, *op. cit.*, pp. 365–7.

The skull bowl (Sanskrit *kapala*, Tibetan *thod pa*) in color pl. 98 has been lined on the inside with silver. The silver lid has crossed *dorjes* in relief on the dome center and a *dorje* finial. The bowl rests on a silver triangular stand decorated at the three corners with applied three-dimensional grinning skulls. Branching flames and lotus petals in low relief decorate the base, recalling the fire-pit used in "violent" action rituals (see p. 143).

Many of the fierce protectors hold a skull cup, filled with blood, brains, etc., in their proper left hand. Often this is paired with a *dorje*-handled chopper in the right, raised hand (see color pls. 115A and 125). The cast-iron chopper in color pl. 99 was probably used in rituals involving "cutting off" evil/obstructions. The Tibetan ritual chopper, as here, is in the form of a *dorje* except that the lower section is a broad curving blade. The *makara* which forms the base of each *dorje* prong here enlarges to one fang-mouthed monster from which the blade emerges.

The double skull drum (*thod-dam*) is used in *Chö* rituals and for invocations to the *yidam* and protectors. The Museum's example, color pl. 100, was obtained by Dr. Shelton in Kham. It has a fine silk banner with embroidered decorations of the Eight Buddhist Emblems.

Bone ornaments are worn by *yidam* and other fierce deities (see color pl. 120). Bone aprons, crowns and armlets are worn by *tantric* practitioners for rituals invoking these deities. The Museum's bone apron, color pl. 101, is made up of some fifteenth- to sixteenth-century plaques and later carvings, sewn to an eighteenth-century Chinese brocade with Buddhist auspicious emblems. The fierce deities carved in large bones, sewn across the top row, are: center, a *dakini* holding a skull bowl and chopper and a skull-topped staff with a Buddha in the arch above and Face of Glory, below; a similar *dakini* in a broken plaque at left and a later plaque with a poorly-carved *dakini*, center left; at right and center right are figures of Mahakala on a corpse, holding a chopper, skull and *khatvanga*, in leaf-scroll settings. The smaller diamond-shaped and oval pieces connecting the bone beads are probably all later in date. They depict dancing figures and auspicious emblems.

PLATE 64

Tibetan Buddhist altar
at The Newark Museum
Phuntsok Dorje,
artist-in-residence, 1988–90

Consecrated by the His Holiness,
14th Dalai Lama, September 23, 1990

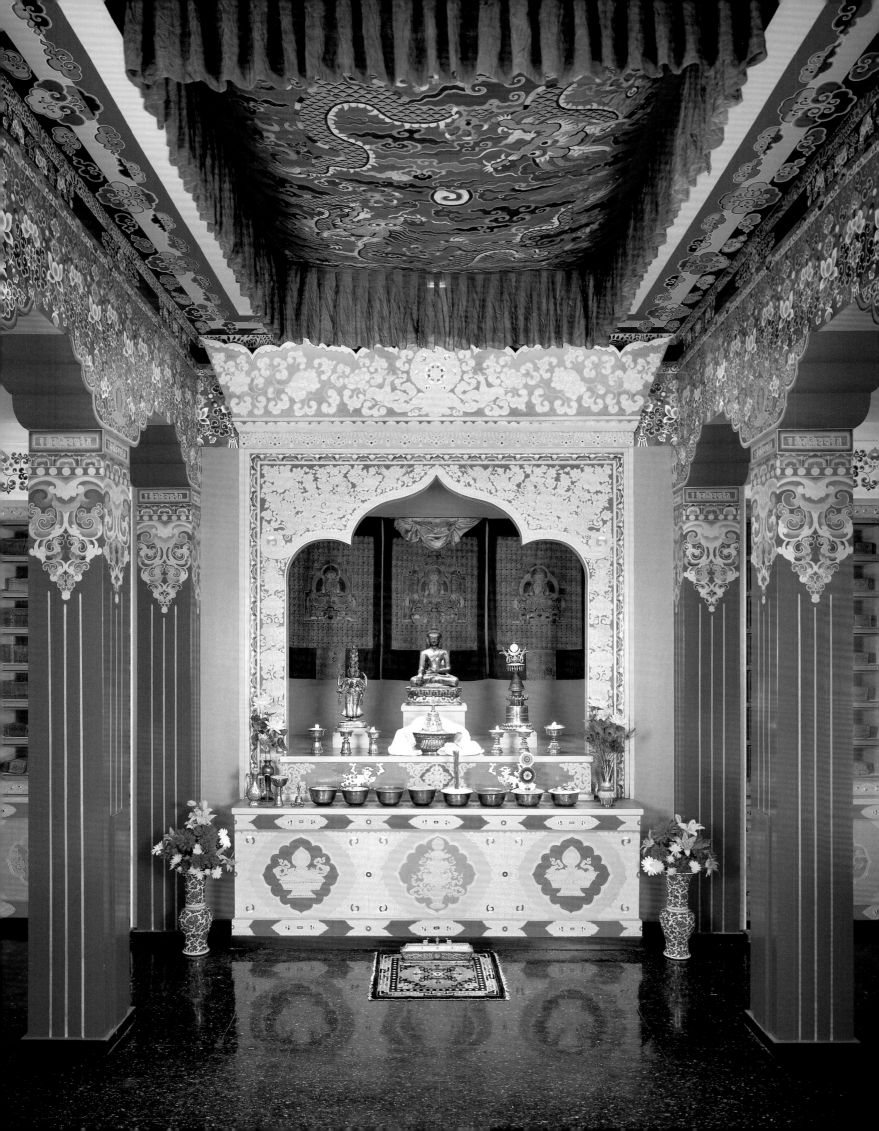

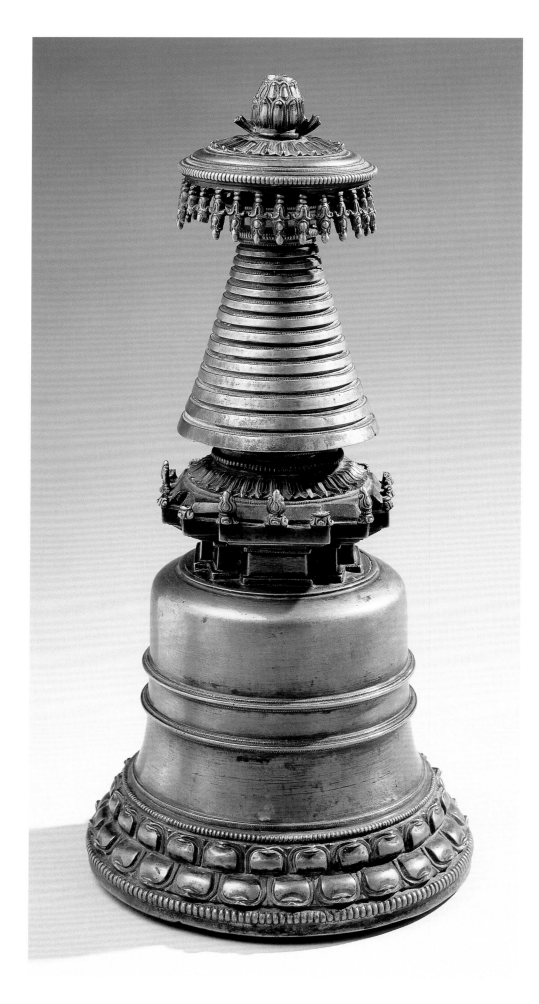

PLATE 65

Chorten

Tibet, *circa* 1230
(contents dated by Carbon-14 tests)

Brass, H. 13 ¹⁄₂ in. (34.3 cm)
Purchase 1981 W. Clark Symington
Bequest Fund 81.23

PLATE 66

Prajnaparamita

Lhasa, Tibet, *circa* 1890

346 folios of dyed paper, gold lettering,
three top folios inset with turquoise
and pearls; carved, painted and var-
nished wood covers, total H. 8 ¹⁄₂ in.,
L. 28 ¹⁄₂ in. (21.6 x 72.4 cm)
Dr. Albert L. Shelton Collection,
purchase 1920 20.495

A Lhasa noblewoman of the Lhagyri
family brought this to Batang in 1890 as
part of her dowry when she married
into the local ruler's family.

PLATE 67

Butter lamp

Batang monastery, Eastern Tibet,
dated second month, Water-Dog Year
[Water-Dog Years = 1862, 1802, 1742, etc.]

Silver, H. 13 ³⁄₄ in. (34.9 cm)
Dr. Albert L. Shelton Collection,
purchase 1920 20.355

Inscription:
"In the Water-Dog Year, on an auspicious
day of the second month [April] the vessel
[was made of] the precious substance
that illuminates all the world. 'Bre-nyag
Dge-slong Bskal-bzang-dbang-idan,
Rtse-gsum Dge-slong blo-bzang-don-gruls
and Gru-rtses Dge-slong Blo-bzang-rgyal-
mtshan, by these three [monks] offered.
Carved out of the second precious substance,
containing 100 oz. + 30 + 4 sho + 2 ¹⁄₂ *skar*,
it is a joyful offering."

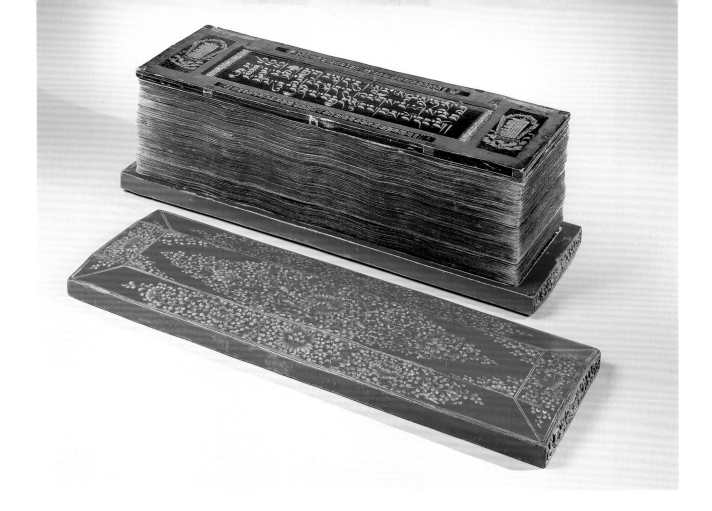

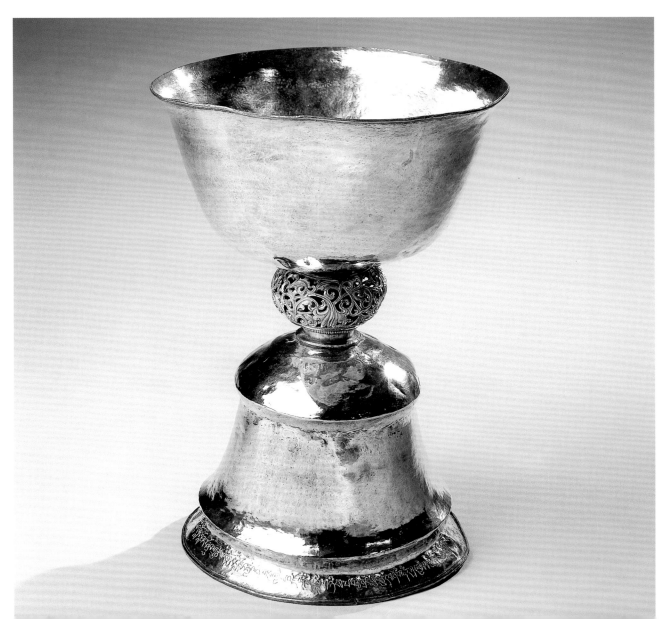

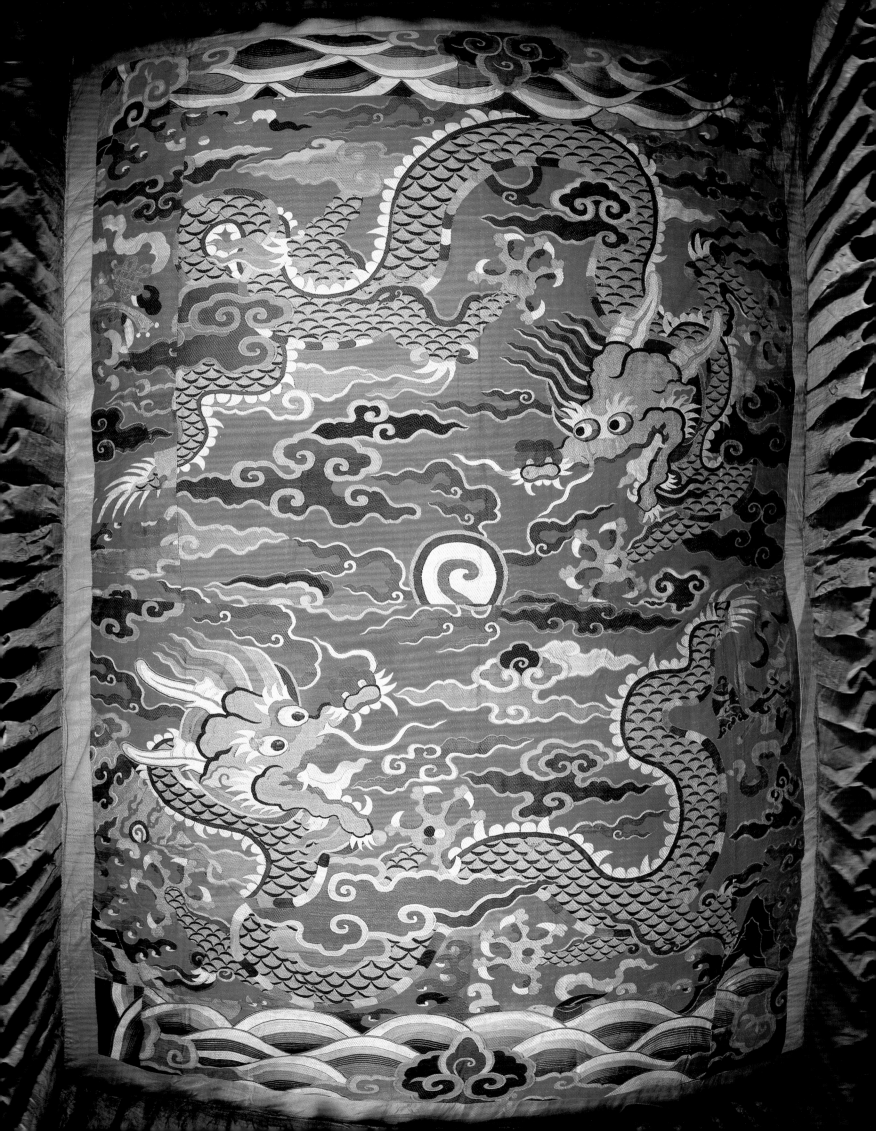

PLATE 68

Altar canopy

Ngor monastery,
southern Tibet,
17th century

Silk tapestry,
L. 77 in., W. 99 in.
(195.6 x 251.5 cm)
Gift of Jacob E. Henegar,
1986 86.255

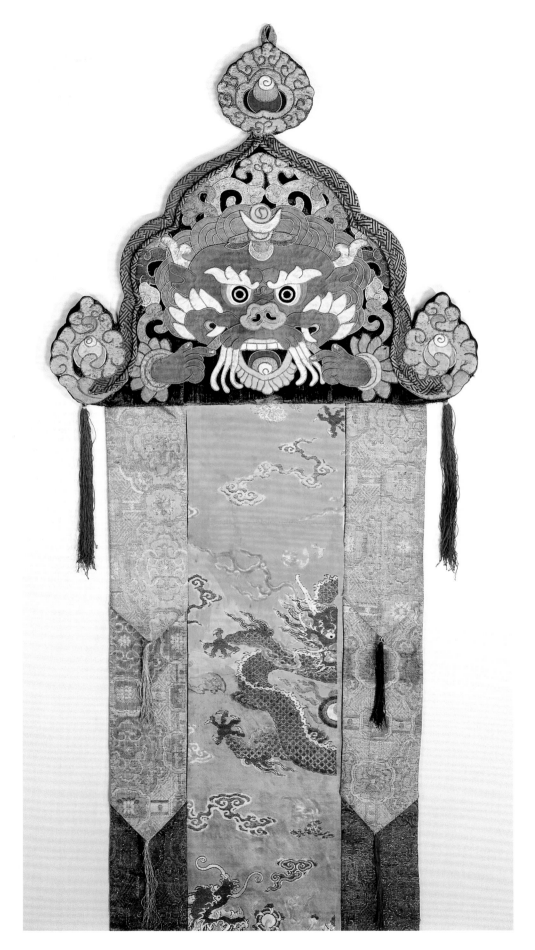

PLATE 69

Banner with
"Face of Glory"
(detail, one of a pair)

Lhasa, Tibet, 19th century

Appliquéd silk brocade
and silk-covered horsehair
outlining, silk tassels,
L. 238 ⅛ in. (604.8 cm)
Purchase 1974
C. Suydam Cutting
Bequest Fund 74.125

PLATE 70

Ceremonial garments of the Ba Lama

Batang, Eastern Tibet,
19th century

Patched silk damask cape

with decorative silk stitching
Edward N. Crane Collection,
gift 1911 11.647

Shown with:

Wool and silk brocade vest

Purchase 1982 C. Suydam Cutting
Bequest Fund 82.112

Leather boots

with wool uppers trimmed
with silk damask and cording
Purchase 1974 C. Suydam Cutting
Bequest Fund 74.127

PLATE 71

Fragment of a ceremonial cape

Tibet, 15th century or earlier

Silk embroidery and silver
foil-covered leather on gauze,
silk damask panels on tabby silk,
H. 42 ⁵/₈ in., W. 29 in.
(108.3 x 73.7 cm)
Purchase 1987
The Members' Fund 87.193

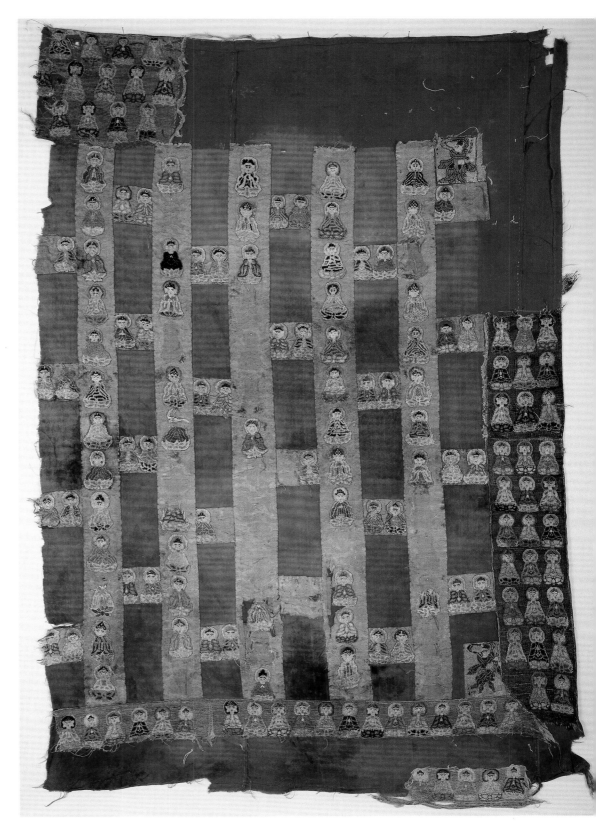

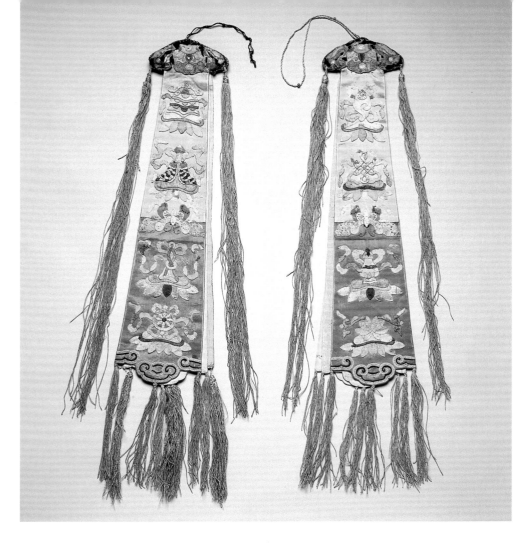

PLATE 72

Pendants from a ritual costume

Batang, Eastern Tibet,
18th–19th centuries

Appliquéd and embroidered
satin, silk tassels,
L. 11 ½ in. (29.2 cm)
Edward N. Crane Collection,
gift 1911 11.650

PLATE 73

Five-leaf crown
from a ritual costume

China, 15th century

Gold and silk embroidery on silk,
W. 20 in., H. 7 ¼ in. (50.8 x 18.4 cm)
Purchase 1994 Louis Bamberger
Bequest Fund, Carrie B. F. Fuld
Bequest Fund and Estate of
Gertrude Woodcock Simpson
in memory of Marshall Simpson
94.225

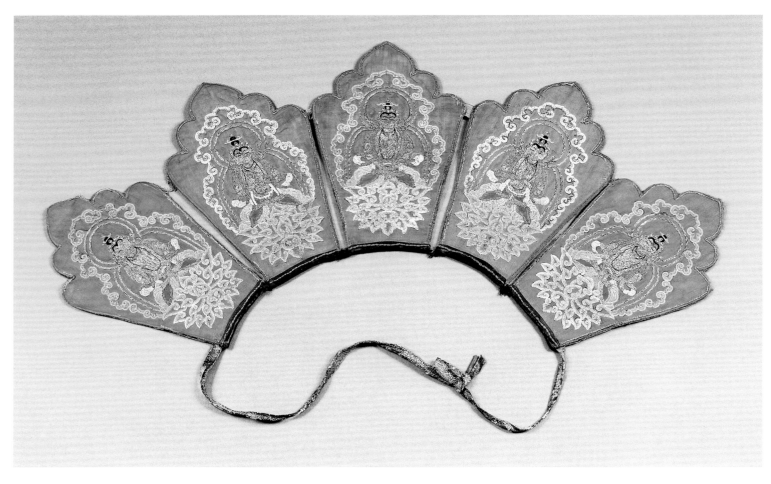

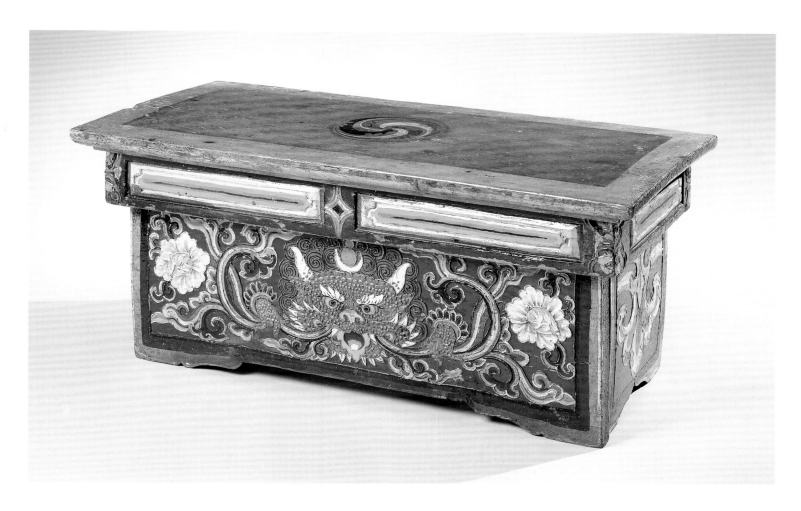

Plate 74

Ritual table

Tibet, 19th century

Painted and coated wood,
H. 11 ¹/₈ in., L. 27 ¹/₄ in.
(28.3 x 69.2 cm)
Purchase 1975
Thomas L. Raymond
Bequest Fund 75.96

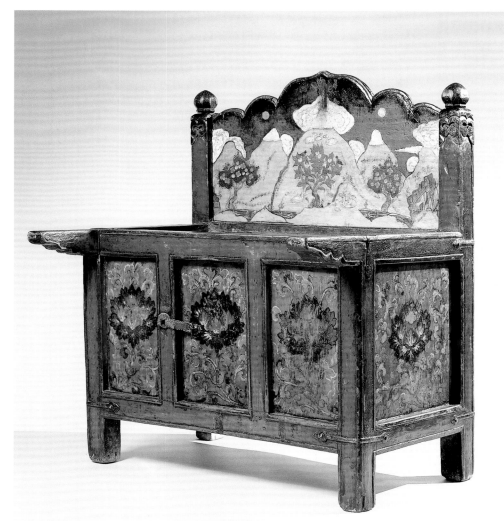

Plate 75

Reading table

Tibet, 17th–18th centuries

Painted and gilded wood,
H. 27 in., W. 25 in.
(68.6 x 63.5 cm)
Purchase 1994
John J. O'Neil
Bequest Fund 94.44

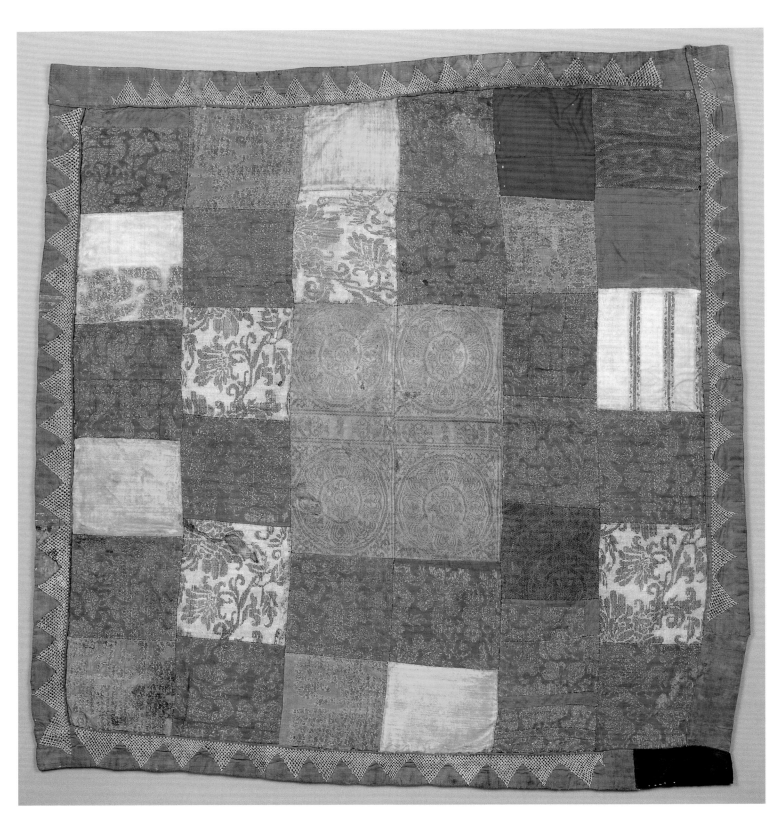

PLATE 76

Patchwork altar cloth

Central Asia or Tibet, 13th century

Silk brocade and *lampas* weave, embroidered
edge, L. 28 in., W. 29 in. (71.1 x 73.7 cm)
Purchase 1996 Estate of Gertrude Woodcock
Simpson and Thomas L. Raymond
Bequest Fund 96.78

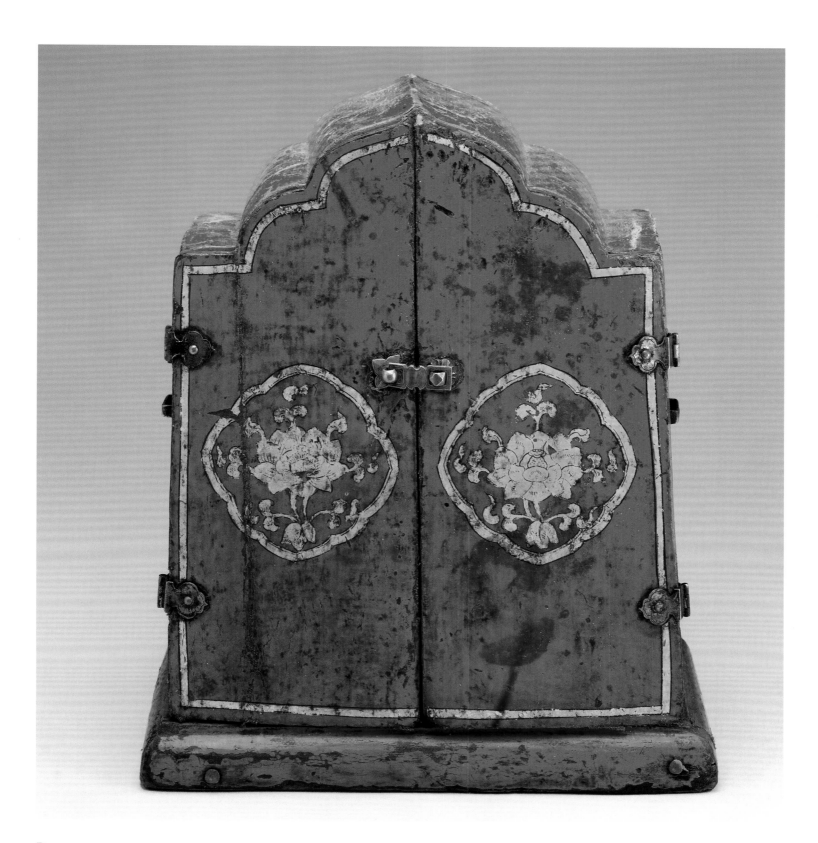

Plate 77

Ga'u (shrine)

Tibet, 15th century

Painted, gilded and varnished
wood, iron and brass metalwork,
H. 11 ¹/₄ in. (28.6 cm)
Purchase 1998 Sophronia Anderson
Bequest Fund 98.20.1

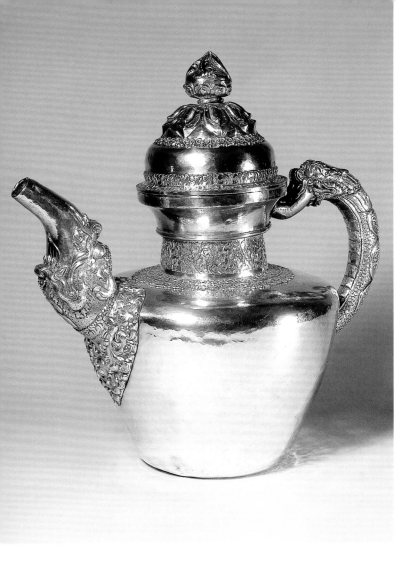

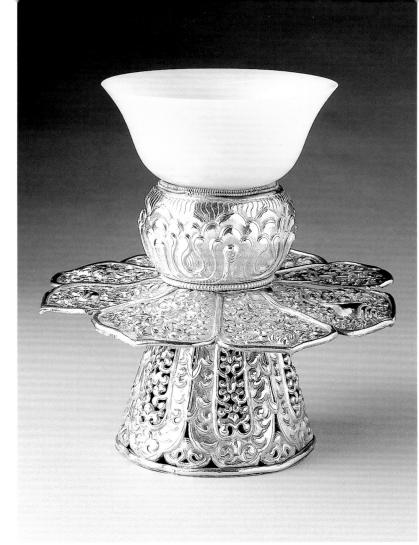

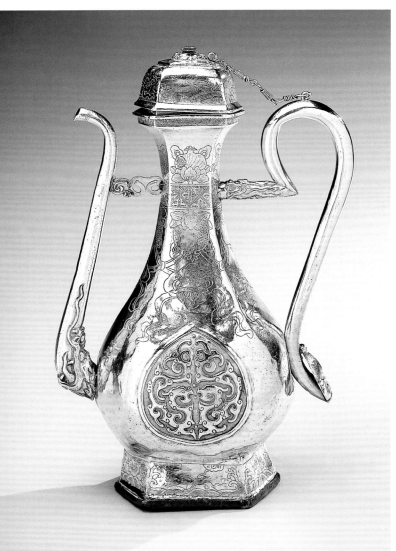

PLATE 78

Teapot

Batang, Eastern Tibet, 18th century

Repoussé silver, H. 14 in. (35.6 cm)
Dr. Albert L. Shelton Collection,
purchase 1920 20.337

PLATE 79

Bowl and stand

Batang, Eastern Tibet,
18th century

Jade, repoussé and openwork
silver, H. 6 $\frac{1}{4}$ in., D. 6 $\frac{1}{2}$ in.
(15.9 x 16.5 cm)
Dr. Albert L. Shelton Collection,
purchase 1920 20.330, .362

PLATE 80

Libation ewer

Batang, Eastern Tibet,
16th century

Silver repoussé with incised
designs and gold wash, copper
base, H. 12 $\frac{1}{2}$ in. (31.8 cm)
Dr. Albert L. Shelton Collection,
purchase 1920 20.333

PLATE 81

Wheel of the Law

Tibet, 18th century

Silver repoussé,
H. 20 $\frac{1}{4}$ in. (51.4 cm)
Edward N. Crane Collection,
gift 1911 11.646

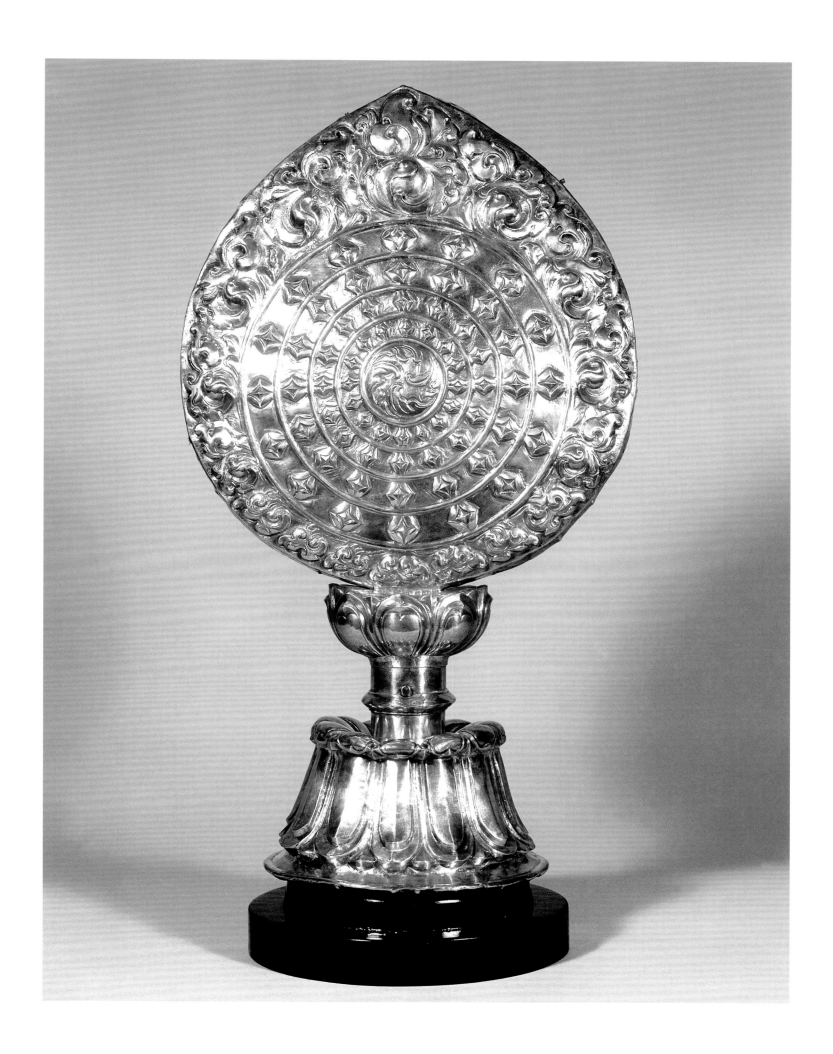

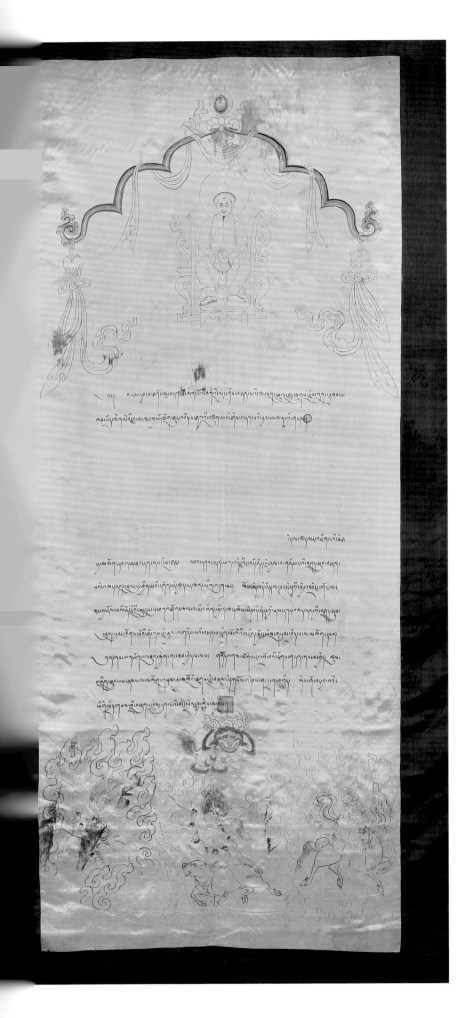

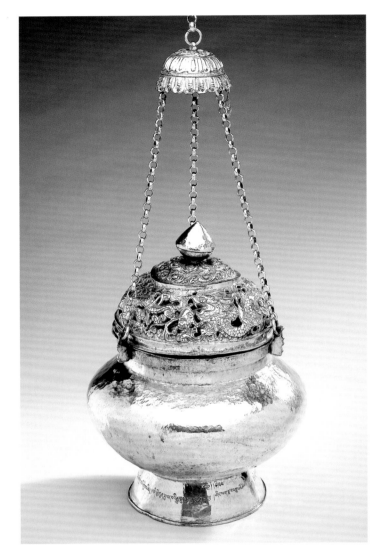

PLATE 83

Censer (one of a pair)

Batang, Eastern Tibet, Fire-Ox Year (1757?)

Silver repoussé and openwork, chains,
H. 14 in. (35.6 cm) (H. with chains 37 in., 94.0 cm)
Dr. Albert L. Shelton Collection, purchase 1920 20.358

Inscription: "In the Fire-Ox Year, on the 25th Day of the 10th
month, the *Dge-skos* [Gekö = lama in charge of monastic discipline]
Dge-slong Rin-chen Phun-Tsogs with immaculate motivation
offered and placed this incense vessel for permanent use.
Fifty-two *srang* of silver are actually present. May it be
a cause of bliss hereafter. *Mangalam* [may blessings descend]."

PLATE 82

Document from the 3rd Changkya Huktuktu

Beijing, China, 1836

Ink and color on satin, H. 118 ½ in. (301.0 cm)
Dr. Albert L. Shelton Collection, purchase 1918 18.142

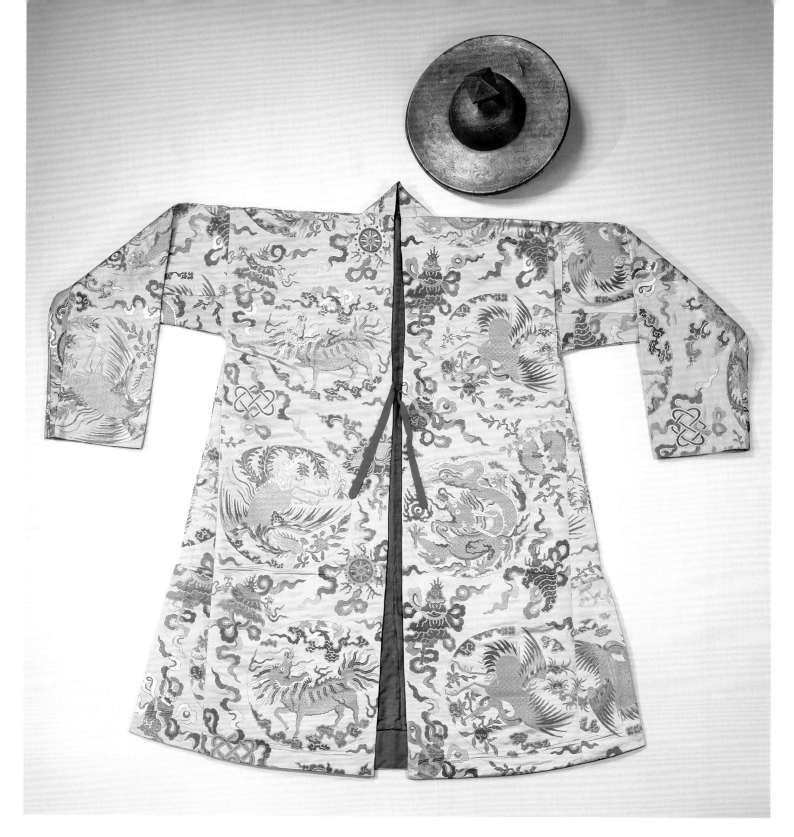

PLATE 84

Monk official's riding coat and hat

Tibet, 19th century

Coat: worn by an abbot at
Ngor monastery, southern Tibet
Chinese gilt brocade, L. 51 ¹/₂ in. (130.8 cm)
Gift of Judith and Gerson Leiber, 1983 83.372

Varnished gold papier-máché hat, with cloth strap,
D. 14 ¹/₂ in., H. 7 in. (36,8 x 17.8 cm)
Purchase 1975 Nathaniel Kent Fund 75.241

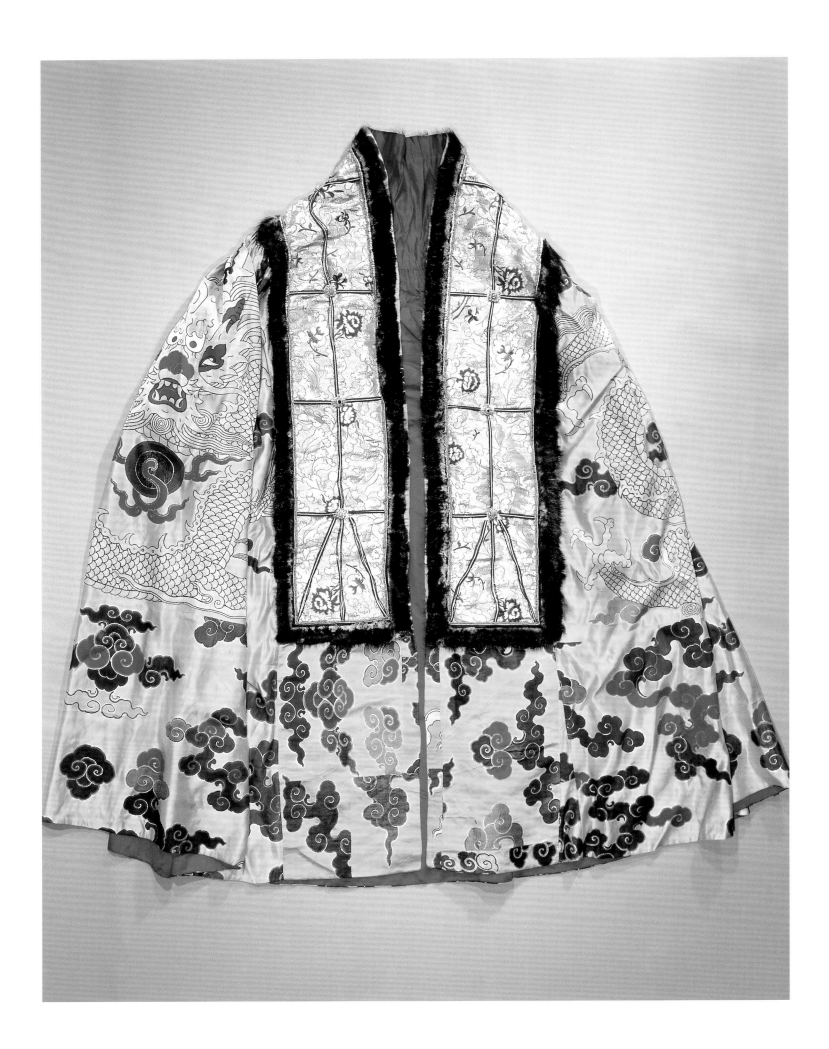

PLATE 85

Regent's cape (*sKu-ber*)

Lhasa, Tibet, 1875;
made for Tatsa Rimpoche II

Chinese brocade with metallic
gold and peacock feather thread,
Russian gold brocade front panel,
fresh-water pearl and coral strands,
sable fur, gold medallions
with turquoise and pearls,
L. 66 in. (167.6 cm)
Purchase 1979 The Members'
Fund 79.59

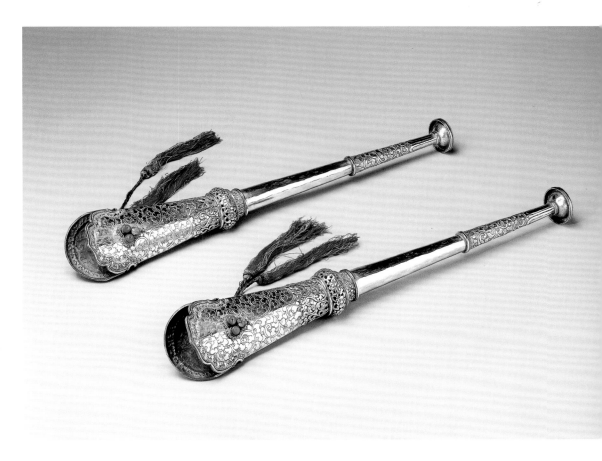

PLATE 86

Pair of trumpets

Tibet, 19th century

Silver set with turquoise
and coral, silk tassels,
L. 16 ¹/₂ in. (41.9 cm)
Gift of Eleanor Olson,
1974 74.26 a-b

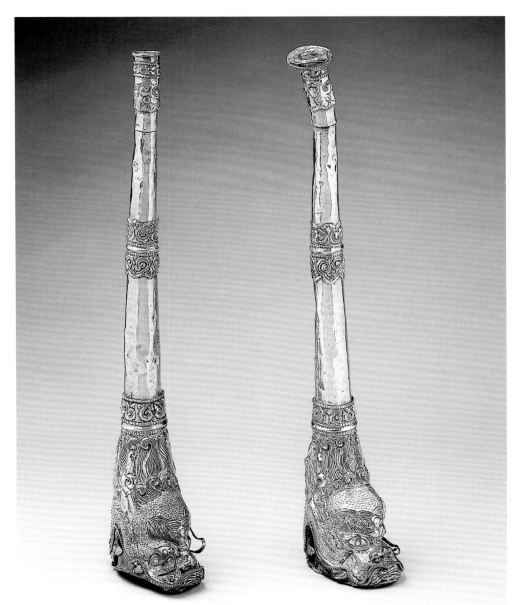

PLATE 87

Pair of dragon trumpets

Batang, Eastern Tibet,
19th century

Silver repoussé over copper,
L. 17 ¹/₂ in. (44.5 cm)
Dr. Albert L. Shelton Collection,
purchase 1920 20.331 – .332

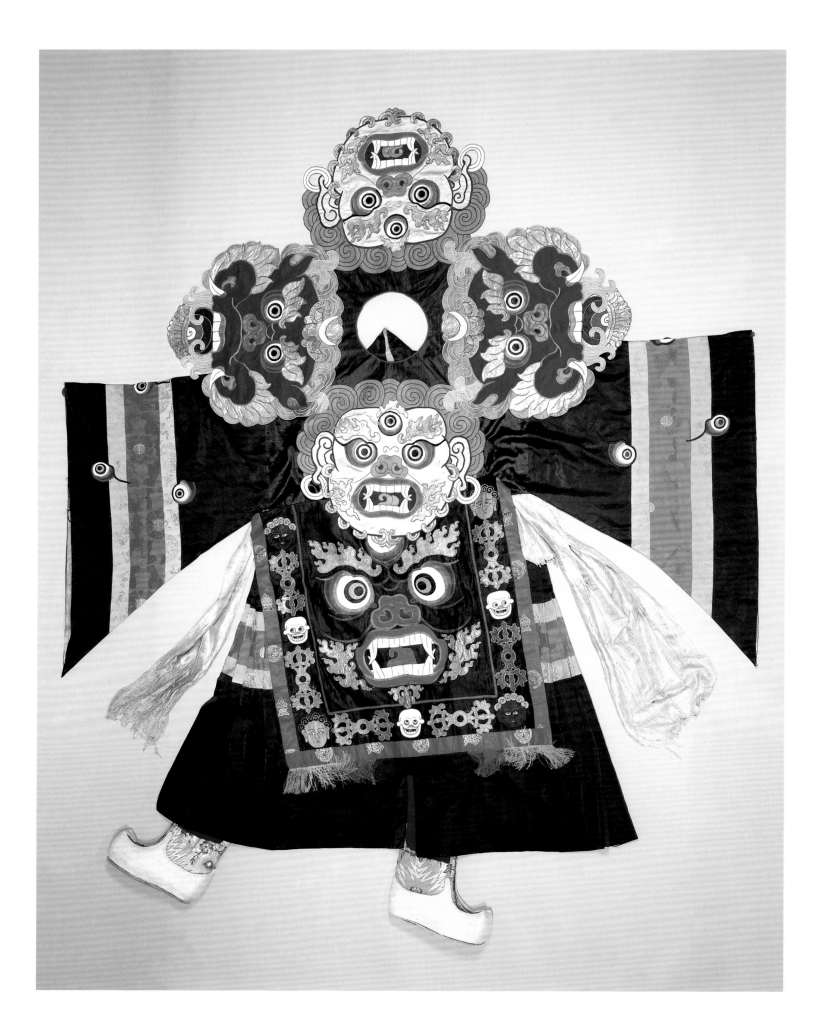

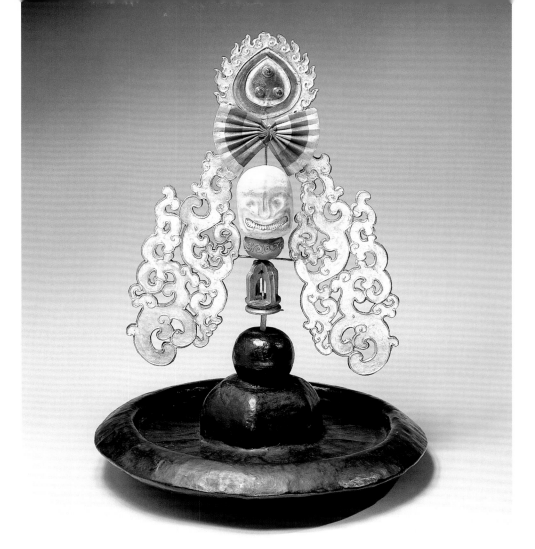

PLATE 89

Hat for the *Black Hat Dance*

Beijing, China, *circa* 1900

Papier-máché, painted, gilded
and varnished, set with mirrors,
H. 22 in. (55.9 cm)
Acquired by exchange with
the American Museum of
Natural History, 1948 48.20

PLATE 90

Vajra and bell

Eastern Tibet, 19th century

Bronze, brass, H. 7 $\frac{1}{4}$ in.
(18.4 cm.) (bell),
H. 4 $\frac{1}{2}$ in. (11.4 cm) (*vajra*)
Dr. Albert L. Shelton Collection,
purchase 1920 20.398, .399

PLATE 88

Cham costume

Nechung monastery, central Tibet,
circa 1900

Silk and silk brocade robe with
appliqué details; silk collar with metallic
thread appliqué; silk and gilt leather
appliqué apron; and cotton cord,
leather and gold brocade boots
Purchase 1980 The Members' Fund
80.286

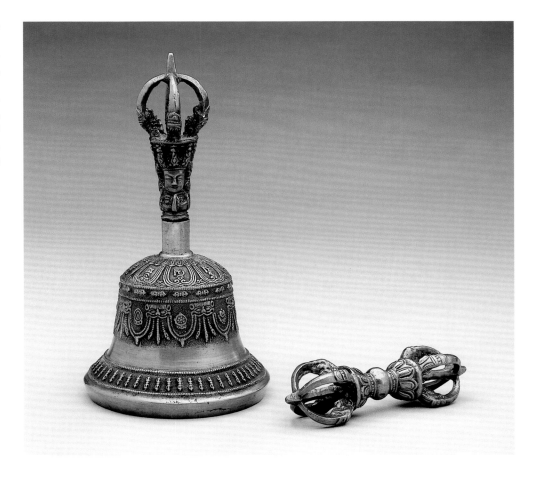

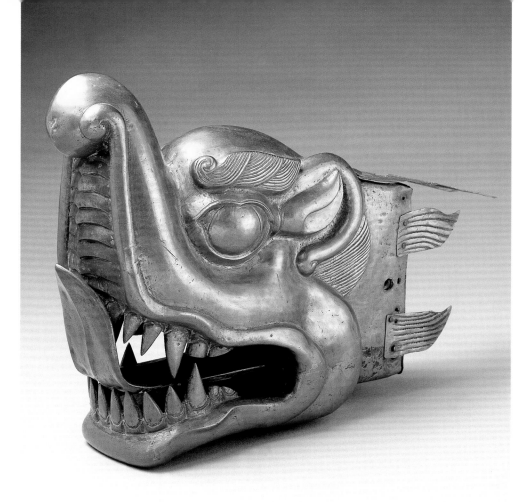

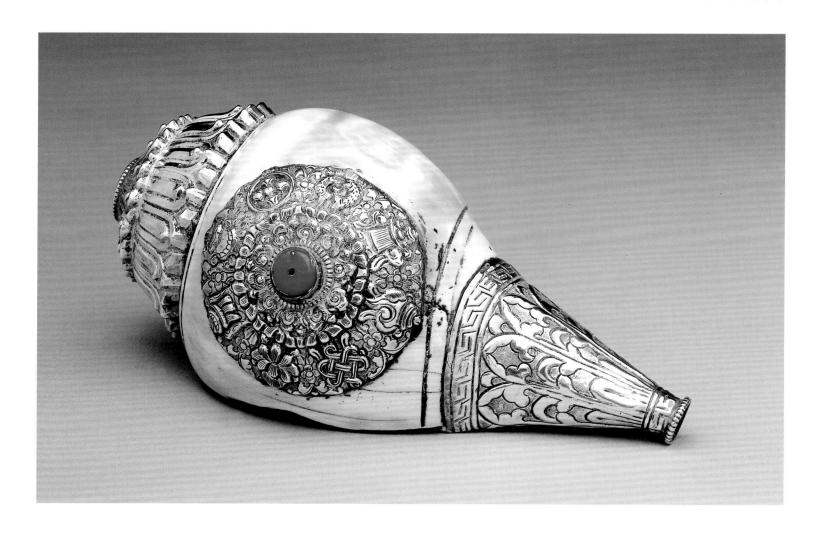

PLATE 93

Vajra sitting carpet

Tibet, early 20th century

Wool pile, cotton warp
and weft, cotton cloth banding,
L. 36 ³/₄ in., W. 34 in.
(93.4 x 86.4 cm)
Gift of Dr. Wesley Halpert
and Mrs. Carolyn M. Halpert,
1996 96.82.2

PLATE 94

Altar cloth with design
of crossed *vajras*

Tibet, 17th century

Gold and silk embroidery
on silk cloth,
L. 15 ⁷/₈ in., W. 15 ¹/₂ in.
(40.3 x 39.5 cm)
Purchase 1993
Mary H. Stanton
Memorial Fund 93.88

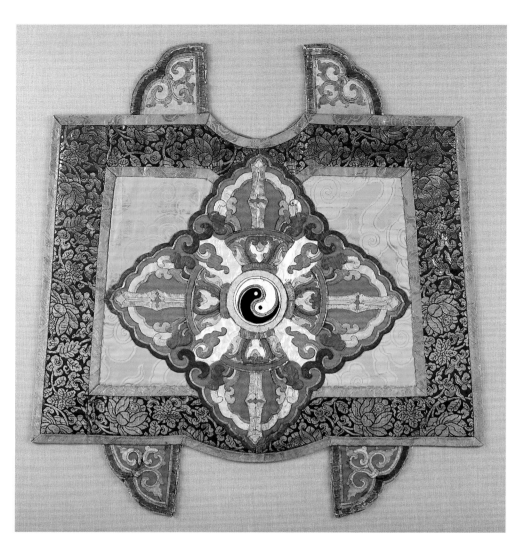

PLATE 95

Lhamo's saddle cover

Tibet, 18th century

Silk, silk brocade and gilt leather appliqué
cover, W. 25 in. (63.5 cm)
George T. Rockwell Collection,
purchase 1918 18.132

PLATE 96

Lhamo's saddle undercloth

Tibet, 18th century

Silk and silk brocade with painted
details, L. 59 in. (149.9 cm)
George T. Rockwell Collection,
purchase 1918 18.133

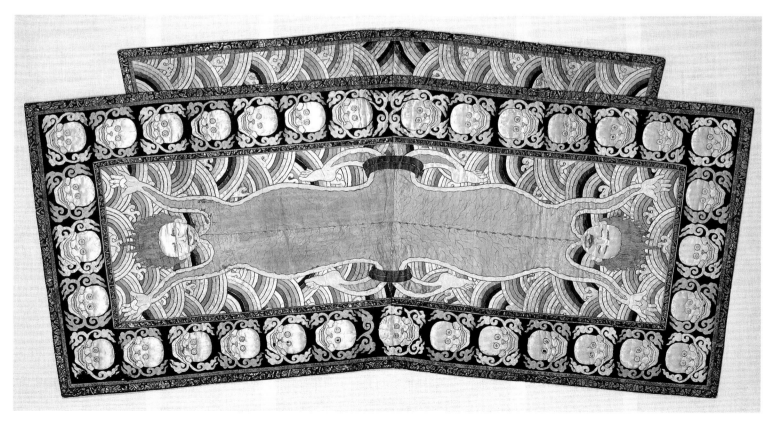

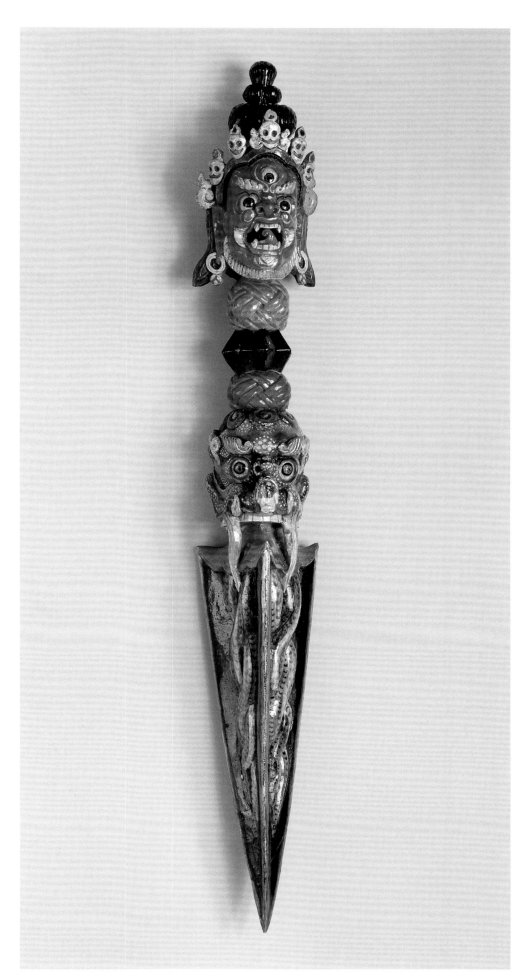

PLATE 97

Phurpa
Northeastern Tibet,
19th century

Painted wood,
L. 16 ¹⁄₄ in. (41.3 cm)
Carter D. Holton Collection,
purchase 1936 36.324

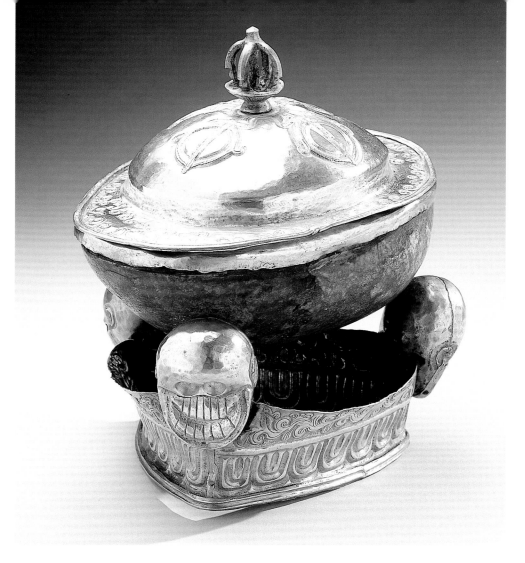

PLATE 98

Skull bowl,
cover and stand

Tibet, 19th century

Skull, silver, H. 8 in.,
L. 7 ½ in. (20.3 x 19.0 cm)
Gift of Paul Jenkins,
1983 83.406

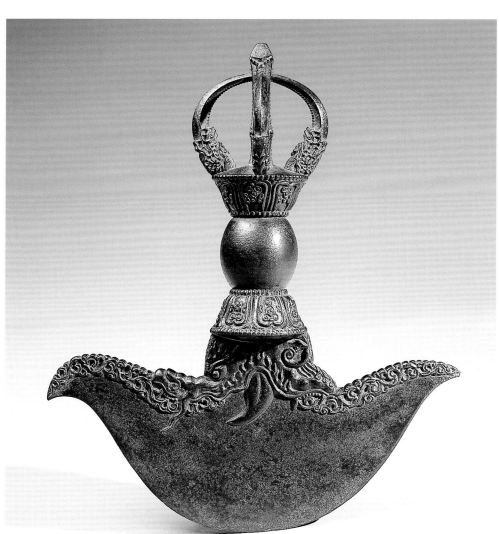

PLATE 99

Chopper

Tibet, 16th century

Iron, H. 11 ½ in. (29.2 cm)
Purchase 1954 54.350

Skull drum

Eastern Tibet, 19th century

Skull caps, leather, embroidered
and brocaded silk banner,
Diam. (drum) 5 $\frac{1}{2}$ in. (14.0 cm)
Carter D. Holton Collection,
purchase 1936 36.317

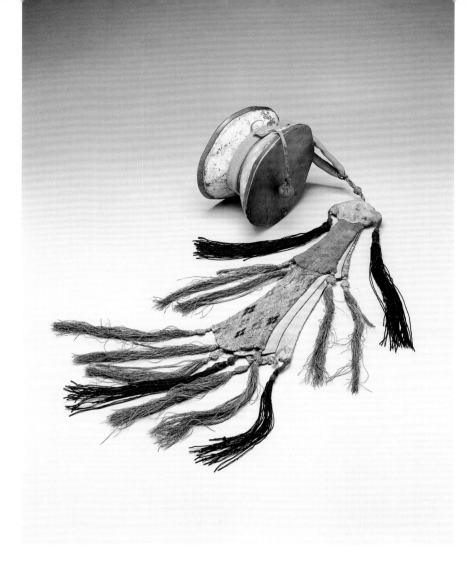

PLATE 101

Bone apron

Tibet, 15th–19th centuries

Bone, leather, silk brocade,
L. 17 $\frac{3}{4}$ in., W. 24 $\frac{5}{8}$ in.
(45.1 x 62.5 cm)
Gift of the Mei Ching
Collection, 1983 83.266

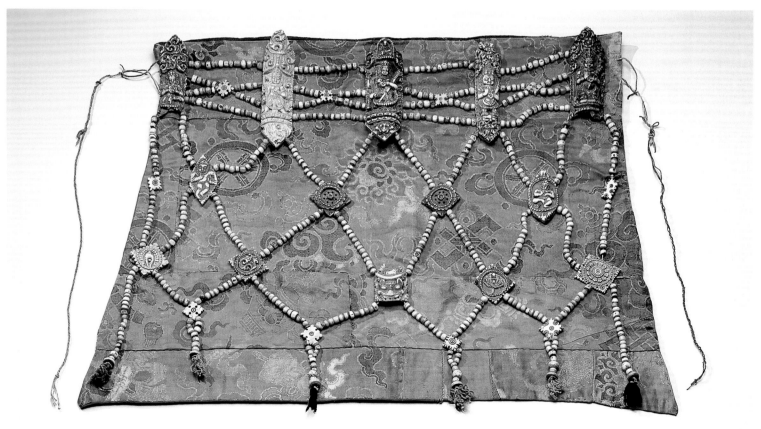

In the Sacred Realm

Image as Presence

by Janet Gyatso

In the Tibetan religious context, a work of art that is a Buddhist image (*kudra*) is not merely a symbolic representation of an ultimate Buddhist truth. Nor is it simply an icon, a rendering of the ideal form of a member of the Buddhist pantheon. It is both of those things but, to the extent that it embodies the form of the Buddha or deity, the image also conveys the presence of that Buddha in its own right.

The canonical sources for the various forms of the Buddha interpret stance, body color, facial expression, hairstyle, number and positions of limbs, clothing, ornaments and accoutrements as manifestations of certain principles of enlightenment. In some ways these elements function as mediating symbols, referring to the ultimately formless, indeterminate nature of the enlightenment experience itself. The sword in the hand of Manjushri shows his severance of emotional attachment, Vajrayogini's three eyes indicate her omniscient vision of past, present and future; the green hue of Tara's skin color expresses her wisdom-as-efficacious-action. There are also measurement grids for the bodily proportions appropriate to each genre of Buddhist deity. However, the referential function of these iconographic prescriptives is secondary. Ultimately, what is being referred to, or symbolized, is the ground of enlightenment, and that is not something which exists prior to, or independent of, its concrete appearance in the world. In accordance with the tenets of Mahayana Buddhism, *nirvana* is never separate from the vow to appear in the world to benefit all beings. In this important sense, Tibetan Buddhist aesthetics of form, color and design are based in enlightenment—the shape of the Buddha's body *is* the act of Buddhahood. The image, partaking in and enacting the proportions, colors and attitudes of an aspect of *nirvana*, becomes an instantiation of that aspect itself. The very perception of those attributes is thought to remind, or put the viewer in mind, of his or her own inherent enlightenment. Thus is the image always more than a substitute for the presence of the Buddha or deity; it radiates its own presence, which for the religious perceiver is the same as that of the Buddha.

The canons for the Buddha/deity's iconography are used primarily for performing visualization meditation (*sadhana*). The key concept here is that the practitioner is not ultimately different from the Buddha. It is only through deluded thinking that such a duality is conceived. Visualization is seen as a technique to reinvoke the presence of the "actual" Buddha (*jnanasattva*) in the practitioner's own body and experience (*samayasattva*). In this sense, the practitioner's body is analogous to the material statue or painting: it becomes a support, or receptacle, for embodiment (*kuten*) in which the living experience of enlightenment is activated.

Thus does the monk or lay aspirant imagine that he or she has become the Buddha—physically, verbally or mentally. Moreover, the entire world is visualized as being the Pure Land, the realm of the Buddha, and all of its contents as expressions of that Buddha. When the practitioner of *sadhana* meets with an image of the Buddha in the real world, it serves specifically as a reminder of one's endeavor to identify the mundane world with that of the Buddha. For this practice, the painting or statue serves as a model and aid in the development of the ability to visualize. Gazing at the image is recommended as a way of improving the clarity of the mental image produced during the meditation period.

Although the sacred presence of a Buddhist image is already accomplished merely by the fulfillment of iconographic requirements, presence is further invoked in a variety of ritual settings. The spirit of a painting or statue is especially important for initiation ceremonies (*abhishekha*, Tibetan: *wang*) in which students are formally introduced to the Buddha/deity and its *sadhana*. The appropriate image, in a prominent position on the altar, is the focus of the rite. During the initiation, the actual Buddha/deity is invited to enter the image and reside there throughout the ceremony. The lama visualizes the image as the real Avalokiteshvara, or Tara, or Amitabha, and at several points explicitly asks the students to share this imaginative projection. This ritualized visualizing of presence then valorizes the disciple's ceremonial meeting with the Buddha/deity-as-physical-image.

A similar sort of invocation is performed regularly for the images of the central Buddhas and protective deities of a monastery or sect. In monastic institutions it is the responsibility of the monks to propitiate these deities daily. Music, offerings and prayers of praise ensure the continued presence and blessings of the deity in the institution.

In many ways the very history of the image is a factor in its vivification: in what rituals the image has been employed, what monasteries have kept it, and especially what lamas have been in contact with it. The effects of having the visualized presence of the Buddha projected onto the image are cumulative. This begins with the very first ritual involving the image, the consecration ceremony, which is performed immediately after its construction. The image is animated for religious use by a lama, who imagines and projects the spirit of the actual Buddha/deity onto the work of art. Symbolic of this animation is the inscription of the mantric syllables *Om ah hum* on the backs of paintings, just at the spots where the corresponding psychic centers (chakra) of the deities depicted on the other side occur. For statues, this is further enacted physically by the depositing of sacred relics, *mantras* and texts inside the statue's body. In particular, relics imbue the statue with their own presence as physical traces of another embodiment of *nirvana*. A "soul pole" (*sog shing*) is also implanted inside statues, providing a central psychosomatic channel. Thus, in the case of statues, not only is its outer form that of the Buddha, but its inner, hidden contents physically repeat the pattern of Buddhahood. Later, the fact that the image was consecrated in these ways is kept in mind by the religious viewer, and this knowledge enhances and enriches his or her perception of the image.

When the image comes to be involved in rituals, and is the object of meditative concentration by accomplished practitioners, its religious value increases in the eyes of the community. And when an image is said actually to have come

to life—to have spoken to a meditater or to have performed some action (of which there are many stories in Tibet)—it is seen as having a powerfully numinous presence.

There is, further, the factor of the painting or statue's physical being as such. The spiritual presence of a religious image is enhanced by the material out of which it is made. Precious substances, for Tibetans, are concrete analogies of spiritual value (just as despised substances are synonymous with what is repellent in the world). It is for this reason that statues are encrusted with jewels, and paint pigments mixed with crushed gems and rare medicines. Rosary beads are made from seeds, bones or stones that are chosen to correspond to the type of visualization practice for which the beads will be used. Similarly, the power of the symbolic form of a ritual thunderbolt (*vajra*) or dagger (*kila*) becomes that much more real and awesome when it is made of the treasured meteorite metal (*namchag*). Again, votive images are thought to commemorate the deceased that much more effectively when their material includes the cremation ashes.

Because, for these reasons, the religious work of art embodies sacred presence, it possesses for Tibetans the ability to "grant blessings" (*chinlap*). This is disseminated in a variety of ways: most physically, it occurs in the contact between the devotee's body (usually at the top of the head) and the image. The meeting of bodies is seen as a concrete instantiation of a shared moment in time and space, an intersection of history. There is also the idea that physical contact transmits a spiritual value. The transmission of the blessing can be effected by the lama, who touches the aspirant's head with the image, or by the aspirant alone, who can simply lift the image to his or her own head.

Physical contact with an image is particularly significant during the initiation ritual. Here, the lama's placing of the image on the head of the student becomes a symbolic enactment of the student's right to meditatively assume the form of the Buddha, a right which is granted just in that moment of ritual touching. The contact has other meanings as well. It symbolizes the student's link with the lineage of practitioners who have meditated on that same Buddha in the past. It also signifies the student's awe and respect for the Buddha, if for no other reason than because the contact occurs with the student physically subordinate to the image. Again, when a lama places the weighty *vajra* on the head of the aspirant, exerting a gentle pressure, it reminds the student, by analogy, of the gravity of the *tantric* vows taken during the initiation and of the heavy consequences if those vows are broken.

Not only does the image physically grant blessings to a person, it also imparts an auspicious cast to its environment. The presence of a holy image renders its immediate surroundings a sacred space. On the large scale, the placement of images and their temples in the landscape relates to ancient ideas about the spiritual nature of Tibet's geography. Some myths conceive of the topography as a dismembered demon. In an important story connected to the establishment of Buddhism in Tibet, primitive Tibet-as-supine-demoness was subdued by the erection of temples, and images at key points on the demoness's body; those structures functioned to pin down the country-demoness, civilizing her by means of the new Buddhist presence.

The long-range perspective of sacred topography might also explain the construction of colossal Buddhist statues, often of the future Buddha Maitreya,

at various spots in Tibet. Such monuments mark the country as a realm of Buddhism, and function both to herald the coming enlightenment, and to gather and focus meditative attention. The powerful effect of a Buddhist image on its location continued to be a prime motivation for the building of such structures in Tibet. One of the principal projects of the fifteenth-century saint-engineer Tangtong Gyalpo was the erection of *stupas* and temples at key points (*metsa*) in Tibet, in order to tame unruly forces.

The presence of a particularly holy image makes its site the focus of pilgrimage. The Jowo Rinpoche image in the Jokhang is an outstanding example; pilgrims prostrate their way there from hundreds of miles away. The climax of their journey will often be a trance experience in the image's presence. In Tibetan biographical literature, there are numerous stories of adepts who have received messages from the Jowo and other images.

Monasteries or villages possessing an important image will take great care in its protection and maintenance; its loss or damage would be thought to have grave consequences for the welfare of the local inhabitants, as if the very life force of the area were threatened. Usually the monastic community or a lay lama is responsible for such an image's physical upkeep. On special occasions, they will also display the image in processions or make it accessible to the public.

On a smaller scale, installing Buddhist art in a room or building is thought to affect that place in a similarly positive manner. A sacred image is often the first thing to be placed in a new house, even before personal belongings. By keeping the image there, the ongoing presence of that deity is maintained in the home. The effect, in the *tantric* imagination, is that the entire house becomes the abode of the deity.

The conviction that a deep interaction occurs between images and their surroundings is reflected in the Tibetan predilection to construct structures to enclose images. Clearly, this is not only to protect the art work; statues and holy objects sometimes have a surprising number of multiple cases and wrappings that far exceed the practical need for shielding or padding. Rather, there is the widespread conviction that images require a seat, a domicile. When possible, statues will have a metal box (*ga'u*) in which they can be kept. For larger images, the temple or shrine room in its totality is the image's seat. In addition, small structures may be built on the roof of a house or monastery to contain images of the protector of that building (*gonkhang*). Other "houses" on rooflines are jsut solid shapes that simply provide a symbolic structure for the presence of the protector (*tenkhang*).

The image inside the house will be installed on an altar, located in a protected and physically high spot in the building, preferably on the top floor. The altar table itself is usually a complex structure of various levels, which allows the images to be placed on the upper levels. On the lower levels are arranged offerings and the symbolic seven cups of water. The water cups are filled every day and emptied the same evening. Other offerings, such as flowers, candles and incense, are common. Personal effects or significant objects may also be put near the image, in order to attract the image's blessing.

Behavior towards an image is the same as it would be if the living Buddha or deity were present. A large part of the protocol concerns bodily position, directionality, and the hierarchy of bodily parts. Profound significance is

attached to the parallel that is thought to obtain between top and bottom in the physical sense, and high and low in the sense of spiritual value. An example of this attitude is the widely observed rule that only a person's head or hand should be pointed towards an image; never the feet. When approaching the image, devotees convey deference by assuming a slightly bent posture, with the palms of the hands held together near the middle of the chest, in the symbolic gesture of reverence. The more elaborate bodily expression of respect is the full prostration, practiced upon entering a temple or altar room, or at the beginning of a meditation or ritual session. Three prostrations are standard, but Tibetans will also perform them for protracted periods as a means of purification. The common sight of Tibetans prostrating themselves on wooden boards outside the Jokhang Temple, even to this day in Lhasa, is an instance of this practice.

The devotee can draw near to the image after prostrations, for the purpose of "receiving the image's blessings", as well as to see and appreciate the work of art at close range. Again, the deferential posture is assumed while approaching. One may seek physical contact by bowing the head and touching the top of one's crown to the lower portion of the image, or to the edge of the table where the image is displayed. When remaining in the artwork's presence, the religious Tibetan sits cross-legged on a level that is below that of the object. In a less structured situation than a ritual or sermon, but one that nevertheless puts the devotee in prolonged proximity to the image, there is further protocol. Smoking, arguing, or any sort of action deemed negative in Buddhism, are considered inappropriate in the image's presence.

The same expression of respect through physical positioning is observed when moving a religious art object. The image is always held head up. It is carried by a part of the bearer's body that is auspicious—in the hands, or perched on the head or shoulder, but never under the arm. If it falls, it is immediately picked up and touched to the carrier's head.

When images are borne in procession, the bearers will sometimes be seen to have a cloth or mask covering the mouth. This is to prevent the impure breath of the bearer from intruding into the pure atmosphere radiated by the image. Such a procession is usually preceded by incense carriers, who prepare the air through which the image will pass with auspicious scents. More elaborate parades are accompanied by music, thought to please the Buddha deity. Special vehicles carry the holy presence, and umbrellas and other standards add further pomp and awesome splendor, announcing the approach of a living Buddhist truth: the same measures that are taken when a living lama passes in procession. An image is packed with much care when it is to be transported for a long distance. In addition to wrapping and protecting the object, efforts are made to ensure that the image will remain head up while in transit. The container holding the object is never set on the ground, but rather is placed in a position of honor, upon its own seat or a high shelf in the vehicle.

When an image is to be disposed of, this is done with cognizance of its spiritual significance. Paintings, as well as texts or illustrated pages or religious writing, or even doodles of a Buddha figure, are not thrown into a trash can. Rather they are interred in *chortens* or hollow places in images, or are burnt solemnly. If the image was particularly revered, even a small piece of it will be treasured. Damaged metal or clay images will be kept in storerooms, treasuries,

or used to consecrate other statues. The older relics link the new image with the history of the previous, and revive it with the same spiritual presence. This occurred recently in a small village in Eastern Tibet when fragments of a destroyed metal image were saved and used to consecrate the new image.

In general, the treatment of images as though they were actual, living Buddhas or deities is not limited to the credulous or uneducated. On the contrary, the most highly literate Buddhist scholar or accomplished yogin will maintain this reverential attitude. For the religiously sophisticated, this attitude is informed by an understanding of the psychological and aesthetic impact of the viewing of images. It is precisely the theoretical knowledge of *tantric* Buddhism that allows full appreciation of the work of art—a consciously devised tool to evoke intimations of the sacred, and of enlightenment. [J.G.]

Creation of the Image

Once a decision has been made to commission an image, the patron—whether a layperson, monk, yogin or part of a group (such as a family, a village or a monastic society)—must next approach a worthy artist or artists. Religious

Fig. 1
Folio showing a *Mahasiddha* embracing an acolyte, from an artist's sketchbook, Nepal, 18th–19th centuries, ink on paper, H. 7 ⅞ in., W. 7 ½ in. (20.1 x 19.1 cm) Anonymous gift, 1982 82.235

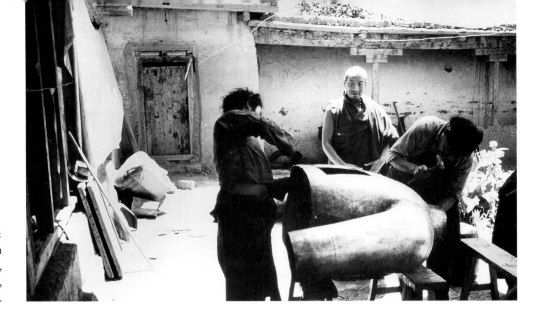

Fig. 2
Artists working on
a large metal image,
Dagyab, Eastern Tibet,
1983.

advisers, who will have already helped to select the appropriate form of deity, may continue to consult with the artist or atelier to ensure the correctness of the image and will, in any case, be called in to officiate at the consecration. The artist will have recourse to the patron's or religious advisers' visualization (whether in a new form or from a codified version in the *sadhanas*) in oral or written descriptions. Sketchbooks are also quite common see (see fig. 1). Extant sketchbooks have been found to contain rough sketches and jottings, as well as finished drawings with accurate proportions and measurements. Existing sculptures and paintings can also serve as models.

The most common, smaller Tibetan sculptures are fabricated in metal, either cast or hammered. Larger images, intended for main assembly halls or chapels in monasteries and temples, can be made of hammered metal (fig. 2) but are usually of clay. Outdoor images in the living rock are carved at auspicious locations. Wood and precious materials, such as bone and ivory, are also used.

Tibetan painted *tangkas* are almost always on a cotton cloth support (fig. 3). This follows in the tradition of Indian *patas* (of which there are no documented surviving examples) which were constructed of cotton cloth and used as banners for processions, temple decoration and individual meditation. Silk and linen supports for Tibetan painting are known, but rare. Cotton, as well as silk and linen, is imported, making the quality and size of the cloth dependent on availability. Tibetan artists would have routinely imported Indian or Chinese cloth, depending on geographical proximity.

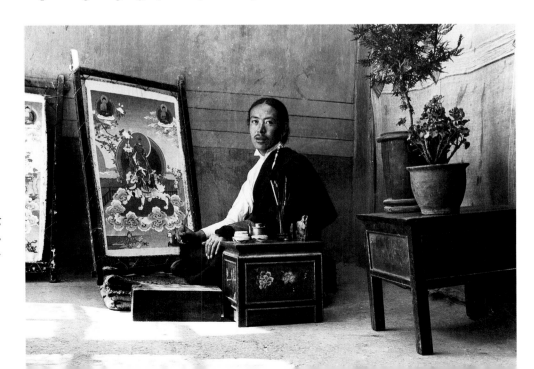

Fig. 3
The artist Tsering completing
a *tangka* at the Norbu Linga,
Lhasa, central Tibet, 1937.

Tangkas are traditionally sewn into cloth frames. Early *tangkas* are sewn onto relatively simple straight, or diagonally-shaped, dark blue cotton or silk mounts, usually only at top and bottom. The top and bottom are made rigid with wooden bars or dowels, and a hanging cord is attached to the top bar. Eighteenth- to- twentieth-century *tangkas* are usually sewn to a more complicated type of blue silk brocade mount (representing the "celestial" realm), deep at the top and bottom, with narrow sides and thin red and yellow stripes immediately adjacent to the painting (the "radiant nimbus" of the painting). Rectangular patches of a contrasting pattern or color might be sewn to the center of the bottom and, more rarely, the top blue brocade areas; these are called the "doors" or "windows" into the *tangka*. In addition, a thin, often patterned, silk covering is hung down over the *tangka* as a protection when it is not in use, and this is folded and draped as a decoration when the painting is viewed. Two flat ribbons of silk often hang loosely from the top edge down the sides of the mount, as a final flourish.

Tibetan books are made of paper. Tibetans were in contact with paper-producing civilizations, primarily China, from at least the seventh century, and they translated the small, narrow imported Indian palm-leaf sacred texts onto larger-format paper folios as soon as their own writing system was developed. Tibetans must have been aware of the deep blue *Sutra* scrolls of China, on which richly decorative gold and silver characters and deities were inscribed, when they first created the type of elaborate manuscript seen in color pls. 66 and 106. Such folios, in which gold and silver script on a dark ground is embellished with rectangular vignettes of deities in the manner of Indian palm leaf folios, continued to be made into the twentieth century for fine editions of the *Kanjur*.

Some of the most important religious works in Tibet were commissioned by major patrons, such as royal families or monastic officials, as part of elaborate projects which involved the erection and decoration of an entire building. In this case, a large team of architects, sculptors, painters and artisans, working together with religious advisers, would be involved and the project could take several years. Biographies of important lamas or political figures and monastic histories relate the background of these grand schemes. Most of the portable sculpture and painting now outside Tibet, however, is of more modest size and intention and may have involved one patron, a religious adviser and an artist. The latter might be a monk but a professional layman is more usual. In any case, certain spiritual preparations are necessary before embarking on the work. Scriptures might be read, offerings made and the workplace and tools blessed by a lama. It is important also for a harmonious relationship to exist between artist, patron and religious adviser. The artist might be subject to certain abstinences (from meat, alcohol, onion or garlic) while creating an image. If the subject of the commission is a *tantric* deity, there are additional precautions, and the artist should be initiated into the appropriate mandala of the deity. Certain sacred ingredients may be required, such as earth or water from a holy site, relics of a lama, or pieces of precious materials such as gold, coral or herbs. If the image is to be made of clay, these ingredients are mixed into the clay; if metal, they are mixed with paint and applied to the inside of the statue after fabrication. Lay artists in Tibet are generally born into the profession, into families of image-makers where they might be raised as apprentices until they

gain master status. It is not unknown, however, for an outsider of talent and ambition to join a family as an apprentice.

Blessing and "empowering" ritual objects and icons is a Buddhist tradition of long standing, seen in one form or another in all countries where the religion is practiced. Gold, silver, precious and semi-precious stones, coins and manuscripts are typical consecration items from early *stupas*. Filling images, as well as *stupas*, has been practiced in Tibet for centuries. The interiors of hollow-cast and hammered metal and clay sculptures are completely filled with consecration items. Hollow recesses are left (usually in the upper backs) in solid-cast metal sculptures and stone, wood, bone and ivory images for consecrations.

The consecration ceremony is performed to empower and honor completed paintings, in the same way as for sculpture. Sacred writings are inscribed, and special invocations made by the officiating monks. The hand and fingerprints or personal seals of holy teachers or officials may be imprinted on the back, and prayers are offered to the deity represented in the painting.

Iconography

The deities depicted in Tibetan art typically conform to iconographic formulae developed over the long history of Buddhism. The pantheon is thus extremely large and varied.

One of the most common ways of classifying the wide variety of Buddha images is the three modes of embodiment, the three *kaya*. *Dharmakaya* is the ultimate state of enlightenment: *Dharma* literally means "law" or "truth"; *kaya* literally means "body". *Dharmakaya* is described as unlimited, unborn, unlocalized and formless, but it is sometimes represented as an unadorned Buddha. This is especially prevalent in Nyingmapa *tangkas* such as color pl. 126. The *Nirmanakaya* ("Body of Emanation") is the form assumed for human perception. The historic Buddha Shakyamuni is considered to be a *Nirmanakaya*, whose role is to allow the omniscience of *Dharmakaya* to appear directly in our world, in a human body, subject to birth and to death. The reason for the great veneration accorded to a living lama is that he, in his physical body, is also representing *Nirmanakaya*. *Nirmanakaya* in Tibetan is *tulku*: "reincarnated lama". Hence, the practice of portraying the religious masters in sculpture and painting developed in Tibet where the *Nirmanakaya* concept not only refers to the historic Buddhas, but is also embodied in a multitude of living or historic religious masters. When the Buddha principle is manifest at the intermediary level, between the mundane human perspective and that of the ultimate abstract truth, it assumes the aspect called *Sambhogakaya* ("Body of Enjoyment"). The *Sambhogakaya* may appear in diverse forms as Buddhas, Bodhisattvas or *yidams* (meditational deities), all representing various aspects of the character, qualities, attributes and powers of enlightenment. Avalokiteshvara, for instance, whether having one head and two arms or eleven heads and one thousand arms, is the *Sambhogakaya* manifestation of compassion and altruism. Peaceful or wrathful protective deities are often described as *Sambhogakaya*.

The images, *tangkas* and manuscripts described in this chapter are arranged in order of historic Buddhas and masters, guardians, *yidams*, Bodhisattvas and Buddhas.

Historical Buddhas and Masters

PLATE 102

Shakyamuni Buddha with Scenes of His Former Lives

Tibet, 18th century

Colors and gold on cotton cloth, H. 26 in. (66.0 cm)
Gift of Mr. and Mrs. John Gilmore Ford 1985 85.411

This lyrical painting is one of a set of eight[1] depicting scenes of the Former Lives of the Buddha (*Jatakas*).[2] In this set, the large, central figure of Shakyamuni dominates the center of the *tangka*. Here, he is placed on a golden and bedecked dais with lotus-petal base and radiant haloes. Two small seated monastic figures are at the lower right of the dais and perhaps depict the donors (or religious advisers to the donor) of this group.

The Former Life Stories, depicted in folk-tale style in a spacious landscape setting, show the virtuous and heroic deeds of the future Buddha in his numerous previous incarnations as animals, sages and kings. The brightly colored pavilions and courtyards are fanciful versions of Chinese and Tibetan noble mansions as the artist envisioned the settings for kings of ancient India. The lush landscape of blue and green rocks, hills and orchards is also idealized, a mix of the Indian setting of the Buddha's former lives and borrowed Ming Chinese stylistic conventions. In Newark's painting there are four main scenes, each identified by fine gold Tibetan script and each emphasizing the virtue of extreme self-sacrifice to achieve charity and compassion for all beings:

"The Story of the Tigress" (*Jatakamala* no. 1, to the right of the central Buddha): the "Great-minded One" beheld a starving tigress with her cubs. Shaken with compassion, he sacrificed his own body to feed the tigress by throwing himself from a cliff. The tigress devoured the lifeless body. The ground that held the treasure of the Bodhisattva's bones was sanctified (shown here by a *stupa* being worshipped).[3]

"The Story of the King of the Shibis" (*Jatakamala* no. 2, lower left, below the line of trees): King Shibi is famed for his charity. Indra, King of the Gods, tests Shibi by coming to him disguised as an old, sick Brahmin who requires blood. The king selflessly cuts his veins, collecting blood in a bowl to heal the Brahmin.[4]

"King Shrisena" (*Avadana* no. 2, across the top of the *tangka*, from left to right): Indra, to test the resolve of the king, assumes the likeness of a Brahmin whose belly has been torn open by a tiger. His six sons carry the Brahmin on a litter to the king and ask him to substitute his abdomen to save the Brahmin. King Shrisena, who is the Buddha, orders two of his men to cut off his lower body with a saw. Indra, with proof of the king's selfless compassion, assumes his real form and heals Shrisena.[5]

"King Chandrapabha" (*Avadana* no. 5, across the *tangka*, from left to right, under the central Buddha): The demon Rudraksha (shown as an ascetic) asks for the king's head as a gift, hoping to trick him into breaking his vow of charity. King Chandraprabha unhesitatingly consents, leaving his palace and going to the forest where he ties his hair to a tree and allows Rudraksha to cut off his head with a sword. The demon departs with the head wrapped in a cloth.[6]

1 Three *tangkas* of the set are still in the Ford Collection; five are now in American museums, one each in the Los Angeles County Museum of Art; Arthur M. Sackler Gallery, Smithsonian Institution, Washington, D.C.; Virginia Museum of Fine Arts, Richmond; Walters Art Gallery, Baltimore; and The Newark Museum (information courtesy of John G. Ford).

2 Some of these are from the most popular text of "Famous Life Stories," the *Jatakamala* (*Garland of Former Life Stories*) written by Aryashura, *circa* first to third centuries, in which 34 tales are recounted. See Rhie and Thurman, *Wisdom and Compassion*, pp. 72–3, 90–7 which publishes another *tangka* from this set, showing *Jatakakamalas* nos. 24–28. In the Museum's *tangka*, however, two of the segments most clearly correspond to stories in the larger *Avadana* group of 108 (see color pl. 103 for a full discussion of the *Avadana*), suggesting that this set of paintings was based on still a third compilation of *Jatakas*.

3 J. S. Speyer (translator), *The Jatakamala, Garland of Birth-Stories of Aryashura*, first published 1895; reprinted New Delhi, Motilal Banarsidass, 1982., pp. 2–8.

4 Speyer, *op. cit.*, pp. 8–19, gives a different version of the King Shibi tale, in which the Brahmin is blind and requires the king's eyes. Two stories involving King Shibi (who is the Buddha in a former life) are in the 108 *Avadana* stories: no. 85 in which the king's blood cures a sick man, and no. 91 in which flesh and blood are required by an ogre who is Indra in disguise. See, Tucci, *Tibetan Painted Scrolls*, pp. 520, 525, nos. 85, 94.

5 Tucci, *op. cit.* pp. 442–4.

6 *Ibid.* p. 448.

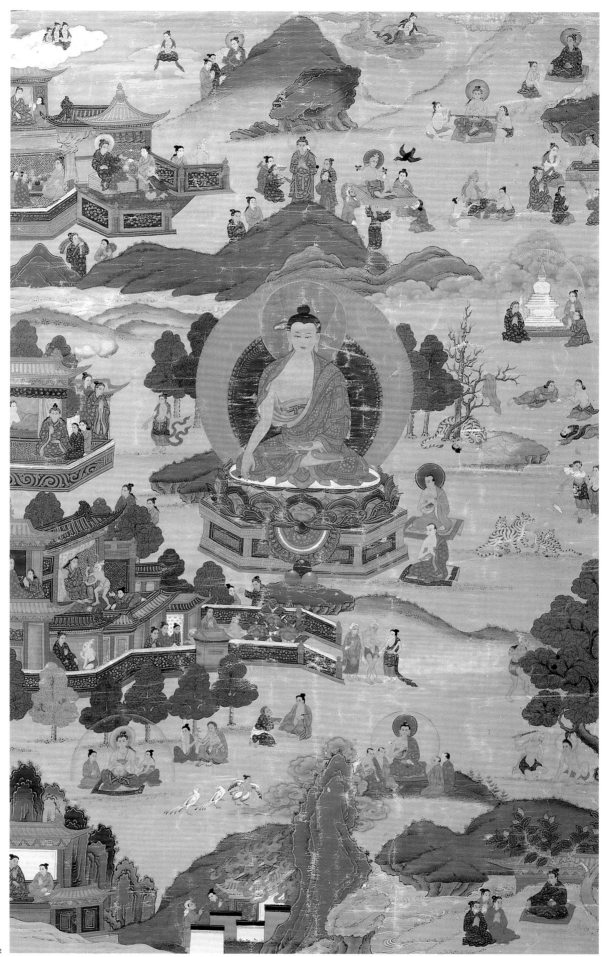

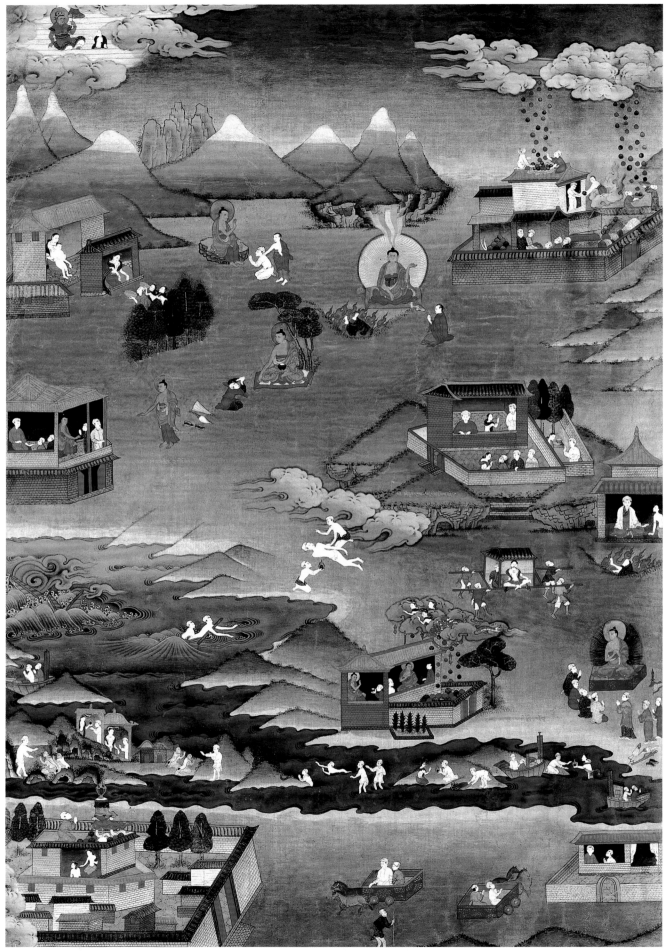

An unidentified scene at the extreme lower left, showing figures in a palace and then next to a flaming gate, may be from *Jatakamala* no. 4, "The Story of the Head of a Guild". In this tale, a wealthy pious man and his wife give alms to all but are tested by Mara, the Wicked One, who sets the entryway to the palace in flames and opens a chasm to hell. The pious man (in reality the Bodhisattva) is lifted above the flames and chasm to reach the alms-seekers.

A sage preaching to devotees at extreme lower right is identified as the "Brahmin Aranemi". It is unclear if this is part of a *Jataka* story.

Notations in golden *Lantsa* script are on the back of the *tangka*, corresponding to the Buddha's body and throne and the two seated monks.[7] All of the *tangkas* in this set are sewn into fine silk mounts with beautiful curtains tie-dyed to show the Eight Buddhist Emblems.

PLATE 103

Scenes from the *Bodhisattva Avadanakalpalata*
Tibet, 18th century

Colors and gold on cotton cloth, H. 30 ⅞ in., W. 21 ⅞ in. (78.4 x 55.6 cm)
Purchase 1985 Helen and Carl Egner Memorial Endowment Fund 85.81

This *tangka* is from a set depicting episodes from the 108 stories in the *Bodhisattva Avadanakalpalata*, a collection of *Jataka* tales by Kshemendra.[8] These stories illustrate, through the adventures of Buddha and his disciples, the laws of *karma* and the importance of self-discipline. A fine gold script identifies most of the vignettes here. Stories 43, 45, 46, 47 and 48 are so labeled; story 44 is illustrated here as well, although not identified as such.

Like the *Jataka tangka*, color pl. 102, the scenes here are executed with jewel-like juxtapositions of color, often with shaded gradations for the larger masses of buildings and rocks. These small scenes are dispersed across a landscape of soft green and tan, with snow-topped, blue-green mountains, rocky outcroppings, and a blue sea. Among the diverse heavenly and earthly individuals depicted, there is a recurrence of men staring out of a door or window directly at the viewer; these represent the "Master" who is in reality the future Buddha.

The Scenes are:

Upper right (story 43): At the palace of King Ser dog, multi-colored gems drop from the clouds above. More treasures are stored in the first storey and courtyard, where a blue-robed, "staring man" (King Ser dog, the future Buddha) and other figures are to be seen. The rain of gems is the king's reward for his selfless gift of food to his people at a time of great drought.

Upper left (story 44): In a shrine-like building, a child is held in the lap of a queen; golden balls flow from his hands. The child is Ser gyi lag from whose hands "20,000 coins miraculously fell each day." These were distributed to the needy. In the upper center, the kneeling Ser gyi lag is ordained as a monk by the Buddha, who sits on a rock pedestal.

Center left (story 45): A Buddha walks towards a palace, inside which are shown the episodes of Ajatashatru. This prince had imprisoned his father the king, who appeals for aid to the Buddha. Sheltered by trees, a Buddha sits on a mat holding a begging bowl; beside him kneels the repentant Ajatashatru, having cast off his royal insignia, fan, whisk and boots.

7 This archaic Sanskrit is often used for ornamental writing. The inscription reads: Om
 A
 Hung
("Body, Speech and Mind")
behind the Buddha
"Om sarvavidya svaha"
("Hail universal knowledge!")
"Om vajra-ayushe svaha"
("Hail diamond lifespan!")
"Om ye dharma hetu…"
(the Buddha's teaching of inter-dependent relativity, *Pratiyasamutpadahridya*: "All phenomena emerge from causes. These causes were expounded by Buddha. The Great Sage spoke about that which eliminates existential causes.") Translation by Lobsang Lhalungpa, courtesy of John G. Ford.

8 Ksemendra was an eleventh century Kashmiri writer. The Tibetan translation, *Chang Chub Sempeh Togju Pagsam Trishing* was done by the Lotsava of Shon (Dorje Gyaltsen) under the patronage of Phagpa Lama, at Sakya, in the mid-thirteenth century. It became incorporated into the *Tanjur* edition at the time of the 5th Dalai Lama in the seventeenth century. The Sanskrit titles and an extensive commentary on each of the 108 episodes is given in Tucci, *op. cit.*, pp. 437–534.

Center (story 46): Inside a palace at right, the marriage negotiations for the virtuous Prince Chesheh takes place. In the sea at left, the prince and his brother return with treasures from a voyage. Their laden wooden boat breaks into pieces amidst clouds and storm waves; they swim to shore with a piece of the boat; on the shore the evil brother puts out Chesheh's eyes with a stick, hoping to keep the riches for himself. The blind Chesheh wanders back to his betrothed who vows her love; because of their joint virtue, his eyesight is restored and they reclaim their place in the kingdom. To the right, Chesheh, dressed in the garments of a Tibetan king, and his queen sit in a pavilion while, below, the evil brother is devoured in flames.

Right, above the shore of the lower sea (story 47): The Buddha preaches to four *nagarajas*; King Prasenajit, dressed in a golden collar and attended by servants, approaches and takes offense at the *nagarajas'* lack of deference to him. In the ensuing battle, the *nagas* send onto King Prasenajit's palace a hailstorm which is changed to a rain of gems by the Buddha. Inside the palace, the Buddha receives the offering of the repentant king.

At the bottom of the *tangka* (story 48), Prince Siddhartha (the future Buddha Shakyamuni), with a servant, is shown twice riding in a horsecart; he vows to seek the miraculous gem *chintamani* and put an end to all poverty. On the island to the left of the sea, he visits the shrines of *naga*-beings. To the right of this island, he is shown wading and swimming towards another island, where he is greeted by the king of the *nagas* and given the *chintamani*. Further to the right, his laden sailboat is shown twice. Siddhartha loses the gem in the sea, but it is returned to him by a goddess. At the bottom left, Siddhartha is shown worshiping an elaborate Buddhist standard surrounded by gems, having accomplished his vow.

The painting has been sewn to red, gold and blue Chinese brocades, with a tie-dyed silk curtain and a bottom roller set with silver-damascened iron ends.

The style of this painting, and of many other extant narrative *tangkas*, has traditionally been called "Karma Gadri", which is associated with the Karmapa School of Eastern Tibet.[9] Although the cloud and rock forms and architecture are derived from Ming Chinese painting, there are elements which are in a purely indigenous style: the architectural details and the misconceived notions of how sailboats and horsecarts function. The pastel color scheme and, especially, the sensitively drawn portraits of secular figures and beautifully rendered umbrellas, boots, etc., show a knowledge of Indian Mughal painting. The inspiration for the spacious setting of these narrative paintings may also have come from Mughal miniatures, which often feature a subtly graded, two-dimensional background.

PLATE 104

Two *Arhats*

Tibet, 14th century

Colors and gold on cotton cloth, H. 44 in., W. 26 in. (118.8 x 66.0 cm)
Purchase 1991 The Members' Fund, Louis Bamberger Bequest Fund,
Avis Miller Pond Fund and W. Clark Symington Bequest Fund 91.265

This *tangka* is from a set depicting a lineage or group of holy men in an unusual double-portrait format. Both gold-skinned figures are dressed in monks' robes and seated on thrones in a manner common for *Arhats*, the saints of Buddhism.

9 David Jackson includes The Newark Museum painting and others depicting the *Avadana* in a group "designed" by Si-tu Panchen (Si-tu Pan-chen Chos-kyi 'byungs-gnes 1700–74), Kham, 18th and 19th centuries, in late Karma-sgar-bris style. See Jackson, *A History of Tibetan Painting*, FN 622, p. 285 and all of Chapter 10, pp. 259–87.

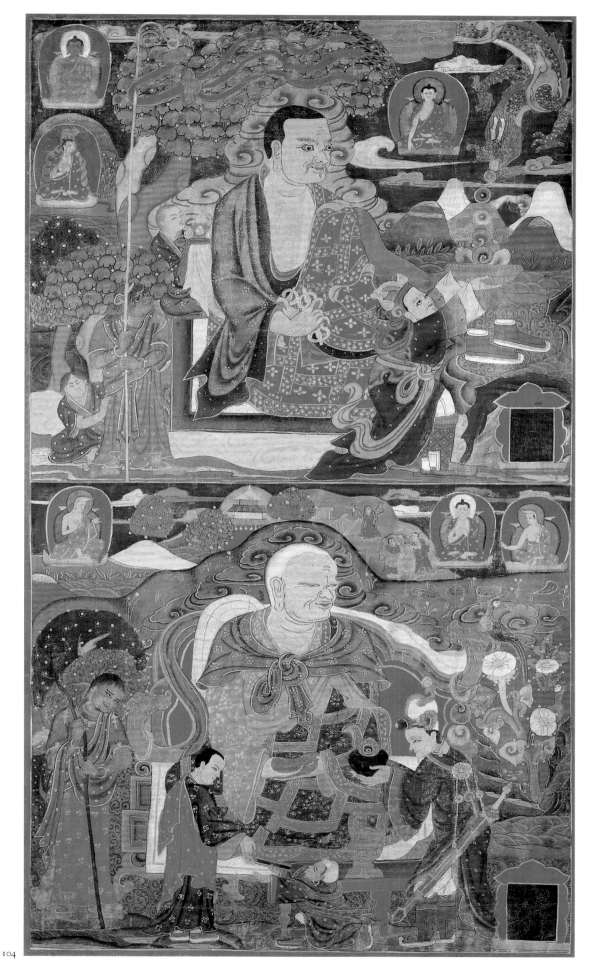

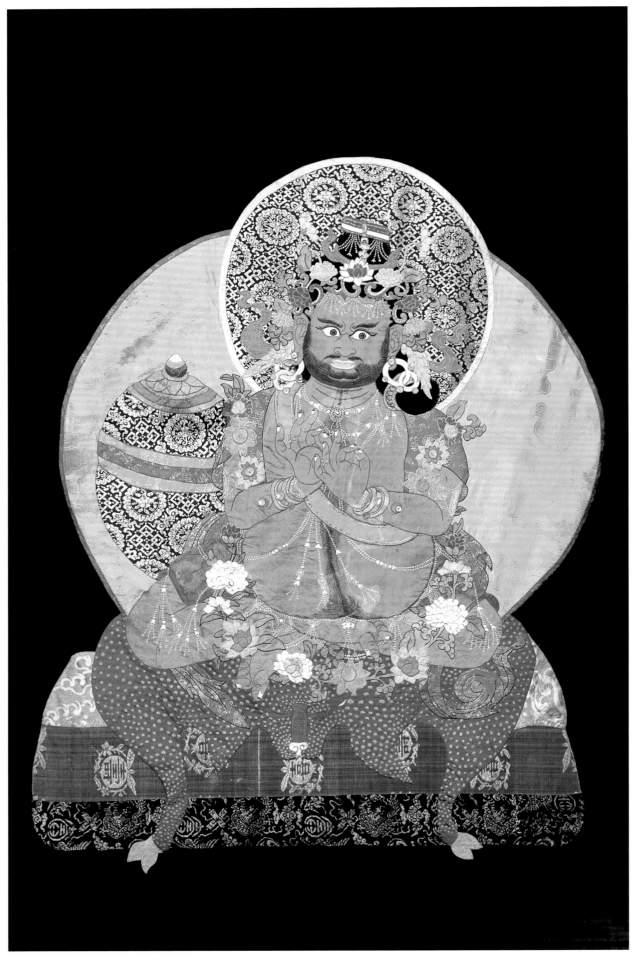

105

Arhats, usually in sets of sixteen, were the apostles of Shakyamuni Buddha. In early Buddhism, they symbolized the ideal patriarch who has achieved *nirvana*.

It is not possible to identify the figures in Newark's painting with any in known sets of *Arhats*. The silver lettering, now faded, in the cartouche at lower right in each register, once identified each figure. The ideal of the *Arhat* can be traced back to early Buddhism in both India and China, but the depiction of groups of such holy men became especially popular in China in the tenth to fourteenth centuries. Early Tibetan portraits of immortal patriarchs, such as here, show strong Chinese influence in the garments and landscape settings. The brilliant color, raised-gold decorations, exaggerated faces and the attire of the royal attendants all speak however, of a specifically Tibetan idiom.

The patriarch in the upper register holds a *dorje* and bell in his hands; he is attended by a smaller kingly figure who catches gems spewed forth from a celestial dragon. Behind the throne stands a monk holding a golden crown and, at left, is a gnome-like creature holding a flying banner. In the lower register, the patriarch rests his hands, in meditation, on his lap. A kingly figure with a large sword offers a begging bowl with a flaming gem and a dark-skinned attendant holds a staff. Enthroned Buddhas and saints and numerous human figures populate the skies and landscapes.

PLATE 105

Mahasiddha Virupa

Tibet, 18th century

Appliqué silk, damasks and velvets with cording and embroidery,
H. 50 ⁵/₈ in., W. 38 ⁷/₈ in. (128.6 x 98.7 cm)
Purchase 1976 Wallace M. Scudder Bequest Fund and The Members' Fund 76.188

Mahasiddhas ("Great Adepts," Tibetan *Grub-thob*), usually grouped in Tibet in a total of eighty-four, are saints and miracle workers in control of mystic forces. Based on historical or semi-historical persons, the *Mahasiddhas* are often por-

Fig. 4
A giant appliquéd banner unrolled on a hillside, Labrang monastery, Amdo, northeastern Tibet, 1920.

trayed as Indian sages, seated on cushions and animal skins (symbolic of their vow to liberate all suffering beings), and with a strap around their chests, for assistance in yogic postures. In this hanging, the round basket at the *Mahasiddha's* right is a container of spiritual food ("discipline, teachings and comprehension"). *Mahasiddhas* have special importance for Buddhist *tantric* schools as they personify the attainment of Buddhahood within a single lifetime.

This rare appliquéd and embroidered example is distinguished by beautiful garlands of lotus flowers on the head and body and a tiny book of scriptures on the piled velvet hair. Details of the body hair and bone ornaments are embroidered. At some point, the figure and his silk halo and aureole were removed from their original mounting; it is probable that this *Mahasiddha* was one of a larger group sewn to horizontal banners for display in a monastery prayer hall. The commissioning of appliquéd banners was an act of particular merit and prestige among Tibet's secular and religious leaders. Large size was crucial if these banners were intended for display in rituals and festivals. The use of brilliantly colored, luxurious (and costly) imported fabric and even jewel adornments was another important aspect of such commissions as recorded in the official biographies of the great lamas and princes of Tibet. Giant appliquéd banners, such as in fig. 4, would be rolled out on steep, bare hillsides or down specially constructed walls in or near monasteries for religious ceremonies. The banners could thus be viewed in reverence by the thousands of monks and lay practitioners who would gather for the teachings and blessings bestowed at such ceremonies. Such banners are in the class of great spiritual icons called *Mt' on grol*, "liberation through sight", images which radiate a spiritual presence which can remind onlookers of their own inherent enlightenment. This practice continues today. The present Dalai Lama frequently commissions appliqué banners for the Kalachakra teachings he gives world-wide.

This image is identifiable as Virupa because of the corpulent dark body and floral adornments, although the teaching hand gesture is not his usual *mudra*. Virupa, an Indian sage of *circa* the ninth to tenth centuries, lived an unorthodox life and became the *adi-guru* of the Lamdre (*lam'bras*), "path as goal" school. Virupa is especially important to the Sakya School. He can be seen in the upper row of the lineage of the Ngor Abbot, color pl. 112.

PLATE 106

Two folios from a *Gyalpo Kachem* manuscript

Tibet, 15th century

Ink, color and gold on paper, H. 22 ⅛ in., W. 6 ⅞ in. (56.2 x 17.5 cm)
Gift of Mr. and Mrs. Jack Zimmerman, 1984 84.396 A, B

The two folios are from a group of illustrated manuscript pages, now dispersed to several collections,[10] which have in turn been removed from the larger body of a text. The text is tentatively identified as the *Gyalpo Kachem* ("Will and Testament of the King"), a *terma* text which, according to tradition, was written by Songtsen Gampo in the seventh century and found by Atisha in the eleventh century.[11] Folio A describes the Potala Paradise of Avalokiteshvara and Folio B includes a narrative on the death of Songtsen Gampo and his merging with Avalokiteshvara. This is an early example of the Tibetan use of the *Nirmanakaya*

106

("Emanation Body"), e.g. Avalokiteshvara assumed a human body, Songtsen Gampo, to enable Buddhism to come to Tibet. Songtsen Gampo's fortress-temple, the Potala in Lhasa, takes the name of Avalokiteshvara's Potala Paradise (see Chapter I, p. 24).

The paper is stained dark blue to set off the fine gold script on both sides. The obverse of each illustrated folio is the beginning of a chapter with seven lines of carefully written gold script; the same script continues on the reverse, also in seven lines. Each folio is illustrated on both sides with two Buddhas. The drawing is in a fine black or red line, each golden Buddha seated in meditation on lotus bases, with the upper body either turned inward or to the front. The stylized landscape backgrounds feature green fields, white-capped conical mountains and blue skies with fluffy clouds. Beneath each Buddha is an inscription in gold giving the name of the Buddha, and above each Buddha are faint silver *mantras*.

The elongated figures of the Buddhas, the delicate line and the rich palette of these folios suggest that they were done at the time of the mature Tibetan style in the fifteenth century. The figures and their framing clouds are comparable to periphery groups in the Paradise of Amitayus, color pl. 142, and to similar paradise scenes on the walls of the fifteenth-century Gyantse Kumbum.

10 The others in public collections are in The Brooklyn Museum of Art and Los Angeles County Museum of Art.

11 The *Gyalpo Kachem* may be one of the many sections of a larger series of texts called the *Mani Kabum*. *Terma* are a type of text brought to Tibet at the time of the "First Diffusion" but hidden for later discovery. They are especially important to the Nyingma Order but are also used by the other Tibetan Buddhist schools.

PLATE 107

Paradise of Padmasambhava (in Tibet *circa* 779)

Tibet, 18th–19th centuries

Colors and gold on cotton cloth, H. 24 ¼ in., W. 16 ¼ in. (61.6 x 41.3 cm)
From the Heeramaneck Collection, purchase 1969 The Members' Fund 69.35

Traditionally, Padmasambhava, an emanation of Amitabha Buddha, is believed to have come to Tibet in 779 from Oddiyana (the Swat Valley, Pakistan?) to help *Tsenpo* Trisong Detsen subdue the native deities opposed to the founding of Samye monastery (see p. 25). Padmasambhava in his characteristic mitre-hat, long-sleeved robe and attributes (magic staff, *dorje* and skull cup), resides in his golden palace which, in turn, sits on the "copper-colored mountain" to which he retired when he left Tibet. The mountain, shown as an orange rock with caves and huts for ascetics, rises out of a swirling sea tossed with demons, animals, pavilions and jewels. On the shore below and to the sides of this sea is the land of the *rakshashas*, demons converted by Padmasambhava, shown as a landscape of rocks, trees, hills, and secular and religious architecture. On a bridge of golden light, two yogins cross from a *chorten* in the mountain to a *chorten* and temple on the shore (lower right). The architecture of Padmasambhava's palace is conceived as celestial (rather than Tibetan) and features golden roofs and garlanded walls, with Avalokiteshvara (and two attendants) and Amitabha in the upper storeys; its entrances are attended by the guardians of the four quarters (South, East and North visible). The celestial quality is further conveyed by the pink and gold nimbus around the palace. Among the deities and saints gathered in the courtyard immediately surrounding Padmasambhava are his two wives, his eight aspects, and figures associated with his legendary life. Clouds and rainbow bands fill the sky above and around the palace, supporting various beings. Shakyamuni, and Buddhas of the past and future, are in the flower-filled clouds at center top, and celestial musicians, offering beings and *dakinis* fill the rest of the upper area. In the middle sky are armored guardians and demonic and peaceful figures, many flying and dancing without benefit of cloud supports.

PLATE 108

Milarepa (*circa* 1038–1122)

Tibet, 15th–16th centuries

Cast brass with silver and jewel inlay, H. 4 ⅜ in. (11.1 cm)
Purchase 1975 Sophronia Anderson Bequest Fund 75.94

Milarepa ("cotton-clad Mila") is a popular figure of veneration in Tibet. Revered as a great mystic and poet, Milarepa exemplifies the way of the yogin in Tibetan Buddhist tradition. One of Milarepa's main disciples, Gampopa, founded the Kagyupa Order. The hand gesture to the right ear, used in Asia while singing, is Milarepa's characteristic sign. The earrings, long hair, meditation band, robes and antelope skin are commonly used for depicting yogins. The biography and songs of Milarepa compiled in 1484 by Tsang Nyon (1452–1507) may have prompted numerous likenesses of Milarepa at this time (see color pl. 7).

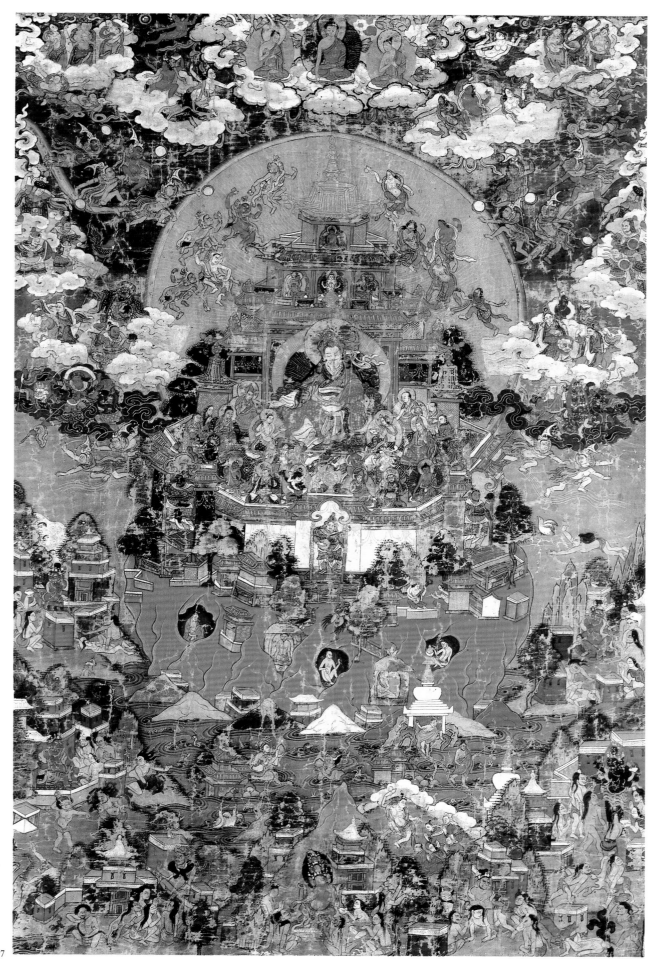

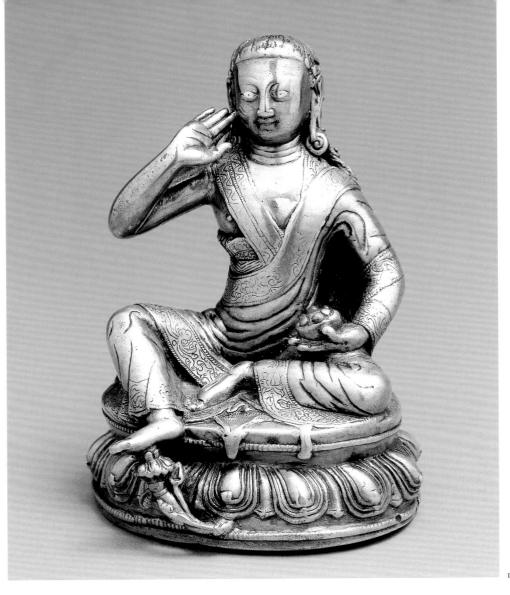

The alert "royal ease" pose, graceful arm positions and bright-eyed face have been skillfully modeled in a golden brass with silver inlay for the eyes. Incised floral and zig-zag patterns decorate the underskirt, shawl and meditation band; the antelope skin, which covers the top of the base, is incised to resemble fur. The saint's hair hangs in thick locks down his back, falling under the shawl at center back and over the two shoulders. Coiled rings adorn his distended ear lobes. The skull cup, held in the left hand, has been cast bearing two brass balls, and recesses hold five more balls, two of lapis lazuli, two of turquoise and a central ruby. The oval base has a single row of lotus petals of lavish, three-layered form with an under-row of petals between each.

PLATE 109

Lama Gyawa Gotsangpa (1189–1258)

Ladakh, Western Tibet, 15th–16th centuries

Cast brass with copper and silver inlay, H. 26 in. (66.0 cm)
Purchase 1969 The Members' Fund 69.32

This large and expressive portrait is of a noted mystic, Lama Gyawa Gotsangpa, who lived in Ladakh and Western Tibet and was a disciple of the founder of the Drukpa branch of the Kagyupa School. The hollow-cast brass body has a golden tan patina; the eyes are inlaid copper, silver and black pitch. Copper is

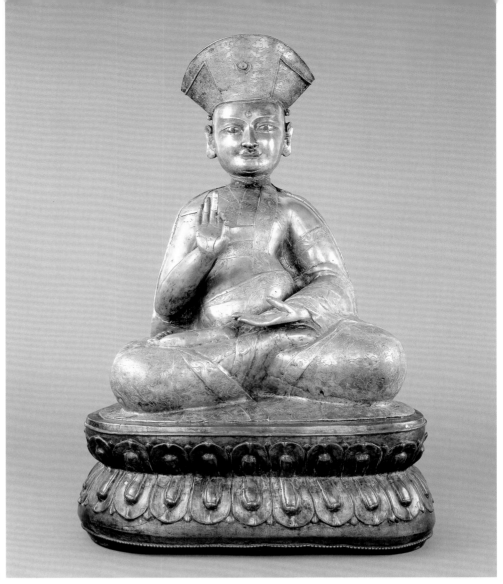

109

used for the lips and floral patterned vest brocade. The sun/moon emblem on the hat has an inlaid silver moon. The wide, staring eyes and prominent ears may be a convention for portraits of lamas, but the corpulent body seems idiosyncratic. The lama wears the stiff spreading hat (with loops for missing streamers) particular to the Drukpa Kagyupa sect and the vest, skirt and pieced robe of all Tibetan lamas. He gives the argument gesture with his right hand; the left rests in his lap and once held a now-missing object. His patterned, spreading robes are riveted to the separately cast, double lotus-petal base, formed from a copper alloy of different hue from that of the figure itself.

A double line of Tibetan script, incised along the bottom front of the base, salutes the image of Gotsangpa as "liberating by sight" and states that it is the personal meditation "support" of Phagod Namkha Gyatso, made by the "masters and students" of Gotsang Drubdeh.[12]

Gotsang Drubdeh is a hermitage near Hemis monastery, Ladakh, and consists of a cave, small temple and monks' quarters. Hemis is the foremost Drukpa establishment in Ladakh, founded by Tag Tsang Repa in the early sixteenth century and expanded under the patronage of Senge Namgyal (*circa* 1570–1642), one of the greatest of Ladakh's kings. The hermitage is presumed to date from Gotsangpa's time in Ladakh. The quality of the metal, use of inlay, and the style of the broad face and figure of the lama are consistent with other images attributed to fifteenth- to sixteenth-century Ladakh.

12 The dates of Phagod Namkha Gyatso and of another individual mentioned in the inscription, *Phyag sor rTse* in the lineage of *Bi-sho*, are not known.

PLATE 110

Sakya Pandita (1182–1251)

Tibet, late 17th–early 18th centuries

Colors and gold on cotton cloth, H. 24 $\frac{1}{2}$ in., W. 14 in. (62.2 x 35.6 cm)
From the Heeramaneck Collection, purchase 1969 Felix Fuld Bequest Fund 69.33

Sakya Pandita (Kunga Gyaltsen) was an eminent scholar, debater and translator who was also influential in broadening the political power of Tibetan Buddhism. He traveled to Mongolia in 1247 to begin the conversion of the Mongols to Buddhism (see Chapter I, p. 27). In this painting, Sakya Pandita is depicted giving the gesture of argumentation, his legs in *lalitasana*; he is dressed in the red lappet hat and orange, red and yellow robes of the Sakya sect. The varied gold patterning of the garments and throne coverings is exquisitely done, though the patterns do not conform to the folds of the cloth. The lacquered dragon throne and foot rest, and the craggy rock which holds offering vessels, gems and fruit, are placed in front of the landscape elements. Below Sakya Pandita is (left) Mahakala, and (right) the yogin Harinanda, whom Sakya Pandita converted, marvelously drawn with matted locks, adept's staff, meditation band and wolfskin-covered throne. Above are (left) Manjushri and (right) Lama Dragpa Gyaltsen, Sakya Pandita's teacher. In the background are monkeys in a bamboo thicket with deer above; a colorful bird is on the right corner of the throne, and a waterfall is at left, beneath receding mountains. The Chinese silk mounts are of fine, lotus-patterned brocade.

This composition has long been associated with a set depicting the previous incarnations of the Panchen lamas which exist in painted form, as well as in a woodblock edition of about 1737.[13] All of the details seen here, from the main figure and four subsidiary deities and yogins to the intricate, Chinese-style landscape, are included in the woodblock, but finely painted features such as the ornate brocades and the beautifully stippled tree-and-rocks landscape, are unique to this painting and a few others known in Western collections.

Questions remain for the paintings associated with the woodblock set, such as: which are derived directly from the set (even printed from the blocks)?; are the paintings necessarily dated concurrently with or later than the woodblocks? David Jackson has recently suggested that the original set of paintings, up to the 1st Panchen Lama (1567–1662) might have been done by the famous seventeenth century artist Chos-dbyings-rgya-mtsho at Tashilhunpo under the patronage of that great hierarch.[14]

PLATE 111

Tsongkhapa (1357–1419)

Mount Wu Tai, China, after 1805

Appliquéd silks, H. 77 $\frac{1}{2}$ in., W. 44 in. (196.9 x 111.8 cm)
Gift of Henry H. Wehrhene, 1942 42.198

Tsongkhapa (1357–1419) is a towering figure in Tibetan history and Buddhist theology. He was born in the Tsongkha district of Amdo (hence his name "person of Tsongkha") in 1357, and came to central Tibet in 1372. Tsongkhapa founded the reformed school of Tibetan Buddhism, the Gelugpa, and authored

13 Sakya Pandita is considered to be the second Tibetan (previous) incarnation of the Panchen Lama. Tucci obtained this *tangka* and one other in Tibet in the 1930s and published them in *Tibetan Painted Scrolls*, pp. 410–17, figs. 90–101, pl. 87 and color pl. L.

14 Jackson, *op. cit.*, pp. 234–43.

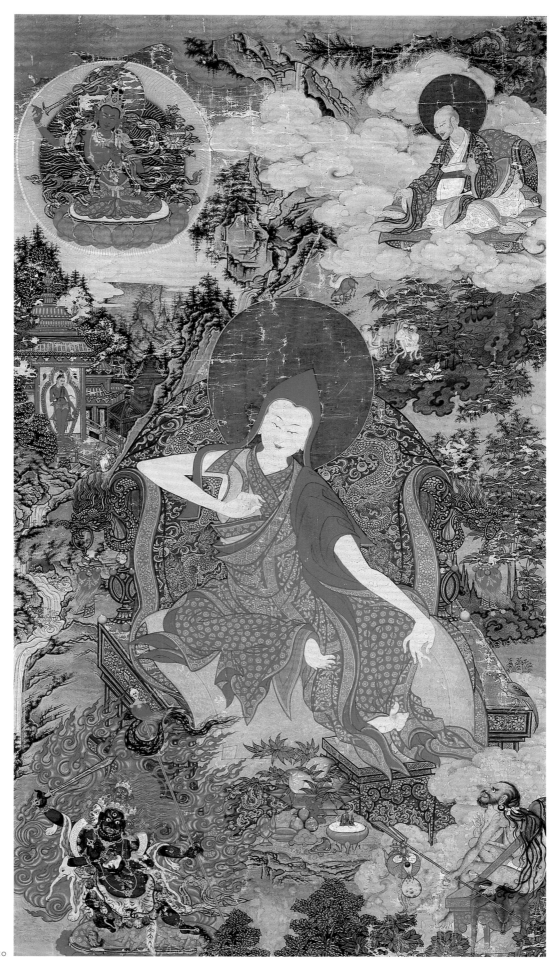

major treatises and commentaries which consolidated and expanded the work of previous great Buddhist masters. In 1409 Tsongkhapa established the first Gelugpa monastery, Ganden, near Lhasa, Tibet's capital, and instituted the Monlam festival in Lhasa (see p. 84). Tsongkhapa's two chief disciples founded the two other major Gelugpa monasteries in the Lhasa area, Drepung in 1416 and Sera in 1419.

More than life-size, the figure of Tsongkhapa is shown here seated in meditation on a lotus base with a nimbus filled with gems and scrolls behind a double halo. The saint's hands are in *dharmacakra mudra* and also hold the stems of lotus flowers on which rest, at shoulder level, his attributes—the flaming Sword of Knowledge and the Book of Wisdom which are also the attributes of Manjushri, Bodhisattva of Wisdom. He is dressed in the peaked yellow hat with side lappets, sleeveless vest, gathered skirt and flowing robe of a Tibetan monk of the Gelugpa School. In front of the lotus base is a low table holding a holy water vase, skull drum, monk's bowl with flowers, bell and *dorje*, and a covered skull cup on a triangular stand. Except for the monk's bowl, a common attribute of the great lamas, these are the chief objects used for *tantric* liturgies.

A Tibetan inscription, in black ink on a coarse cotton cloth, is sewn to the entire back of the appliqué. It states that this cloth image of Manjushri (manifested as Tsongkhapa) was given to the *geshé Sudhi* by "the lady of noble lineage, the jewel-holding protectoress". It is to be placed in the cave of *Nor-bzang*, at Mount Wu Tai, together with the *chorten* of the "remains of the Master *Jnana*".[15]

Although it is clearly related to Tibetan painted portraits, the Newark appliqué has many features that are Chinese. The most noticeable of these is the three-dimensionality of the nose, cheeks, neck, hands and arms, which was achieved by stuffing cotton batting under the silk fabric of these fleshy areas. Sculptural shaping is also seen in the delicate folds of the garments, especially the vest armhole and the robe draped over Tsongkhapa's left arm and legs. The appliqué technique used here is quite different from Tibetan practice and may be the style of a workshop at Mount Wu Tai catering to pilgrims.

During restoration in the 1980s, several Mongolian inscriptions, on fine paper, were discovered inside the appliqué, sandwiched between the pieced silk front and cotton back. These inscriptions, both handwritten and woodblock-printed, were carefully positioned to correspond to the head, chest and other body areas of the portrait of Tsongkhapa and were secured to the silks with the original appliqué stitches. Therefore the Mongolian inscriptions were original to the piece and specific to its consecration.

The printed sections are sacred texts associated with the consecration of a Buddhist object. The handwritten sections are copies of a letter dated in accordance with 1805 from a Jampal Dorje who was studying to be a *geshé* at Drepung Gomang Monastery, near Lhasa, to his "noble" older sister.[16]

The relationship of the Mongolian text to the appliqué remains mysterious. Clearly the "elder sister" of the letter was the patroness of her younger brother Jampal Dorje who was studying at Drepung. Many learned and influential Mongols went to study at such Tibetan monasteries and it was expected that the scholar monk's expenses would be underwritten by his family. The letter itself is a rare example of such personal correspondence.

15 Elliot Sperling, translation. See Reynolds, "A Sino-Mongolian-Tibetan Buddhist Appliqué in The Newark Museum", *Orientations*, April, 1990, pp. 81–7 for full inscription. Mount Wu Tai, in Shanxi province, northern China, is a great Buddhist pilgrimage site.

16 Nicola Di Cosmo and Gyorgy Kara, translation. See Reynolds, *Ibid.*

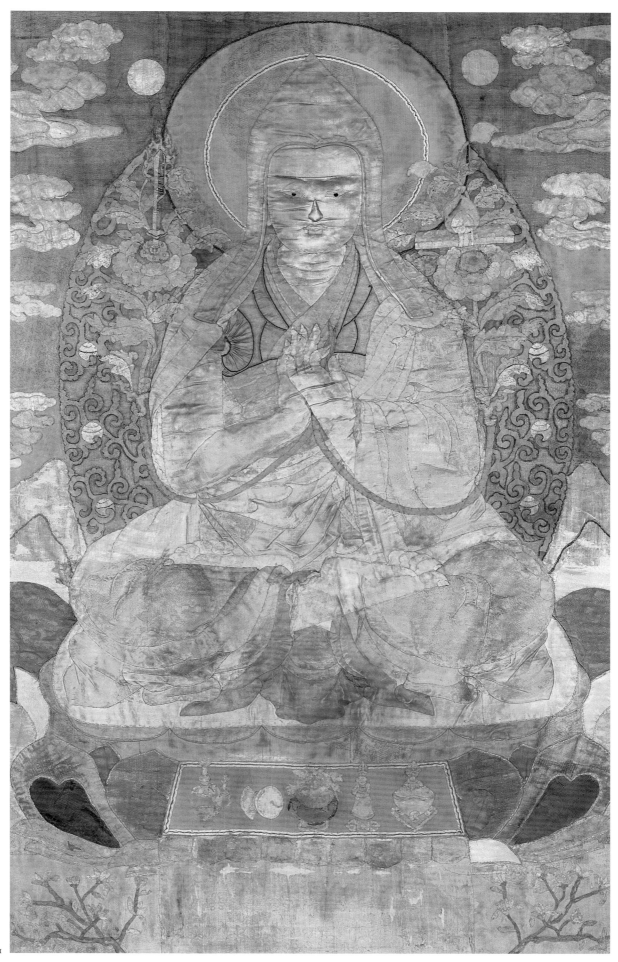

It would not have been unusual for an important Tibetan Buddhist art object to have been commissioned by a noble and pious Mongolian lady at Mount Wu Tai, which had been a Buddhist pilgrimage center since at least the fourth century. The area's specific role as the seat of the Bodhisattva Manjushri had special significance for the Mongols. Kublai Khan (1214–94), considered by the Mongols to be an incarnation of Manjushri, began a tradition of imperial identification with Manjushri and patronage at Mount Wu Tai.[17]

Although for now it can only be speculation, it is possible that a Mongolian noble lady commissioned the Tsongkhapa appliqué sometime after 1805, either in honor of or as a memorial to her younger brother, the *geshé* Jampal Dorje. She might have done this while personally on a pilgrimage to Mount Wu Tai.

PLATE 112

Portrait of Sonam Gyatso (1617–67)

Ngor Pal Evam Choden monastery, southern Tibet, circa 1667

Colors and gold on cotton cloth, H. 77 $\frac{1}{4}$ in., W. 62 $\frac{3}{4}$ in. (196.2 x 159.4 cm)
Purchase 1979 Anonymous Fund 79.65

This over-life size portrait with rich pigments and gold depicts Sonam Gyatso, the 20th Abbot of Ngor Pal Evam Choden monastery in southern Tibet.[18] The linear scrollwork in the red trilobed outer nimbus; the ornate gold scrollwork; the lion throne supports; the lotus-topped columns rising out of vases flanking the throne, and the hierarchic placement of *Mahasiddhas* and Sakya lineage figures in the four borders of the picture can all be seen in Nepalese-style Sakya portraits of the fourteenth to sixteenth centuries.[19] The use of Chinese elements is, however, a prominent feature of this painting. These include the playful dragon curling around the columns at left and right, the peony-like lotus flowers (gold on red), and the cloud and wave patterns (gold on gold) on the central figure's robes. The detailed accuracy of these elements suggests that they were copied from actual Chinese brocades, fabrics known to have been in monastery treasuries and possessed and used by important lamas. Sonam Gyatso's family connection to the court of the Princes of Gyantse would have ensured his access to such finery.

The calm central figure dominates the painting by sheer size. His thin, pale face and body are schematically rendered, with crossed eyes, large pierced ears, large hands in teaching position and feet in meditation position. He wears the Sakya red hat with domed top and gold-on-gold, cloud-pattern-edged lappets in a manner favored by several hierarchs at Ngor and Sakya, where the lappets are flippped up and cross at the top of the dome to create a helmet effect. Sonam Gyatso's ornate adornment is set off by the plain green halo and deep blue nimbus. His lotus base rests on a plinth inset with gold and precious stones. Grinning out from under the plinth are four lions of fantastic form. To the left and right are golden vases out of which spring flaming gems, stalks and leaves and flowers. At the tops of the stalks are flowers and gold-on-gold *chortens* decorated with *mantras* and garlands.

To the sides of the Abbot's head are two smaller portraits: on the left is a bearded lama holding a book and making the gesture of argumentation. He wears a hat with lappets flying back. On the right is a lama with an angular face

17 The retreat cave of Norzang mentioned in the Tibetan inscription was one of two caves on Mount Wu Tai associated with the 2nd Changkya Huktuktu (1717–86), where he spent much time after he became blind in later life. It is probable that, following his death in 1786, relics were enclosed in a *chorten* in the Norzang cave. Since Jnana/Ye-shes were alternative names for Changkya, it would seem that The Newark Museum's appliqué was consecrated specifically to be worshipped with Changkya's relic *chorten*, which by the nineteenth century would have been a focus of devotions in the cave associated with Changkya at Mount Wu Tai. One connection between the younger brother of the Mongol letter and Changkya is that both studied at the Gomang college at Drepung, the monastery which had been founded by Tsongkhapa's disciple.

18 Ngor was established in 1429 as a center of Sakyapa teaching, in a remote area near Shigatse. The buildings were almost completely destroyed following the Chinese occupation of Tibet in 1959.

19 The founder of Ngor, Ngor-chen Kun-dga'-bzang-po (1382–1456) and succeeding abbots were known as patrons of Nepalese artists who travelled from the Kathmandu Valley to work at Ngor on wall paintings and *tangkas*. See Jackson, *op. cit.*, pp. 77–82.

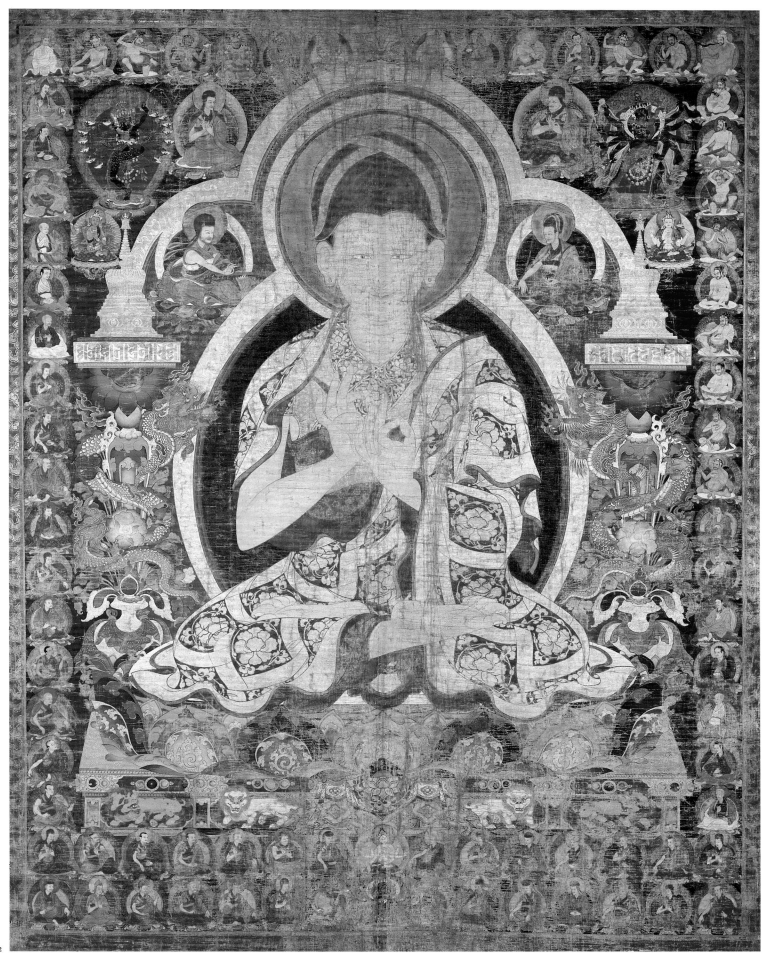

holding a blue gem(?) and giving the gesture of gift-bestowing; he has a similar hat to the main figure. A red scrollwork nimbus encloses the Abbot and two lamas who must be the closest to him in the lineage.

Beyond the throne and outer (trilobed) aura is a field of dark blue; on this are arranged eighty-two deities, *Mahasiddhas* and saints. The horizontal row across the top consists of ten *Mahasiddhas* flanking a central flaming-jewel motif and four figures (much worn) which appear to be deities. The corner spaces to the left and right of the lobed aura have groups of figures of various sizes. On the left are Hevajra and consort, Manjushri and a seated lama; on the right are Samvara embracing Vajravarahi, Avalokiteshvara and a seated lama. Each side is composed of vertical columns of sixteen *Mahasiddhas* and saints. The horizontal row across the bottom contains twelve saints, flanking Mahakala as Lord of the Tent, a blue figure holding a skull and thigh bone, and Lhamo. Above is a second line of fourteen saints, turning toward a central white Ushnishavijaya.

The extraordinary size of this work, one of a set depicting the Ngor Abbots,[20] suggests that it was originally installed permanently at Ngor. The mixed Nepalese-Chinese style is seen also in smaller scale in Sakya portrait sets attributed to the sixteenth to seventeenth centuries. Assuming that the portrait was done at the time of Sonam Gyatso's death in 1667 (or soon after), the portrait proves the survival of this school of painting, under Sakya patronage, through the seventeenth century.

PLATE 113

7th Dalai Lama (1708–57)

Tibet, 19th century

Part of the consecration contents of an image of Shakyamuni Buddha
Tsa-tsa (votive image), clay, H. 2 3/8 in. (15.3 cm)
Dr. Albert L. Shelton Collection, purchase 1920 20.455 L

The 7th Dalai Lama Lozang Kalzong (*blo-bzang skal-bzong*) spent much of his life in seclusion or exile because of foreign threats and internal government rivalry. He is shown here seated at center on a high dais decorated with carved scrollwork. He wears typical Gelugpa robes and hat and holds a lotus in his raised right hand and a book on his lap with his left hand. A canopy hangs over his head. A small table, also decoratively carved, is placed in front of the hierarch to hold ceremonial ojects which are too effaced to identify.

Three young monks attend him (one kneeling and offering jewels) and behind them, at right and left, are bookcases. The books are a special attribute of the 7th Dalai Lama who was revered as a great scholar. A Tibetan inscription across the bottom identifies the image as the 7th Dalai Lama.

Tsa tsa are small, flat clay images usually formed in molds. They are made of clay mixed with paper and sacred substances and are popularly used as amulets or for consecrations (see pp. 179). Such clay amulets are known from Pala-period India, *circa* eleventh to twelfth centuries, and are referred to in Buddhist ritual texts of the seventh century. This *tsa tsa* of the 7th Dalai Lama was but one of many sacred objects placed inside an image of Shakyamuni Buddha for consecration. These included 85 rolls of *mantras* packed in deodar chips and medicine balls.

20 A fine gold inscription, much worn, at the bottom of the painting identifies the portrait as "Sonam....Gyatso... 20th [Abbot] of Pal Evam Choden".

Guardians

PLATE 114

Mahakala as "Lord of the Tent"

Tibet, 14th–15th centuries

Tsa-tsa (votive image), clay with paint, H. 3 ³/₄ in. (9.5 cm)
Gift of Mr. and Mrs. Lorin B. Nathan, 1998 98.62.3

Mahakala, "The Great Black One", is one of the chief protector deities, here depicted in his *Gurgon* ("Lord of the Tent") form. Unlike most flat-backed *tsa-tsa* (see also color pl. 113), this image has a rounded, three-dimensional back (now damaged) and flat base (hollow, with a coarse cotton cloth glued on to secure consecration contents) so that it sits upright. The finely-molded front shows many nuances of the blue-bodied deity: the crown and garland of severed heads, the fanged and gaping mouth and the chopper and skull cup held in his hands. The green scarf swirling around his ears and looping around his arms and legs seems to be characteristic of wrathful forms of the early fifteenth century.[21] Red paint delineates his flaming hair, popping eyes and club.

This two-armed form of Mahakala, with his distinctive, squatting pose on a supine human form and the magic club across both his arms, is a special protector of the Sakya Order. A stone image of Mahakala of the Tent, inscribed with a date in accordance with 1292, gives firm evidence of the early establishment of this form in Tibet.[22]

PLATE 115 A & B

Two Protectors: Mahakala as "Lord of the Tent" and Begtse

Tibet, 18th–19th centuries

Colors and gold on cotton cloth, each H. 30 in., W. 20 in. (76.2 x 50.8 cm)
Dr. Albert L. Shelton Collection, purchase 1920 20.265, .268

The energetic drawing and strong coloring of these two paintings show the skill and power of comparatively late work. In both, the central fierce deity is given a vivid and dramatically modeled face and body, juxtaposed with elegant ornamentation. Above the flames and smoke of the deities and their fearsome entourages are pastel skies filled with deities and saints.

A: Mahakala (*Gonpo*) as "Lord of the Tent" (*Gurgon*) (see also color pl. 114) is depicted with a deep blue body, adorned with a garland of severed heads, a snake, a tiger skin, gold and bone ornaments and brocade scarves. A fanged and gaping mouth, flaming whiskers, brows and hair, a third eye and a *dorje*-topped skull crown are the main elements of Mahakala's expressive head. His two hands hold a chopper and skull while balancing a gem-set magic club across his arms; he treads on a pale-blue-skinned human figure lying on a lotus base. Flames encircle the body and fierce offerings spill out of two skulls at the base. To the lower left is Ekajata dressed in a leopard skin, holding a vase of elixir and seated on a lotus base. To the right is a blue-skinned demonic form dressed in robes and a garland of heads, with a sword and skull cup, treading on a human being. Directly below Mahakala is Lhamo on her mule. Flanking Lhamo are four more ferocious manifestations, Mahakala's "ministers", brandishing diverse weapons. All the fierce forms are enveloped in smoke and flames.

The beautiful landscape in the middle ground shows Mahakala's cemetery with a vulture devouring a body, a jackal (at right) and a she-demon (at left), while the black bird and black dog of his retinue appear at the left and right respectively. In the sky above, in pale pastel clouds, is Vajradhara at the center with three saints at each side from the Sakyapa lineage, bearing their attributes and seated on cushions. The 1292 stone image (see color pl. 114) features Ekajata and Lhamo in Mahakala's entourage, as in Newark's painting. The stone inscription mentions Phagpa, the great Sakyapa political figure.[23]

B: Begtse is red-bodied, with a third eye and fangs, and wears a golden helmet with a banner, flags and a skull. The chain mail cuirass (*beg-tse*: "hidden shirt of mail") is his definitive emblem, worn with a severed-head garland and a "frog-demon" front attachment. He steps to his right, with elaborate *makara* boots, onto a horse and a human, and brandishes a scorpion-handled sword, right, while holding a human heart to his mouth and clasping a bow and arrow and lance (with severed head and scarf), left. Flames envelop the deity, who is supported by a lotus base before which is a skull cup of ferocious offerings. Begtse's "sister" appears at the lower right of the painting, with blue body and red face, riding a man-eating black bear, and wielding a sword and *phurpa*. At the lower left, "the red master of life", attired in a manner similar to Begtse, rides a blue wolf and spears a human with his lance. The other beings who surround the central deity are (upper center) Yama, Lord of Death, in *yab-yum* pose with his consort, and the eight red acolytes known as the "eight butchers who wield swords", enveloped in smoke, each brandishing sword, knife, skull

21 Compare wrathful deities in the wall paintings of the Gyantse Kumbum (Ricca and Lo Bue, *The Great Stupa of Gyantse*, pls. 40, 42, 46).

22 Heather Stoddard, "A Stone Sculpture of mGur mGon-po, Mahakala of the Tent, dated 1292", *Oriental Art* (Autumn, 1985), pp. 260, 278–82; and G. Béguin, *Art Esotérique de l'Himalaya: La Donation Lionel Fournier*, Paris, 1991, pp. 53–5.

23 *Ibid.*

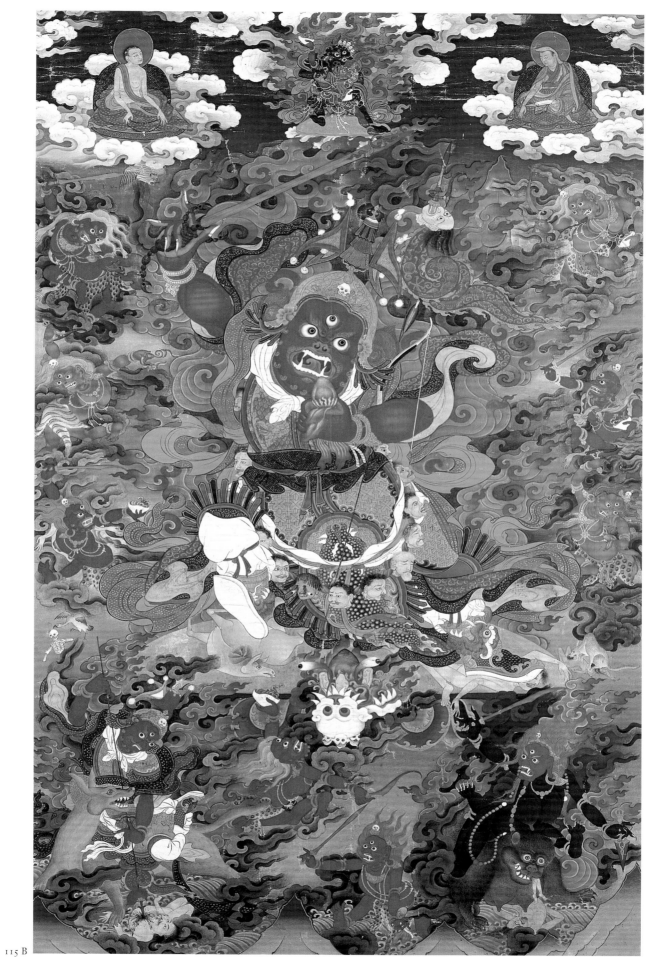

cup or human heart. Begtse's cemetery setting and lake of blood are shown in the middle and foreground. Two saints are in pale clouds at the top corners.[24]

Both paintings are sewn into handsome Chinese brocade mounts, and there is a pair of hand prints on the back of each, part of the consecration ritual.

PLATE 116

Vaishravana and the Nine Dralha Brothers

Tibet, 18th–19th centuries

Colors and gold on black satin, H. 31 3/8 in., W. 23 1/8 in. (79.7 x 58.7 cm)
Purchase 1972 The Members' Fund 72.159

"The Great Yellow Vaishravana", a form of the God of Wealth, is shown here as a warrior figure and Guardian of the North. He sits in the upper center on a fantastic spotted lion, wearing fine robes over his armor, holding a banner of victory and the "treasure-producing" mongoose. He has a halo and a radiant nimbus. Surrounding him are eight similarly-attired warriors on ghostly white horses; each holds a mongoose and a weapon or ritual object. As guardians of one of the eight directions (South, Southwest, West, etc.), these attendants of Vaishravana are known as the "Eight Masters of the Horses" (T. *Tadag Gyed*). In the lower section of the painting, eight more warriors race on horses around a central ninth rider. These are the nine *dralha* brothers. Their copiously detailed equipment includes red-tasseled helmets, tiger-skin cases for bows and arrows, and whips (each followed by a falcon); miniature tigers and lions sit on their shoulders. Demonic figures whirl among the brothers, either on foot or on various animal and human mounts. Herds of animals, common to Tibet, move in from both lower sides toward a central pile of bones and entrails. Below these is a "clothes line" of gargoyle heads, alternating with skins of tigers, humans and a *yeti*. Auspicious offerings, musical instruments and weapons are arrayed at the bottom. Vajrapani is situated at the very top of the painting, serving as spiritual progenitor to the scene. Paintings on dyed black silk are rare,[25] and this *tangka* is an especially effective sample of Tibetan black-background demonic visualizations. The transparent colors used in the painting give the swirling figures an eerie quality. They, and their enveloping flame and cloud aureoles, appear to vaporize into the dense black environment.

PLATE 117

Guardian Deity

Eastern Tibet(?), 9th–10th centuries

Cast brass with painted details, H. 11 1/4 in. (28.6 cm) (with wood pedestal)
Dr. Albert L. Shelton Collection, purchase 1920 20.451

This vigorous though crude image is solid-cast in one piece. The heavy muscled body of the deity steps to the right, both feet planted on a prone demon which struggles to rise, digging its hands into the rectangular wood base. The demon underfoot has a beak-like face, claw hands and raised vertebrae along the back. The six-armed deity wears a swirling drape across the hips, and over this an animal (tiger?) skin tied with a sash. Another sash swirls behind the hair and over the shoulders and arms, while still another crosses the chest. Snakes encircle

24 The helmeted manifestation of Begtse is the Shakyapa form of the deity. The bare-headed saint could be any one of many Shakyapa hierarchs; the yellow-hatted lama may be the 2nd Dalai Lama (1475–1542) who transmitted the Begtse liturgy to Shakyapa students.
25 This may be because silk is much more difficult to paint on than the more common cotton supports.

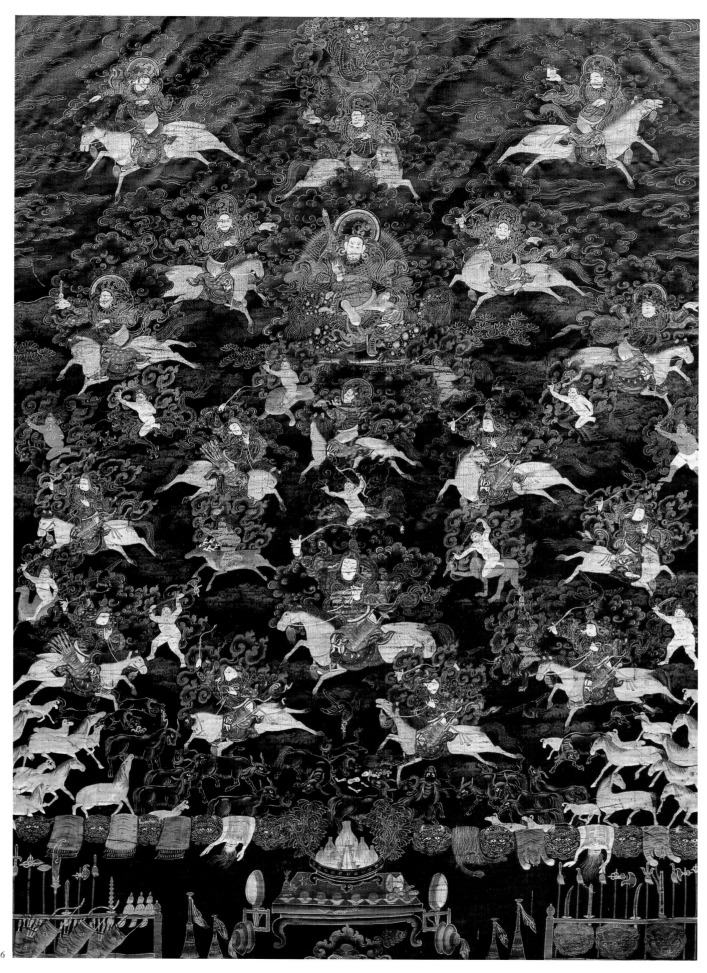

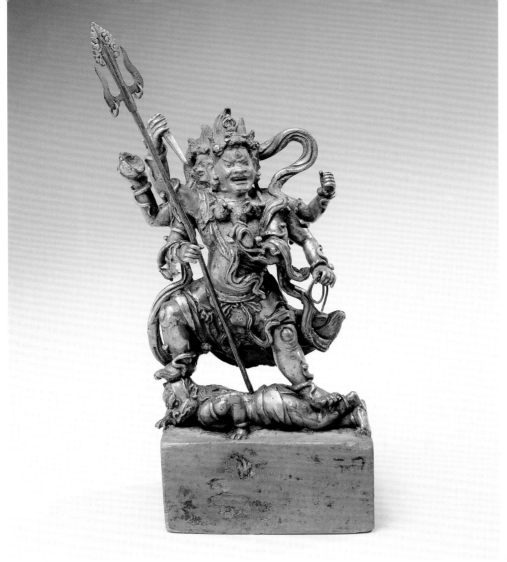

ankles, wrists and all six arms. The necklace the god is wearing appears to be three severed heads entwined with snakes. Tufts of flaming hair adorned with snake-and-skull crowns rise above each of the three, grimacing faces. Snakes are also at the deity's ears. A *dorje* (front prong broken off), on a lotus bud, is placed above the center face. Three of the god's six hands hold, respectively, a skull cup, a dagger blade and a noose. The other three hands were cast empty, but were intended to hold implements; the gold and silver damascened and red-painted iron trident now in the center right hand, and the iron noose now in the center left hand, are no doubt later replacements.

Fierce multi-armed guardians in menacing poses, wearing swirling scarves similar to the Museum's image, are found in Central Asian art of the ninth to tenth centuries where a blending of Chinese and Indic *tantric* sources is evident. Mahakala is one of the most important of these guardians, having developed in India from a fusion of ferocious Hindu and Buddhist deities. By the time of surviving written iconographies in the twelfth century, several forms of Mahakala are listed, featuring multiple heads and arms; skulls, severed heads, snake- and tiger-skin ornaments; flaming hair and heavy bodies. The Museum's guardian deity, however, follows a prototype which traveled from India across Central Asia at an earlier period, appearing in the Far East by the eighth century. The gnarled nose and brow, which gives the image such an emphatic expression, are conventions found on *lokapala*, *dharmapala* and Mahakala forms from several sites in Chinese Central Asia, dating from the eighth to tenth centuries.

Guardians with semi-nude and muscled bodies, adorned with swirling scarves, skulls, animal-skin loincloths and vigorously striding to one side, are frequently seen at the gateways to mandalas or protecting Buddhist icons at the same Central Asian sites. Bird- or animal-headed demons or attendants are often associated with these deities.

PLATE 118

Dorje Phurpa

Southern or Western Tibet, late 11th–early 12th centuries

Cast brass, H. 10 ³/₄ in. (27.3 cm)
Gift of Mr. and Mrs. Jack Zimmerman in honor of Eleanor Olson, 1970 70.27

Dorje Phurpa (Sanskrit: Vajrakila) is the personification of the "obstacle-removing force" more commonly seen in the ritual implement *phurpa* (the triangular-bladed device in the deity's lower left hand, see Chapter IV, pp. 140–143), and is particularly important in the Nyingmapa tradition. The Newark Museum's image is one of the earliest known Tibetan sculptures of this deity. Dorje Phurpa strides menacingly to his right on four legs. In the six hands are (right, top to bottom): a nine-prong *dorje*, a five-prong *dorje*, and an open palm; (left, top to bottom): a lotus(?) (stem broken off), a trident (top and bottom broken off) and a *phurpa*. The central and left faces have curved fangs; all three faces have a third eye, knotted brow, bulging eyes, bulbous nose and cleft chin. The headdress over the faces features a quatrefoil crown, piled hair with lotus bud finial and a coiled snake. Additional snakes adorn the ears, shoulder, wrists and ankles.

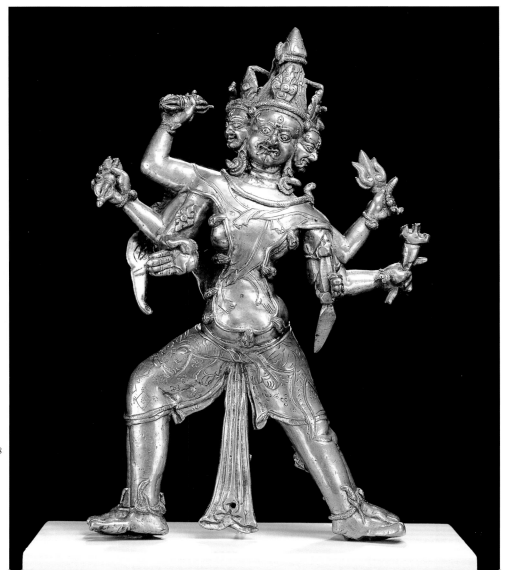

A chain of heads hangs around the torso; elephant and human skins are tied at the chest and a tiger skin is tied across the hips over a patterned loincloth.

This heavy, hollow-cast image has a golden-brown patina on the front; the back is completely unfinished, showing patches and gouges, with areas of black residue. Iron chaplets (from the lost-wax casting) are evident on the legs and chest, and a large, irregular patch of lead repairs a casting flaw in the neck. Traces of red paint remain in incised areas of the elephant skin the god is wearing and on the multiple arms and weapons; orange paint remains on the hair; faint traces of white paint can be seen on the two side faces. The "hour-glass" torso, the unfinished back and the method of attaching additional arms and legs are seen in Western Tibetan castings.

This form of Dorje Phurpa may represent an early sculptural adaptation of imported Indic concepts. Pala and Kashmiri semi-wrathful forms, Samvara, Vajrapani and Yama had been developed between the eighth and twelfth centuries, and these are comparable in stance and attributes with Dorje Phurpa.

PLATE 119

Palden Lhamo

Tibet, 18th–19th centuries

Colors and gold on cotton cloth, H. 35 in., W. 24 $^3/_4$ in. (88.9 x 62.9 cm)
Gift of Dr. and Mrs. Eric Berger, 1984 84.383

The fierce blue figure of Lhamo astride her white mule dominates this energetic painting. She wears a crown of five skulls topped by a crescent and peacock feather finial, golden earrings, bracelets, anklets and a brown brocade robe, open in front and swirling at sleeve ends and hem to reveal golden lining and red brocade trim. She grips a tiny human body in her rolled tongue, carries a *dorje*-mounted and silk-festooned club and skull cup of blood. Her other fierce accoutrements include flaming hair, human skin, a snake, and skull adornments on chest and belly; flames and smoke springing forth from her robe and green sash provide a fearsome aura. Her mule is attired in snake bridle, human and tiger skin blankets, and a skull pendant around his neck. A staff, tied to a skin bag with a snake and dice, is attached to the skin blanket. Lhamo's six acolytes, fierce-headed and sagging-breasted are shown dancing amidst her flames or riding their animal mounts at the corners. All of these visualizations fly over a sea of blood, from which emerge craggy green rocks with trees and bushes, and a jewel offering. A skull, with a heart and blood, is the central *tantric* offering below Lhamo. In the upper area, a pale blue sky shades to dark blue, with pastel clouds and, at the center, a tiny blue Buddha in a rainbow. The *tangka* is mounted in faded and damaged plain silks of the usual red, yellow and blue.

Lhamo is the special protectoress of Lhasa and the Dalai Lamas, particularly venerated by the 2nd Dalai Lama (1475–1542). When Lhamo's cult was first brought to Tibet, *circa* eleventh century, its already complex mix of Hindu and Buddhist aspects, as the Indian goddess Shri Devi, became enriched by assimilation with indigenous protectoresses. Her bloodthirsty attributes are drawn from legend. Once queen of the cannibal demons of Sri Lanka, she vowed to slay her only son because she failed to change her people from their evil habits. The flayed skin of her son is used as the blanket on her mule, see color pl. 96.

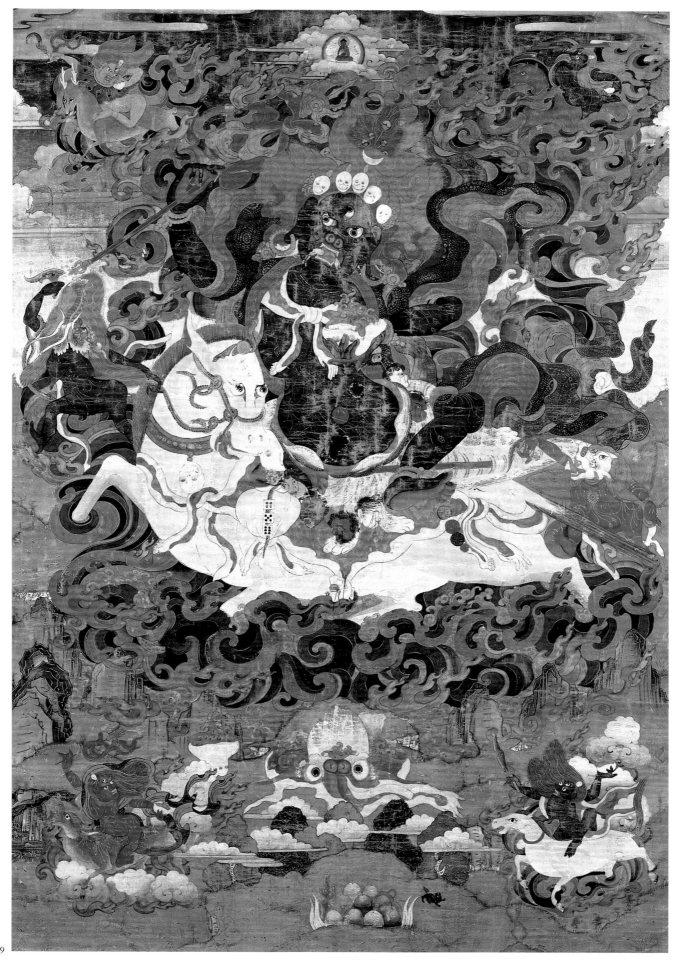

Yidams

PLATE 120

Vajravarahi

Tibet, 16th century

Cast and hammered silver with partial gilt and jewel inlay and painted details,
H. 12 ³/₄ in. (32.4 cm) (without base)
Purchase 1970 Mary Livingston Griggs and Mary Griggs Burke Foundation 70.3

Vajravarahi ("Diamond Sow") is a form of *dakini*, goddesses who "dance in the sky", "clothed in air" and symbolize wisdom. The sow's head emerging from her skull is her special symbol, representing the delusion which must be conquered and transformed in *tantric* practice. Vajravarahi is an important deity in her own right and also as a consort of Shamvara ("Supreme Bliss"), a *yidam*.

This extraordinary solid silver image of the "Diamond Sow" has been cast in one solid piece. A girdle of bone ornaments which completely encircles the figure's hips and upper legs, and the lower section of hair in back have been hammered from a separate sheet of silver and attached by hidden tabs at center back. Bands with trefoil ornaments at elbows, wrists, ankles and feet, a rosette and scroll necklace, rosette earrings and a crown with sashes are lightly gilded and set with turquoise beads (most of which are missing, revealing a red wax setting material). The crown has five skulls with red-painted eye sockets, and gilt scroll flourishes once set with turquoises. The "bone" ornaments on Vajravarahi's chest, belly and hips are set with turquoises at juncture points. An eight-spoke wheel set with turquoise decorates the top of her head (behind the crown). The goddess's face and the boar's head are painted in cold gold with naturalistic polychrome features. The antecedents of the ornaments can be seen in Nepalese versions of Vajravarahi, but there seem also to be links with Chinese and Mongolian ornamentation.

PLATE 121

Yamantaka Vajrabhairava

Tibet, 17th–18th centuries

Brass, cast on several parts with gilding, gold paint and pigments, H. 22 in. (55.9 cm)
Gift of Dr. Wesley Halpert and Mrs. Carolyn M. Halpert in memory of Rudi, 1996 96.84

The massive buffalo-headed Conqueror of Death, a fierce form of Manjushri, symbolizes the triumph of Buddhist Wisdom over Death. The head of Manjushri appears on top of the two tiers of eight ferocious heads, in front of a tower of flames. He embraces his consort, Vajravetali ("Diamond Zombie") with his two principal arms which hold a chopper and skull cup of blood and she feeds him from another skull cup and also clasps a chopper. They are both adorned with bone and skull ornaments. Fine gold and polychrome painting emphasizes the rapt expressions on their faces.

Yamantaka's other thirty-two arms, depicted in double rows of eight on each side, hold weapons and severed body parts of humans and animals expressive of his great powers. His sixteen legs trample over the prostrate figures of gods, humans and animals above a lotus base. Yamantaka is an important protector

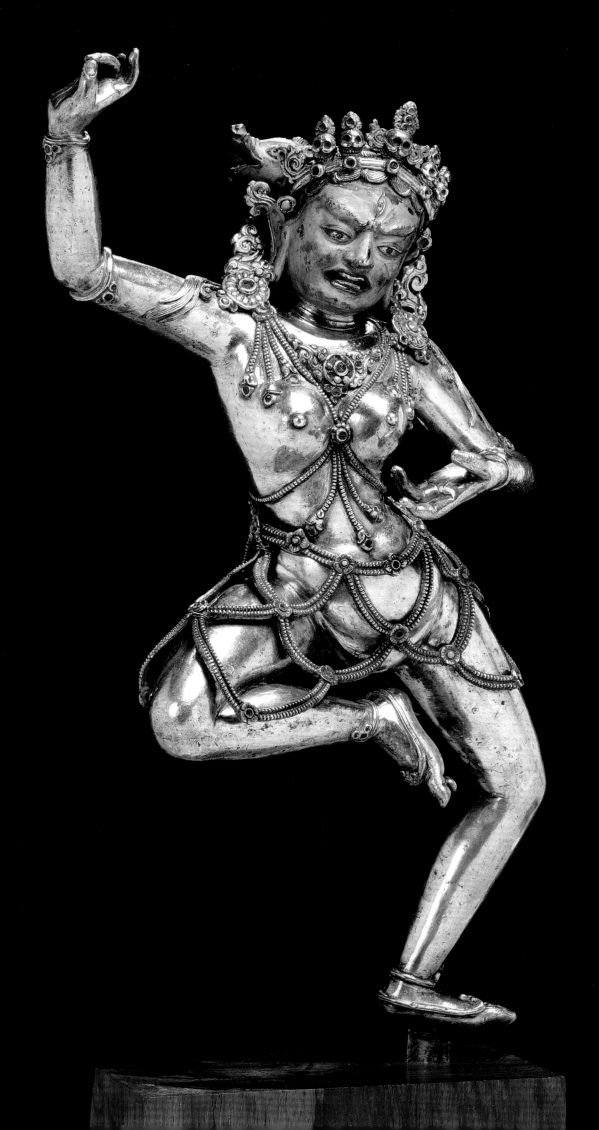

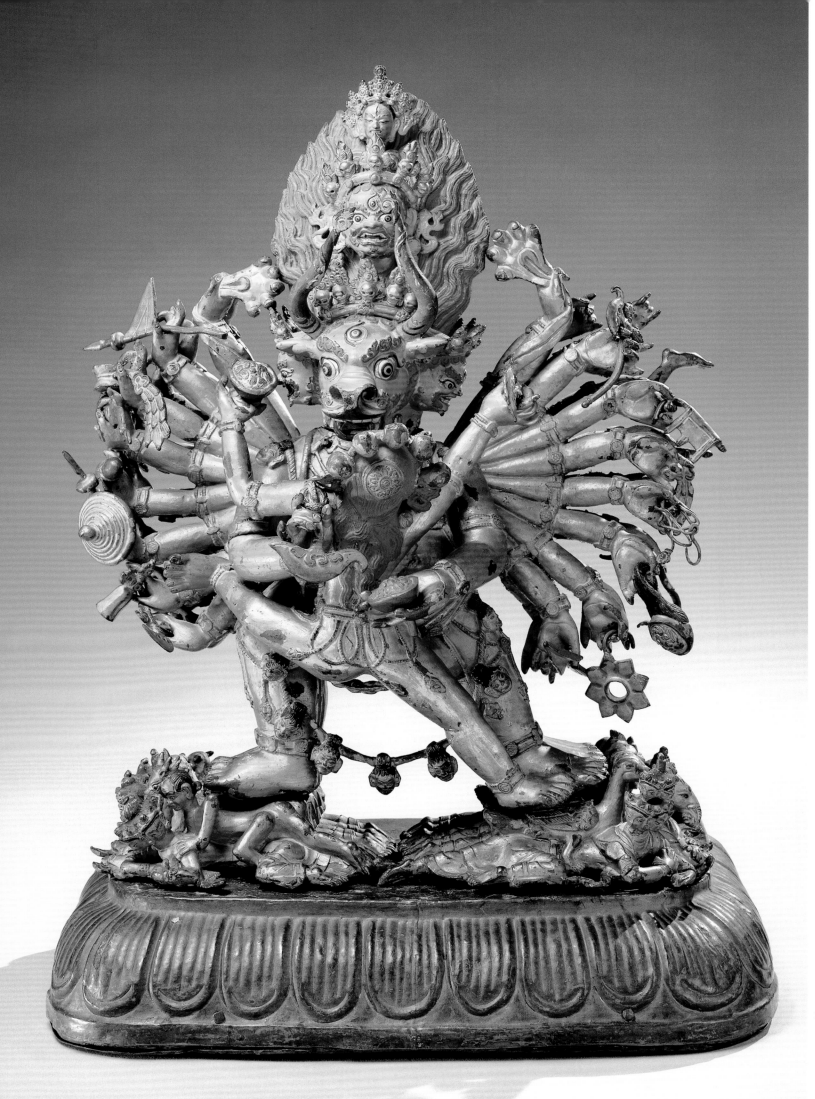

for the Gelugpa Order because of the special role he played in the life of Tsongkhapa, himself believed to be a manifestation of Manjushri (see color pl. 111). The iconography of Yamantaka Vajrabhairava combines aspects of the buffalo-headed Lord of Death, Yama, with the "Diamond Terrifier" form of the Hindu deity Shiva. In Tibet, this protector emerges in both sculpted and painted forms as a visualization of the transcendent power of Buddhist Wisdom.

PLATE 122

Achala

Tibet, 12th century

Cast brass with silver, copper and iron inlay, H. 5 $\frac{1}{4}$ in. (13.3 cm)
Gift of Judith and Gerson Leiber, 1985 85.404

The solid figure and hollow base are cast in one piece of golden-yellow brass; traces of gold paint and polychrome remain on the face and hair. The fine casting depicts the heavy-bellied deity in *alidha* pose, with a sword (forged iron blade attached to the brass *dorje* handle) in his raised right hand, and a *vajra*-noose in his left hand. Both hands give the *karana* gesture. His bulging eyes are

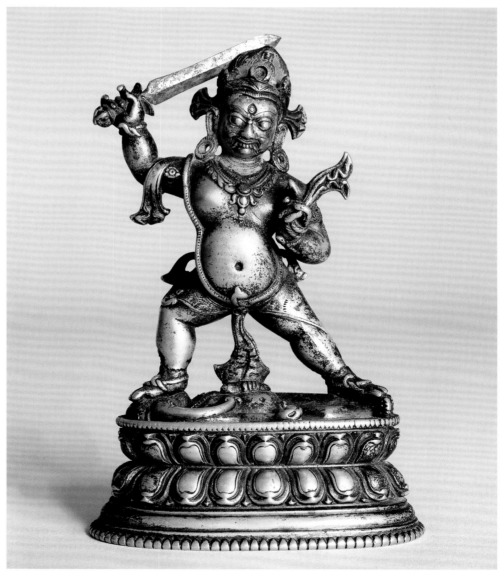

122

formed of silver and copper; the third eye, knotted brow, fangs, "flame" whiskers and large nose are carefully wrought. He wears a three-leaf crown (center leaf missing its inlay) and a patterned brow-band, with side flourishes behind the ears and a smooth band behind the head; the striated hair is pulled up to a flaming top-knot, tied with a serpent and with a seated Buddha at center. The figure is adorned with earrings, a floral necklace with center dark stone inlay, leaf-decorated arm bands and snakes at his neck, wrists, torso and feet. A tiger skin loincloth and scarves wrap the hips and hang between the legs, while another scarf encircles his arms.

On the oval, double-lotus base is the supine form of the elephant-headed deity, *Ganapati*, holding a boss, or fruit, in the left hand and a conch in the right. He wears a necklace similar to Achala's and is strongly modeled, with grimacing face.

This is an early Tibetan interpretation in a faithful Pala Indian style of the Buddhist conqueror "Immovable". Similar semi-wrathful gods appear in eleventh- to twelfth-century Pala sculpture and manuscript illustrations. Aspects of that style are seen here, especially in the crown, sashes, lotus pedestal, facial type and ornaments. Three *sadhanas* for this particular form of Achala exist, all written or translated by Atisha (see p. 39), so the form is called "Kadampa style" Achala.[26]

Plate 123

Kalachakra

Western Himalayas, 11th century

Cast brass, inlaid silver eyes, H. 8 1/2 in. (21.6 cm)
Purchase 1976 The Members' Fund, The Membership Endowment Fund,
The Bedminster Fund, Inc., The Mary Livingston Griggs and Mary Griggs Burke Foundation,
Samuel C. Miller and Dr. Andrew Sporer Funds 76.27

This extraordinary image was cast in one piece in a golden-yellow brass. The figures of Kalachakra and partner and the four prostrate figures underneath proved too heavy for the hollow lotus-petal base and ridged pedestal, resulting long ago in the loss of the front and side petals and in numerous cracks and holes in the back. Kalachakra's front and back faces, and all four faces of his partner have inlaid silver eyes. Worship practices have severely worn away the frontal head of the god, giving the bulging silver right eye and vestigial silver slit of the left eye a distorted appearance. Thus, the original lively quality of the faces, with their wide open eyes and indented pupils, can now be seen only on the two side faces of the partner and the rear face of Kalachakra.

Kalachakra, "The Wheel of Time", is the principal deity of the *Kalachakra Tantra*, believed to have originated in northwestern India in the tenth century, at a time of growing pressure from Islam on the western borders.

The image conforms to most of the *sadhana* requirements[27] for Kalachakra except that it is in seated rather than standing position. The innovative and unique use of bifurcation at the wrists has allowed the sculptor to show all required twenty-four hands and implements without the further crowding and confusion that twenty-four arms would have caused. Kalachakra and partner are adorned in jewels and wear five-leaf crowns over each face. Kalachakra also

26 Amy Heller has suggested a change in the identification of this image from Vighnantaka ("obstacle-conqueror") to the more specific Kadampa title of Achala, based on Atisha's ritual (*Tanjur* T. 3060) "Praise to the noble Achala King of the Wrathful Ones", which specifies the lunging pose trampling "obstacle-creating deities", snake and tiger adornments, "blazing sword of wisdom" and "*vajra*-lasso".

27 Bhattacharyya, *Iconography*, pp. 186–8, quoting the Nispannayogavali which was composed by the Buddhist author and mystic Mahapandita, Abhayakara Gupta who flourished *circa* 1084–1130 C.E., in northeastern India.

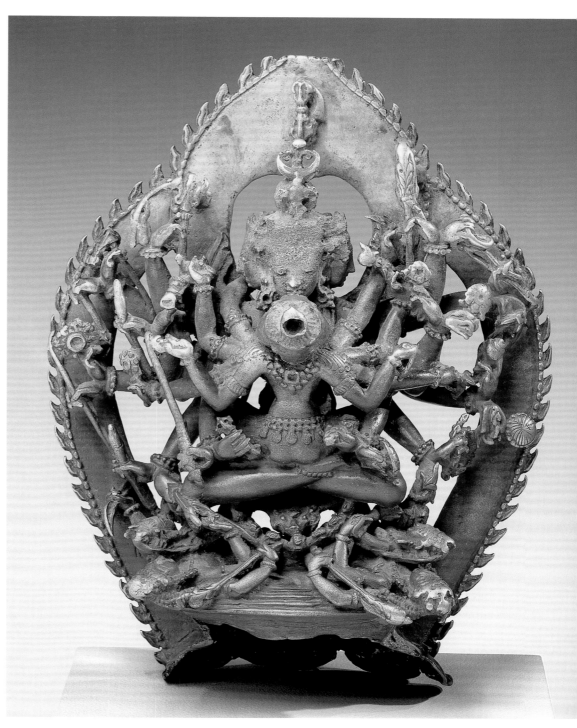

123

wears crossed *vajras* in front of his piled hair (below a crescent moon/sun emblem), a tiger skin covering and a rope of human heads encircling his body. The joined halo and nimbus has an outer edge of flames and a *vajra* at its apex. The quality of the casting, the graceful positioning of hands and heads on complex forms, the penchant for seated deities, and the shape of nimbus and base place the Museum's image stylistically with a group of brass images from Himachal Pradesh, dating from the tenth to eleventh centuries. These western Himalayan workshops produced both Hindu and Buddhist images, and were under the influence of Kashmiri artists. It is probable that Hindu as well as Buddhist traditions have been drawn upon to create this unusual image. All later surviving examples of Kalachakra, painted or sculpted, are of the standing form.

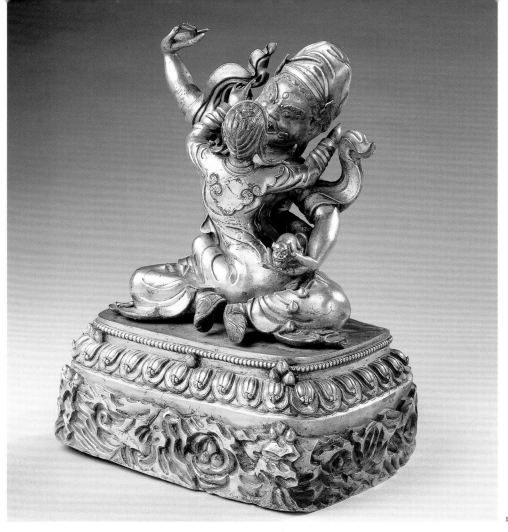

124

PLATE 124

Guru Sengye Dadog (*Sgras sGog*),
one of the Eight Aspects of Padmasambhava

Tibet, 17th century

Cast gilt copper with painted details, H. 8 ¹/₂ in. (21.6 cm)
Dr. Albert L. Shelton Collection, purchase 1920 20.456

This unusual image of Padmasambhava (see p. 25 and color pl. 107) depicts "the lotus born" in a wrathful form, embracing his mystic consort. The Guru's loose robe with sleeves flaring out like scarves, decorated boots and turban, and his consort's flowing robe "cloud collar", boots and tiara are the garments of ancient Tibetan royalty. He gives the *karana* gesture with raised right hand and holds a mongoose spitting jewels in his lowered left hand; she reaches out around her partner, both hands in *karana*. Both faces are fierce, with third eyes and fanged mouths, showing traces of paint. The rectangular base has a beaded edge above a single row of petals, and below this a wide band of craggy rocks, often used as a setting for wrathful forms. The mongoose's jewels roll down Guru Sengye's knee; additional gems are placed about the base. The finesse in depicting flowing drapery, the fine casting and gilding, and the knobbed-petal type of lotus base can all be related to Ming Chinese sculptures. The garments, animated poses and facial types, however, are particularly Tibetan. The earlier identification of the Newark image as the wealth-bestowing deity Jambhala was based on the presence of the mongoose, but it is now thought to represent a special form of Guru Sengye Dadog ("Lion's roar") from the Nyingmapa tradition.[28]

28 Dudjom Rinpoche, *The Nyingmapa School of Tibetan Buddhism: Its Fundamentals and History* (transl. Dorje and Kapstein), Boston, 1991, pp. 97–8.

29 This form of Padmasambhava is identified by Dr. D. I. Lauf as a special form according to the Terton padma Lingpa (1450–1521) of the Nyingmapa Order.

PLATE 125

Guru Dragpoche

Tibet, 17th–18th centuries

Colors and gold on black painted cotton cloth, H. 31 in., W. 25 in. (78.7 x 63.5 cm)
Edward N. Crane Collection, gift 1911 11.718

This emanation of Padmasambhava (see p. 25 and color pl. 107) is shown as a fierce, translucent, red-winged divinity with three heads, six arms and four legs.[29] Charged with fiery energy, he clasps his consort in *yab-yum* pose as they crush human beings on a lotus base. She is black, has a boar's head in her hair and holds a skull cup. Both have the third eye and wear skull crowns. His primary hands hold a chopper and skull cup; his remaining hands hold a sword, *dorje*, ritual wand and scorpion with an eye in each of its seven claws. He wears silk scarves, armor, elephant and tiger hides, garlands of skulls and a human

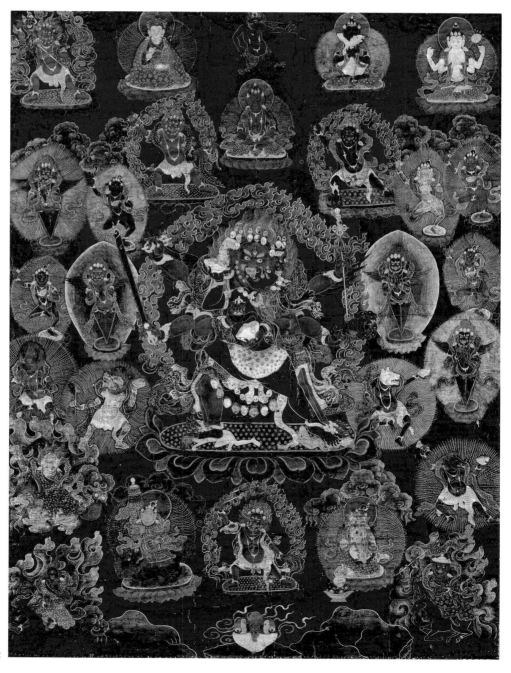

125

head; his consort wears a leopard-skin lower garment. They are encircled in flames. Twenty-seven deities loom out of the cloudy black ground around the central figures, some overlapping one another; they are all seated or dancing on lotus bases, except for the "sky-dancing" forms of *garuda*, the animal-headed "cloud fairies" and the animal-mounted kings. *Garuda/kyung* stands at the upper center between Padmasambhava and Samantabhadra. Amitayus sits below *garuda*, and Avalokiteshvara is at the upper right. The four *phurpa*, winged forms whose bodies end in triangular blades, can be interpreted as personifications of the implement *phurpa* (see pp. 140–143). The four animal-headed protectors and the four flame-encircled fierce protectors, all wearing tiger-skin loin cloths, and the five *dakinis* are part of the retinue of beings who guide the disciple. Closer to the earthly realm, represented by dark rocks and a fierce offering, are Vaishravana on a lion and the "Bearer of Life" with a golden vase, plus three robed fierce protector kings riding a lion, mule and horse respectively.

The rich, transparent coloration, the golden radiances around the figures and the black ground, unite to produce an effect of luminous beings in a world of midnight darkness. This *nagtung* ("gold line on black") format is used to particularly dramatic effect in *tangkas* of wrathful deities.

PLATE 126

Mandala of the Fierce and Tranquil Deities

Tibet, 18th–19th centuries

Colors and gold on cotton cloth, H. 28 1/2 in., W. 19 in. (72.4 x 48.3 cm)
From the Heeramaneck Collection, purchase 1969 The Members' Fund 69.34

The painting shows visions that confront the individual in the Bardo, the stage between death and rebirth. We learn from the *Bardo Todol* that, during the forty-nine days in the Bardo, each seed thought in the individual's consciousness revives. During the second stage called the Chönyid Bardo, the devotee sees visions first of the peaceful deities, then of the wrathful ones. The devotee who is spiritually prepared recognizes these fearsome ones as manifestations of the beneficent Buddhas. The spiritually unprepared soul is frightened; as the increasingly terrifying visions overwhelm him, he sinks into rebirth in one of the six realms instead of escaping from *samsara*.

The tranquil (upper) and fierce (center and lower) deities are, in this painting, combined in a single vision although two separate compositions are often used. The fierce deities are here given prominence with Chemchog Heruka, the winged, wrathful form of Samantabhadra, and his consort in the center; his hands hold the bell and *dorje* and the trident, mirror, noose and skull cup. The transcendent Buddha Samantabhadra[30] and consort, in peaceful forms, are placed in the center at the topmost point of the painting. Also in the peaceful region are the Five Buddhas (*yab-yum*), four accompanied by Bodhisattvas and guardians: Vairochana (below Samantabhadra); Akshobhya (lower circle at left); Ratnasambhava (upper circle at left); Amitabha (upper circle at right); and Amoghasiddhi (lower circle at right). The six *Loka-Buddhas* are interspersed in the upper section, holding the appropriate implement for the six regions ("*lokas*"). Filling the rest of the space are the five knowledge-holding deities

30 Samantabhadra is the primordial Buddha of the Nyingmapa Order; this *tangka* is identified by D. I. Lauf as from the tradition of Terton padma Lingpa (1450–1521).

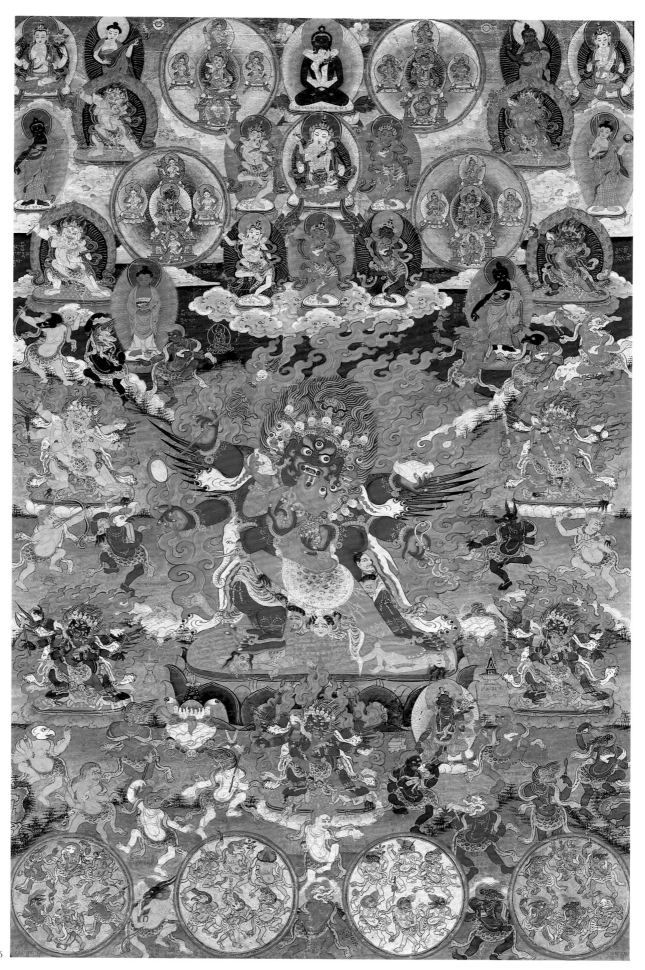

(also *yab-yum*) in dancing form, wearing tiger-skin loincloths, and the fierce doorkeepers of the Four Directions. Vajrasattva is at the upper right and Shadakshari at the upper left.

Surrounding the central fierce Chemchog Heruka are the five *Heruka* Buddhas (*yab-yum*), with the wrathful forms of the Five Buddhas above: Ratnaheruka (upper left), Vajraheruka (lower left), Padmaheruka (upper right), Karmaheruka (lower right) and Buddhaheruka (below center). Various animal- and bird-headed or fierce beings dance about in the rock and hill landscape. In the lower zone, within four circles, are the 28 animal-headed gatekeepers. Green Tara is on the right and fierce offerings on the left of the central lotus base. A caption in red Tibetan script is given for each deity or group of deities.

Bodhisattvas

PLATE 127

Avalokiteshvara

Tibet, 18th century

Appliqué silk damasks on brocades, cording,
embroidery, pearls and corals, H. 54 $^1/_2$ in. (138.4 cm)
Purchase 1957 Mr. C. Suydam Cutting and
Mrs. C. Suydam Cutting Endowment Funds 57.55

Avalokiteshvara (in Tibetan: *Chenrezig*, "with pitying look") is the Embodiment of Compassion and the most popular Bodhisattva ("Enlightenment Hero") in Buddhist art and practice. Avalokiteshvara is emulated in Mahayana teachings in which the practitioner strives for the collective salvation of all beings.

The four-armed form (*Shadakshari*, "Six-Syllable One")[31] of Avalokiteshvara is believed to be incarnate in the Dalai Lama. He is depicted here seated in meditation with his forward hands in a devotional gesture while his rear hands hold a rosary and a lotus flower. Attendent Bodhisattvas, also four-armed and giving the same gestures, stand at right and left.

Surrounding them is a charming paradise scene. The lotus pedestal supporting Avalokiteshvara arises from a pond in which float ducks and jewels. Peony-like flowers grow up and around the nimbus and halo encircling the central figure. Amitabha, the spiritual father of Avalokiteshvara, is at center top in a sky filled with conventionalized clouds.

Fine silk damasks and brocades imported from China have been used to beautiful effect both in the pictorial section of this hanging and in the mountings, which retain their original eighteenth-century form. Traditional Tibetan-style cording (silk-wrapped horse hair) is used to outline the landscape elements, while fine silk embroidery is used to delineate facial features and floral details. Finally, actual pearls and glass beads and gold thread have been sewn on for the rosaries and jewels.

Three different damasks woven in the same cloud-pattern form the deep blue "universe", and the red and yellow radiant borders of the *tangka*. The triangle-faceted patchwork rectangle at bottom can be variously interpreted but it is commonly used to demarcate sacred spaces in Buddhist liturgy.

31 "Six-Syllable One" is a personification of the *mantra "om mani padme hum."* See Martin, "Prayer Wheels", p. 23, footnote 14.

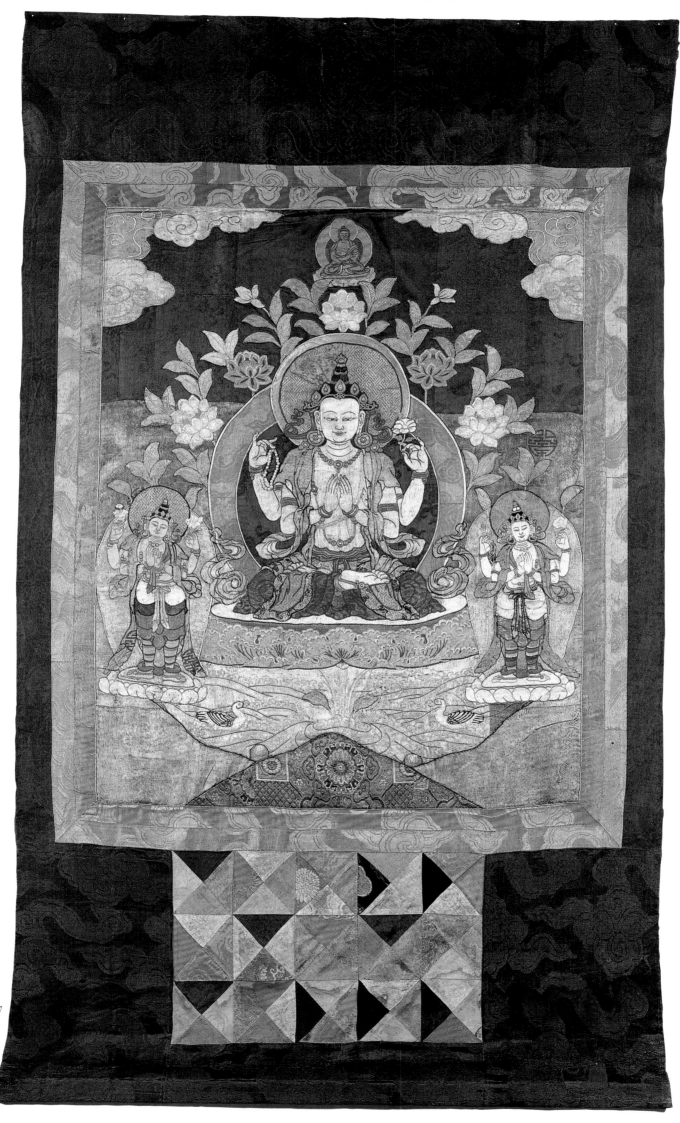

PLATE 128

Bodhisattva

Tibet, second half of the 13th century

Cast copper alloy with silver and gold inlay, H. 6 ³/₄ in. (17.1 cm)
Purchase 1979 The Members' Fund 79.442

This intricately-worked image is cast in one piece in an alloy whose reddish-gold color suggests a high percentage of copper. This reddish tone sets off the silver and gold inlay of floral and striped patterning in the deity's *dhoti*, the floral and lozenge design of the sash across the chest, and the diapered meditation band secured around the left knee. Silver has been used to form the double-beaded sacred thread which runs from the left shoulder to loop at the pelvis and returns up the back. The inlay work is carried fully around; indeed, the image

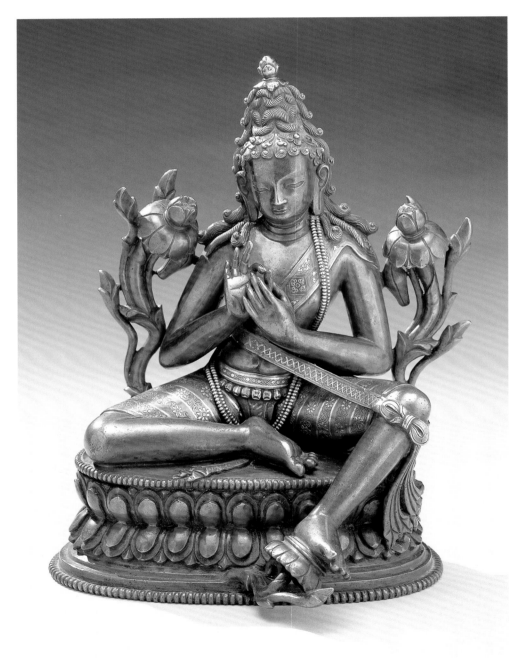

32 The pose and *mudra* are often used for Manjushri and Maitreya; the syncretic forms using Shiva's attributes, such as the headdress and meditation strap here, include the Lokeshvara ("Lord of the World") and Lokanatha aspects of Avalokiteshvara.

33 von Schroeder, *Indo-Tibetan Bronzes*, p. 240, and no. 71A; also published in Pramod Chandra, *The Sculpture of India: 3000 B.C.–1300 A.D.* (Washington, D.C.: The National Gallery of Art, 1985, no. 62)

34 I am indebted to Michael Henss for pointing out the Vajrapani and Tara images, and suggesting the existence of such a late thirteenth-century atelier. Vajrapani, Philadelphia Museum of Art, no. 1997-4-1 (published in Pal, *Tibet, Traditions and Change*, 1997, pl. 50). The Tara is published in *Xizang Budala Gong*, Beijing, 1996, pl. 298.

128

is as exquisite from the back as from the front. The lack of specific symbols and the presence of the meditation strap and lotus indicate a possible identification with any number of Bodhisattvas.[32]

The image is unmistakably in the Pala style and several elements correspond closely to twelfth-century northeastern Indian pieces: the teaching hand pose; thick, curving *utpala*-type lotus plants; base of double-layered lotus petals arranged in two rows under a beaded edge; piled, coiled locks of hair with jewel finial and the pendent left leg. Undoubtedly, the artisan had access to an actual Pala example. Small metal sculptures could easily have been carried from India to Tibet in the twelfth century and kept in a place of honor, to be copied in succeeding centuries. An ornate style of metal casting with extensive inlay and even gilding, attributed to the late phase of Pala art, may have been especially attractive to Tibetan patrons and pilgrims visiting Buddhist centers in northeastern India. One such image, found at Kurkihar, has many similarities to The Newark Museum piece: a patterned cloth band across the chest with a swirl at the left shoulder, a striped and floral patterned *dhoti*, thick, curving, lotus plants, a pendent leg pose and piled hair.[33]

Unusual elements in the Museum's image have made the place of manufacture and date difficult to determine until recently. The tenderly-featured face is unlike the sharply-defined, strong features of Pala images. Here, broad, smoothed brows, eyes, nose, mouth and the downward cast of the head resemble Newari casts of the eleventh to thirteenth centuries. Two remarkably similar images have now come to light, however, pointing to an atelier in Tibet operating *circa* second half of the thirteenth century. The other two sculptures are of the Bodhisattva Vajrapani in the Philadelphia Museum of Art and of a Green Tara in the Potala Palace. All three share a similar metal content, elaborate inlay, schematic double lotus-petal bases and suave seated postures. The decided Newari influence used on Pala models indicates the late thirteenth-century dating, when metalcasters and painters from the Kathmandu Valley were in southern Tibet working for Tibetan patrons.[34]

129

PLATE 129

Phagpa Lokeshvara

Lhasa, Tibet, date uncertain

Ivory, H. 5 ½ in. (14.0 cm)
Purchase 1973 Wallace M. Scudder Bequest Fund 73.130

A fascinating group of similar wood or ivory images, all identical in pose and attire, is now known. The components are: a rigid (as here) or very slightly curved pose; the left hand on thigh at the sash, the right hand in gift-bestowing gesture at the right thigh (missing in the Museum's ivory); a bare chest with a curved suggestion of breast line and raised nipples; a diagonal sash with a loop tie and a pleated drape down the left leg; a beveled belt, with a central disk buckle, from which "hooked" flourishes and vertical pleats fall in ripples between the legs; faceted cube earrings with pendent bottoms and a three-leaf, plain crown with striated hair, gathered up in back to a topknot from which two fat side loops extend and two locks come down behind the ears, ending in curls at the shoulders.

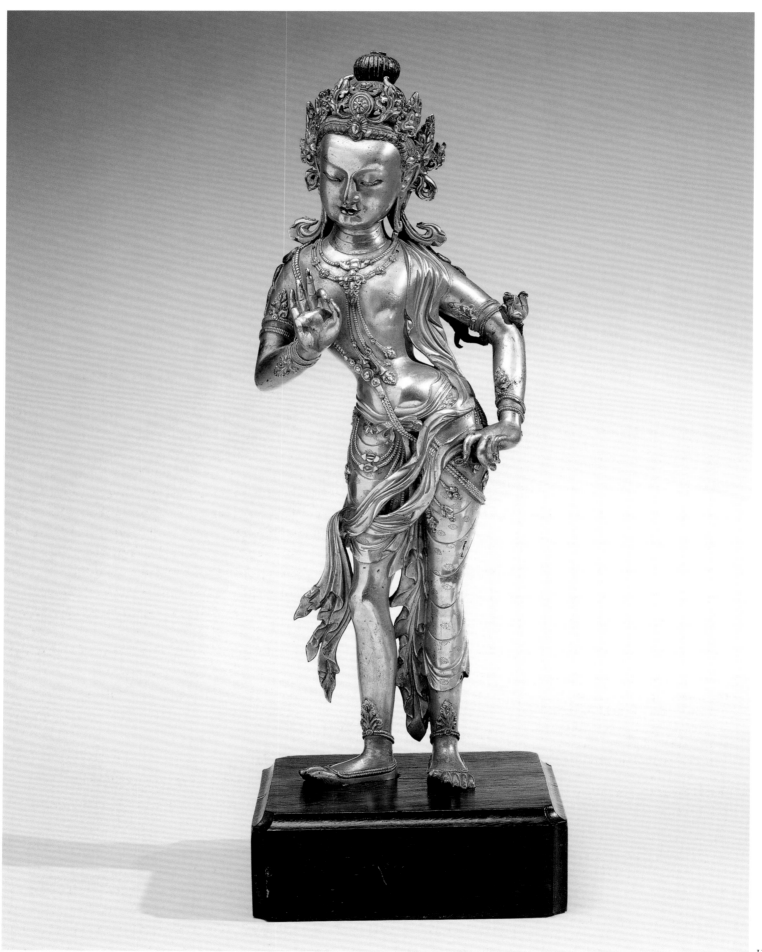

The Newark Museum's ivory has a separate piece, attached with two iron pins, to form the front of the feet, and it once had arms socketed in. A small square recess is cut into the center back for consecration.

The extraordinary exactness of pose, garments, earrings, hair and crown for this group has long suggested that an important original icon was being copied. The hairstyle recalls Indic and Nepalese images of both Hindu and Buddhist deities, and the pose and garments are seen on early Nepalese Bodhisattvas. Ian Alsop has now proved that this group is modeled after the famous sandalwood Avalokiteshvara, Phagpa Lokeshvara ("Noble Lord of the World"), in the Potala Palace which is traditionally believed to have been brought to Lhasa by Songtsen Gampo in the seventh century.[35]

PLATE 130

Bodhisattva

China, *circa* 1700

Cast gilt copper, H. 18 in. (45.7 cm)
Gift of C. Suydam Cutting, 1950 50.146

This image displays influences reflecting Nepalese, Tibetan and Chinese traditions and has, therefore, proved difficult to identify. The heavy precise casting, deep gold gilding, and the attention to the intricacies of looped and swirled drapery are characteristic of Chinese craftsmanship, yet the smooth sweetness of the face and the exaggerated and graceful sway of the body are distinctly Nepalese. The image appears to have been one of two Bodhisattvas flanking a central figure; vertical tabs cast on the soles of the feet would have been inset into a base perhaps large enough to accommodate three images. This might also explain the lack of attributes, although marks on the left arm indicate that there was once a lotus plant from the hand to shoulder. The entire top of the headdress is missing and has been replaced with a wooden topknot.

The felicitous combination of Nepalese and Chinese styles now seems to correlate most closely to Buddhist images of the Kangxi period (1662–1722). A fresh influx of Nepalese influence via Tibet may have come to China and Mongolia at this time, as many ornate, gilded statues in a Nepalo-Chinese style are known. There was also a conscious effort, under Kangxi, to recreate the fine Sino-Tibetan Buddhist art of the early fifteenth-century Yongle period.[36]

PLATE 131

Tara with Throne and *Prabhamandala*

Nepal, 10th–12th centuries; throne and *prabhamandala*: Tibet, 15th century or later

Assembled gilt copper, cast and hammered; silver wire and jewel inlay with traces of paint;
H. (goddess only) 14 $^3/_4$ in. (37.5 cm), (total) 28 in. (71.1 cm)
Dr. Albert L. Shelton Collection, purchase 1920 20.453

This large and complex image of the Buddhist "Savioress" was obtained by Dr. Shelton in Kham, but his notes give no particular provenance. The figure of the goddess is in the style of Nepal, but where and when were the figure, throne and *prabhamandala* made and assembled? The goddess is cast in one piece. Her hands give gestures of blessing and gift-bestowing. She wears a striped lower

35 Alsop, "Phagpa Lokésvara of the Potala", *Orientations*, April 1990, pp. 51–61. In a subsequent trip to Lhasa, having acquired the requisite gold, Alsop was able to witness the image unwrapped from the heavy clothing and jewelry which normally covers it. Although thickly covered in gold, the wooden image appears to be seventh century in style.

36 An important Buddhist project under Kangxi was the Golden Temple at Dolonor (Inner Mongolia), built in 1707 for the Tibetan Lama Ngawan Choden (the 1st Changkya Huktutu, 1642–1715). I am grateful to Michael Henss for bringing these references to my attention.

garment which is wrapped around her hips and legs, and is fastened by a wide hip-belt and a buckle. An undulating pleat hangs from belt to hemline. Each stripe of the garment is fitted with a central groove, set with fine beaded silver wires. A separate sash swoops from the left shoulder across the chest, under the right arm and across the back, to loop at the left shoulder and swing down behind on the left side. Heavy bands with a cross-hatched surface and jeweled buckles clasp her feet. Spiral bands, ending in upright leaves, encircle her upper arms and additional bands are at her wrists. The large earrings are mismatched: a long smooth tube is in the left ear and a thick, up-curving floral form is in the right. Her hair, marked with striations, is pulled up to a topknot with two side loops and two cascades down behind the ears, ending in curls at the shoulders. The crown, with a tall, central leaf and two smaller side leaves, curves down to frame her face, with grooves set with silver beaded wire. Chips of turquoise and turquoise- and red-colored glass are inset into all of the jewelry.

This image's exaggerated swelling hips and belly, upper arm ornaments, lower garment with heavy belt, body sash arrangement, necklace close to the throat and hair and crown type are found on Nepalese goddess figures of the seventh to tenth centuries. Mismatched earrings are seen in Nepalese images of the tenth to eleventh centuries. Precedents for silver wire are found in Indian Pala sculpture and in Tibetan images in the Pala style, but not in Nepalese castings. Similar grooves are cast onto Nepalese images, however, to receive strands of seed pearls or small garnets. The oval base is common to early Nepalese images. Originally, the figure would have been set onto a small lotus pedestal.

The reticulated throne base is constructed of hammered sheets of gilt copper. Separately hammered gilt copper ornaments (*dorje* with foliage, two lions, two caryatids, elephants with jewels on each side) have been riveted to the recessed section. A lion-like "Face of Glory" is part of the relief decoration at the center of the scroll border (above the *dorje*). A thin copper sheet, slightly recessed and decorated with an incised double *dorje*, is attached to the bottom of the throne enclosing the consecration materials. The weight of the goddess has caused the base to partially depress, so that the image now leans backward.

The *prabhamandala* is also constructed from a sheet of gilt copper, with both shallow and deep hammered designs. The throne-back and scroll-filled nimbus were obviously made specifically for this Tara. Fanciful animals frolic amidst the scrolls with a high-relief *garuda* and *nagas* at the apex. An outer rim of vines rises from a base of bird creatures to enclose flowers, leaves and banners. Outside this is a flame rim with a three-jewel apex. Matte gilding covers all the relief surfaces and red paint all the recessed surfaces.

It is proposed that the Tara image, so similar to the early Nepalese type of stately and voluptuous goddess-figure, is tenth to twelfth centuries in date. The technique and materials are indicative of Nepalese work. The base and *prabhamandala* are perhaps fifteenth-century additions, and seem more Tibetan in type. Accepting the supposition that a replacement base and *prabhamandala* were fashioned in Tibet for a large and fine imported image, it can also be argued that the image was regilded and silver wire placed in the grooves originally holding pearls or garnets, at the same time. Certainly the turquoise and glass inlay and the painted face are Tibetan work. Such "enthronement" and embellishment of an honored image are entirely in keeping with Tibetan practice.

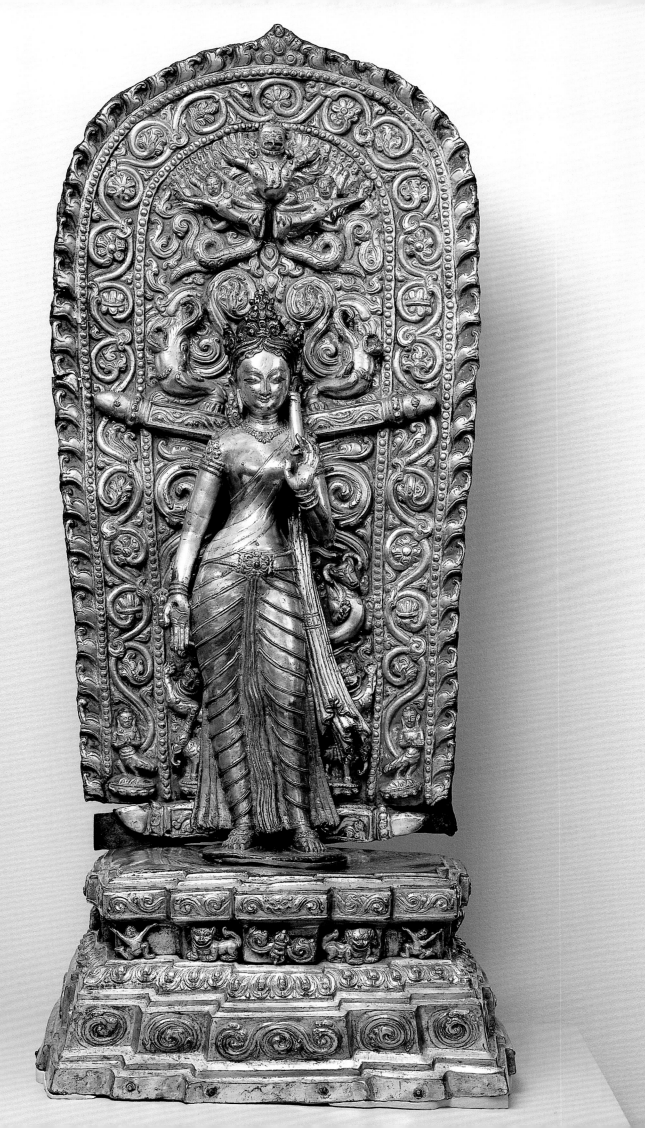

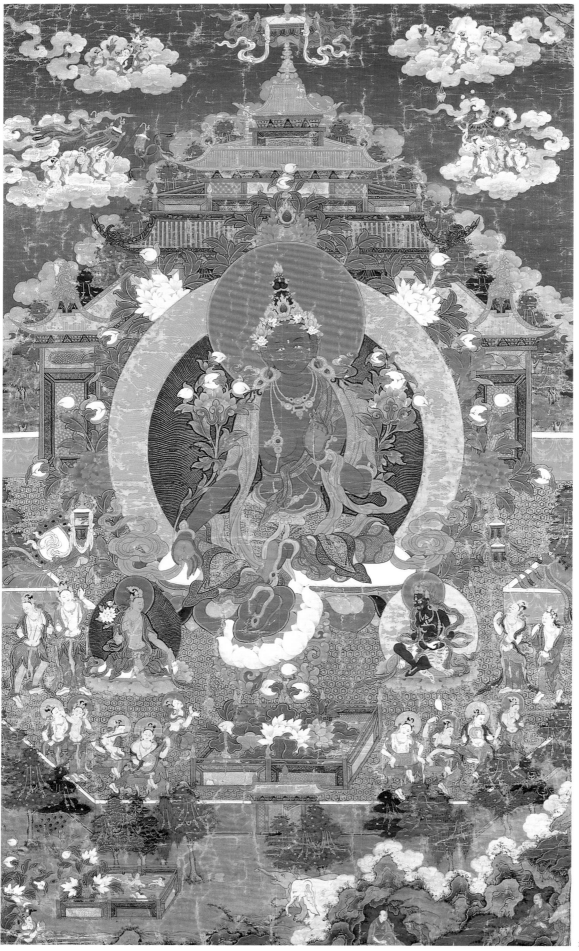

PLATE 132

The Paradise of Green Tara

Tibet, 18th century

Colors and gold on cotton cloth, H. 24 $\frac{1}{4}$ in., W. 21 in. (61.6 x 53.3 cm)
From the Heeramaneck Collection, purchase 1969 Felix Fuld Bequest Fund 69.36

The green form of the Buddhist "Savioress" is seated in her signature pose of royal ease on a lotus base, gesturing in *varada mudra* and holding the stems of lotus plants which bloom at her shoulders in blue and pink flowers and buds. She is adorned with golden-patterned silks of red, orange and blue, and golden jewelry. A red halo and blue-and-orange nimbus, backed by peonies and lotuses, set off her head and body. Her palace of golden and orange roofs, patterned walls and tiled floors, follows the Tibetan convention for sacred or royal architecture. The gold peaceful goddess, Marici, and the blue fierce goddess, Ekajata, are seated just below Tara. Celestial musicians, dancers and attendants celebrate the deity within the tiled courtyard, in the pale clouds above and in the lotus pond garden at lower left. From a similar pond, also surrounded by a tent wall, in the center of the courtyard, a lotus grows to support Tara's pendent foot. Fine, golden garlands festoon the beautiful green and blue trees outside the palace as well as the exterior walls of the courtyard. Two carefully painted individuals, a bare-headed monk and a red brocade-robed man, meditate in caves at lower right. Behind them wander a pair of elephants. The painting is sewn into fine Chinese silk brocades. The high quality of the drawing and jewel-like color are similar to that of the portrait of Sakya Pandita (color pl. 110). It is also interesting to see, in the eighteenth century, the retention of "paradise" devices, such as nymphs in walled pools, which appear in earlier vignettes, seen in the fifteenth-century Paradise of Amitayus, color pl. 142.

PLATE 133

Vajrapani

Tibet, 17th century

Cast gilt copper with painted details, H. 8 in. (20.3 cm)
Gift of Doris Wiener, 1969 69.30

The heavy body of the deity steps to the right and gestures menacingly, with a five-prong *vajra* held in his right hand and a snake in his left. He is adorned with snakes at ears, neck, wrists and ankles, and a long snake wraps itself from his neck to his groin. A beaded chain hangs from neck to belly and bands decorate his upper arms. A long scarf swirls behind his head, in front of his arms and behind his legs; an animal skin covers his loins with its head on the right knee and its two legs tied, along with a sash, between the legs. The god's fierce visage has fangs, "flaming" moustache, whiskers, a third eye and knotted brow. A bone bead-and-skull headdress ties with sashes at each ear, in front of raised and striated red-painted hair. The back of the figure is fully modeled; a rectangular opening at the center back (once closed with a plaque) reveals consecration scrolls. The separately-cast, hollow base is assembled from two sections which are joined between the upper and lower petal rows. Vajrapani treads on four snakes. Two rectangular slits in the back upper surface would have received pegs

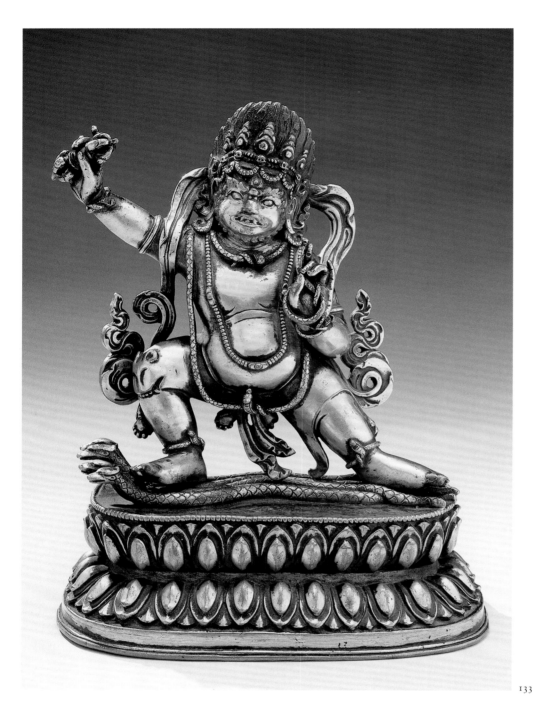

for the missing nimbus. The base is sealed with a copper plate on which a small crossed *dorje* is incised. Deep gold gilding covers all surfaces except for the hair, the back and the bottom of the base; where not cleaned, there is a heavy, dark brown patina.

The identity of this deity is problematic; the stance and arm positions are common to several wrathful forms and the *dorje/vajra* in the raised right arm is usual for many manifestations of Vajrapani ("*vajra*-wielder"). The proliferation of snakes here, especially the one held noose-like in the left hand and the four underfoot, would indicate a particular form, as yet unidentified. The style seems to be a synthesis of early Nepalo-Tibetan types of fierce deities and the heavy, ornate forms seen in fifteenth-century Chinese castings. The precise yet simplified rendering of the adornments and lotus base are similar to those on seventeenth- to eighteenth-century Chinese and Tibetan images.

Buddhas

PLATE 134

Book cover with the Five Transcendent Buddhas
flanked by Shakyamuni and Prajnaparamita
Tibet, 12th–13th centuries

Carved wood with gilding, silver and colors, L. 27 ¹/₂ in., W. 8 ³/₄ in. (69.9 x 22.2 cm)
Purchase 1988 C. Suydam Cutting Bequest Fund and Louis Bamberger Bequest Fund 88.291

37 Many such "orphaned" covers have left
 Tibet in the last decades. The original
 manuscript books seem to have been
 destroyed during the first phase of the
 Chinese occupation of Tibet, 1959–75.
 For a complete book of similar size,
 see color pl. 66.

38 The Transcendent Buddhas are often
 called *Tathagata*, a Sanskrit title meaning
 "One who has gone over into suchness,"
 e.g. realized the transcendent reality of
 all things.

This finely carved, gilded and painted wooden block was once the top cover of a Tibetan manuscript volume of scriptures.[37] The slightly convex outer side is deeply carved with seven niches enclosing the Five Transcendent Buddhas flanked by Shakyamuni (left) and Prajnaparamita (right). The Five Buddhas, representing the Five "Families" and the Five Directions, were developed in Mahayana Buddhism in India, *circa* first to second centuries C.E. (see Chapter I, pp. 35–36).[38]

On this book cover, they are shown in royal garments and jewelry, seated on throne cushions in recessed, arched and columned niches. Vairochana ("Resplendent") is at the center with "wheel-turning" *mudra* and lion supports; Akshobhya ("Imperturbable") is at left center with "earth-witness" *mudra* and elephant supports; Ratnasambhava ("Jewel-Born") is at second left with "gift-bestowing" *mudra* and horse supports; Amitabha ("Boundless Light") is at center right with hands in meditation and peacock supports; and Amoghasiddhi

134

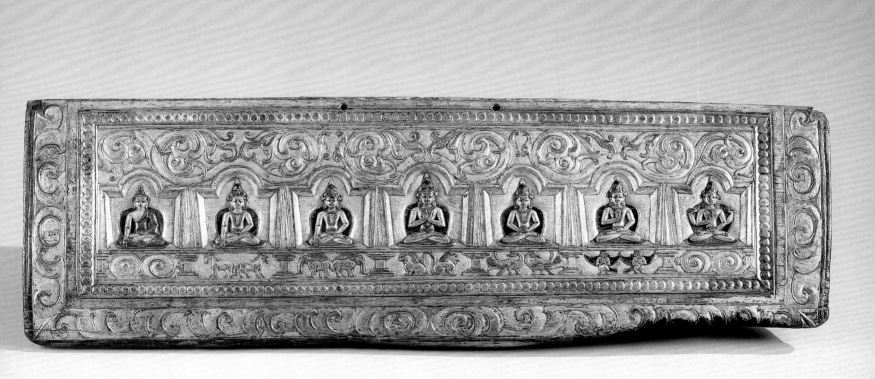

("Infallible Success") is at second right with "fear-not" *mudra* and *garuda* supports. Shakyamuni Buddha is in the furthest left niche, dressed in his usual monk's robes and Prajnaparamita, Goddess of the "Perfection of Wisdom", is at furthest right, her four arms holding the *dorje* and book and making the teaching ("wheel-turning") *mudra*.

Elegant floral scrolls, in three segments, decorate the space over the seven niches; simpler scrolls are under Shakyamuni and Prajnaparamita. A beaded border frames the entire central rectangle. The entire upper edge is missing, although three wedges remain to indicate where this section was attached. A fire has damaged the lower right corner. Fine carved scrolls fill the surviving outer borders and the two short ends. Rich gilding covers the entire upper surface with accents of silver, red and blue on the garments, jewelry, thrones and animals.

PLATE 135

Ratnasambhava

Central Asia, 13th century

Colors on plaid cotton cloth, H. 19 ¾ in. (50.2 cm)
Purchase 1993 The Members' Fund, Sophronia Anderson Bequest Fund,
William C. Symington Bequest Fund, C. Suydam Cutting Bequest Fund
and Life Memberships 93.247

Ratnasambhava is one of the Five Transcendent Buddhas (see color pl. 134). He is associated with the south and with the conquest of pride and avarice. Dressed in the garments of royalty, he gives the gesture of "boon-granting" with his right hand. Ratnasambhava sits on a lotus base, enthroned in a rectangular structure decorated with stylized gems. An elephant supporting a leaping bejeweled leogryph frames each side of the Buddha's scroll-filled back cushion, and *makaras* spit jewels on the roof-like throne-back. A golden scrolling halo topped with a winged creature frames the Buddha's head. A lobed arch springs over the central space, resting on plant-form columns.

Ratnasambhava's special color is yellow, shown here in his golden body, and his vehicle is the horse, two of which support the throne. The fine diaphanous fabric which covers his legs has a design of tiny seated Buddhas in medallions. Two small seated monks are to each side of the nimbus, turned toward Ratnasambhava and giving a teaching gesture. Across the top are eight Buddhas giving, alternately, the teaching and earth-witness gestures. Rows of enthroned figures are at the left and right edges of the *tangka*: a teaching monk above five Bodhisattvas, each side, holding various ritual implements. A single Bodhisattva is at the center of the throne base, holding a noose. Seven protectors are across the bottom.

Loss of paint, especially on the sides, has allowed much of the unusual plaid cloth support to show through. The plaid cloth and details such as the stylized three-leaf plants at the corner of the nimbus are characteristic of the paintings known from the Tangut empire in Central Asia of the twelfth to thirteenth centuries. This art is, however, closely linked stylistically to paintings in central Tibet of this period, suggesting that Tibetan artists traveled to the Tangut kingdom to work on Buddhist projects.[39]

39 See Piotrovsky, ed., *Lost Empire*,
pp. 55–8, 62–88, and nos. 4, 13 and 55
and Karmay, *Early Sino-Tibetan Art*,
pp. 35–42.

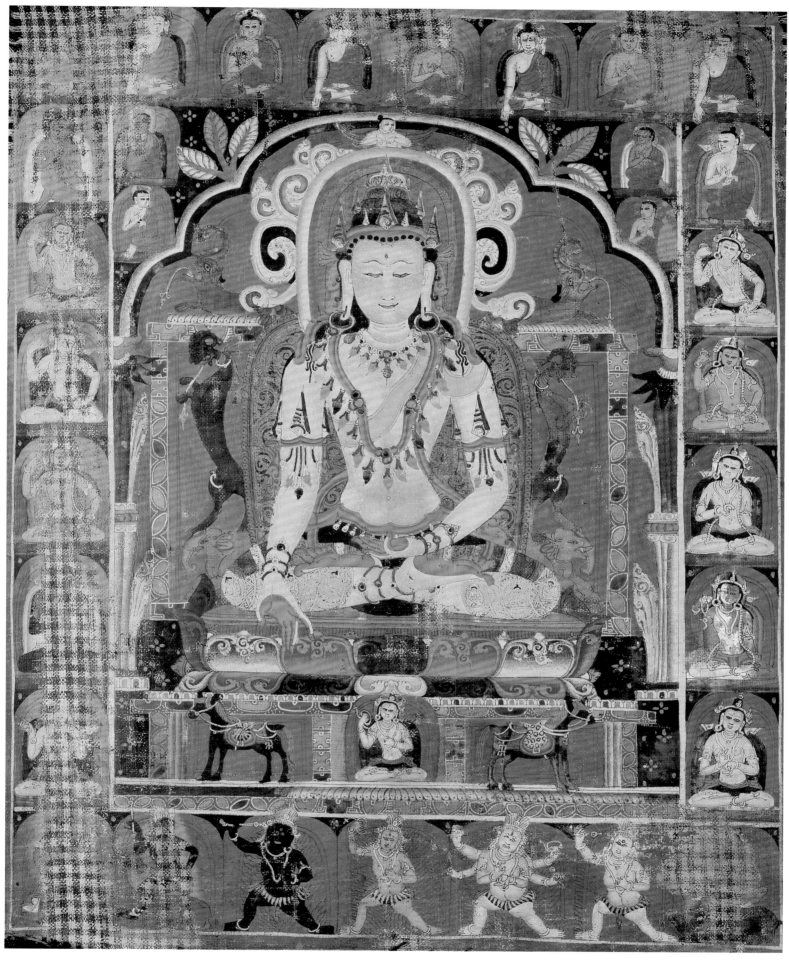

PLATE 136

Book cover with enthroned Akshobhya flanked by two Adepts

Tibet, 12th–13th centuries

Carved wood with traces of gilding and color, L. 19 $\frac{1}{2}$ in., W. 6 $\frac{1}{4}$ in. (49.5 x 15.9 cm)
Purchase 1994 C. Suydam Cutting Bequest Fund and The Members' Fund 94.46

This is the top or bottom cover of a now-lost small Buddhist manuscript. The central figure is Akshobhya, one of the Five Transcendent Buddhas (see color pl. 134), here depicted in simple monastic robes and giving the "earth witness" *mudra*, accompanied by his signature attribute, the elephant (shown to left and right of the lotus vase).[40] The oval halo and throne cushion and triangular throne supports are consistent with the Pala-influenced style of such early book covers and paintings (compare color pls. 134 and 137B). Leaping horned-lions flanking the oval nimbus are enclosed in beaded rectangular frames. Over these are a pair of *makaras* whose tails form elaborate floral scrolls. Above the central deity is a *garuda/khyung*.

The portraits at left and right are rare for a book cover and probably reflect a specific manuscript commission. The figure at right is tentatively identified as the *Mahasiddha* Nagpopa (Padampa Sangye), an Indian adept who came to Tibet in the second half of the eleventh century. Nagpopa is traditionally shown in this particular squatting pose with his upper garments thrown off, indicating the practice of "inner heat" yoga, and giving the unusual open-handed, thumbs and fore-finger-joined *mudra*.[41] The figure at left is difficult to identify. It may be Indra Bhuti (or Indra Bhodhi), one of the original eighty-four

40 Compare the crowned Akshobhya *tsakali* in color pl. 137B. An alternate interpretation is that this figure is Shakyamuni Buddha, whose *mudra* is also "earth witnessing" and that the elephants are but the lower segment of the throne support, see color pl. 135.

41 Rhie and Thurman, *op. cit.*, no. 38, p. 150.

42 Kossak and Singer, *Sacred Visions*, no. 33, pp. 130–33.

43 Heller, "A Set of Thirteenth Century *Tsakali*", *Orientations*, November 1997, pp. 48–52.

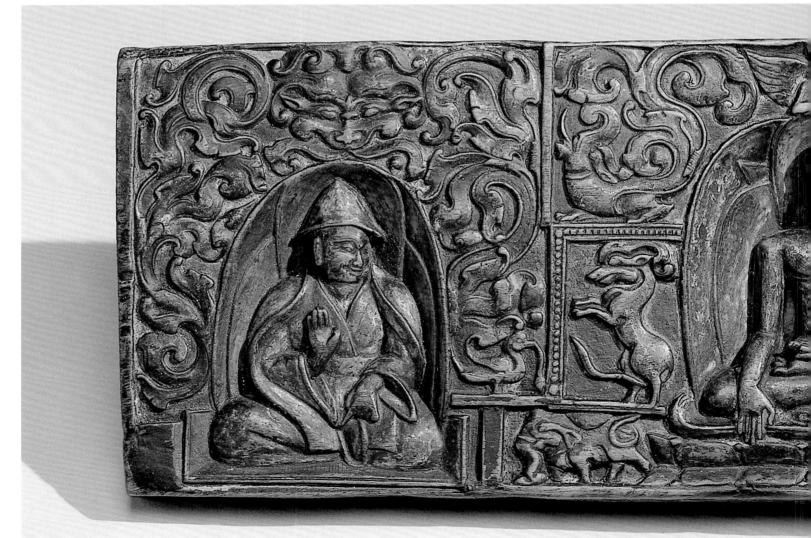

Mahasiddhas, who was a king in Orissa *circa* 700, noted for propagating Vajrayana Buddhism. Here the figure is dressed like a Tibetan king, with sashed under-robe and long cape and gives the "fear-not" *mudra*. The floppy turban worn by Indra Bhuti[42] is shown here as a helmet-like hat. Both portrait figures have halo and nimbus and are set, appropriately, lower than Akshobhya, on cushions. The space around them is densely filled with a monster mask (top center) and writing scrollwork. Gilding and red paint remain on the bodies, haloes and nimbuses.

PLATE 137 A, B, C

Three Consecration Cards (*Tsakali*)
Tibet, 13th century

Ink, color and gold foil on paper, H. 4 in., W. 3 in. (10.2 x 7.6 cm) each
Purchase 1994 The Members Fund 94.221

The format and composition of these three small paintings on thick paper identify them as *tsakali*, the Tibetan term for cards used during Buddhist rituals to consecrate a temple or to give an initiation. In this case, the reverse of each card bears several inscriptions in red ink; these provide precise information concerning their date and provenance, and confirm that these three *tsakali* once belonged to a much larger set commissioned by a specific patron. Although it may never be possible to know how many *tsakali* formed the entire series, more than thirty from this set have now also been identified in private collections throughout the world.[43]

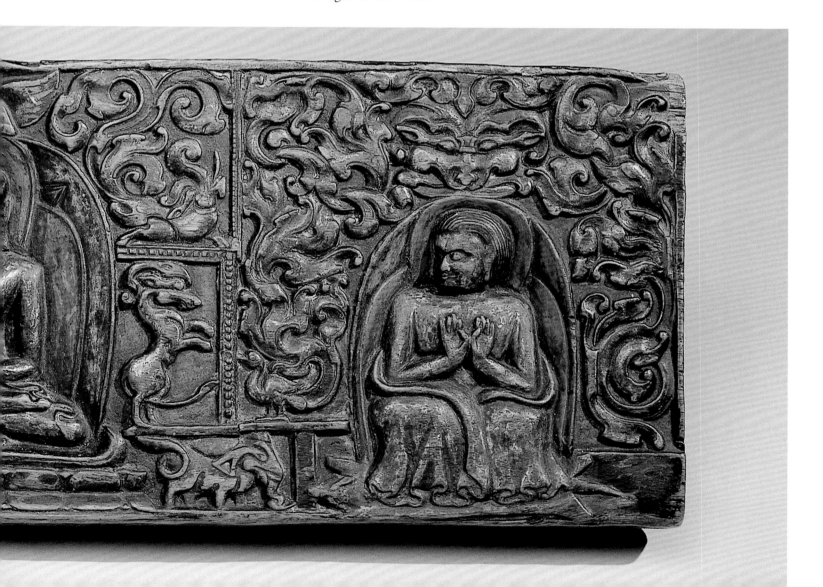

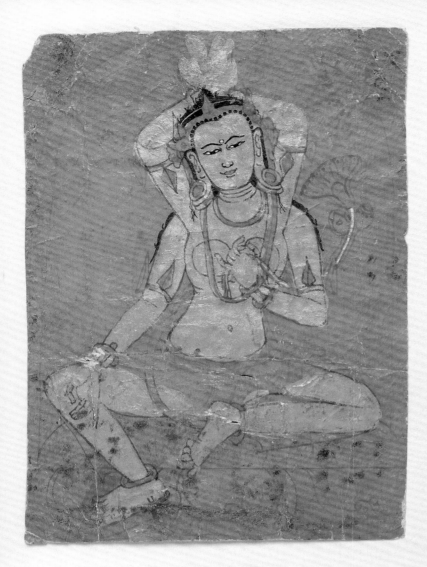

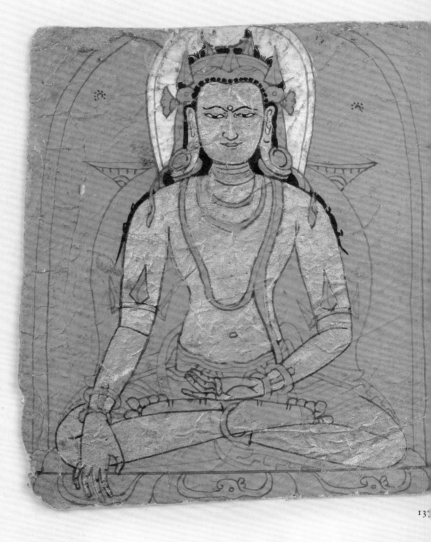

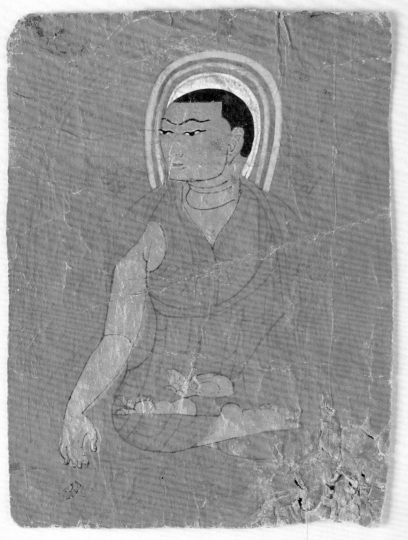

The *tsakali* at upper left represents a special form of the female deity Tara. She is seated on a lotus pedestal delineated in red ink against the red wash covering the surface of the card. An oval outline defines her sacred space, an expanse of sky, as shown by the small sun and moon dotted in above her shoulders. Her tiered crown, disc earrings, armbands with triangular appliqués and simple necklace extending to mid-torso are all inspired by the styles of the Indian Pala kingdom (*circa* 750–1200). Tara wears the typical Indian costume of short *dhoti* and loose, transparent gauze pants, indicated by the hem extending from the red anklets. Rather than the usual third eye, in the center of her forehead is a ritual dot, as if she were an Indian devotee. Her hair lies in braids on her shoulders. The principal right hand is in the *varada mudra* and the left clasps a stem of a lotus which comes up to her shoulder. Two supplementary arms are raised above her head; the hands are partially effaced here but they appear to be crossed at the wrists as in Indian dance. Tara's *mantra* is among the inscriptions on the reverse.

The center *tsakali* represents the Buddha Akshobhya, one of the Five Tathagatas, here shown in *Sambhogakaya* ("Body of Enjoyment") aspect. The depiction is quite similar to that of Tara in terms of his crown, earrings, anklets, braids and short *dhoti*. Their coiffure and faces are virtually identical except that Tara's head is inclined. Gold lines are used on both figures to highlight the axis of the nose, as well as to emphasize the dip in the upper eyelid. At shoulder level, two small triangles, vestiges of a throne back, extend into the oval outline of Akshobhya's sacred space.

The third *tsakali* portrays a lama, identified by the first lines of the inscription on the reverse: "The glorious name of a jewel guru, wisdom guru, *hum*. Praise and reverent salutations to the precious lama Sangye Yarjon." The handwriting is elegant, well proportioned and clear. The verses continue with excerpts from a Buddhist text frequently used in consecration rituals, and conclude with an explicit dedication to the "holy lama" [Sangye Yarjon] signed by one of his disciples (who was also his nephew), Grags pa Pal Ozer zang po (1251–96). Like that of Sangye Yarjon, this name also appears on almost all the known cards. The lama portrayed on this *tsakali* is seated on a throne quite similar to that of Akshobhya, but his halo has a progression of bands of colors, somewhat like a rainbow. The "rainbow body" is a metaphor in Tibetan Buddhist literature for highly-accomplished spirituality, which is said to be visible as an aura; a Buddha may also be said to have a "rainbow body".

Sangye Yarjon (1203–72) was the third successor to the founder of Taglung monastery, located to the west of Lhasa in central Tibet. Named Abbot in 1236, he wrote biographies and monastic rules and commissioned religious art, but also played a role in Tibetan politics. In 1263, Mongol armies threatening to invade Tibet were appeased by Sangye Yarjon's sumptuous offerings. As avid hunters, the Mongols were regarded as sinful by the Buddhists, and Sangye Yarjon implored them to stop such activities. The Abbot was successful and even proceeded to give the Mongols teachings. To celebrate the repulsion of the Mongol attack, every year thereafter, on the fourteenth day of the fourth month, until Sangye Yarjon's death, thousands of *tsakali* were offered, all inscribed with prayers. In addition to the *tsakali*, more than 3,500 images and *tangkas* were commissioned by Sangye Yarjon.

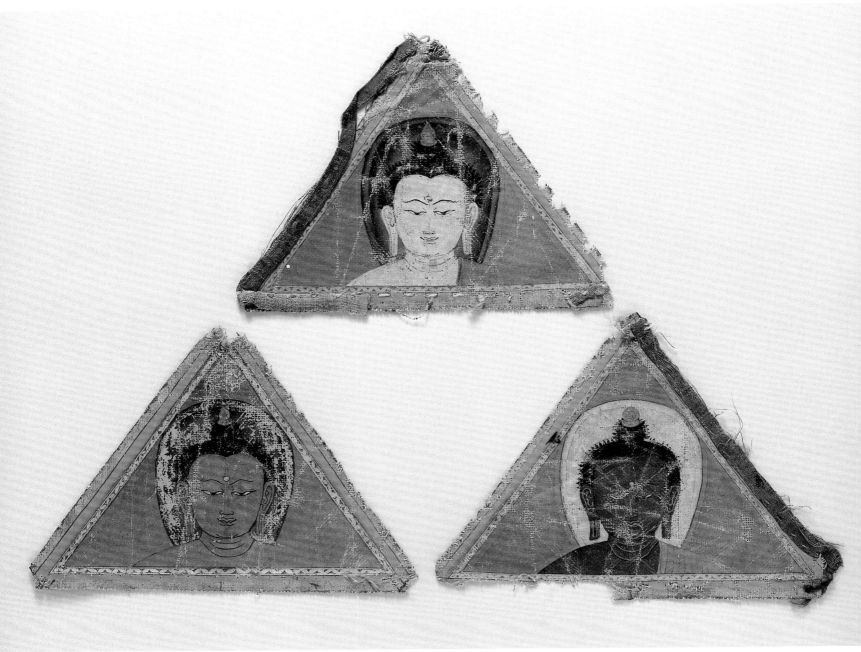

PLATE 138

Three Triangular Paintings

Tibet, 15th century

Colors and gold on cotton cloth, traces of silk edging, H. 5 ¹/₈ in. each (33.1 cm)
Gift of Mr. and Mrs. Lorin B. Nathan, 1997 97.65

These paintings in triangular format are rare examples of a type of banner which has a long history in Buddhist art. Traces of silk trim and of stitching on the edges indicate that these were the top of vertical banners, probably from a set of the Five Transcendent Buddhas (see color pl. 134). The three triangles here unusually depict only the head and shoulders of the Buddhas, each enclosed on all three sides with finely drawn gold leaf-form borders. They are (top) the golden-bodied Ratnasambhava, (left) red Amitabha and (right) green Amoghasiddhi. Each Buddha has a halo of contrasting color and a flaming jewel

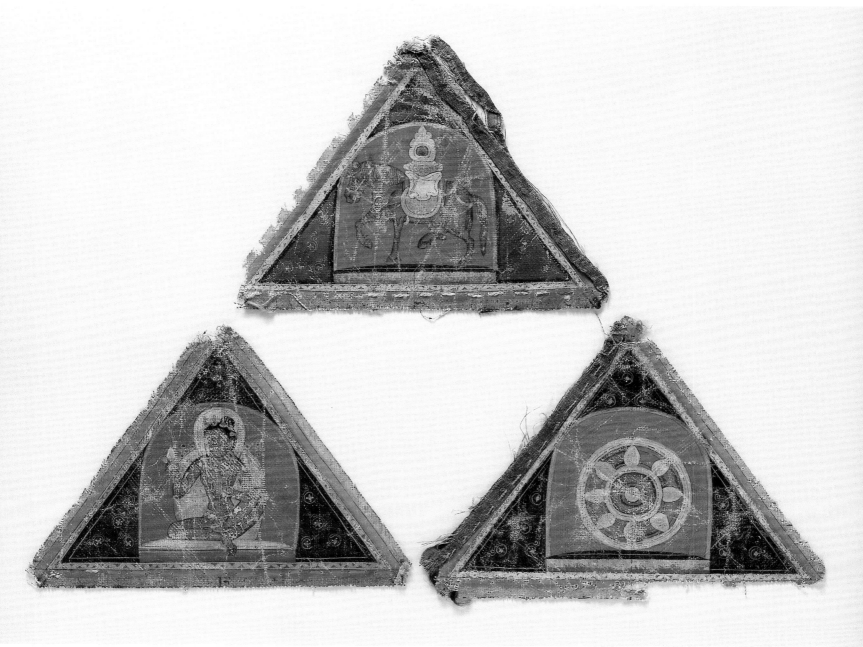

138 B

on the top of his *ushnisha*. The "spikes" outlining the hair are associated with paintings of the fifteenth century.

On the reverse of each triangle is an auspicious symbol; these appear to be from the set of Seven Treasures of Royalty: Flaming Jewel, Queen(?) and Wheel, each set in a red nimbus on a dark field with tiny jewels. The same gold leaf-border as on the front is on all three sides of the reverse.

Banners with triangular "heads" are often seen in Buddhist altar settings, serving to mark and enhance sacred space. Actual silk banners with painted Buddhist figures have survived from Dunhuang, China, *circa* eighth to tenth centuries, and many of these have triangular tops.[44] Banners of ramie with triangular tops have been recovered from Buddhist sites at Khocho, Toyok and Yarkhoto (eighth to ninth centuries) even further west in Central Asia. Like the Museum's triangles, these have small separate Buddhas in the triangular field as well as larger Buddhist images in the lower main vertical banner section.[45]

44 Whitfield and Farrer, *Caves of the Thousand Buddhas, Chinese Art from the Silk Route*, pls. 23, 24, 31, 41, 45, 46, 50, 51, 114.

45 *Along the Ancient Silk Routes, Central Asian Art from the West Berlin State Museums*, The Metropolitan Museum of Art, N.Y., 1982, pls. 121, 125, 127, 136, 140.

PLATE 139

Vajrasattva

Tibet, 14th–early 15th centuries

Cast brass with copper, silver and jewel inlay, H. 17 $^{7}/_{8}$ in. (45.4 cm)
Purchase 1973 The Members' Fund and Membership Endowment Fund 73.131

Vajrasattva, "Diamond Being", is one of the Cosmic or Transcendent Buddhas, appearing in crowned celestial form. The image and lotus base are hollow cast, all of a piece, in a golden-brown brass with inlaid copper eyes, lips, fingernails, and sections of body ornaments and *dhoti*. Silver and black pitch complete the detailing of the eyes; turquoise and coral stones are set in the crown and body decoration. Two loops, cast on at the arms, were once attached to a nimbus or encircling scarf. The deity holds his identifying symbols, the *vajra* (*dorje*) and bell, in right and left hands respectively; the bell is held in a manner variant to the usual hip position for Vajrasattva. The wide and exaggerated eyes and brow, the highly schematic headdress (with finial missing) and the patched, unfinished state of the entire back of the image are qualities associated with Western Tibetan casting. The tubular body, foliate crown, rosettes and scarves over the ears, as well as beaded body ornaments, are legacies from earlier Indian forms which, via Kashmir, eastern India and Nepal, came into Tibet in the tenth to twelfth centuries.

PLATE 140

Vajradhara

Tibet, 15th century

Cast gilt copper with inlaid turquoise, coral and lapis lazuli; traces of paint, H. 18 $^{3}/_{4}$ in. (47.6 cm)
Purchase 1970 The Members' Fund 70.5

Vajradhara, "Diamond Holder", is the Supreme Buddha for Vajrayana teachings, shown wearing the crown and ornaments of royalty. This beautifully modeled and gilded image has been cast in six parts: the hollow body is attached with clamps to the hollow triangular-form lotus base; the separately cast lower arms, *vajra* (*dorje*) and bell are assembled into a crossed position at the chest. It is this crossed hand position of "highest energy" which identifies the Vajradhara form of the Transcendent Buddha. Turquoise, coral and lapis stones are inlaid in the five-leaf crown, headdress finial, earrings and body ornaments; traces of polychrome remain on the face, and blue paint on the hair, which is gathered in a high chignon and falls in curling locks to the shoulders. The shoulder scarf and *dhoti* are decorated with incised floral patterns, and lotus wheels are incised on the soles of the feet. Many of the separate elements of this image can be traced to Nepalese and Chinese prototypes. The face, headdress and crown are of Nepalese derivation. The festooned bead ornaments, scarf and floret-centered, lotus-petal base are found on fifteenth-century Chinese imperial sculptures. Here they decorate a graceful, attenuated figure that is distinctly Tibetan: a style seen in a wide range of paintings and sculpture executed in southern Tibet in the fifteenth century. The crown, earrings, patterned shoulder drape and ornaments on the Amitayus painting, color pl. 142, are especially close to this image.

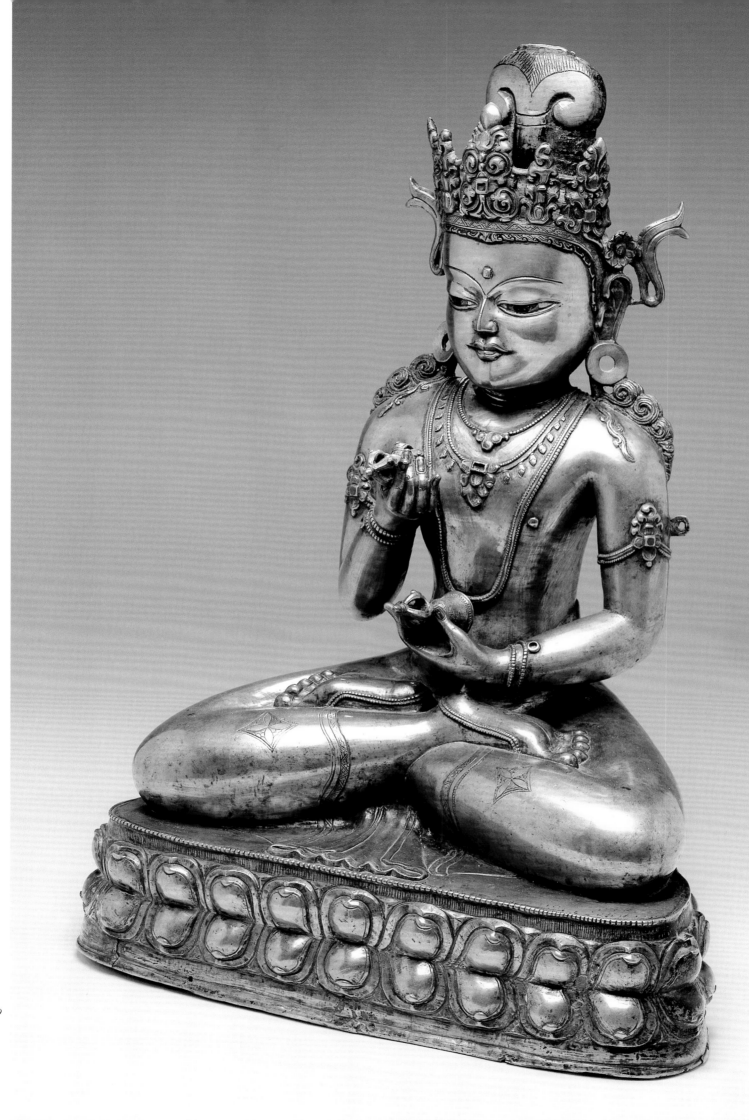

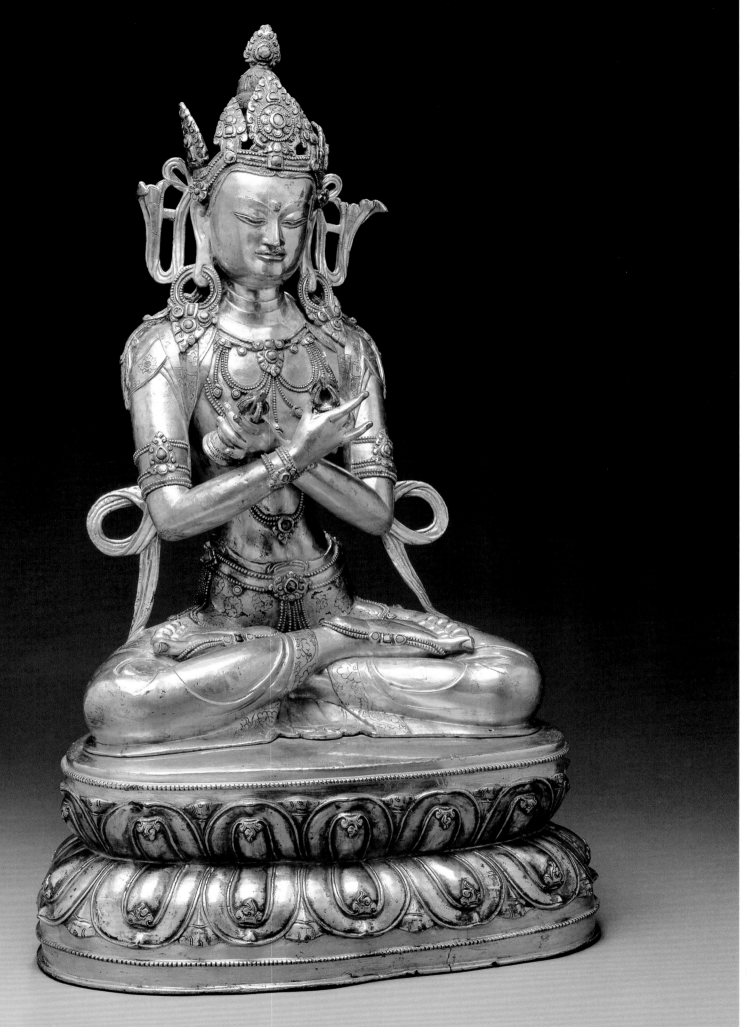

PLATE 141

Amitabha in His Paradise

Central Asia, 14th century

Colors and gold on plaid cotton cloth, H. 36 $\frac{1}{4}$ in. (92.1 cm)
Purchase 1996 C. Suydam Cutting Bequest Fund, Wallace M. Scudder Bequest Fund, W. Clark
Symington Bequest Fund, Membership Endowment Fund and The Members' Fund 96.97

Amitabha, Buddha of Infinite Light, presides over his Sukhavati Paradise
("Pure Land of the West"). He holds an alms bowl in his hands which are
clasped in meditation. His color is red and his symbol, the lotus, is seen
throughout the paradise. The ancient Indian texts which describe the Sukhavati
Paradise speak of its myriad lotus flowers from which thousands of Buddhas
spring, each teaching the Law. Those who reside in this paradise may also
inhabit beautiful palaces. The palaces, Buddhas and lotus flowers are all evident
in this *tangka*.

The unusual blue, red and white plaid cloth support for this painting is
revealed in areas where water damage has caused the pigments to come off. The
plaid cloth links the painting to color pl. 135 and to the group found in the
ruins of Kharakhoto, an outpost of the Tangut Empire in Gansu, northwestern
China. However, this painting is later in date than the thirteenth-century
Kharakhoto group, indicating that a local (Gansu?) workshop continued even
after the fall of the Tangut Empire in 1227.[46] Stylistically, the *Amitabha Paradise*
is close to the *Amitayus Paradise*, color pl. 142, and to other fourteenth-and fif-
teenth-century Tibetan paintings. Many elements of this painting are idiosyn-
cratic, suggestive of a local tradition. The highly abstracted treatment of foliage
is most striking, especially the balloon-like tree which arises behind the central
raised-gold nimbus and, again, in a rosette intersecting the "canal" which forms
a border of all four sides of the *tangka*. Single "balloon" trees or bushes, in the
same vivid greens, reds, yellows and pinks, dot the entire paradise landscape.

Another unique feature is the rosette-in-a-lozenge-pattern of red line on
dark blue which forms the entire background to the painting, mimicking a tex-
tile pattern (initially concealing the actual plaid textile support). Parallels for
this exist only on the earlier Tangut paintings, many of which feature painted
textile patterning underlying the Buddhist scenes.[47]

Ribbons and rainbows are another element used throughout the painting.
Gold and red ribbons or sashes decorate the "balloon" trees, and rainbow-like
undulating bands of red, yellow, green and blue connect many of the seated
Buddha figures. Other celestial figures, including "baby" Buddhas enclosed in
lotus flowers, are connected by leaf, vine and floral forms. A rainbow forms the
lobed border of the central nimbus which encloses Amitabha and his two ador-
ing Bodhisattvas, white Avalokiteshvara and blue Mahasthamaprapta.

Five pavilions with tiered roofs topped by golden finials are set at upper left
and right and bottom left, right and center. In each are turbaned royal figures
on golden thrones, adored by small nymphs. The "canal" is filled with the con-
vention for water: cross-hatched lines. In lobed sections between the "balloon"
trees are monks on lotus bases, praying.

The green drapery folds of Amitabha's and the two Bodhisattvas' lower gar-
ments, and the swag on the throne, are deeply shaded, as are the blue halo and

46 See note 39.
47 Piotrovsky, *op. cit.*, nos. 25, 27, 31, 32
 and 43.

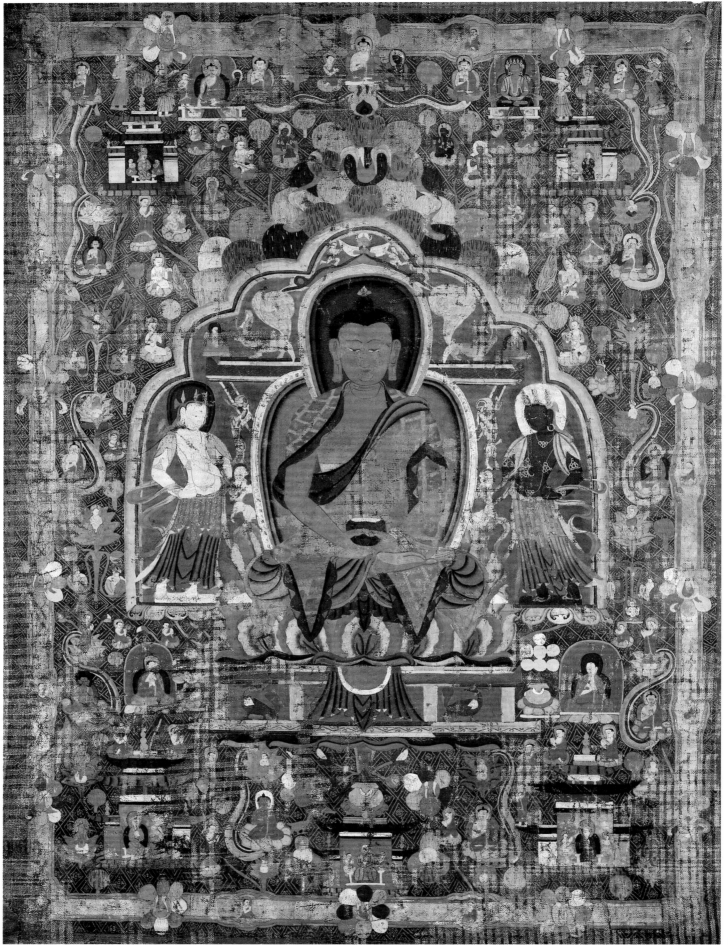

green nimbus behind the central Buddha. In contrast, the red "patched" *kashaya* worn over Amitabha's upper body and the red girdles worn by the Bodhisattvas are delicately painted with gold flowers. A similar gold line delineates the jewelry of the Bodhisattvas. Very fine black line is used to show the features of all of the celestial residents, even the birds poised almost imperceptibly in the "balloon" trees.

Amitabha's throne which rises out of a golden vase is complex. A base of serrated lotus petals rests on a stepped rectangle supported by peacocks, Amitabha's vehicle. A "stack" of animals (elephant, monkey, horned lion with tiny rider) flank the "jewel" edge nimbus. On top of the braced, patterned throne back are praying monks, *makaras* with gold plumed tails and, above the raised gold halo edge, a *garuda/kyung* clasps *nagas*, flanked by two nymphs.

PLATE 142

Paradise of Amitayus
Southern Tibet, 15th century

Colors and gold on cotton cloth, H. 33 ⁵/₈ in., W. 29 ⁵/₈ in. (85.4 x 75.2 cm)
Purchase 1976 Sophronia Anderson Bequest Fund, Membership Endowment Fund
and Charles W. Engelhard Bequest Fund 76.189

This many-layered paradise scene, expressed in lyrical color and sensitive line, is similar to those decorating the walls of fifteenth-century monasteries and temples in southern Tibet. These paintings, as here, show a complex mingling of Indian, Nepalese and Chinese elements.[48] The varied styles have been brought together to form a beautifully realized ideal world. The central deity, Amitayus, Buddha of Infinite Life, sits in meditation holding the golden vase of the Elixir of Life. The lush flowers and dense green foliage, outlined strongly in black, which spring from the vase are repeated throughout the painting. Amitayus is adorned in gem-set golden jewelry and garments of finely patterned silk. His red body is depicted by schematized smooth, flat forms with thin black outlining and, in some areas, a second, pale red line "shadow". The joined green halo-and-nimbus is densely filled with a black-and-gold-line lotus scroll pattern, with an edge of gold flames filled with colored leaf-form gems. The lotus-petal base under Amitayus is supported by a pink stalk, from the sides of which grow leaves and tendrils encircling peacocks and sprouting white and golden flowers. These curve up to the sides to hold, at left and right, the multi-colored petal bases of two standing Bodhisattvas, adorned in crowns, jewelry and patterned garments similar to the central deity. At right, the green Bodhisattva (Vishvapani?) holds in his "threatening" right hand a blue lotus plant, which supports a *dorje* at his shoulder, and gives the *karana mudra* with his left hand. At left, Avalokiteshvara holds in his blessing right hand the stem of a golden lotus plant and gives the "mesmerizing" gesture with his left. Jewel-garlanded, thickly-leaved flowering plants and golden clouds surround the halo and upper nimbus of Amitayus and the two-tiered, beribboned umbrella of patterned silks with golden vase finial which hangs above the deity.

As is characteristic of these fifteenth-century paradise *tangkas* and wall paintings, the background is filled with hierarchical groups of deities and adoring figures. Here, the entire ground is painted a deep blue with subtle black and

48 See Ricca and Lo Bue, *op. cit.*, pls. 13, 36, 37, 90–97.

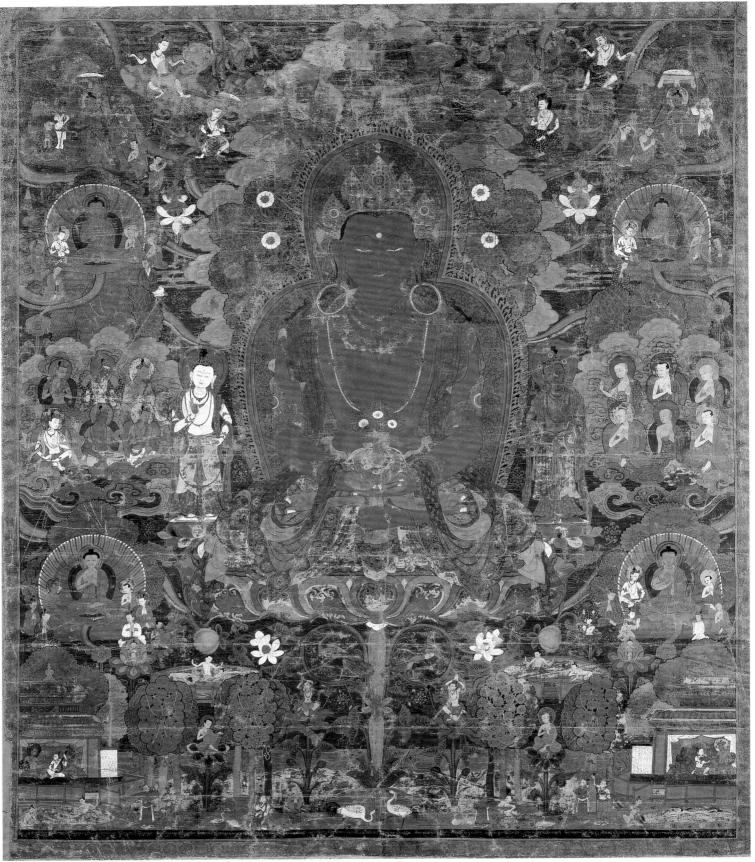

gold lines in a swirling pattern, which can be interpreted as both magical water and celestial settings. At the base of the *tangka* is a golden flower- and tree-filled landscape with a central lake and two small ponds. Human figures swim in the ponds, ducks and fish swim in the lake, and birds and crowned princely figures, attended by heavenly beings, stroll on the golden shores. In addition to the central lotus stalk, four smaller plants rise from the lake: two red flowers holding adoring beings and two blue flowers bearing haloed monks. At the left and right of this "golden land" are two tiered roof pavilions with curtained interiors, each enclosing a Bodhisattva seated on cushions, entertained by dancers, musicians and gift-bearers. Above the gem-filled trees (left and right) are another two ponds in which humans swim, enclosed by fences similar to those around the pavilions.

Covering the rest of the blue background are dispersed groups of deities and attendants. Their cloud-and-flower settings are connected to Amitayus and to various golden flowers by curving rainbows. Four preaching Buddhas in red robes of varied pattern, with rainbow-striped nimbuses, worshiped by groups of monks, princes and divinities, occupy both the upper and lower sides. At the center sides are six monks (right) and six Bodhisattvas (left). Enthroned golden Buddhas in red mountainous settings, attended by umbrella-bearers and various royal, divine and holy figures, are ranged top left and right. Garlanded beings holding musical instruments, umbrellas and standards hover near the clouds and flowers over Amitayus's head. Many decorative devices and small vignettes fill the remaining space with flowers, banded clouds, Buddhist emblems and divine figures on lotuses. Especially beguiling are naked "infant Buddhas" seen through the transparent petals of closed lotus buds growing above the two pavilions. Golden rosettes, in a pale green scroll trellis, fill the red borders.

A single line of Tibetan script is written in gold on the black band across the bottom. It extolls the heavenly abode of Amitabha (the Buddha "father" of Amitayus) and dedicates this *tangka* to the rebirth of all sentient beings into the Sukhavati Paradise (see color pl. 141). The lengthy inscription on the back of the painting includes *mantras* for long life and a dedication for the sponsor and his family and all beings.

Selected Bibliography

Alexander, Andre and Pimpim de Azevedo. *The Old City of Lhasa, Report from a Conservation Project*. Berlin: Tibet Heritage Fund, 1998.

Beckwith, Christopher I. "Tibet and the Early Medieval Florissance in Eurasia, a Preliminary Note on the Economic History of the Tibetan Empire." *Central Asiatic Journal*, no. 21 (1977), pp. 89–104.

———. "The Tibetan Empire in the West." In *Tibetan Studies in Honour of Hugh Richardson*, editors Michael Aris and Aung San Suu Kyi, Warminster, England: Aris and Phillips Ltd., 1981, pp. 30–38.

———. *The Tibetan Empire in Central Asia*. Princeton: Princeton University Press, 1987.

Béguin, Gilles. *Dieux et démons de l'Himâlaya*. Paris: Editions des musées nationaux, 1977.

———. *Art ésotérique de l'Himâlaya. La donation Lionel Fournier*. Paris: Musée national des arts asiatiques Guimet, 1990.

Bell, Charles. *The People of Tibet*. Oxford: Clarendon Press, 1928.

Bhattacharyya, Benoytosh. *The Indian Buddhist Iconography*. Calcutta: Firma K. L. Mukhopadhyay, 1968.

Blondeau, Anne-Marie. "Les Religions du Tibet." In *Histoire des Religions*, vol. III. Paris: Encyclopédie de la Pléiade, 1976.

Conze, Edward. *Buddhism: Its Essence and Development*. Oxford: Bruno Cassirer, 1951; New York: Harper, 1959.

Dagyab, Loden Sherap. *Tibetan Religious Art*. Wiesbaden: Otto Harrassowitz, 1977.

Dalai Lama, Fourteenth. *My Land and My People*. New York: McGraw-Hill, 1962.

———. *The Buddhism of Tibet and the Key to the Middle Way*. Wisdom of Tibet Series, no. 1. Translated by Jeffrey Hopkins and Loti Rinpoche. New York: Harper and Row, 1975.

Fisher, Robert E. *Art of Tibet*. London: Thames and Hudson, 1997.

Goldstein, Melvyn C. and Cynthia M. Beall. *Nomads of Western Tibet. The Survival of a Way of Life*. London: Serindia Publications, 1989.

Haarh, Erik. *The Yar-lun Dynasty: A Study with Particular Regard to the Contributions by Myths and Legends to the History of Ancient Tibet and the Origin and Nature of Its Kings*. Copenhagen: Gads, 1969.

Huber, Toni, "Some 11th-Century Indian Clay Tablets (*Tsa-Tsa*) from Central Tibet," *Tibetan Studies*, Proceedings of the 5th Seminar of the International Association for Tibetan Studies, Narita (Japan), 1989.

Huntington, Susan L. *The Art of Ancient India*. With contributions by John C. Huntington. New York: Weatherhill, 1985.

International Commisson of Jurists, Legal Inquiry Committe on Tibet, *Tibet and the Chinese People's Republic*, Geneva, 1960.

Jackson, David P. and Janice A. *Tibetan Thangka Painting, Methods and Materials*. London: Serindia Publications, 1984.

Jackson, David. *A History of Tibetan Painting: The Great Tibetan Painters and Their Traditions*. Beiträge zur Kultur- und Geistesgeschichte Asiens, no. 15, Vienna, 1996.

Karmay, Heather. *Early Sino-Tibetan Art*. Warminster: Aris and Phillips, 1975.

Karmay, Samten G. "A General Introduction to the History and Doctrines of Bon." *Memoirs of the Research Department of the Toyo Bunko*, no. 33. Tokyo, 1975.

Kolmas, Josef. *Geneology of the Kings of Derge*. Prague: Oriental Institute and Academia, Publishing House of Czechoslovakia Academy of Sciences, 1968.

———. *Tibet and Imperial China: A Survey of Sino-Tibetan Relations Up to the End of the Manchu Dynasty in 1912*. Canberra: Center of Oriental Studies, Australian National University, 1967.

Kossak, Steven M. and Jane Casey Singer. *Sacred Visions. Early Paintings from Central Tibet*. New York: The Metropolitan Museum of Art, 1998.

Lopez, Jr., Donald S. *Prisoners of Shangrila, Tibetan Buddhism and the West*. Chicago and London: University of Chicago Press, 1998.

Loseries-Leick, Andrea. "The Use of Human Skulls in Tibetan Rituals," in *Tibetan Studies*, Proceedings of the 5th Seminar of the International Association for Tibetan Studies, Narita (Japan), 1989.

Macdonald, Ariane. "Une lecture de P. T. [Pelliot Tibétain] 1286, 1287, 1038, 1047 et 1290. Essai sur la formation et l'emploi des mythes politiques dans la religion royale de Sron bcan sgam po." In *Etudes Tibétaines dédiées à la mémoire de Marcelle Lalou*. Paris: Maisonneuve, 1971.

——— and Yoshiro Imaeda. *Choix de documents tibétains conservés à la Bibliothèque Nationale, complété par quelques manuscrits de l'India Office et du British Museum*, vols. I and II. Paris: Bibliothèque Nationale, 1978 and 1979.

Martin, Dan. "On the Origin and Significance of the Prayer Wheel According to Two Nineteenth-Century Tibetan Literary Sources," *The Journal of the Tibet Society*, vol. 7. Bloomington, 1987.

———. "Pearls from Bones: Relics, Chortens, Tertons and the Signs of Saintly Death in Tibet," *Numen*, vol. 41. Leiden: E. J. Brill, 1994.

———. "On the Cultural Ecology of Sky Burial on the Himalayan Plateau," *East and West*, vol. 46, nos. 3–4, December, 1996.

Nebesky-Wojkowitz, René de. *Oracles and Demons of Tibet*. The Hague: Mouton & Co., 1956.

———. Edited by Christoph von Fürer-Haimendorf. *Tibetan Religious Dances*. The Hague: Mouton & Co., 1976.

Norbu, Thubten Jigme, and Colin M. Turnbull. *Tibet: An Account of the History, the Religion, and the People of Tibet*. New York: Simon and Schuster, 1969.

Pal, Pratapaditya. *The Art of Tibet*. New York: The Asia Society, 1969.

———. *Art of Tibet*. A catalogue of the Los Angeles County Museum of Art Collection. Los Angeles: Los Angeles County Museum of Art, 1983.

Pelliot, Paul. *Histoire Ancienne du Tibet*. Paris: Maisonneuve, 1961.

Petech, Luciano. *China and Tibet in the Early 18th Century: History of the Establishment of the Chinese Protectorate in Tibet.* Leiden: E. J. Brill, 1950.

_____ . *Aristocracy and Government in Tibet (1728–1959).* Rome: Istituto Italiano per il Medio ed Estremo Orienti, 1973.

Piotrovsky, Mikhail, ed. *Lost Empire of the Silk Road: Buddhist Art from Khara Khoto (X–XIII Century).* Milan: Electa, 1993.

Rahula, Walpola. *What the Buddha Taught.* New York: Grove Press, 1974.

Rhie, Marylin M. and Robert A. F. Thurman. *Wisdom and Compassion: The Sacred Art of Tibet.* New York: Harry N. Abrams, 1991.

Ricca, Franco and Erberto Lo Bue. *The Great Stupa of Gyantse: A Complete Tibetan Pantheon of the Fifteenth Century.* London: Serindia Publications, 1993.

Richardson, Hugh E. *A Short History of Tibet.* New York: Dutton, 1962.

_____ . "The Rva-sgreng Conspiracy of 1947." In *Tibetan Studies in Honour of Hugh Richardson,* edited by Michael Aris and Aung San Suu Kyi. Warminster, England: Aris and Phillips, Ltd., 1981.

_____ . *A Corpus of Early Tibetan Inscriptions.* London: Royal Asiatic Society, 1985.

_____ . *Ceremonies of the Lhasa Year.* London: Serindia Publications, 1993.

Ross, Joanna. *Lhamo, Opera from the Roof of the World.* New Delhi: Paljor Publications, 1995.

Schafer, Edward H. *Golden Peaches of Samarkand: A Study of T'ang Exotics.* Berkeley and Los Angeles: University of California Press, 1963.

Schroeder, Ulrich von. *Indo-Tibetan Bronzes.* Hong Kong: Visual Dharma Publications, 1981.

Shakabpa, Tsepon, W. D. *Tibet, A Political History.* New Haven: Yale University Press, 1967.

Singer, Jane Casey and Philip Denwood, eds. *Tibetan Art: Towards a Definition of Style.* London: Laurence King Publishing, 1997.

Snellgrove, David. *Buddhist Himalaya.* Oxford: Bruno Cassirer, 1957.

_____ . *Indo-Tibetan Buddhism. Indian Buddhists and Their Tibetan Successors.* Boston: Shambhala Publications, 1987.

_____ and Hugh Richardson. *The Cultural History of Tibet.* New York: Frederick A. Praeger, 1968.

Sperling, Elliot. "A Captivity in Ninth Century Tibet." *The Tibet Journal,* vol. IV, no. 4 (1979).

Stein, Rolf A. *Tibetan Civilization.* Translated by J. Stapleton Driver. London: Faber and Faber, 1972; *La Civilisation Tibétaine,* revised and enlarged second edition. Paris: Le Sycomore-L'Asiathèque, 1981.

Taring, Rinchen Dolma. *Daughter of Tibet.* London: Camelot Press, 1970.

Teichman, Eric. *Travels of a Consular Officer in Eastern Tibet.* Cambridge: University Press, 1922.

Tucci, Giuseppe. *Indo-Tibetica,* volumes I–IV. Rome: Reale Accademia d'Italia, 1932–41.

_____ . *Tibetan Painted Scrolls.* 3 volumes. Rome: La Libreria dello Stato, 1949.

_____ . "The Wives of Srong btsan sgam po," *Oriens Extremis,* IX. Wiesbaden: O. Harrassowitz, 1962.

_____ . *Tibet Land of Snows.* Translated by J. Stapleton Driver. London: Elek Books, 1967.

_____ . *Transhimalaya.* Translated by James Hogarth. Geneva: Nagel Publishers, 1973.

_____ . *The Religions of Tibet.* Translated by Geoffrey Samuels. Berkeley: University of California Press, 1980.

Vitali, Roberto. *Early Temples of Central Tibet.* London: Serindia Publications, 1990.

Watt, C. Y. James and Anne E. Wardwell. *When Silk was Gold: Central Asian and Chinese Textiles.* New York: The Metropolitan Museum of Art, 1997.

Whitfield, Roderick, with Anne Farrer, S. J. Vainker and Jessica Rawson. *The Caves of the Thousand Buddhas: Chinese Art from the Silk Route.* New York: George Braziller, Inc., 1990.

Yuthok, Dorje Yudon. *House of the Turquoise Roof.* Ithaca: Snow Lion Publications, 1990.

The Newark Museum Collection: Specialized Bibliography

Cutting, C. Suydam. *The Fire Ox and Other Years.* New York: Charles Scribner's Sons, 1947.

Ekvall, Robert B. *Cultural Relations on the Kansu-Tibetan Border.* Publications in Anthropology, occasional paper no. 1. Chicago: University of Chicago Press, 1939.

Olson, Eleanor. *Catalogue of the Tibetan Collections and Other Lamaist Articles in The Newark Museum.* 5 volumes. Newark: The Newark Museum, 1950–71.

Reynolds, Valrae. *Tibet: A Lost World.* New York: The American Federation of Arts, 1978.

_____ and Amy Heller. *Catalogue of the Newark Museum Tibetan Collection, Volume I: Introduction* (revised edition), 1983.

_____ , Amy Heller and Janet Gyatso. *Catalogue of The Newark Museum Tibetan Collection, Volume III: Sculpture and Painting* (revised edition), 1986.

_____ . *Tibetan Buddhist Altar.* Newark: The Newark Museum, 1991.

Shelton, Albert L. *Pioneering in Tibet.* New York: Fleming H. Revell Co., 1921.

Shelton, Flora B. *Sunshine and Shadow.* Cincinnati: Foreign Christian Missionary Society, 1912.

_____ . *Shelton of Tibet.* New York: George H. Doran Co., 1923.

Still, Dorris Shelton. *Beyond the Devils in the Wind.* Tempe (Arizona): Synergy Books, 1989.

In *Orientations* magazine:

Reynolds, Valrae. "New Discoveries About a Set of Tibetan Manuscripts in The Newark Museum," July, 1987.

Alsop, Ian. "Phagpa Lokesvara of the Potala," April, 1990.

Heller, Amy. "Tibetan Documents in The Newark Museum," April, 1990.

Reynolds, Valrae. "A Sino-Mongolian-Tibetan Buddhist Appliqué in The Newark Museum," April, 1990.

_____ . "Myriad Buddhas: A Group of Mysterious Textiles from Tibet," April, 1990.

Heller, Amy. "A Set of Thirteenth Century *Tsakali,*" November, 1997.

Poses, Hand Gestures, Symbols, and Attributes

S. = Sanskrit
T. = Tibetan

Body Marks, Poses (*Asanas*) and Hand Gestures (*Mudras*)

Auspicious marks on the head of a Buddha:
S. *ushnisha*; T. *tsugtor* (top knot or bump on head)
short "snail" curls or wavy hair
S. *urna*: T. *dzopu* (circular mark between the brows)
distended earlobes

Flexed standing pose:
S. *abhanga* (light flexing)
varies to *tribhanga*
(exaggerated "triple" flexing)

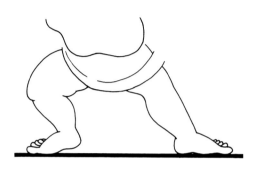

Lunging to the right:
S. *alidha*; T. *yehpeh kyang* (the opposite variation, lunging to the left:
S. *pratyalidha*; T. *yonpeh kyang*)

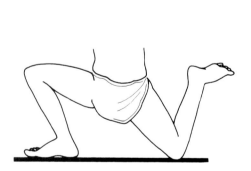

Combative kneeling pose:
S. *achalasana*; T. *miyoweh zug*

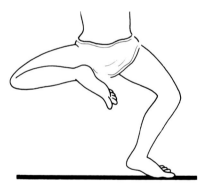

Dancing pose:
S. *ardhaparyanka*; T. *gartub*

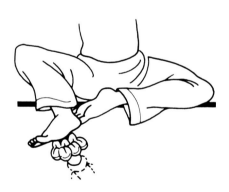

Seated in "royal ease":
S. *maharajalilasana*; T. *gyalpo rolpa*

Seated, relaxed:
S. *lalitasana*; T. *yeh rol*

Seated, legs pendent:
S. *bhadrasana*; T. *zangpo dugdang*

Seated in meditation:
S. *vajraparyanka*, *padmaparyanka*, or *dhyanasana*; T. *dorje kyildrung*

Protection or blessing of fearlessness:
S. *abhaya*; T. *jigme* (upraised or outstretched)

Gift-bestowing:
S. *varada*; T. *chog chin*

Meditation:
S. *dhyana or samadhi*; T. *samden* or *tingedzin*

Earth-witnessing:
S. *bhumisparsha*; T. *sanon*

Teaching:
S. *dharmachakra*; T. *chokyi korlo*

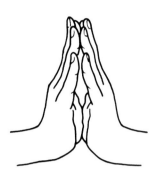

Reverence:
S. *anjali*; T. *talmo jar*

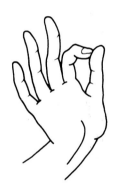

Argumentation:
S. *vitarka*; T. *tokpa*

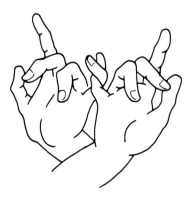

Gesture of the indestructable *Hum* syllable:
S. *vajrahumkara* or of triumph over the three
worlds: S. *trailokyavijayamudra*

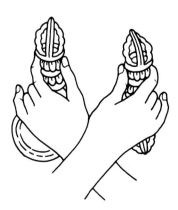

Gesture of embracing the *prajna* (wisdom):
S. *prajnalinganabhinaya*

Mesmerizing:
S. *karana*

Threatening:
S. *tarjani*; T. *dzubmo*

Symbols as Substitutes for Aspects of Buddhahood

The Wheel and The Wheel of the Law
(S. *cakra* and *dharmacakra*; T. *korlo* and *cökhor*)

The wheel was chosen in early Indian Buddhist iconography to represent Shakyamuni's First Sermon, in the Deer Park at Sarnath. The act of preaching is called "turning the Wheel of the Law" (S. *dkarmacakra*), incorporating an ancient Indian emblem for the world-ruler (S. *cakravartin*; "he who sets the world in motion"). In early Buddhist art, the wheel is one of several symbols signifying the great events of Shakyamuni's life.

As Buddhism developed and spread across Asia, the wheel came to symbolize the Buddhist doctrine. The Tibetan wheel retains its significance as an emblem of sovereignty and is thus associated with the empowerment of important lamas such as the Dalai Lama.

As an architectural ornament, the Wheel of the Law is almost always shown in Tibet flanked by two deer-like animals. The common worshipping animals in early Indian iconography are gazelles, recalling Shakyamuni's sermon in the Deer Park. In Tibet these animals (T. *seru*), one of which has a single horn in the center of its head, are described as unicorns or as rhinoceroses, which symbolize renunciation and solitude.

The Lotus (S. *padma*; T. *pema*)

This singular water plant was associated with divinity throughout the ancient world. The Egyptians, Assyrians, Greeks and Persians all ascribed sacred qualities to the white or blue flower which grows undefiled out of its muddy water base. The early Buddhists adopted the lotus symbolism already existing in India, connecting the flower's purity and perfection with divine birth and the emancipation of Buddhahood. As Mahayana Buddhism developed and anthropomorphic representations of the Buddhas began to appear in India and elsewhere in Buddhist Asia, lotus flowers in conventionalized disk-form were shown sprouting from the feet of Buddhist images or, in naturalistic or stylized form, supporting seated or standing images of saints and divinities. The lotus throne or support was a concrete symbol of the attainment of enlightenment. The Mahayanist doctrines of Buddhist paradises with their lotus pond settings (as in the *Lotus Sutra*) reinforced the lotus symbolism. The lotus has a further Mahayanist meaning as the female element, paired with the male element *vajra*.

The *Chorten* (S. *stupa* and *dhatu garbha*)

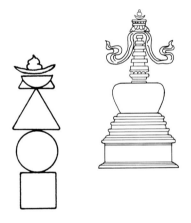

Perhaps the single most potent symbol of Buddhism, the *chorten* is analogous to the Christian cross. Like the cross, the *chorten* has specific associations with death and triumph over death. According to legend, Shakyamuni's remains were divided up and enshrined in thousands of tumulae or reliquary mounds. These *stupa* (mounds) or *dhatu garbha* (relic preservers) were an ancient funerary tradition for rulers and saints in India. When adopted by Buddhism, the *stupa* came to symbolize the departed lord and the ultimate state of *nirvana* into which he had passed. The donation of *stupas* by both monks and laymen was an important element in Buddhist religious life.

Stupas, both as actual buildings of earth, stone and brick, and as relic containers of gold, silver, copper, crystal, stone or wood, spread throughout Buddhist Asia, enshrining the remains of saints, marking sacred sites, and serving as devotional objects on altars. The *stupa* always retains its essential form: a dome or bell-shaped base (S. *anda*; "egg"), surmounted by a vertical column or tower of stepped form (S. *harmika*; "sanctuary above earth beyond death and rebirth") and a crowning canopy, or umbrella, signifying royalty.

Mandala (T. *kyil-kor*)

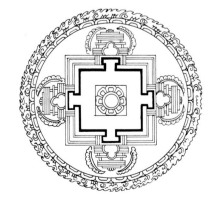

The perfect nature of the circle came in Buddhist doctrine to be embodied in the *mandala* or mystic circle. Although many types of geometric diagrams both in two dimensions and three dimensions are considered *mandalas*, the most common form is the two-dimensional complex of circles and squares, representing a sacred enclosure and related to the concept of *chorten* as a container of sacred power.

Tantric Buddhism in Tibet made use of such *mandalas* as meditational tools. The basic form involves an outer circular border of flames and an inner border of lotus petals. The inner sanctuary is a "divine mansion", shown as a square with four symmetrical gateways. The walls and gateways are often shown decorated, similar to those of a Tibetan temple. The arching prongs over each gateway are the tips of the underlying crossed *vajras* below. Inside the walls of the mansion is the innermost realm of divine power.

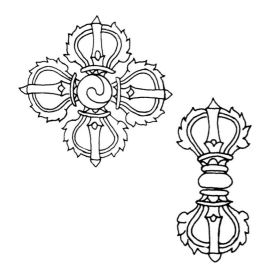

Vajra (T. *dorje*)

This "thunderbolt" emblem first appeared in Indian Buddhism as the symbol of Vajrapani ("thunderbolt-in-hand"), the special protector of Shakyamuni, a direct borrowing of the trident weapon of the Vedic god Indra. In later Buddhism, Vajrapani became the chief deity of the powerful beings converted to Buddhism. The *vajra* thus symbolizes indestructibility and over-whelming power. The Tibetan word *dorje* can be translated "diamond" or "sovereign of stones". Thus *vajra/dorje* is expressive of the adamantine ("diamond-hard") quality of Buddha-mind. The *vajra* is seen in Tibetan art as the attribute of several deities who either hold it in one of their hands or have it placed near or on their body. The *vajra* is also used as an element in religious architecture and decoration, both in the single and crossed forms. This symbol furthermore occurs in Tibet as a tool for ritual use. As such it is always paired with the bell (T. *dril-bu*; S. *ghanta*). The bell must match the *vajra* in size and have as its handle a half-*vajra* of similar form.

Mahayanist doctrine developed a scheme of pairing the *vajra* symbol which is conceived of as "means" and masculine, with the lotus symbol, conceived of as "wisdom" and female. The union of *vajra* and lotus symbolizes the supreme truth. In Tibet the bell replaces the lotus as the female emblem of wisdom and is manipulated together with the *vajra* in rituals.

Mantras (symbolic sounds)

Sound is an important aspect of the spiritual world in Asia. Chants and spoken prayers are essential elements of all worship, invoking aspects of the sacred realm of pure sound. Such aural devices can be seen as well, and their presence should be assumed when viewing mandalas and other meditative tools. For example, "seed-syllables" (S. *bija*) for specific Buddhas can take the place of representations of the deity in mandalas and other paintings or cult objects. Two often-encountered *mantras* in Tibetan art are:

All-Powerful Ten (S. *dasakara vasi*; T. *namchu wangden*)
This is a mystic monogram composed of ten Sanskrit syllables, *Om Ham Ksha Ma La Va Ra Ya Hum Phat*, surmounted by the sun/moon/flame symbol as in the *chorten*. The ten syllables represent the elements of the cosmos as put forth in the Kalachakra doctrines.

Mani
The most popular *mantra* in Tibet is *Om mani padme hum* ("Hail the jewel-lotus") associated with Avalokiteshvara. This *mantra* is not only chanted but is also inscribed on stones in either Sanskrit or Tibetan letters. The stones are then placed in walls or piles at auspicious spots.

Sets of Symbols

Eight Glorious Buddhist Emblems (S. *ashta-mangala*; T. *tashi takgye*)

The eight emblems—umbrella, fish, conch, lotus, wheel, banner, vase and endless knot—are the most common decorative elements in Tibetan life as seen in costumes, tents, architecture and in much of the paraphernalia of everyday life. Two emblems in the set have quite early origins in Indian Buddhism and have been discussed as independent symbols: *The Wheel of the Law* and the *Lotus*. The other six have less profound symbolism but are still found as independent emblems:

The Umbrella (S. *chatra*; T. *duk*)
The early royal connotations of the umbrella in India were incorporated into Buddhist lore signifying the Buddha as universal spiritual monarch.

The Golden Fish (S. *matsya*; T. *ser-nya*)
The twin fish, shown with adorsed arching bodies, are symbolic of freedom from restraint (i.e. in the fully emancipated Buddha state, no obstacles to freedom are encountered). The fish also con-note the life-giving properties of water.

The Conch Shell (S. *sankha*; T. *dung*)
The conch is symbolic of the spoken word, a tradition originating in Vedic India. The shells were valuable and rare items in Tibet, imported from India for ritual use, both as musical instruments and as offering vessels.

The Standard of Victory (S. *dhvaja*; T. *gyaltsen*)
The standard is taken from the banner of victory of military battles and symbolizes the attainment of enlightenment. Because it is believed effective in combating the powers of evil, the standard is often found as roof and gateway decoration, fabricated out of gilt copper, painted wood or cloth.

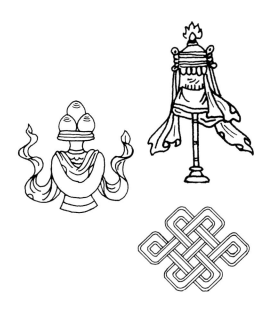

The Vase (S. *kulasa* or *dhana kumbha*; T. *bumpa*)
The vase is symbolic of longevity when it contains life-giving water. As the container of treasures it symbolizes the fulfillment of highest aspirations.

Endless Knot (S. *shri vatsa*; T. *palgyi be'u*)
This emblem symbolizes the interrelatedness of all things and the endless interaction between wisdom and compassion. It can also be interpreted as a symbol of longevity or the "knot of life".

The Seven Treasures of Royalty (S. *sapta ratna rajya*; T. *gyalsi nadun*)
These ancient Indian treasures of royalty—the Wheel, Jewel, Horse, Elephant, Queen, General, Minister—were adapted as the special treasures of the Buddha in his role as Universal Spiritual Monarch. The treasures are shown as offerings to deities in various groupings, especially in paintings.

The Wheel, discussed above, can stand as a separate emblem. The wish-granting jewel and the horse also appear as independent emblems in Tibetan art and ethnography.

The Wish-Granting Jewel
(S. *cintamani*; T. *yizhin norbu*)
The mother of all gems is usually depicted in Tibetan Buddhist art as a bouquet of six or nine elongated jewels surrounded by flames.

The Horse (S. *asva*; T. *tamchog*)
Since he carries his rider pegasus-like through the air in whatever direction desired, the jewel horse is associated with the idea of the realization of material wishes. On his back is a single flaming jewel or The Three Jewels. The same horse appears on the prayer flags where he is known as the *lungta* or "wind horse".

The Elephant (S. *hasti*; T. *langpoche*)
Taken from Indian mythology, the elephant is the mount of kings and symbol of royal splendor. Like the horse, the elephant carries the flaming jewel on his back.

The queen, general and minister can either be shown together, as here, or separately.

The Queen (S. *rani*; T. *tsunmo*)
Symbolizes constancy and royalty.

The General (S. *kshatri*; T. *magpon*)
Conquers all enemies.

The Minister (S. *mahajana*; T. *lonpo*)
Regulates the business of empire.

Precious Jewels

(T. *rinchen dun*, "seven precious jewels," and *newai rinchen dun*, "seven semi-precious jewels"). Like the treasures of royalty, the jewels of wealth are frequently depicted as offerings in paintings and as auspicious emblems in textiles, architectural decoration and domestic implements. These groups, which seem to follow closely the various sets of eight treasures known in Chinese mythology, occur in Tibet in sets of seven. Shown are the most common.

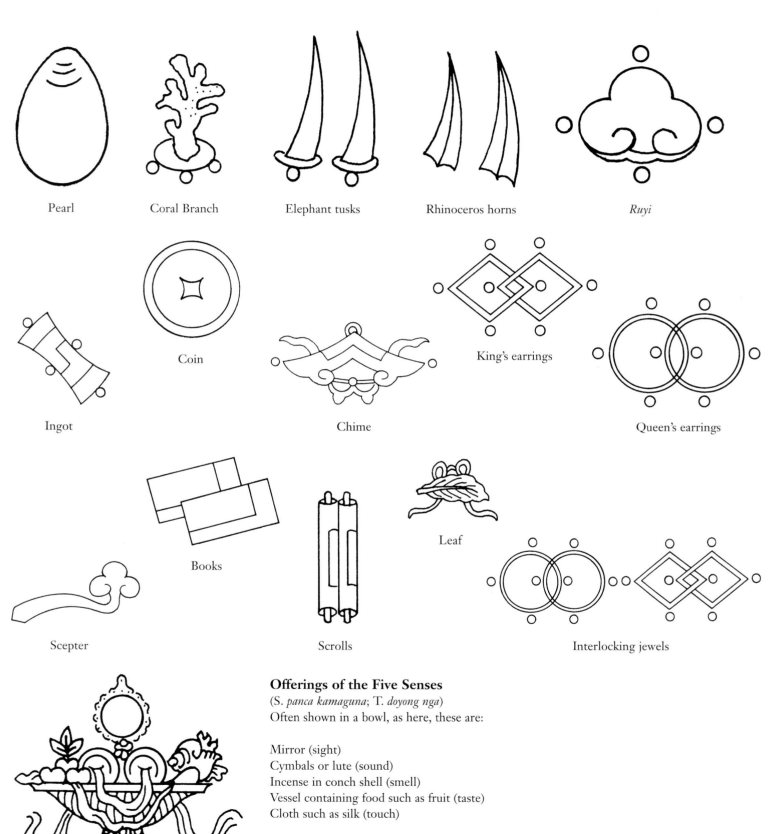

Pearl Coral Branch Elephant tusks Rhinoceros horns *Ruyi*

Coin

Ingot Chime King's earrings Queen's earrings

Leaf

Scepter Books Scrolls Interlocking jewels

Offerings of the Five Senses

(S. *panca kamaguna*; T. *doyong nga*)
Often shown in a bowl, as here, these are:

Mirror (sight)
Cymbals or lute (sound)
Incense in conch shell (smell)
Vessel containing food such as fruit (taste)
Cloth such as silk (touch)

The offerings can also be spread out as individual items.

Individual Symbols

Sun-Moon Emblem (T. *nyi-da*)
This emblem can occur as an independent celestial emblem, or surmounting *chortens* where it symbolizes the element air.

The Three Jewels (S. *tri-ratna*; T. *konchog-sum*)
This is the Buddhist symbol of the Holy Triad (S. *Buddha, Dharma, Sangha*) in which every professing Buddhist takes his daily "refuge". *Dharma* signifies the Word of Buddha or the Law. *Sangha*, originally signifying Buddha's order of monks, is generally interpreted by Tibetans as meaning the Congregation of Lamas or the Buddhist Church.

Swastika (S. *svastika*; T. *yüng-drung*)
The swastika is one of the most ancient and widely diffused symbols, present in prehistoric Asia, Eurasia and the Americas. Tibetan Buddhists regard it as a symbol of the eternal state of enlightenment (*bodhi*). It is also used as an auspicious emblem for longevity. The arms of the Buddhist swastika characteristically point to the right or in the direction of the sun's course.

Whirling Emblem (T. *gakhil*)
This circle enclosing three (sometimes four) "whirling" segments signifies the blissful mind radiating compassion. Alternately it can represent ceaseless change and movement, like the swastika.

Peacock Feather
This auspicious feather with an "eye" at its tip is the special symbol of certain deities and saints. Peacock feathers are placed in vases containing the Water of Life. According to legend the peacock can swallow poisons without being harmed; therefore its plumage is used to symbolize the eradication of spiritual poisons.

Yin-Yang
This is an ancient Chinese symbol of the two First Causes or Creative Principles, *Yang* and *Yin*, expressed in opposites such as heaven and earth, light and darkness, male and female, movement and repose, etc.

Astrological and Divination Symbols

The Twelve Animals
The *twelve animals* designate hours, days, months, years and points of the compass. They are the mouse, ox, tiger, rabbit, dragon, serpent, horse, sheep, monkey, cock, dog and boar.

The *five elements* which link to the twelve animals to form sixty possible combinations in the calendar year are water, fire, metal, wood and earth.

The Tibetan calendar is based on a complex system derived from ancient Chinese, Indian and perhaps western Asian concepts. The use of twelve animals and various groups of elements as astrological symbols was probably well established in Tibet when Atisha introduced the cycle of sixty years in 1027 C.E. Under this system, based philosophically on the *Kalachakra Tantra*, the twelve animals combine with five elements to designate sixty years. Since the names are repeated every sixty years it is impossible to determine exact dates in Tibet unless the cycle is known or the animal-element designation is linked to the name of an historical individual or event.

Tri-grams (T. *jung-kham*; Chinese: *bagua*)
These ancient Chinese tri-grams are attributed to a legendary emperor named Fuxi. The three unbroken lines symbolize the active male principle, *Yang*, of which the most complete expression is heaven. The three broken lines symbolize the female, passive principle, *Yin*, expressed by earth. The combinations of broken and unbroken lines symbolize essential elements in the universe in which Yang and Yin are variously combined: sky, lake, fire, thunder, wind, river, mountain and earth. Tibetans use these tri-grams in astrology and divination.

Mythological Animals

Monster Mask (S. *kirtimukha*, "glory face"; T. *chibar*, "that which resembles nothing", and *shi-dong*, "face of splendor"; Chinese: *taotie*)
This disembodied face represents a god of the skies. The mouth is shown devouring or giving forth snakes, dragons, sprays of vegetation, clouds or other substances, showing perhaps that like the sun the god of the skies has the dual function of creator and destroyer. The *chibar* is characteristically shown in conjunction with two other creatures: his human arms hold the tails of snakes or dragons, or he is flanked by dragons, sun-birds or other animals. The mask can appear armless as well. Both forms of the mask lack a lower jaw. The face is a composite monster using elements of ferocious beasts such as the lion. The masks, often connected by festooned pearls, frequently occur as decoration on Buddhist altars and on such ritual objects as bells.

Makara (S. *makara*; T. *chusin*)
This Indian mythological sea monster symbolizes the life-giving power of water. Like *nagas*, the *makara* is a keeper of treasure. Pairs of *makaras* appear on the sides of aureoles which surround deities. Pearls, flames and treasures can issue forth from their mouths. The single *makara* is often used to form the spout of vessels or as an architectural finial. In the latter function, the *makara* is popularly regarded as an auspicious emblem to ward off evil.

Naga (S. *naga*, *nagini*; T. *lu*, "serpent")
The *nagas* are serpent demigods in Indian mythology but they also figure in Tibetan folklore, probably predating Indian influence. Serpent demigods appear in Bon cosmology in which they rank in the lowest quadrant of the universe. The cult of *nagas* was widespread throughout Buddhist Tibet since they are believed to enhance the fortune of devotees and send rains for crops and pastures, but will also send diseases called *lu-ne* if displeased by humans.

Dragon (T. *druk*; Chinese: *long*)
Although it interrelates somewhat in Tibetan mythology with the Indian idea of the *naga* water monster, the Tibetan concept of dragon is primarily based on the Chinese model. In ancient China, the dragon symbolized renewal and transformation with special power over rain and association with the season of spring. The *long* dragon, the commonest form in Chinese and Tibetan art, is the most powerful and inhabits the sky. According to Chinese mythology, the *long* should have the head of a camel, horns of a deer, eyes of a rabbit, ears of a cow, neck of a snake, belly of a frog, scales of a carp, claws of a hawk and palms of a tiger, thus incorporating the many powers and talents of the animal world. The fully developed Chinese dragon which was transmitted in textiles, ceramics and other decorative arts to Tibet is often shown chasing or clutching a flaming jewel or disc. A very stylized dragon or pair of dragons is encountered in Tibetan art, with the body or bodies dissolved into cloud-like forms.

Garuda (S. *garuda*; T. *khyung*)
The *garuda* is a mythological bird of Indian and Tibetan folklore. He wages continual warfare against the *nagas* or serpents. Thus he is considered to be a protection against poisoned water and other maladies sent by the *nagas* when they are angered. The *nagas* also bless mankind by sending rain, and so the *garuda*, due to his power over them, is looked upon as a rain bringer.

The *garuda* is part bird and part human. His human arms hold a serpent which he chews. Frequently he treads upon serpent gods. In Tibet the *khyung* form of *garuda* has horns and is a comprehensive sky god. The *khyung* is one of the four animals in Bon mythology.

Kinnara (S. *kinnara*, *kinnari*; T. *mihamchi*)
These heavenly musicians of Indian origin are represented as half human and half bird. They have an angelic role as peripheral creatures of auspicious nature.

Phoenix (T. *gyaja*; Chinese: *feng huang*)
The Tibetans use the Chinese phoenix as a general auspicious emblem but do not give it the special significance which it has in Chinese mythology.

Lion (S. *sinha*; T. *seng*)

The lion has an indigenous history as a mystic animal in Tibet, which was reinforced when Buddhism was introduced with its use of a lion throne for the Buddha. The lion can be seen in many roles in Tibetan art. It is the third of the Bon mythological animals. The lion of Buddha remains as a peripheral supporting beast for the thrones or bases of various deities, often literally supporting the base with its up-raised hands in an Atlas-like pose. There is also a rather separate concept of the snow lion as an emblem of the Tibetan state. As such it appears on the Tibetan national flag where it stands for the fearlessness and superiority of the religious law which the Dalai Lama upholds.

Tiger (S. *byaghra*; T. *tak*)

The tiger is the fourth Bon mythological animal. It symbolizes the king of wild beasts, possessing special dignity and courage.

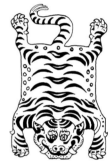

Mongoose (S. *nakula*; T. *ne-le*)

The mongoose symbolizes wealth since, according to Indian tradition, he conquers the serpent demigods or *nagas* who guard the treasures hidden beneath the earthly waters. He is shown disgorging jewels.

Flayed Skins (T. *pag*)

The flayed skins of various wild animals can be seen as the covering of deities' thrones or seats, as attributes of deities, and as offerings to deities. The animals chosen for this role are most commonly tigers, elephants and antelope, but all manner of beasts including humans can be used in this way. The basic meaning of the flayed skins is the power of Buddhism and its skilled practitioners to subdue the wild forces of nature. These wild forces can be interpreted as our own inner psyche or as external evils.

Miscellaneous design elements derived from Chinese mythology

The symbols in this group occur frequently in Tibetan textiles and decorative arts but do not have the potent meaning in Tibet that they did in their native China. Tibetans admire the beauty of these elements and have knowledge of their general auspicious nature.

Bat (happiness)

Shou (long life)

Mountain/sea (earth)

Clouds (sky)

Peony
(spring, good fortune)

Chrysanthemum
(autumn, joviality)

The three fruits: peach,
pomegranate, citron
(immortality, fertility, happiness)

Attributes

These objects are held by (or displayed in front of) deities and religious figures.

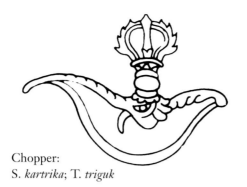

Chopper:
S. *kartrika*; T. *triguk*

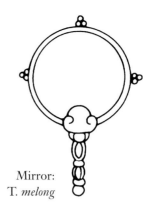

Mirror:
T. *melong*

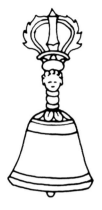

Vajra bell:
S. *ghania*; T. *drilbu*

Prayer beads:
S. *malla*; T. *trengwa*

Dagger or "peg":
S. *kila*; T. *phurpa*

Begging bowl:
S. *patra*

Arrow:
S. *shara* or *bana*; T. *da*

Alarm staff:
S. *khakkara*; T. *kharsil*

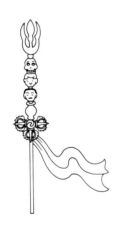

Trident: S. *trishula*;
T. *khatvamga tsesum*

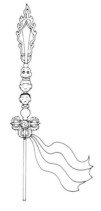

Ritual wand:
S. *khatvanga*

Book, scriptures:
S. *poti, pustaka*; T. *pecha*

Skull cup:
S. *kapala*; T. *todpa*

Noose:
S. *pasha*; T. *zhag*

Butter offerings:
T. *torma*

Fly-whisk:
S. *chamara*; T. *ngayab*

Sword:
S. *khadga*; T. *raltri*

Skull drum:
S. *damaru*

Index of Names and Places

Photographic Credits

All photographs by Richard Goodbody unless otherwise noted.